D1239628

Digital Photography
Expert Techniques

Digital Photography
Expert Techniques

SECOND EDITION

Ken Milburn

O'REILLY®

BEIJING • CAMBRIDGE • FARNHAM • KÖLN • PARIS • SEBASTOPOL • TAIPEI • TOKYO

BOCA RATON PUBLIC LIBRARY
BOCA RATON, FLORIDA

Digital Photography Expert Techniques, Second Edition

by Ken Milburn

Copyright © 2007, 2004 O'Reilly Media, Inc. All rights reserved.
Printed in Italy.

Published by O'Reilly Media, Inc., 1005 Gravenstein Highway North, Sebastopol, CA 95472.

O'Reilly books may be purchased for educational, business, or sales promotional use. Online editions are also available for most titles (*safari.oreilly.com*). For more information, contact our corporate/institutional sales department: 800-998-9938 or *corporate@oreilly.com*.

Print History:

March 2004: First Edition.

October 2006: Second Edition.

Editor: Colleen Wheeler

Production Editor: Genevieve d'Entremont

Copyeditor: Laurel Ruma

Indexer: Johnna VanHoose Dinse

Cover Designer: Mike Kohnke

Interior Designer: David Futato

Illustrators: Robert Romano and Jessamyn Read

The O'Reilly logo is a registered trademark of O'Reilly Media, Inc. The Digital Studio series designations, O'Reilly Digital Studio, *Digital Photography Expert Techniques*, and related trade dress are trademarks of O'Reilly Media, Inc.

Many of the designations used by manufacturers and sellers to distinguish their products are claimed as trademarks. Where those designations appear in this book, and O'Reilly Media, Inc. was aware of a trademark claim, the designations have been printed in caps or initial caps.

While every precaution has been taken in the preparation of this book, the publisher and author assume no responsibility for errors or omissions, or for damages resulting from the use of the information contained herein.

0-596-52690-3

978-0-596-52690-0

[L]

Contents

Introduction

If you've picked up this book, you're obviously interested in digital photography. And there is a wide variety of digital photography books available these days. However, if you've ever dreamed of being a *serious* digital photographer, the second edition of *Digital Photography Expert Techniques* is the place to start.

Since the first edition of this book was written, the focus of the book has moved to a nondestructive workflow. The term "workflow" has been bantered about so much that it can mean most anything. In the context of this book, it means an organized process of creating a finished photograph that starts with an idea and ends by being shown or passed on to other people. That organization is structured so that when a change in the interpretation of the image is required, it is possible to go back only to the specific stage at which the re-interpretation must be made. That is because each new step is done in a way that does not disturb the original image, or the process does not use any more adjustment steps than absolutely necessary in order to make the needed change.

Organization of This Book

This book consists of 12 chapters. At the beginning of most chapters is a sidebar titled "How This Chapter Fits the Workflow," which gives you perspective on what you will be doing and why you're doing it at that stage of the organization. After that, I address common issues that you're likely to face as you move further into that domain. As the title of this book suggests, the combination of these issues form a set of "expert techniques" that you can use to successfully master that task.

Chapter 1, *A Plan for Nondestructive Workflow*
 Puts the organization of the entire book in perspective, so that you know what my concept of start-to-finish workflow is all about, as well as the rationale for the sequence.

Chapter 2, *Be Prepared*

Tells you everything you need to know about getting ready to start shooting. The chapter covers how to set your camera to be prepared for shots, what accessories are likely to be helpful, what settings are likely to work when you don't have time to think, how to keep the camera steady, and how to freeze action.

Chapter 3, *Bridging the Gap*

Is all about Bridge; this image management program now comes with any and all the Adobe CS2 Suite applications. In this instance, however, Bridge is discussed primarily in relation to Photoshop and to the myriad ways that it helps to keep your workflow organized.

Chapter 4, *Streamlining Camera Raw*

Gets into a great deal more depth about streamlining your processing while in Camera Raw and the benefit of doing as much of your processing as possible while you're in this completely nondestructive stage of operations.

Chapter 5, *Nondestructive Layering*

Describes, in detail, how layers can be used to isolate destructive operations so that they can be carried out without affecting anything else you've done to the image.

Chapter 6, *Nondestructive Overall Adjustments*

Shows how to use adjustment layers, which are completely nondestructive, to make overall image adjustments. There are tips and tricks for using almost all the different types of adjustment layers. Image adjustments administered by commands that are not available as adjustment layers are covered in Chapter 8, when you've exhausted all the possibilities for completely nondestructive editing.

Chapter 7, *Making Targeted Adjustments*

Discusses making and using selections, masks, and other means of making adjustments that pertain only to portions of the image. You also learn how to modify layer masks after the basic adjustments have been made to further enhance a portion of the image.

Chapter 8, *Repairing the Details*

Covers all types of image repair, including retouching. Retouching is always maximally destructive, so you are also taught how to isolate the image to preserve all the work you have done up to this point.

Chapter 9, *Collage and Montage*

Discusses making one image from multiple images using the techniques of both collage and montage. A collage is an image obviously composed of multiple images and doesn't require doing such things as matching shooting angles, hiding cutout borders, and otherwise attempting to "fool" the viewer into thinking that this is a factual photo. A montage

takes the viewer to a time and place that, though it looks real, never really existed as a visual reality...at least not when a camera was present to record it.

Chapter 10, *Creating the Wow Factor*

Presents the next stage of progressively more destructive editing: special effects. Most special effects are created by filters and plug-ins that respecify every pixel in the targeted portion of the image.

Chapter 11, *Special Purpose Processing*

Covers "specialized" (for lack of a better, all-inclusive term) image processing. More specifically, it discusses panoramas and enhanced resolution images (including how to shoot them so the multiple images required to make them blend together seamlessly), dynamic range extension techniques, and converting photos to "paintings."

Chapter 12, *Presenting Your Work to the World*

Contains the most effective techniques for communicating your photographic talents to the world. In other words, this chapter is all about preparing your image for output and then how to use that output to show off your talents in an efficient and cost-effective way.

Appendix, *Workflow Alternatives*

Takes a look at some workflow alternatives, including software tools such as Capture One, Aperture, and Raw Shooter. You'll also find information there about how to access the bonus chapter on Adobe's Lightroom (*http://digitalmedia.oreilly.com/lightroom*).

Who This Book Is For

This book is for photographers who are serious about producing the highest quality photographs in the most efficient and cost-effective way possible. For that reason, I speak as though I'm talking to fellow professionals, all the while knowing that any serious photographer can do her best by taking a professional approach to creating images that communicate as effectively as possible.

Because there are so many solutions and techniques to cover, I faced a conundrum: should I try to make it easy for everyone to understand, or assume that readers have at least a little familiarity with Photoshop? I opted for the latter. For example, I assume that you know how to use common commands and tools (e.g., the Magic Wand and the Move tool), and I also saved a lot of time, words, and pictures by making liberal use of keyboard shortcuts or by simply putting the command in brackets.

Does this mean that Photoshop novices shouldn't buy this book? Not at all. It just means that you may need a beginning Photoshop book as a quick tutorial. If you're looking for a good place to start, consider Deke McClelland's *Adobe Photoshop CS2: One on One* (O'Reilly).

This edition concentrates on digital single-lens reflex (SLR) cameras, which have become the hallmark of serious digital photographers in the time since the first edition was written. This book focuses on digital SLR cameras that have higher megapixels of noninterpolated resolution, interchangeable lenses, and larger, more noise-free sensors—in other words, professional-quality cameras that let you clearly see exactly what the lens sees. Because these cameras are all capable of producing high-quality RAW files, this book also explores how to get the most out of RAW files.

This book is more about workflow than it is about procedures in a specific program. Because the majority of serious digital photographers use Photoshop, that's the program used in most of the examples in this book.

So does this book contain all the information you'll ever need as a professional digital photographer? Of course not. Hundreds of books have been written on the subject of digital photography and digital image editing. If anyone could have fit all that information between the covers of one or two books, it would have been done a long time ago. Be sure to let me and the folks at O'Reilly know if we've missed any that are especially dear to your heart. We'll try to squeeze them into the next edition.

About Photoshop Versions

Adobe Photoshop CS2, which first appeared in the summer of 2005, is the ninth iteration of Adobe's world-famous image editing program. I'll gleefully point out new features in Photoshop CS2 that are especially notable at particular stages of the workflow recommended in this edition of *Digital Photography: Expert Techniques*.

Conventions Used in This Book

This book is meant to be equally useful to both Mac and Windows aficionados. There is virtually no difference in the operation of Photoshop and the other programs mentioned herein.

Menu commands are exactly the same unless followed by a parenthetical remark that points out a difference or distinction. Menu commands are given in hierarchical order, with an → preceding each new appearance of a cascading menu—for example, Image→Adjustments→Levels. If a menu appears from a palette or dialog menu, the name of the menu or dialog will precede the naming of the command hierarchy.

Macs and PCs use different but equivalent keys for keyboard shortcuts, so I'll give you both commands in one breath. Because Photoshop first appeared on the Mac, the Mac command abbreviation is given first, followed by the Windows command abbreviation. So a keyboard shortcut is given like this: Cmd/Ctrl-Opt/Alt-D (that is, Cmd-Opt-D on the Mac and

Ctrl-Alt-D on the PC). Today, there is no meaningful difference in the functionality of the Mac or Windows versions of Photoshop CS2.

The following typographical conventions are used in this book:

Plain text

Indicates menu titles, menu options, menu buttons, and keyboard accelerators (such as Alt and Ctrl).

Italic

Indicates URLs, email addresses, filenames, file extensions, pathnames, and directories.

Comments and Questions

Please address comments and questions concerning this book to the publisher:

O'Reilly Media, Inc.
1005 Gravenstein Highway North
Sebastopol, CA 95472
800-998-9938 (in the United States or Canada)
707-829-0515 (international or local)
707-829-0104 (fax)

We have a web page for this book, where we list errata, examples, and any additional information. You can access this page at:

http://www.oreilly.com/catalog/digphotoet/

To comment or ask technical questions about this book, send email to:

bookquestions@oreilly.com

For more information about our books, conferences, Resource Centers, and the O'Reilly Network, see our web site at:

http://www.oreilly.com

Safari® Enabled

When you see a Safari® Enabled icon on the cover of your favorite technology book, that means it's available online through the O'Reilly Network Safari Bookshelf.

Safari offers a solution that's better than e-books. It's a virtual library that lets you easily search thousands of top tech books, cut and paste code samples, download chapters, and find quick answers when you need the most accurate, current information. Try it for free at *http://safari.oreilly.com*.

Acknowledgments

Thanks to Steve Weiss, the O'Reilly executive editor for digital media who has groomed many a Photoshop author into achieving fame and fortune. He's also fun to talk to and a superb human being. Colleen Wheeler, the developmental editor, is supremely intelligent and has a wonderful sense of humor as well as organizational and technical perspectives. James Duncan Davidson was the technical reviewer for this book, providing insight and helpful comments every step of the way. And I have to give credit to the great O'Reilly production team.

Also, many thanks to Margot Maley Hutchinson, my agent at Waterside Productions. She is simply the cream of the crop: honest, loyal, brainy, hard-working, and a great mom.

Many of the best lessons in life are taught to us by our families. My son, Lane, has been a great teacher, and the directions his life is taking today are just downright inspiring. I also owe a lot to my extended family: Bob Cowart, Janine Warner, Nancy Miller, Jane Lindsay, Sherry Epley, Kim Friscia, Jim Coe, Roger Mulkey, Rick White, and a host of other friends and neighbors.

I'd especially like to thank Tatyana You'no, the amazing face painter who did a job on herself especially for this book's cover. Her baby daughter is also on the cover. If you're looking for a face painter or a very patient model, you can reach Tatyana by email at *fairyfacepainting@gmail.com*.

Finally, this book couldn't have happened without support and help from every manufacturer or publisher whose products are mentioned or featured.

A Plan for Nondestructive Workflow

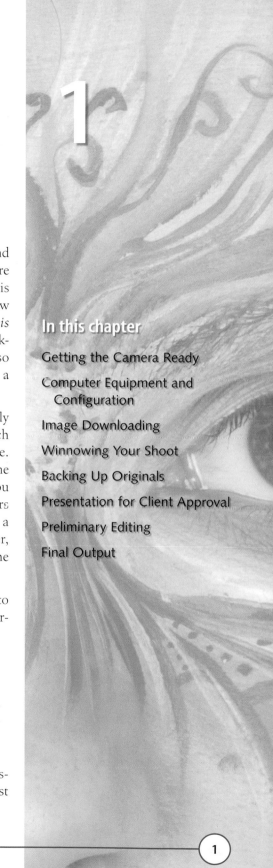

This chapter gives you an abbreviated overview of the workflow around which the rest of this book is structured. It's a sort of quick guide. More importantly, it orients you to the way this book builds itself on what is currently being called *nondestructive workflow*. Although the workflow buzzword has lately been thrown around with a variety of meanings, *this* workflow is very carefully structured so that you are guaranteed to be working in what will ultimately be the most productive and efficient way. It also guarantees that you will never have to start from scratch when you need a different interpretation of the same subject.

So what's nondestructive all about? Well, first of all, the procedure only starts with being nondestructive. Of course, certain operations, such as retouching or using special-effects filters, are maximally destructive. However, when it comes time to do such work, you will have already done all the completely nondestructive work that you can. Furthermore, you will have protected that nondestructive work, keeping it on separate layers within the same file, so you never need do it again. So if you ever want a different look in that respect, you can simply turn off that destructive layer, then create a new layer (or layers) from the nondestructive layers for the process required by the alternative operation.

Another thing that's all-important to efficient workflow is being able to track your images and their variations—the DAM work. We're not swearing; DAM stands for *digital asset management*.

> **NOTE**
>
> *The DAM topic in this book is much more abbreviated than in* The DAM Book: Digital Asset Management for Photographers *by Peter Krogh (O'Reilly). On the other hand, you can do a lot of work here that will eventually blend with advanced techniques when employing the full scope of* The DAM Book.

Something else that's different here: this book doesn't start with processing in Photoshop, but with planning your shoot to give the best and most

data-rich images possible as a starting point. After all, it does you no good to work extensively on images that don't have the best potential right from the start.

Getting the Camera Ready

Chapter 2 will go into great detail about your equipment needs and setup. However, for this overview, I've listed a few key thoughts about how to have your camera ready to create the best input data for the rest of the process:

- Keep your basic lens on the camera unless you know you're about to shoot a special situation. For instance, if you normally do photojournalistic work, you'll probably want to keep the 35mm equivalent of a 28–120mm lens on the camera.

- Always keep a strap on each camera and wear the camera you use the most around your neck, ready to shoot. Then all you have to do when the moment comes is "ready, aim, fire." If a passerby bumps you and the camera flies out of your hands (or someone tries to steal it), it stays around your neck.

- Neutralize the camera settings. That is, set them so that you're most likely to be ready for what happens next. If you're shooting RAW (read Chapter 3 to see why you should be—and when you shouldn't), if you have to shoot JPEGs, turn off all the settings that cause the camera to preprocess the photo: color balance, saturation, and special effects (such as sepia or infrared), and situational settings (sun, shade, snow, portrait, etc.). You can always turn them on when you need them.

- Most cameras give you the choice of naming all files in sequence or restarting the sequence each time you change a card. Make certain that this setting *always* stays at the default of naming all files in sequence.

- I like to keep my camera set for sequence shooting. If there's fast action going on, I'm more likely to catch the peak moment. If there's any doubt about whether the camera will be steady enough to ensure a sharp shot, shooting a sequence makes it likely that one or two of the shots will be sharper than the others. Remember, there's no such thing as wasted film in digital. You just delete whatever doesn't work out.

- It's a good idea to carry two camera bodies. I often use a full-frame body and back it up with a slightly less expensive DSLR. On the other hand, if your base camera is relatively affordable (for some time, mine was a Digital Rebel XT and now it's my No. 2), it's worth considering simply buying two of them. Any pro will tell you that the only time your camera breaks down is when you can least afford it. You're on the vacation or assignment of a lifetime when a donkey kicks the tripod and knocks it off an 800-foot cliff.

NOTE

Many pros like carrying a compact camera as a second or third camera. You can be assured of having it with you all the time, it makes it easier to shoot from extremely low or high angles, and it is especially well-suited to macrophotography (extreme closeups) due to the greatly extended depth-of-field afforded by their tiny sensors.

- Don't change lenses when there's visible moisture, dust, smoke, or other "stuff" in the air. No, not even if your camera has a built-in dust remover. It is possible to over-power any technology. If you don't have a proper sensor cleaning kit, then you're definitely going to spend hours retouching the same spot on hundreds of frames. The best plan, whenever possible, is to take along a pair of bodies. Put a long zoom on one and a wide-angle zoom on the other—or whatever two focal lengths you're most likely to need. Having two bodies with different lenses also makes it faster to switch focal lengths. Or get one of the new 18–200mm zoom lenses being offered by many manufacturers.

- Because you're bound to change lenses sooner or later, be sure to take along a sensor-cleaning 'kit. *Do not* even think about trying to clean your sensor with lens-cleaning spray, cotton swabs, or blower brushes. Those are all good items to keep handy for lens and body cleaning, but they will *ruin* your sensor. There are many sensor-cleaning kits on the market and it seems like a new one is introduced every week. My two favorite sites for checking out the latest reviews on these prodcuts are *www.dpreview.com* and *www.robgalbraith.com*. Figure 1-1 shows two of the more popular sensor swabbing kits. Be sure to get the one that is sized to fit the width of your particular camera's sensor.

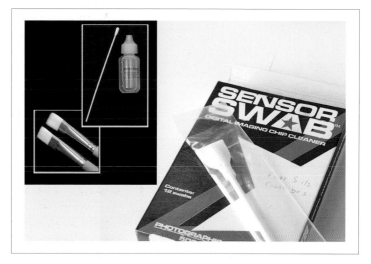

Figure 1-1. Sensor-specific cleaning kits are the only appropriate tools for cleaning your sensor.

Finally, you want to make sure you have all the right accessories at hand. You'll find all the basics listed in Chapter 2.

Computer Equipment and Configuration

Today's images are getting bigger and better than ever. If you were used to shooting 5 MP JPEGs and then jumped to the 8 MP RAW files that some of today's $900 DSLRs shoot, your file size will increase from about 1.5 MP to between 5.5 MP (saved to DNG) and 8 MP (Canon CR2 file in 16-bits [only 12-bit of image data] for 8 MP image). Once you've processed that file according to the recommendations in this book, you'll have between 5 and 15 layers and several will be image layers. You could easily end up with 100 MB files for all your best images—that is, the ones you have the incentive to really put some effort into processing to perfection. For example, last year I shot some 8,000 images in CR2 format. Let's say the toss-out rate is about 15 percent. That still leaves 6,800 images I have to store and find...and I have to spend *most* of my time writing books! Still, this isn't too bad. I've used only about 54 gigabytes of storage so far. If about 10 percent graduate to stardom, that's only 680 images. The problem is, each image is going to

need about 100 MB of space by the time I finish editing them nondestructively. So I need another 54 GB for the special 10 percent that survive. You begin to see the problem when you realize that a lot of pros shoot at least 10 times as many images as I do.

The bottom line is that you need to start with a very fast computer with lots of storage. For either Windows or Mac, I'd suggest a dual core or 64-bit processor running at around 2.4+ gigahertz. Plug at least 1 MB of RAM into the motherboard and move up to 2+ MB as quickly as you can afford it. This book is going to teach you to truly appreciate speed and horsepower.

Every time you see a sale on 250–500 GB external hard drives, get yourself another. External drives make the most sense for storing large image libraries. They're easy to copy to one another for backup and they can easily be moved from computer-to-computer. At sale prices, you'll pay around 75 cents per gigabyte or $180 for a 250 GB drive. Make backups by copying one drive to another while you're sleeping. External hard drives love to crash—a much unpublicized fact—and you don't dare risk your valuable images. Be *very* careful to follow the prescribed routines for installing the software for the drives, plugging them in and out, and turning them on and off.

When it comes to your ability to see your images clearly so you can judge them accurately, you'll want to pay attention to your video system. You want a high-performance video card. The NVIDIA GeForce, ATI Radeon, and Matrox are presently considered best-in-class. Check out current web reviews and information for what is considered state-of-the-art. (You don't need the top of the line cards that are intended for the gamers' market.)

It's also time to move up to a state-of-the-art flat-panel screen unless you're doing pre-press work in a production house. There are now excellent 19-inch models on the market for less than $300. Look for a model with a contrast ratio better than 500:1 (the higher the contrast ratio, the better) and the widest possible viewing angle. Most of us will gladly trade a tiny margin of brightness and contrast ratio for a steadier image that is much easier on the eyes and has virtually no screen glare. Besides, you need the extra room on your desk for a Wacom graphics tablet and all those hard drives.

Given the resolution that pros are expecting from their images, I wouldn't even consider a screen size smaller than 19 inches. If you have an older 17-inch monitor, consider getting a dual monitor video card and using the second monitor strictly for menus, Bridge, or DAM software.

Speaking of image backup, don't even think about anything less than a state-of-the-art DVD writer—8X write speed minimum. CDs just aren't capacious enough for contemporary files, and you have to spend way too much of your time swapping disks when they fill. *Do not* write on the disks with Sharpie markers or paste labels on them. Instead, go to your local office supply store and ask for acid-free markers. They look just like Sharpies, cost

a bit more, but won't send your images to heaven when you least expect it. Archival qualities of optical media are covered later in this chapter.

> **NOTE**
>
> *Delkin* (http://www.delkin.com/products/archivalgold/scratcharmor.html) *now makes gold DVD disks with a guaranteed life span. As soon as I've done my winnowing for a shoot, I put a duplicate of its folder into a folder reserved for DVD backup. I keep checking its properties until it's nearly a full DVD's worth of data, and then I copy that data to a Delkin gold disk and store it in an acid-free binder. I also make a contact sheet of what's on that disk, so I can quickly find the files I'm looking for.*

If you travel or hike while shooting, a high-horsepower laptop is a lifesaver. Look for the following features: 1+ MB RAM, 100+ GB HD, 15.4- or 17-inch widescreen, DVD writer, built-in WiFi, and built-in card reader. Even a duo-core 64-bit processor is an affordable option nowadays. You should be able to get all this for around $1,200 in a Windows laptop or for around $2,200 in a Mac laptop.

Image Downloading

One of the most critical points in an efficient workflow is the disciplined process by which you get your pictures from camera to computer. You want to combine downloading with both an efficient and effective naming process and a disciplined and regular means for backing up. As a part of this process, you want to get rid of anything that might be embarrassing to you, your client, or your model. Never was the phrase "out of sight, out of mind" more appropriate than when winnowing out the crap. The difference between an average photographer and a great one is that the great ones know what to throw away. Then, you want to immediately get your images to your client in a professional-looking presentation that makes you look as good as possible. Generally speaking, the more pictures the client likes, the more you'll get paid, and the more often you'll be asked to shoot again.

Downloading Alternatives

There are several devices you can use to download your images from camera to computer. First, most all digital cameras, and certainly all DSLRs, have either a USB or FireWire port that allows you to connect your camera directly to your computer. Second, you can buy a card adapter that plugs into either a USB or FireWire port. Finally, there are computers that have card readers built into them. You can see two of these devices in Figure 1-2.

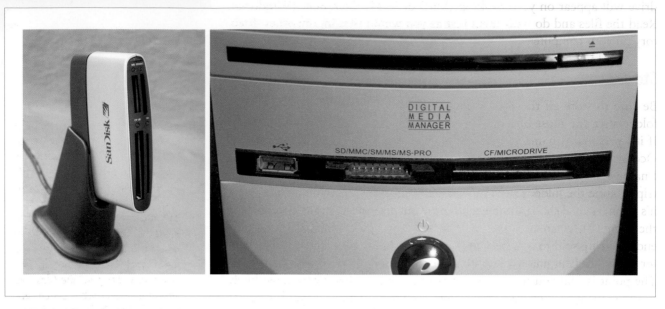

Figure 1-2. Left to right, an external card reader and a built-in card reader.

NOTE

The speed designations that manufacturers give their cards are only useful as a guideline. One maker's 4X card is not necessarily the same as another's. Borrow several brands and speeds, fill each with photos, and test them for yourself. It's easy to test download times for the cards.

It won't do much good for me to tell you which downloading device to use, because there are too many variables between devices, card speed, and internal computer circuitry to make that opinion meaningful. However, I will tell you that download speed is important. I've seen a difference of a minute and a half to 12 minutes just to download the same images from the same card through different devices to different computers. My advice to you: get or borrow all three types of devices, take them home, and test them with a stopwatch. A state-of-the-art digital card reader only costs about $25 these days, and spares come in handy if you're traveling without a computer or have to loan one to a client or friend. Actually, you'll need one if you have a Mac. Macs aren't available with built-in card readers! (Duh! Hello Apple, do you know how many of your customers are digital photographers?) Anyway, back to reality: Put your card filled with photos into each device and clock the download time for that card in that device. Put your camera in sequence shooting mode and fill a card with images. Then, download that card's images through an internal card reader, a USB 2.0 card reader, and (if you have a FireWire port) through a FireWire card reader. Make sure you download from the same card each time; that way, you know that it's not the speed of the card that is influencing your decision. Now you know which download device is fastest. Regardless of the speed of the card itself, the device that downloads that card fastest will download any card of any speed faster than the other devices you tested.

All things being equal, I'm in favor of the convenience of built-in, front-mounted card readers. They're always where you can reach them easily, don't require any operating expertise, can be used while you're camera is shooting something else, and require no software expertise. Plug a card into the appropriate slot (it won't fit if it isn't the right slot). Immediately, a new

drive will appear on your desktop (Mac) or in My Computer (Windows). Read the files and do with them just as you would files in any other directory on your computer.

Storing the Files

Be sure to store all the files from a shoot in the same folder. Name that folder after the most broadly applicable name you can give to the shoot. If it's personal, I name it after the person or place where I did the shoot. Occasionally, an entire shoot consists of a study of one subject. In that case, I name the folder after the subject. If the subject is something like a road trip, I name the folder after the farthest or most memorable destination. If it's a commercial shoot, I name it after the purpose of the shoot—never after the client. There are a couple of reasons for that: some of the photos may end up being sold to a variety of clients, and I may have folder after folder for the same client, many of which can contain very different subject matter. The point is that you want to name your folders so that you're most likely to know what they contain. You won't always be right, but you'll be right more often than not.

The first part of the folder name is the six-character date of the shoot organized by year, month, day—for instance, 060224. I don't use dashes or slashes or characters that are illegal in filenames. Here are some typical folder names:

> 060912 Lydia furs
> 051227 Morgan Hill
> 050612 Smith Wed
> 050707 Small Town Stock

Back up RAW files to DVD

Up until now, the workflow procedure has been the same for both RAW and JPEG. At this point, however, you want to convert your proprietary RAW files to a more archival and universal RAW file format called Adobe DNG. If you shot JPEG, skip the backup procedure here and move on to the sections about naming and winnowing files.

> **NOTE**
>
> *A few high-resolution digital camera backs (and possibly some upcoming Canon cameras according to current rumors) will shoot their RAW files in DNG format. If that's the case, you obviously needn't concern yourself with the procedures in this section.*

For the rest of you, as soon as you've downloaded your RAW files and put them into folders, back up those files to DVD. If you don't have a DVD burner, get a 16X dual-layer, read and read-write (R+RW) DVD burner or Apple Super Drive. If you want to install a new one internally, you'll save

> **NOTE**
>
> *Another photographer just suggested naming the file with the date ahead of the descriptive name. She puts the two digits for the year first, then month, then day. That way, the files automatically sort so that the most recent is at the bottom of the list. After trying that approach, I really like it. It's much faster to find the files I've shot most recently, which are the ones I'm likely to need most often.*

desktop real estate. If you already have a DVD recorder but want a faster and more capable one, keep both. Then you can easily copy CDs and DVDs directly from one drive to another without having to recopy them. That will be a big timesaver when you need to copy DVDs every three to five years to avoid their untimely demise.

Be sure to get some name-brand DVDs. Don't buy those no-name or store-name bargain-priced disks. With rare exceptions, you'll end up throwing away a huge percentage just because you can't write to them. When they do work, don't be surprised if you pop one in the drive a few days or weeks later, only to find that the computer can't read it.

> **NOTE**
>
> *The number of possible configurations for backing up your files is endless. For an in-depth look at back-up systems and archiving strategies, again, I'd recommend* The DAM Book: Digital Asset Management for Photographers *by Peter Krogh (O'Reilly).*

Converting to DNG

As I just mentioned, there is one nonproprietary RAW format that belongs to us all, even though it was invented by Adobe. It's called DNG—short for "digital negative." It has more features than proprietary RAW files and may eventually become a universal format. Any future version of this format is promised to be backward compatible with older versions, so it is unlikely that your files will be orphaned by the discontinuance of their format. Furthermore, you can rest assured that virtually all image editing software invented or updated since late 2005 will be compatible with DNG files. DNG files can even be read now as thumbnails by your operating system's file browser, provided you have updated your system.

If you haven't already downloaded the DNG converter from the Adobe site, do it now. It's a small utility that installs on your system's desktop and doesn't cost a penny. If you're familiar with Dr. Brown's Image Processor or its descendant, Photoshop CS2's Image Processor, you'll feel quite at home with the interface.

Here's the routine:

1. Install the Adobe DNG converter according to the instructions that come with the download. (In Windows, the installer places a shortcut on your desktop by default.)

2. Double-click the Adobe DNG Converter icon. The DNG Converter dialog will open (see Figure 1-3). As you can see, the DNG Converter dialog is divided into four sections. The next steps show you the settings to use for each section. If your eyes (or magnifying glass) are good enough to decipher the small print in the figure, you can just use the same settings.

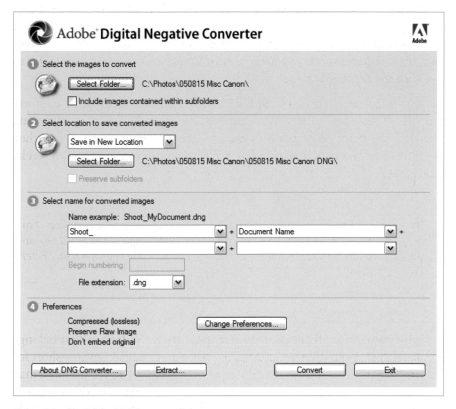

Figure 1-3. The Adobe DNG Converter dialog.

3. In Section 1, click the Select Folder button. You'll get a browser/finder-type dialog that lets you navigate to the folder where you just downloaded your images. At this stage, should you have any subfolders, they may not contain any RAW files. If that is the case, leave that box unchecked.

4. In Section 2, click the Select Folder button. Another browser/finder dialog opens. Select the folder you downloaded your RAW files to, then click the Make New Folder button. A new folder icon will appear with the name New Folder highlighted. Overtype the New Folder name with the same name as the parent folder, but with *.dng* added to the end.

5. In Section 3, you have a chance to put the appropriate prefix on the original filename (see the "Storing the Files" section earlier in this chapter). If all the images in this folder are of the same subject (often the case in a product or fashion shoot), then rename all the files so they are preceded by the subject's name. If that's the case, highlight Document Name and type over it with the name of the subject. Then, pull down the menu to the immediate right and choose Document Name. You needn't do anything more, because the camera has already put all the filenames in a series (see "Storing the Files"). So there will

never be a duplicate filename—unless you have multiple cameras that use the same naming convention. That's a pretty common occurrence for pros who are carrying multiple bodies of the same brand. If you do have multiple cameras with the same naming convention, put a sticker on the bottom of the camera with a letter on it. (Surely you don't have more than 26 of these cameras, but if you do, use double letters.) Now, if you have multiple sources for the same naming convention, type the letter(s) for the appropriate camera into the third field.

6. Still in Section 3, make sure the File Extension menu choice is *.dng*.

7. The chosen preferences should be Compressed (lossless) and Preserve RAW image (you can change either of these by clicking the Change Preferences... button). Don't embed the original (takes more space and you're about to back it up). If those aren't the settings, just click the Change Preferences button and a dialog will appear that lets you specify the settings I've just specified. Is that specifically clear?

Here are the steps to complete the DNG backup routine:

1. Open Bridge and drag the new DNG directory above the icon of its parent folder. This simply moves it.

2. Insert a blank DVD or CD into your DVD drive. Your CD/DVD burning software opens. Hopefully, you've read the instructions and know how to use it. If not, you may want to download the manual from the company's web site.

3. Drag the original folder into the data space in the CD/DVD burning dialog and click whatever buttons are necessary to make the backup CD or DVD (probably the latter, but why waste space if this was a short shoot?).

4. When the disk has been burned, you should get a dialog telling you that the data has been successfully written to the disk. The disk usually auto-ejects, but if it doesn't, close the disk burning software and eject the disk.

5. Reinsert the disk and open an image or two in Bridge to make sure the images are there and haven't been corrupted. It will take longer to read all the files, but checking the thumbnails is a good way to make sure that none of your image data has been corrupted in the disk-writing process.

6. Eject your disk, label it with the shoot's folder name using an acid-free marker, and store it in an acid-free CD album.

7. Erase your original RAW files.

Send proprietary RAW files to CD and erase them from your drive. Now you have one backup that you're not likely to touch.

Winnowing Your Shoot

Photographers who are moving from film to digital are fast learning that they have to establish a whole new routine for what used to be called "initial editing." To distinguish it from the simple business of looking at slides and negatives on a light table and throwing out anything that isn't worth keeping, that process has acquired a new trade name—*winnowing*—which encompasses the following:

Organizing and regrouping

Photos that are closely related or that show a time sequence should have their thumbnails moved next to one another. These days, that process is called Lightableing. You should do the same to all photos of the same subject that were shot in the same location, lighting condition, and cropping. This results in arranging photos into what I call *sequences*. You do this to automate the basic processing of whole groups of images at one time and to batch rename and add metadata to whole groups of files at one time.

Renaming

Once images have been grouped into sequences, you can use the Batch rename command to add an abbreviation that indicates the subject of that sequence, such as "red dress cu." You can then Batch rename the entire sequence.

Adding metadata

You will want to add metadata such as copyright information and descriptive keywords. Once entered, metadata stays with the file as it is copied and manipulated. This way it's easier to prove copyright or find and collect files that belong to a particular group or category.

Ranking the images

You are able to rank images with a star rating. It then becomes possible to show only those images that have a minimum or better ranking.

> **NOTE**
>
> *In Chapter 3, we'll go through how to do most of these tasks using Adobe Bridge. The Appendix touches on some of the new software alternatives for this phase of the workflow, including Adobe Lightroom.*

Backing Up Originals

This is the time to copy all the files you've named and ranked to external media so that you have the means to recover if something should happen to your original file. For the sake of speed and efficiency, I suggest you purchase and install an external hard drive and make your first copy to that drive. You should also have a second drive stored someplace away from your main property. At regular intervals (say twice a week), bring in the second drive and copy the contents of the first drive to it so that you end up with two identical hard drives full of data.

For the sake of portability, I also suggest that you immediately copy your originals to optical media. Not only do you have the added insurance of yet

another backup, but you can take images with you if you want to work on a laptop on the road or need to make copies of files to send elsewhere—especially if you want to send your advanced processing to an outside facility.

Presentation for Client Approval

Once you have your images adjusted to the point where they are at least presentable to the client, you should be aware of a couple of further considerations. First, if it's a portrait, fashion, or product shoot, consider whether you can get away without retouching before you present. Second, you will have to decide how you're going to make the presentation. You didn't think Photoshop was going to give you only one choice, did you?

Retouching for Client Approval

First, regarding retouching, there are two more problems: retouching can be destructive and, although there are ways to retouch nondestructively, they can't be done in Camera Raw. Then, of course, there's the fact that retouching can be one of the most time-consuming facets of image processing. Next, you have to realize that the glamorization of the subject is the whole point of the three disciplines of photography that I mentioned above: fashion (including glamour), portraiture, and product photography. You shouldn't present the image in less than its best form. That's a bummer, because otherwise you can simply create all the presentation formats directly from your RAW files. The compromise I make is to retouch the shot I'd most like to see chosen and then make it clear in the presentation that this is how all the images in that series would look, should one of them be chosen. So I save that shot as a Photoshop file before I put the images into the presentation and use only the Healing and Clone tools that will put their retouching strokes on a blank layer. You'll find the steps for doing this in Chapter 8.

On rare occasions, I may use other tools if it's the only way to sell the client, but even then retouching is all done on a copy of the main subject layer (usually the Background layer). Once again, Chapter 8 will outline most types of retouching that will be needed. The reason it's mentioned so late in the book is due to the extreme potential for destruction in retouching, which dictates that it be placed as far along as possible in the workflow to eliminate repeating other steps if you need to make a revision. So just remember that there's a very good chance you'll want to delete this retouching later in the process and that you'll have to do it all over again. It won't be as painful if you avoid doing any more than is necessary this early in the game.

Presentation Options

As I said, Photoshop CS2 gives you many options for presenting a shoot to the client. Most of these methods have other uses as well. All are discussed thoroughly in Chapter 12 since many of these tools are also tools for presenting your work in its final form on electronic media or on the Web.

Contact sheets

Contact sheets have have the advantage of being very quick and easy for a client to physically mark the chosen images with a marker. Images are also automatically rotated to be vertical or horizontal, according to how they've been rotated in Bridge. Also, the images can be passed around for a committee vote without requiring each participant to have a computer. (Of course, these days, most anyone likely to be voting will have a computer.) Finally, you can email a JPEG of the finished contact sheet files and the client can then print as many copies as are needed to pass around the office. You can see a finished contact sheet in Figure 1-4. (See Chapter 12 to learn how to create contact sheets.)

Galleries

Galleries are similar to the multiple-image Camera Raw view or the Slideshow mode of Bridge. That is, thumbnails of each image are shown on one side of the gallery, while a larger preview image appears on the other side whenever you click on a thumbnail. Chapter 12 discusses the particulars of how to create and prepare your images for a web gallery.

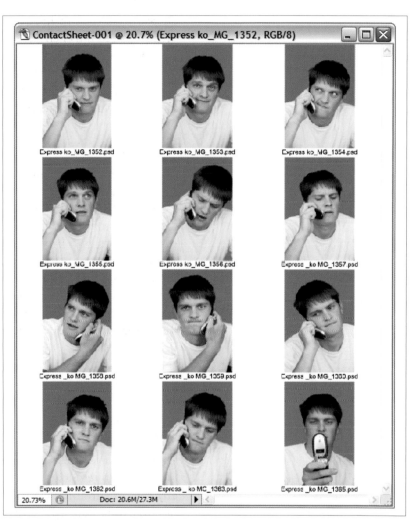

Figure 1-4. A finished contact sheet.

Photoshop's built-in galleries, along with a few that are available from *www.adobe.com*, are the easiest to incorporate into your workflow. However, almost all image editing and image management programs also automatically create galleries from a folder and, generally speaking, the designs are all different from one another. I know photographers who have collected half a dozen or so third-party programs that they use primarily for creating galleries.

> **NOTE**
>
> *All the automatically created galleries are editable in any HTML editor. So if you don't like the style, you can always open the gallery in Adobe Go Live or Dreamweaver and redesign it interactively.*

PDF presentations

If you're still in love with the tradition of inviting the client over for a live slide show, this is the way to do it. The advantage is that the audience gets to chime in all at once and it's easy to have the conversation bounce around among art director(s), client reps, photographers, and assistants. The big downside is that there's no way to put the image's filename on screen so it can be noted. Furthermore, there's no equivalent to taking the slide out of the projector to give to the photographer as a sign of approval. The potential versatility of PDF documents—they can be read on most computers and over the Internet—holds a lot of promise. Unfortunately, the potential is limited. You'd be better off hooking up an LCD projector to your laptop and running a web gallery from a CD as a means of running a slide show.

Preliminary Editing

Now we come to the point in this book where the workflow of Photoshop editing and manipulation begins to take place. There are two main stages in this workflow: Camera Raw and Photoshop.

Editing Stage 1: Camera Raw

Before you get into Photoshop, make sure you've done everything possible in Camera Raw to give yourself a good foundation. Remember, everything you do in Camera Raw is nondestructive, so you want to do as much as possible before you move on. You want to make your image look as gorgeous as you can in regard to color balance, dynamic range, cropping and leveling, lack of fringing and noise, and controlling contrast within specific ranges of Brightness with the new Curves tab.

If you don't mind spending the money and taking the time to work outside of Photoshop, you might want to do even more on your RAW files with a third-party application such as Phase One Capture One or Pixmantec Raw Shooter Premium. The Camera Raw workflow is covered in Chapter 4.

Editing Stage 2: Photoshop CS2

As amazing as Camera Raw is, it just doesn't do everything you might want to do. Rather than list all the things it doesn't do, I'll just list the things you'll most likely want to do in the most constructive and efficient order:

Adjustment Layers

Use to do overall image corrections on all the layers beneath that layer.

Masked Adjustment Layers

Use when you want an adjustment to apply only to a preselected portion of the image.

Clipping Layers

Use for an Adjustment Layer that affects only one layer below or selected layers. Masked layers can be clipped, too.

Merged Copy Layers

Use for applying destructive processes, such as filters (including knockouts, filters, and destructive adjustments) and certain types of retouching. Destructive adjustments are those that don't work as adjustment layers and, therefore, make significant changes to the image when applied.

Transparent Layers

Use for retouching and compositing.

Duplicate the image when you must convert from 16-bit to 8-bit mode

That way, you can always go back to make changes in the 16-bit mode. Also, add "8b" to the end of the filename. You should assume that all the other images were output from Camera Raw to 16-bit mode, where you'd have the most adjustment latitude.

By following the steps above in order, you will easily locate the point where you made a revision to your image. Moreover, you're working from the place where the adjustment affects more of the overall image to the place where it affects less—at least until you get past the point of using Adjustment Layers. You are basically turning off layers from the top down. When you get to the point where your image is free of any content or characteristics you don't want it to have, stop and start building new layers.

Now here's the really good part. You can keep the old layers, group them into a set or sets, and then turn off the set. Then, if you want to show yourself or an art director the difference between one version of the image and others, you just turn the layer sets on and off. This allows you to display whole ranges of interpretations of an image without ever having to change images. The specific tasks you'll do during this phase are covered in Chapters 5 through 11.

Final Output

The very last stage of processing is to create your invaluable and nearly irreplaceable digital positive. First of all, calling it a negative is technically incorrect and, well, negative. Besides, we've gone well past the point where the image was RAW. You're now making a copy that can be flattened, sized, converted to a more universal format (such as JPEG or TIFF), and assigned

the proper color profile for the destination reproduction vehicle. How you create that digital positive (Figure 1-5) will depend on what your purpose is for any given version of a final output file: web, online media, offset printing, or output to a desktop printer. The process may also require switching Color Spaces and Color Management Profiles. We'll cover the ins and outs of all of that in Chapter 12.

Figure 1-5. In the end, the goal is a beautiful photograph that can be sent out into the world.

Be Prepared 2

This chapter is about what you need to do to make sure that the pictures you shoot will be of the highest possible quality (given the circumstances you are shooting in at the time). When I start to shoot a job, I want to make certain I think about all the things I can do to ensure that I'm capturing as much of the scene's full dynamic range as circumstances permit, that the pictures will be sharp, and that I am exposing for the most important part of the subject. You may be surprised at how comprehensive that checklist should be. On the other hand, I'm not going to crowd these pages with every esoteric possibility. Photoshop is important, yes, but it works best when it starts with good data.

HOW THIS CHAPTER FITS THE WORKFLOW

Your Preparation Does Not Start with Photoshop

People tend to think of the Photoshop workflow as something that starts in Photoshop. In fact, if you hope to get the best results from Photoshop, the first step in your digital photo-making workflow should be making sure you're prepared. Of course, being completely prepared could entail all manner of complexities. So nope, we're not even going to try that. Instead, this chapter is about making sure you've covered the pre-planning basics. If what you need to do entails more than this chapter covers, chances are you've been in business long enough to know what to do and have an assistant or two who might even know more than you do. If you've been shooting film and are just jumping into digital, you may already know most of what's here. If that's the case, at least read the parts of this chapter that have to do with calibrating your camera and using your camera's Histogram feature.

Pre-Set Your Camera

This section is all about helping you get the most out of the data you create with your camera.

NOTE

JPEGs are not losslessly compressed, so be sure you always shoot at the highest level of JPEG quality. Remember that each time a JPEG is opened and saved, it is recompressed, so more of your original data is destroyed each time. Consequenbtly, there's actually no such thing as a nondestructive JPEG workflow. If you must shoot JPEGs, at least this book can help you with minimally destructive workflow.

If you're shooting JPEGs, you should be doing so because you have no time at all to work on the images before you hand them off to your client. You want to set your camera up so that when it does all the processing, it knows what it's supposed to accomplish in terms of color balance, noise reduction, saturation, sharpening, and even shooting modes such as black and white, sepia, snow, shade, and night shot.

If you're shooting RAW, there's no need to use situational adjustment settings, such as cloudy or portrait. The RAW file records everything the camera sees, regardless, and leaves it up to you to adjust things in whatever RAW image processor you choose. So there's no need to waste the camera's energy. Of course, you may want to use those settings if you're shooting simultaneous JPEGs, since the JPEGs will be affected.

If you have no control at all over what the next lighting situation will be, make sure your ISO is set to 200. If you're shooting after sunset or indoors (or both) make that ISO 800. Then you have a reasonable expectation of getting enough depth-of-field (DOF) or a fast enough shutter speed in a wide range of shooting conditions. What you're doing is making the best compromise between getting a noisier image than you're willing to put up with and having enough "film speed" to get a steady shot in the broadest variety of outdoor daylight shooting situations. If, once you're shooting, you find you have the leeway to drop your ISO setting, you'll have less noise.

If you're going to be shooting at night or indoors, take along a flash even if you prefer not to use it most of the time. Instead, take test shots and set your ISO high enough to create a steady hand-held shot. You probably shouldn't worry much about extending DOF unless you can afford a battery-powered external flash system. You'll also want to be able to remove the flash from the camera and, ideally, fire it by infrared remote control. Figure 2-1 shows several portable external flash units.

Figure 2-1. External strobes come in a variety of sizes.

Plan on using tungsten bulbs if you need to keep your budget down when shooting interiors or in the studio. If you want to have maximum depth of field and the ability to freeze all movement (such as hair blown by a fan), use studio strobes (see Figure 2-2). Battery powered studio strobes cost a bit more but make it possible to use them at locations where there's no easy access to power or where a person is likely to trip over the cords and damage your equipment.

Set Up Your Camera for What's Most Likely to Happen Next

If you miss an important moment because you had to stop and fiddle with your camera, remember that I said this: any time you're about to move from one situation to another and don't know exactly what the upcoming shooting conditions will be, set your camera's mode dial to P, which is short for "Point and Shoot." That is, the camera does the best to automatically figure out the best compromise between shutter speed and aperture. It also assures you that you're going to get a picture. At the very least, you'll be able to look at that picture after you've shot it and be able to figure out whether you need to be able to go to Aperture or Shutter priority or whether you need to switch to entirely manual control.

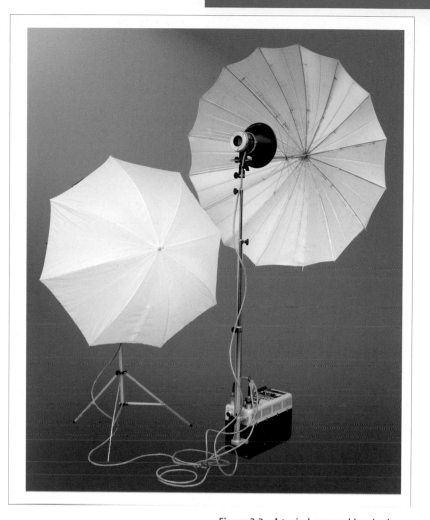

Figure 2-2. A typical, reasonably priced studio strobe system.

Speaking of manual control, there's one situation where it's always called for—when shooting with an external flash that's not made specifically to be controlled by the camera. The best clue as to whether your camera can control the flash is whether the brand name on flash and camera are the same. You should also read the instructions for the flash.

Shooting a Calibration Target or Gray Card

It's always a good idea to put a gray card in the same position as the subject in at least one frame of any sequence that is shot of the same subject in the same location and lighting conditions. Later, it will be very easy to set your white balance. The best candidate for utility and price is the Digital Gray

Card from Robin Myers Imaging. It is made of washable plastic, has full instructions on the back of the card, and comes in two sizes (4×6 and 6×9 at $9.95 and $14.95, respectively). This gray card is 10 percent, rather than the 18 percent gray that is more traditional for film photography, and is said to work much better for calibrating digital sensors.

Get in the Histogram Habit

Digital sensors have a greater tendency than film to block highlights. They also have a tendency to exhibit more noise in the shadows. However, don't loose heart. The flexibility you have in interpreting digital images—especially RAW files—far outweighs what you can practically expect from film. Just try to make sure you don't over- or underexpose.

You do that by not relying on the camera's preview monitor for checking your exposures. Almost all digital cameras, especially those likely to be used by readers of this book, will let you check the histogram for any image you've shot. If you're shooting with a DSLR, you won't be able to do that until after you've taken the picture. So, as soon as you've put yourself in a position where you're likely to shoot, take a picture. Then look at the Histogram for that picture. You want it to look as much as possible like the Histogram (drawn in Photoshop Elements 4) in Figure 2-3. You *do not* want the histogram to look like those in Figures 2-4 through 2-7.

> **NOTE**
>
> *The shape of the histograms will vary greatly from one picture to the next because the shape reflects the distribution of pixels assigned to a given area of brightness. It only matters that the histogram stops and starts with some space between the endpoint of the histogram and the beginning of "the mountain."*

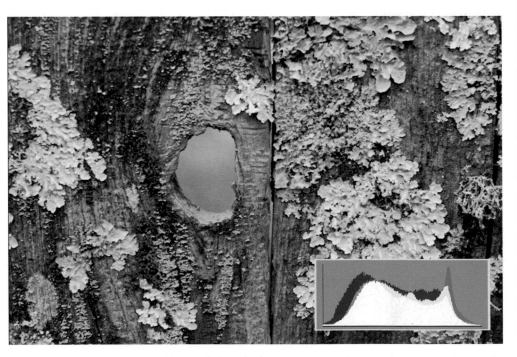

Figure 2-3. The histogram for a properly exposed image.

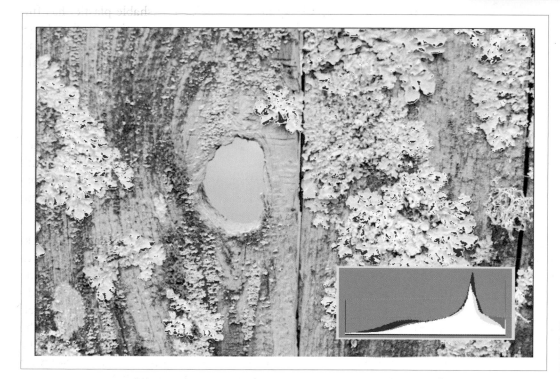

Figure 2-4. A histogram showing blocked highlights. This is the biggest no-no.

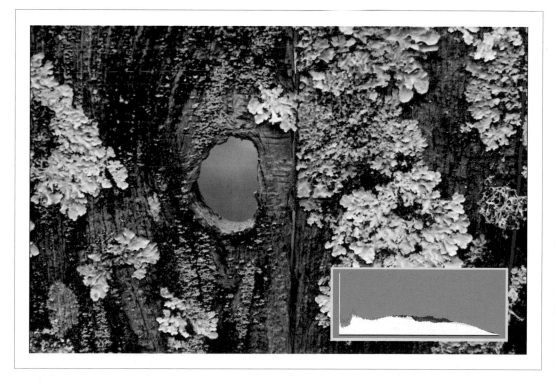

Figure 2-5. A histogram showing blocked shadows. Some blocking is OK, as long as the tones that are blocked don't convey important information. For instance, you wouldn't expect to see much detail if looking directly into the sun or at a black velvet curtain.

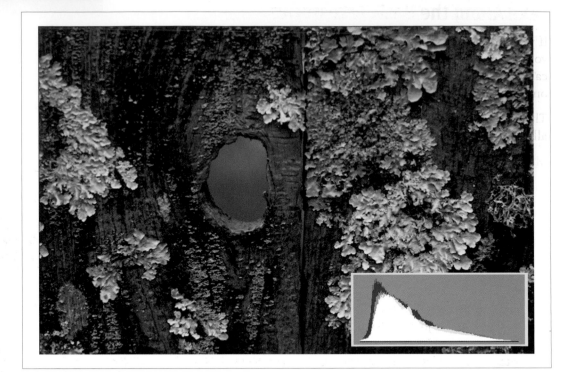

Figure 2-6. Most of the pixels are in the shadows. There are likely to be increased noise levels when the image is properly adjusted because noise tends to reside mostly in the shades below the midtones.

Figure 2-7. Midtones are posterized because they are all the same brightness value. Try lowering the camera's saturation value and/or dropping exposure by one-half stop or so.

Take Along the Basic Accessories

If your DSLR is just too clumsy to keep around your neck all the time, get your hands on a prosumer pocket camera that has a 7 MP sensor, a 3:1 optical zoom, has full manual controls, and shoots RAW files. As soon as I see one that also has image stabilization and is waterproof, I'm going to buy it.

The other accessories are listed here in order of importance, although ideally it's a good idea to have all of them along all the time:

Memory cards and batteries

Memory cards and batteries are two things you should collect more of any time there's a bit of spare cash in your account. Having plenty of both is simply insurance that you won't have to stop shooting just when you happen on the most exciting shot of the day. Extra memory cards are also the best insurance against card failure.

Gray card

You can get a 10 percent digital gray card for $10 that's washable and is just small enough to fit inside your camera bag (see Figure 2-8). I bought two of them and cut one up into 3×4 inch pieces that fit neatly in a shirt pocket. Then, even if I don't have my camera bag along, I can just set it near my subject and snap a shot that will then allow either Photoshop or my RAW processor to automatically set a technically perfect white balance for all the other pictures I've taken in the same lighting conditions.

Figure 2-8. A photo of the Digital Gray Card.

Flash

Flash is your best assurance that you'll be able to get some sort of picture, no matter how bad the light is. You probably have one along with you even if you haven't given it a thought: they're built into virtually every digital camera that sells for between $300 and $5,000 dollars. However, an external flash produces at least three times as much light and can be positioned so that its lighting is much more flattering than anything that can be produced by an on-camera flash.

Reflector

Anything white or silver that produces a good reflection from the main light source can be used to control the brightness of shadows. This can make all the difference between an image that looks professional and one that looks like a snapshot. The sort of silver and white folding reflector that is often used as a sun-shield for a car's windscreen folds, is easy to carry, costs next to nothing (less than $5), and weighs next to nothing. They're also large enough to provide fill lighting for a small

group of subjects. Foam-core white and silver boards also serve well as reflectors. Black foam core works well for absorbing light on the shadow side of the subject and increases the depth of shadows.

Tripod

Blurring as a result of camera movement is the most common reason for throwing out pictures. It's important that you practice, practice, practice holding the camera as steady as possible. I actually know photographers who are so good at this that they can keep a camera steady as a rock for a full second. However, it's just plain stupid to take chances when you needn't. If you have a tripod and you suddenly see that award-winning shot just as the sun is setting, no problemo. If you realize you need to stop down to f-22 to keep the grass in the foreground of your scenic sharp, no problemo. Granted, there's not always room on your bike for a tripod, but at least you can carry along a monopod or a clamp with a pan head attached. If you can't do that, at least look for a fence post, banister, car hood, or any other steady object. By the way, tripods with flip-open leg extensions are faster to set up than those that have a screw-threaded clamp. Ball heads are easier to move quickly and work well for fashion and portraiture. The traditional pan head is better when you have to make sure the camera is consistently level, such as when you're shooting interiors or panoramas.

Portable hard drive

If you are short on memory cards or are going away on a long trip, it's a very good idea to take along a battery-powered hard drive. That way, you can download all your memory cards as you shoot them so they can be reformatted and reused. Portable hard drives come in an ever-widening range of prices and capabilities, and the companies come and go. A good source of up-to-the-minute reviews and prices can be found at *www.dpreview.com*.

Know When Not to Shoot RAW

I started to call this section "Knowing When to Shoot RAW," but the fact is, you always want to shoot RAW unless there's some good reason why you can't, such as:

- **Demand for an extremely fast turnaround time** that simply allows no extra time for processing in RAW, even though the latter is bloody fast these days.

- **Demand for the fastest sequence shooting** with the largest number of contiguous images.

JPEGs may be less work, but sooner or later, you'll be sorry if they're your only digital negative because you can always be assured there's more creative leeway in a RAW file.

Start in Program Mode

I've already told you why you want to start in program mode. I once worked at Macy's assisting Stanley Ciconne, the fashion photographer. The second Stan saw the darkroom lights come on he'd yell, "Ken, do we have images?" He was wise enough to know that as long as there were images, we were closer to a finished ad than without them. As long as you start with your camera's mode dial set to P (and you've taken your lens cap off and turned on the camera), you will be able to get an image.

When to Switch to Manual Mode

Switch to manual (M) mode when you know you don't want the camera to reset the exposure because you just point the camera at something in the scene that just happens to be brighter or darker. If I've set my camera in P mode and I have a few seconds to check my exposures, I play back what I've shot most recently, pick the image in the series that I think has the best exposure, then press the Info button on the back of the camera to see what the actual exposure was. I can then switch to M mode, set the aperture and shutter at the successful settings, and then reset the dials to favor shutter speed (because I want to stop motion, create a blur, or make sure my old hands aren't shaking the telephoto lens) or aperture (because I intentionally want DOF to be either extended or narrowed). Once I've done that, all my exposures for that "scene" will remain consistent and I will get the results I expect.

There's another time you need to switch to manual mode: when you're shooting a panorama or want absolute control over shutter speed for bracketing a high dynamic range (HDR) exposure (see Chapter 11).

When to Use Aperture Priority

Use Aperture priority (A or Av) to make sure the aperture setting stays exactly where you set it, no matter what happens in front of the camera. You can also use this for bracketing in HDR mode, since only the shutter speed will change. Note, however, that there is a greater chance that something unexpected (such as someone popping into it wearing a white shirt or dress) could make the changes in shutter speed less predictable.

When to Use Shutter Priority

Use shutter priority when you know you want to do one of three things:

- Stop action
- Cancel camera motion (although an image stabilizer is a better solution and, if you have time to set one up, a tripod is an even better one)
- Make sure you have a motion blur effect when the one in Photoshop just won't cut it

Light Metering Tricks

There are all sorts of ways to measure exposure.

You can use one of your camera's metering modes in P shooting mode or (better yet) bracket a sequence of shots in half stop increments. You can look at the actual photo on your preview monitor after you shoot the test. Most cameras will also show you the exposure if you tell them to "show info." So, just pick the shot in your sequence that has the best exposure, get the info, switch to M mode, and set the exposure accordingly.

Or you can shoot a gray card in spot metering mode. This ensures that you're only metering the image's midtones, so you should get the best compromise in exposure for all the prevailing levels of brightness. Your camera's color balance is calibrated at the same time, so you can set the white balance for all these exposures with one of the White Balance droppers that are available in both Photoshop and Camera Raw. In Photoshop Elements 4, you can only use an eyedropper to set white balance by choosing a Levels Adjustment Layer from the Layers palette. If the result is too much or too little brightness, you'll have to correct it by adjusting the midtone slider in the RGB channel (see Chapter 5).

Types and Uses for External Meters

Although you can preview a shot and adjust your exposure according to the exposure information for that shot, there are times when an external meter can save time. That's because you can read for proper exposure before you start taking pictures. Also, most meters read exposure in such a way that you see a variety of aperture and shutter speed combinations that allow the transmission of equal amounts of light to be recorded by your sensor. That way, you don't have to do calculations each time you switch to manual mode but want to use a different shutter speed and aperture combination (see Table 2-1).

Table 2-1. A chart of equivalent f-stop and shutter speeds at ISO 100 in average daylight. For each doubling of ISO speed, decrease the f-stop by raising it to the next highest number in the chart. Most digital cameras allow you to adjust both shutter and f-stop in half-stop increments.

1/8 sec	1/15	1/30	1/60	1/125	1/250	1/500
f-16	f-11	f-8	f-5.6	f-4.0	f-2.8	f-2

There are two types of meters that might come in handy: Incident and Spot.

Incident light meters

These meters are held in the area that is the center of interest and are pointed toward the camera. You set the ISO on the meter that will be the same ISO for your camera. You then press a button and the range of alternative exposures in Table 2-1 suddenly appears. Gossen makes

an incident light meter that can measure either available light or strobe. You can see an incident light meter in Figure 2-9.

Figure 2-9. An incident light meter being held as it is used to measure exposure.

Spot meters

Spot meters that aren't built-in generally look a bit like miniature telescopes and can be used to measure a small portion of the subject, even if it's too far away to get close to. If you frequently use long telephoto lenses, you might want to consider an external spot meter. However, if you shoot with a camera back or a DSLR, your built-in meter is measuring an area that is always within the angle of view for that particular lens. So there's far less need for a spot meter. Table 2-2 shows the ISO ranges of several popular DSLR camera models.

Table 2-2. A chart showing the actual ISO ranges of several DSLR cameras.

Canon 350D		100	200	400	800	1600	
Canon 20D		100	200	400	800	1600	3200 option
Canon 5D	50 option	100	200	400	800	1600	3200 option
Canon 1DS Mk II	50 option	100	200	400	800	1600	3200 option
Nikon D2X		100	200	400	800	1600 option	3200 option

Table 2-2. A chart showing the actual ISO ranges of several DSLR cameras. (*continued*)

Model	Auto	100	200	400	800	1600	3200
Nikon D200		100	200	400	800	1600	3200 option
Nikon D70	Auto		200	400	800	1600	
Nikon D50	Auto		200	400	800	1600	
Olympus E-500	Auto	100	200	400	800 option	1600 option	
Olympus	Auto	100	200	400	800 option	1600 option	
Pentax DL	Auto		200	400	800 option	1600	3200
Pentax DS2			200	400	800 option	1600	3200
Fuji S3 Pro		100	200	400	800	1600	
Minolta 7D	Auto	100	200	400	800	1600	3200
Minolta 5D	Auto	100	200	400	800	1600	3200
Contax		100	200	400	800	1600	

Tricks for Steady Shooting

Unintentionally blurry pictures are almost always the first to the trash. Most of the time, it has nothing to do with the movement of the subject, but with the fact that you haven't been careful enough to keep the camera steady. So it pays to practice avoiding blurry shots that happen because a camera is too unsteady for the shutter speed called for by the conditions of lighting and subject motion. Of course, there are ways to minimize or even ensure that the camera won't move when the shutter fires.

Antishake Mechanisms

There's at least one DSLR manufacturer, Sony (Alpha 100 DSLR), that has an antishake mechanism built into its sensor. It's a feature I wish all DSLR makers would offer, especially those that have higher-resolution (8+ MP) sensors. The advantage is that the antishake mechanism works for up to a three-f-stop difference in exposure. So a nightclub shot that had to be taken at ISO 400 at 1/80th of a second can now be taken at 1/20th of a second. If you shoot a lot of news, parties, and events, it's worth having one of these cameras—you'll hardly ever have to shoot with flash. Heck, even when you do shoot with flash, you could use a slow enough shutter speed to get a lot more detail in the background that *isn't* motion blurred.

If you have a DSLR that doesn't have built-in anti-shake (aka *image stabilization*)—particularly a higher-resolution, lower-noise one—all is not lost. Most lens vendors make antishake lenses. The bad news is that you will pay significantly more for the lens. Furthermore, you have to buy one in every focal length you need the feature for. Heaven forbid you have to shoot both wildlife and weddings.

Bracing and Breathing

By far, the most common situation you will find yourself in is simply holding the camera in your hands while you grab a shot before the opportunity flits away. So you want to keep your shutter speed at around 100th of a second, just to ensure a reasonable chance of sharpness. Wide-angle shots are less likely to appear blurry than telephoto shots. Telephoto lenses much more than 150mm in effective length require either a rock-steady camera or some image stabilization mechanism in the camera.

If you don't have a tripod, or the time to set one up, brace yourself by leaning against something solid. If you're near a flat surface like a table top or guard rail, brace your elbows on it. If you're not, press your elbows tight against your torso. Take a deep breath. Just before your lungs are filled and you have to let your breath out, squeeze the shutter button so smoothly that you're surprised when you hear the shutter (or mirror) click.

You can also use your camera strap to make sure the camera is steady. Put your elbows inside the strap and then spread your arms so that there is tension between your body and the camera.

Once you've done all the above, reduce the shutter speed to about one-fifth of a second and make a test shot of a motionless subject. Press the Preview button and then do what your camera requires to enlarge the preview image to 100 percent (or more). If the edges of the subject are sharp, you've either got it down or got lucky. Try this a few more times until you know you've got it down.

Repeat this exercise every time you get a chance until you are so good at it that you can shoot at even slower shutter speeds. I have a friend is so good at it that she can hand-hold for a full second. Figure 2-10 shows a photographer practicing all of the above.

Figure 2-10. A photographer taking all the steps to keeping the camera steady when there's no chance of setting up a tripod.

Tripods and Monopods

Surely nobody who is reading this book doesn't know what a tripod is. Just in case you don't, though, it's a three-legged stand with variable length legs and a swiveling head that screws tightly to the bottom of your camera. The bigger and tougher the tripod, the steadier it's likely to be. However, the trick is to get one that's just big, steady, and precise enough to keep your camera motion-free. After all, if it's too heavy, you'll never take it with you. The tripod you need for a point-and-shoot could be about half the weight of the one you need for an entry-level DSLR, for example, as cameras grow in size and price. One big caution: don't use a tripod that doesn't stay adjusted while you're working. A funky tripod head or leg tightener just isn't worth having. Furthermore, they become looser and more useless over time. The more you tighten them up, the looser they get.

Tripods are expensive, but look for one that is unusually steady for its light-weightness. If you see the words *magnesium alloy* or *carbon fiber*, you're probably in good shape. Figure 2-11 shows you a reasonably priced tripod.

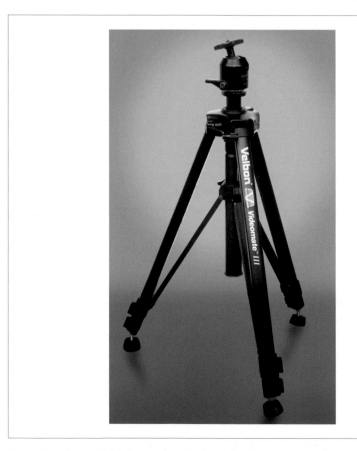

Figure 2-11. Popularly priced but sturdy tripod with a ball head.

Let's face it; sometimes tripods are just too much of a pain to lug around. A monopod can do very nearly as good a job, as long as you brace it. A monopod is, essentially, one tripod leg with four, rather than three, sections so you can collapse it to about a couple of feet in length. For hikers, monopods can also double as walking sticks.

> **NOTE**
>
> *It is much harder to keep the camera in exactly the same spot between shots when using a monopod. Therefore, they're rarely suitable for making multiple exposures for use in a panorama, stitched mosaic, or HDR image. (See Chapter 11 for more on HDR.)*

Shoot, but Don't Touch

One of the most common causes of unintentional camera shake is the act of punching the shutter release. The remedy? Squeeze—don't push. You want to be so gentle with your depression of the shutter release that you are a bit surprised when you hear the shutter click.

An even better solution is a device that makes it possible to fire the shutter without touching the camera at all. The devices used for touchless shutter release are even more valuable when the camera is just placed on a flat surface for bracing, rather than on a tripod or clamp.

The best, cheapest, and most old-fashioned of all touch-free shutter releases is something called a cable release (see Figure 2-12). You can buy one for next to nothing, and it is always reliable.

Making a camera that has a cable release socket doesn't cost a single penny more, either. It's just that crafty camera makers have found a way to boost their profit margins by not drilling a threaded hole in the shutter release button. You then have to buy an electronic device known as a remote control. Really reliable remote controls are wired to the camera because they go off the instant you push the button. The more common type is infrared. The disadvantage here is that there has to be a clear line-of-sight between the remote control device and the infrared receptor on the front of the camera. Of course, if you're not careful, holding it in front of the camera can be difficult without including it in the picture. Once again, practice to the rescue. Before you have to use the remote, practice your holding position when you're shooting with it until you don't see anything in front of the lens that shouldn't be there.

Figure 2-12. A cable release.

Stop the Action

Although some blurring can be effective in communicating a sense of high-speed motion, most of the time you want your subject frozen in time, especially if you're shooting high-speed action such as sporting events or

car races. The other problem that goes right along with freezing the action is managing to catch the most expressive instant that lasts for only hundredths of a second.

High Shutter Speed Considerations

The first thing you need to know is just how brief your exposure must be to stop the action. You also need to know that the required shutter speed will increase with the angle at which the subject is approaching or going away from the camera. It is easier to freeze the action of a cyclist who's heading straight toward you than one who is passing perpendicular to you.

You also have to consider how much of the subject you want to freeze. For instance, the legs of a running horse or the wings of a flying bird are moving much faster than the body. So you have to decide whether you want the subject completely frozen or whether the blurred movement of some limbs or other parts simply makes the subject look like it's moving faster. A photograph of a flying airplane with frozen propeller blades will simply make you think the plane is about to crash.

Panning with the Subject

If the subject is moving perpendicular to the camera's line of sight, you can often keep the subject sharp—even at relatively slow shutter speeds—by panning. Panning is lensman-speak for rotating the camera on a pivot point. The pivot point is usually the tripod thread. However, if you're hand-holding the camera, you just have to *pretend* there's a pivot point under the camera. The cyclist in Figure 2-13 was shot at a shutter speed of 1/30th of a second while the camera's spot metering point was centered on the tip of the seat. For a different subject, just find any point that is at the center of the subject and at the same distance from the camera as the main body of the subject.

When I was shooting the cyclist, the camera was set in sequence mode so that the camera fired several shots as it was panned. I then threw away all but the steadiest shot. If you don't have a sequence mode (or weren't thinking ahead), just try to shoot several shots of a similar subject. Of course, if the subject is Lance Armstrong, you'd better think ahead. You may have only one chance.

Figure 2-13. A cyclist shot at 1/30th of a second while panning.

Shooting Sequences

Some Nikon cameras have a setting called Best Shot mode. Best Shot mode lets you fire a sequence and then automatically throws away all but the sharpest image. Whoever thought of it was a genius. However, I'm guessing that Nikon patented the idea, so you'll just have to do the next best thing. When you have to hand-hold for the steadiest possible shot, follow the appropriate recommendations above. Then put the camera in sequence mode, and when you've got the camera as steady as possible, shoot a sequence. If you don't have time during the shoot to kill the blurry shots, don't worry. You can do it better when you can enlarge them on your computer (preferably in Camera Raw).

The Electronic Flash Advantage

One of the advantages of shooting in a studio is that you will likely use an electronic flash as the lighting source. Since electronic flash (aka *strobe*) stays lit between 1/800th and 1/2000th of a second, and because you will usually be shooting at f-stops above f-8, everything in the image is razor sharp. If you need to shoot a photo of a girl's hair flying or freeze the splash of a pouring drink, strobe is the way to do it.

Usually, you will want to use strobe to stop action when there is no other lighting source. That is because the camera (with few exceptions) has to use a shutter speed of about 1/125th of a second to synchronize properly with the flash. However, there's a very nice effect to be had for some subjects when you balance the lighting so that about half the brightness comes from the strobe and the other half from ambient light. Move the subject fast enough to blur at the shutter speed you're using. The subject will be razor sharp at the instant the flash is fired and, especially if you use a slow enough shutter speed, very blurry for the time leading in and out of the moment the flash is fired. You can see an example of this in Figure 2-14.

The Fast Lens Advantage

If you're just getting into using professional DSLRs, you are probably smart enough to buy your first one with a "kit" lens or two. After all, if you don't have any lenses to go with the camera, you might as well save a few hundred dollars by investing in a starter kit. Most of those I've tested have been very worthwhile bargains (please don't interpret this to mean that they are the best optics money can buy, however). There's one thing they lack, though: an ultra-wide aperture that lets you shoot in low light or easily throw distracting backgrounds out-of focus.

Figure 2-14. Using a combination of strobe and continuous lighting can lead to an effect similar to the one seen here.

Go Where Few Have Gone Before

The more unusual your point of view, the more likely your photo will be noticed and you will rise to creative genius status.

Sometimes, there's more emotion in an image that has been abstracted in some way than in one that is clearly recognizable. If you just can't seem to get a fresh point of view and everything around you seems boring, try one of the following:

- **Climb way up high.** Look for a staircase, tree, ladder, or hot-air balloon.

- **Shoot from underground.** Get into a manhole, down a flight of stairs, or underwater.

- **Use a radically different focal length.** That will force a perspective that isn't typical for this particular subject. Extreme telephoto lenses will make all similar objects seem the same size, regardless of their distance from the lens. Wide angles will make everything but the main subject seem much further away or will emphasize only one portion of the subject.

- **Blur it all.** Throw it out of focus or drop the shutter speed and wiggle the camera in all sorts of strange ways.

The wonderful thing about digital photography is that you can try all kinds of stuff. If you don't like what you see, ask why and delete the picture. After all, it hasn't cost you a penny.

Collect Backgrounds, Clouds, and Stuff

Remember, this is the world of digital photography, the world in which you can easily combine objects from different scenes into whole new worlds. If you just happen to see something that might look great when combined with another photograph, shoot it and put it in a folder named after its category. You'll save *so* much time when you suddenly realize you need a beautiful summer sky in that real estate shot, a graffiti-covered wall as a background for the cycle punk, or a crawling baby for that shot of stalled freeway traffic. You should also be on the lookout for textured walls, gardens, race cars, or anything else that might work in the background.

Calibrate Your Monitor

Just about any book for serious Photoshop users and digital photographers will tell you to calibrate your monitor with a hardware calibration spectrometer. "Hardware calibration spectrometer!?!" The words themselves are scary enough to make your hair fall out.

Relax. The first time you use one of these systems you'll go to the mirror and ask yourself why you weren't smart enough to catch on to this earlier. It takes about 10 or 15 minutes to install the software and about 5 minutes to run it; the only reason to read the instructions is to give yourself a little self-assurance. In fact, all of these systems tell you exactly what to do for each of the four or five needed steps. The software itself, in conjunction with the spectrometer, does the rest (see Figure 2-15).

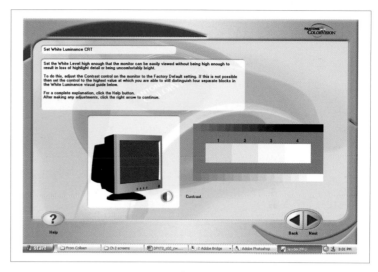

Figure 2-15. The ColorVision Spyder 2 monitor calibration interface.

Although you can spend a small fortune on calibration, for a mere $89 you can buy a tool that will put you miles ahead of using the Adobe Gamma manual calibration software that comes with Photoshop or the ColorSync utility that comes with Mac OS X. Of course, if you don't have a spectrometer, at least make sure you're taking advantage of Adobe Gamma if you're a Windows user or ColorSync if you're on the Mac. If you feel like taking the spectrometer jump to instrumental calibration, the ColorSync Color Plus is a bargain.

When you're ready to invest in a colorimeter (aka *spectrometer*), you should know that both the ColorVision and GretagMacbeth products can now measure flat-panel LCD monitors and laptops, in addition to CRT monitors. So you can ignore the old caveat that spectrometers can only measure CRTs.

Bridging the Gap

3

When it comes to managing the digital workflow, and especially your files, Bridge is the digital asset management answer where Photoshop CS2 is concerned. In fact, it's the DAM answer for the whole Adobe CS2 Suite.

In this chapter

How Bridge Differs from the Browser

Customizing Workspaces

Working in Bridge

Using Bridge for Winnowing the Shoot

Add Metadata for the Record

Ranking Images in Bridge

HOW THIS CHAPTER FITS THE WORKFLOW

Bridge Is Your Command Center

Bridge is the replacement for what was called "The Browser" in Photoshop CS. However, Bridge is a standalone application that can be used to catalog, manage, and open files for any of the Adobe Creative Suite programs.

Bridge is the best tool to use for locating and opening RAW and Photoshop files. Using the same imaging pipeline as Adobe Camera Raw, it reads virtually every RAW file format. Occasionally, when new formats are introduced, it may take Adobe a few weeks to catch up, but the reality is that no manufacturer can afford to use a RAW file format that can't be read by Photoshop, no matter how hard they try to resist. Not only does it read virtually any format (RAW or not) in which you're likely to receive an image, but it instantly lets you size the thumbnails to virtually any size you like. You can also size the Preview window to use as much or as little of the screen as necessary.

Bridge is the key to winnowing and organizing the images from all your shoots. It is the very first tool you should use with Photoshop and the key to digital asset management—even though you have the option of adding other, more powerful tools as you get the files organized and the metadata entered for your photos as you create them. Figure 3-1 shows the screen for Bridge and points out the key Bridge features.

> **NOTE**
>
> *I'm approaching this phase of the workflow with an eye toward helping you do your work with the tools you probably already have. Alternates to the Bridge/Photoshop workflow are discussed in the Appendix, including Apple's Aperture and Adobe Lightroom.*

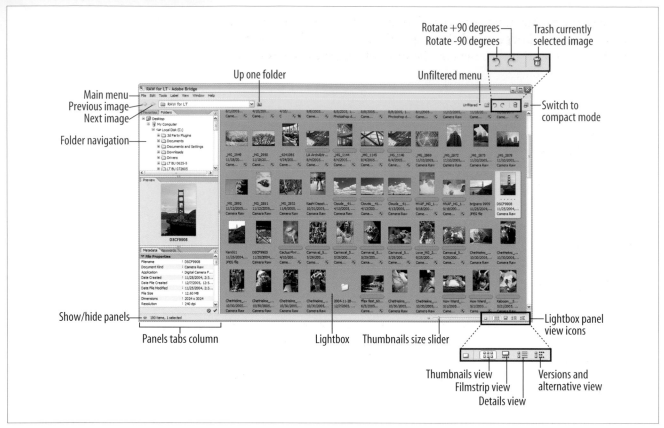

Figure 3-1. The Bridge interface, with all its windows opened and all its features showing. You must use screen resolution of at least 1024×768 to see all these features.

How Bridge Differs from the Browser

If you're already familiar with the File Browser in Photoshop CS, you'll be happy to know that Adobe Bridge is one of the great reasons why you might want to move up to CS2. One of the most important enhancements is that, although Bridge can act as though it's built into Photoshop, it isn't. It's a standalone program and it works equally well with all the Creative Suite apps. Once you're editing, you can really speed up Photoshop by closing Bridge and, therefore, turning considerable horsepower over to Photoshop. If you want to restart it, it's so easy you'd almost think it had been there all along.

The following features are significantly new and different in Bridge for CS2:

A new ranking system

> This feature is an important distinction between Bridge and Browser. To put it simply, Bridge's system is better because it's more simply and direct. You rank with Stars and classify by Labels. What each means is up to you, so there's less to think about.

Bridge is scriptable

If you're the programmer type (I'm definitely not), there may be ways you can enhance Bridge's workflow capabilities. After a while, you may also be able to find such scripts on the Internet (in fact, maybe even by the time you read this).

Customizable background shades

I find this especially useful when using the Slideshow or Filmstrip for showing a client approval slideshow on an LCD projector. It's just more likely to impress the client if you can give your presentation its own "look." You can't actually change the color, because only gray is neutral and, therefore, doesn't compete with the colors in the image.

Drag and Drop is implemented exactly as it is in Windows Explorer or Mac Finder

You can move a folder into or out of another folder by dragging it from the Lightbox window to one of the folders in the Folders panel or to a subfolder or parent folder in your OS.

Multiple browser windows can be open at the same time

If you view Bridge in Compact Mode, you can see several windows at once, making it easy to use the drag and drop feature to consolidate files from several different folders into a single new folder. If you want to copy the file you're dragging to a new folder, press Cmd/Ctrl while dragging.

Variable thumbnail sizing is as easy as dragging the sizing slider

Of course, you can still size the Preview window just by dragging its bounding bars.

> **NOTE**
>
> *It's a good idea to put the Bridge cache file for a given folder inside that folder. Then Bridge doesn't have to recalculate large, detailed thumbnails and previews or the sort order of files if the folder is moved. From the Bridge menu, choose Bridge→Preferences on a Mac or Edit→Preferences→Bridge in Windows, or press Cmd/Ctrl-K. In the Preferences dialog, select Use Distributed Cache Files When Possible.*

Customizing Workspaces

One of the very best characteristics of Bridge, and one that you will certainly want to make use of, is the ability to create and use panel layouts that allow you to see and sort your images in virtually any way imaginable. This section shows you all the choices for automatic layouts (see Figures 3-2 through 3-6). You can instantly switch to any of these by either making a menu choice or by clicking an icon. The captions for each of these layouts will tell you how to access them.

Compact Mode

It is a little known secret that you can have as many Bridge windows open at a time as you like. If you put them all into Compact Mode (Figure 3-2), you can browse and open files from several different folders. You can toggle Compact Mode instantly from any Bridge layout by clicking its icon, by choosing it from the View menu, or by pressing Cmd/Ctrl-Enter.

Figure 3-2. Bridge in Compact Mode.

Slide Show

Some prefer this view (Figure 3-3) for ranking images. I find it ideal as a means to show clients a slideshow, rather than making a PDF slideshow. It's faster and I can easily switch to another view if the discussion leads to wanting to add keywords, a label, or some "sticky" notes to the image itself by opening it in Photoshop.

Figure 3-3. Bridge in Slide Show mode.

Filmstrip view

This view (Figure 3-4) allows you to see a selected image with a very large preview window, while the rest of the images in the folder are in a "strip" either across the bottom or down the righthand side. Ordinarily, you'd see the panels on the left, but I like to remove them by dragging the divider bar all the way to the left. This is an ideal view for ranking and labeling images. You might want to save this view without the panels as a custom view. If so, choose Window→Save Workspace and enter the name you like into the Save Workspace dialog. Clicking the left and right arrows change the images one at a time. Clicking the dotted circle icon moves the filmstrip to different positions on the screen.

Figure 3-4. Bridge in Filmstrip view.

Details view

This can be a great switch to make if you quickly want to find some information about how the picture was taken. You can see elements such as whether the image has been adjusted in Camera Raw, when the file was created and last modified, the image's title, and more. (See Figure 3-5.)

Versions and Alternates

Using Versions and Alternates requires using the entire suite, so we're not covering it in this book. However, if you do own the entire suite, you should know that Versions and Alternates allows you to reference the various versions of a file so that you can keep track of them and the order in which they were done.

Figure 3-5. Bridge in Details view.

Customize your own view

Figure 3-6 shows my own customized and preferred view. Simply drag the bar that divides the Lightbox from the Panels until it divides the screen roughly in half. This will give you the largest possible preview window, displaying either vertical or horizontal images. Drag all the panel tabs into one window.

> **NOTE**
>
> *But wait, there's more: Bridge allows you to automate certain types of processing, such as creating web galleries, contact sheets, slide shows, making multiple prints on a single sheet of paper, and image conversion. You can also merge multiple images into either an HDR or a panorama, but I'll cover those operations in later chapters.*

Figure 3-6. Bridge customized view. This is the view that I customized for myself and the one that I highly recommend.

Working in Bridge

Bridge is fairly intuitive. The following features of Adobe Bridge will be useful at almost all stages in the workflow, but most are *required* at this stage.

Sizing Thumbnails and Previews

Sizing thumbnails is dead easy and totally interactive. You just drag the Thumbnail Sizing slider to the right to enlarge. Furthermore, you can do it any time, so it's no big deal if you need to see larger thumbnails when you have to make a critical decision about which image is a keeper. To go back to your original sizing scheme, drag to the left to make them smaller.

There will also be times when you want a smaller or larger area in which to show the thumbnails. That, too, is totally easy and interactive. Of course, you'll gain more room for thumbnails if you've clicked the Maximize Window button.

You can also size the Lightbox panel by simply dragging the vertical bar that separates it from the other panels on the left. This doesn't resize the images, but it does give you room to see more columns of images. It also gives you more room to see a thumbnail, which means that you can create the largest thumbnail possible when the vertical panel divider is dragged farthest to the left. However, the largest thumbnail you can make is only large enough to fill about half your screen. One of the reasons for this is that verticals must be the same size as horizontals, so you really never have any more room than it takes to fill the screen horizontally (see Figure 3-7).

Figure 3-7. The maximum size thumbnail you can get. If you don't need any of the panels In the left column, you can get two columns of images at this size.

> **NOTE**
>
> *The only view modes you can't resize thumbnails in are Filmstrip and Slide Show. Slide Show is the one mode that makes the preview fill the entire screen, so it's the Workspace to use when you need to preview as much detail as possible.*

Lightboxing

This doesn't have anything to do with the weight class you fight in. (After all, if you weren't a Photoshop heavyweight, you wouldn't be reading this book.) It has to do with the fact that you can rearrange the order of slides (thumbnails) by simply dragging and dropping; this allows you to compare apples to apples and rename and automate a thumbnail's RAW processing more easily.

> **NOTE**
>
> *It's called lightboxing because you can drag and drop thumbnails into any position in any of the View modes. You're not restricted to using Lightbox view to do lightboxing. To drag a thumbnail to a row higher or lower than you can see in the current screen, just drag the thumbnail to the very top or bottom of any space between two columns of thumbnails.*

Batch Renaming

You can easily rename all the images in a folder at anytime. Moreover, you don't have to completely rename them. Often, you can just add to the file-name. So, say that two years after you originally processed an image, you

want to employ a new feature or you have a new inspiration. With batch renaming, you can simply add an abbreviation after the part of the filename that was originated by the camera. Batch renaming is completely interactive. The original filename is displayed alongside the new name you've just created, which means you know instantly if the information doesn't work or make sense, so you can make the appropriate correction right then.

> **NOTE**
>
> *As far as I'm concerned, the real beauty of this feature is that you can use it over and over to modify your existing filenames so that you can more easily recognize a version or workflow stage.*

In the "Batch Rename the Images for the Shoot" section, I'll go over how to use this tool specifically to rename all the images in a shoot. In general, all you have to do to start batch renaming is select the images you want to rename, then either press Cmd/Ctrl-Shift-R or choose Tools→Batch Rename. You see the Batch Rename dialog in Figure 3-8.

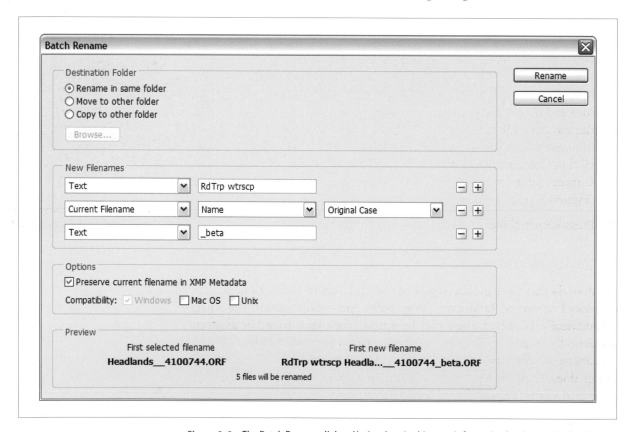

Figure 3-8. The Batch Rename dialog. Notice that, in this case, information has been added to the filename both before and after the existing filename. Also, there's no need to add the extension after changes to the end of the filename.

Digital Photography Expert Techniques

One of the coolest tricks with the Batch Rename dialog is that you can move or copy files to a new destination folder at the same time you rename them. All you have to do is select the appropriate radio button in the top-left corner of the dialog.

Renaming Individual Files

If you've just spent time editing one image, you want to rename it immediately so the name reflects its workflow state. To change the name of an individual file, there's no need to go through the batch rename routine. Just click on the filename in the thumbnail. It will be highlighted, as you see in Figure 3-9. You can type over the highlighted name if you want to completely rename the file. If you're maintaining your workflow, however, you probably want to add an abbreviation to the end of the filename that reflects its current state. Later, if you make further modifications, you'll probably want to rename it to reflect that workflow stage. This makes it very easy to look at the filename and know whether the image still needs work before it's delivered. So do it this way:

1. Ctrl/right-click (Windows) on the thumbnail of the image you want to rename. The filename will be highlighted. On a Mac, you have to (regular) click and wait for name to highlight. If you want to completely rename the file, just type over it. I *do not* recommend you do that, because you'll lose the camera's filename. Instead, click at just the point in the filename where you want to insert the workflow stage abbreviation (for instance, *ret* for retouched or *crv* for an overall Curves Adjustment layer). Then type your abbreviation (Figure 3-9).

2. Press Return/Enter or click elsewhere on the thumbnails.

Figure 3-9. A thumbnail showing the filename undergoing a partial change.

Rotating the Image

I seldom do this since graduating almost exclusively to DSLR cameras. The cameras I've owned (and even some point-and-shoots) rotate the image automatically. However, there may be a time when your friend or assistant accidentally rotates an image. As long as it was rotated in Bridge, there's no data destruction as a result of the accidental rotation. That's because all Bridge does is tell the Metadata to rotate the image in Bridge and to open it as rotated when in Photoshop.

To correct the problem, click the rotation arrows at the top right of the Bridge workspace. If you click the left one, the image rotates 90-degrees to the left. And guess what happens if you click the right one.

Duplicating Files in Bridge

There may be times when you want to create a completely different look and approach for a file that you've already started working on, without messing up the workflow you originally intended for that file. In that case, the smart thing to do is to work with a duplicate.

No problem. No steps. Just highlight the thumbnail and press Cmd/Ctrl-D. Be sure to rename the duplicate in a way that tells you later that this is a completely different interpretation of the image that had the same original camera name.

Deleting Files in Bridge

This operation is a perfect demonstration of how Photoshop lets you do it, as Sinatra would've said, your way. There are three (well, four on a Mac) ways to delete a file in Bridge, and they're all just about equally as easy. First, highlight the targeted thumbnail(s), and then:

- Press Backspace/Delete
- Click the Trash icon in Bridge's Options bar
- Choose File→Move to Trash
- On a Mac, Ctrl/right-click and choose "Move to Trash" from the context menu

Using Bridge for Winnowing the Shoot

Remember back in Chapter 1 when I mentioned the steps you would take to properly winnow your shoot? Bridge is the Photoshop tool for this kind of work. Let's take a look at the specific tasks and how to do them efficiently in Bridge.

Organizing and Regrouping in Bridge

If your shoot consisted of photos for different purposes or clients, you'll want to start by physically placing those photos next to one another in their appropriate groups. Say you took a road trip to a location portrait assignment and going to and coming from the location, you shot some scenics and nature. While in the town where the assignment took place, you saw a few subjects for stock photos. Then, of course, there were the portraits from the shoot. This is how you would organize your images:

1. At this stage, you don't need a large preview, folder navigation, or Metadata info. All you want to do is to get your files grouped together. There are two ways to do this: drag and drop images into place or temporarily assign a color label to each category, then drag all the images that have the same color label together, then delete the labels (you'll need them for other images later).

2. For both of these operations, use the lightboxing technique I mentioned earlier. To get there, navigate to your target folder, and then press Cmd/Ctrl-F2. If you prefer tedium, you probably shouldn't be reading this book, but you can choose Window→Workspace→Light Table. The Bridge interface will suddenly consist of nothing but small thumbnails, as seen in Figure 3-10.

Figure 3-10. Bridge in Light Table mode before sorting.

If your collection is fairly small (say, fewer than 200 shots, just as a guideline), it's probably easier to drag and drop. Bridge allows you to physically drag images into any arrangement you like. The thumbnails will stay in that position forever, too—as long as you don't move them again. Here's the quick way to rearrange a relatively small group of files:

- At the bottom-right of the thumbnails you'll see a slider. Drag it as far to the left as you can without making the images so small that you can't identify the contents. The more images you can see at once, the more quickly you'll be able to find those that belong together.

- Click on the top-left thumbnail. Now press Cmd/Ctrl and click on each of the other images in the collection that has a lot in common with the first image. If there are a variety of subjects, start by gathering together all the images that are the same subject. Then, within that group, arrange the images that have the same lighting together and do the same for each of the other groups.

 When you are finished, all the images that have the most in common will be next to one another, as seen below in Figure 3-11.

Figure 3-11. Bridge in Light Table mode after sorting.

If your collection is quite large, place a color label under images that belong in the same large category, such as people, buildings, and nature. You only have a choice of six colors for labels (none, red, yellow, green, blue, purple) and six star ratings (0–5), so you can have only twelve categories. Make a list on a piece of paper or index card of what each color or star grouping should be, something like the list in Table 3-1.

Table 3-1. Using stars and labels for temporary categorical sorting

Stars/label	Keyboard shortcut	Category
No stars	Cmd/Ctrl-0	Waterscapes
One star	Cmd/Ctrl-1	Landscape
Two stars	Cmd/Ctrl-2	People
Three stars	Cmd/Ctrl-3	Cityscape
Four stars	Cmd/Ctrl-4	Products
Five stars	Cmd/Ctrl-5	Nature
No label	No shortcut	Backgrounds
Blue	Cmd/Ctrl-6	Abstracts
Yellow	Cmd/Ctrl-7	Flowers
Red	Cmd/Ctrl-8	Still life
Green	Cmd/Ctrl-9	Transportation

Table 3-1. Using stars and labels for temporary categorical sorting (*continued*)

Stars/label	Keyboard shortcut	Category
No stars	Cmd/Ctrl-0	Waterscapes
Purple	No shortcut	Signs

NOTE

Remember that the use of the ratings mentioned above is temporary. You can very quickly get rid of them when you're through doing this "quick grouping" by selecting all the images in the folder. Then, from the Browser menu, choose Label→No Label and then Label→No Stars.

By the way, I set up a table in Word with these colors and categories attached. When I have a different type of group to sort, I just rename the categories and print out the chart. You may want to copy the one above and do the same thing.

These are pretty good large categories, but if you specialize in certain types of subject matter, you may want to substitute them. Also, note that I've assigned what are probably two of my least-used categories to the categories that have no keyboard shortcut for assigning the rating. It may also be that you can think of far more large categories than these, but chances are that you can consolidate them into larger categories in the beginning. For instance: glamour, portrait, men, women, boys, girls, seniors, strippers, and hippies are all subcategories of people. There may even be subcategories in those subcategories, such as male hippies, female hippies, senior hippies, teen hippies, and juvenile hippies. Some categories also overlap. Don't worry about any of these smaller categories yet. Once you've organized a large shoot into large categories, you can either reassign the labels to subcategories and resort just that area or simply drag and drop to make the categories more obvious.

Now, keeping your list handy, click on each image individually and use the keyboard shortcut in the table to assign it to the proper category. When it's easier, you can do this to multiple files at one time by Ctrl-clicking to select the individual images and then pressing the appropriate keyboard shortcut to assign the same category to all of them.

Once you've labeled everything, follow these steps:

1. Put Bridge back in Light Table mode if you've changed it for some reason.

2. Press Cmd/Ctrl and click on each image that has been given some kind of rating. Unfortunately, Bridge does not yet provide the means to do that automatically.

3. As soon as you've chosen all the images with a given star/label combo, drag them all to the upper-left corner of Bridge's Light Table.

4. Keep repeating this process for each ranking, in order, until the whole shoot is ordered by category.

5. Repeat this procedure for each subcategory you want to process.

Once you have the files physically organized into groups, select all the files in the group and batch rename (see the "Batch Rename the Images for the Shoot" section later in this chapter) each group according to what your

list(s) say those names should be preceded by. Be sure to batch rename each subcategory from the camera's filename. Your finished file organization should look like Figure 3-12.

Figure 3-12. Batch renamed and sorted files in Light Table view.

Once you've done that, you should remove all the rankings and labels so you can assort them into winners, keepers, don't show, and trash.

> **NOTE**
>
> *Later on, you will want to add keywords to the metadata for these files. So be sure to keep and refine these lists. The more consistent you are in your naming scheme, the easier it will be to find what you're looking for when you search by keywords.*

Trash the Trash

At this point, I change the Bridge layout so that I can see both thumbnails and a large preview side-by-side. This is the layout I use most of the time. If you've already had some experience with Bridge, you'll probably know it just from looking at Figure 3-13.

Now I just navigate up to the top left corner of the lightbox area, then push the Right Arrow key to move through each image one at a time. Right now, I'm only looking for images that will never make it to any practical use.

Either they are too blurry, out-of-focus, or were accidentally shot pictures of the ground, my foot, or the sky. Of course, I'm also looking for blanks. Each time I encounter one of these images, I press the Delete key.

Do not, at this stage at least, delete any images that you may think you'll ever have a use for—even if there's just a part of one image that you might want to combine with another image. Also, don't delete images just because they're blurry. This morning, Regina McConnell, the owner of my mail suite, showed me a picture she took out the window of her car of a fat guy in a Santa suit riding a red motorcycle with reindeer horns attached to the handlebars. The picture was blatantly blurred and yet very effective. It really looked like Santa was having fun with his reindeer.

Figure 3-13. My own preferred layout for Bridge. I can get a large enough preview of each image to give me a good idea of how the image compares with its competitors in the same category.

Doing the Critical Winnowing in Bridge

At this point, it's time to make sure that none of the images that are left have a defect (the most common are slightly blurred images due to camera movement or images that are out-of-focus). You have to do this while in a magnified mode. So put Bridge in Light Table mode, select as many images as your computer's memory and Photoshop are willing to deal with (I have a gig of RAM and lots of free hard drive space), which is typically about 16.

If you shot JPEGs, you'll have to delete the painful way. Do this for each of the shots you've opened, then open the next 16 or so and do it to them, then continue until you've checked the whole shoot. To do this:

1. Double-click the Zoom tool, so you immediately see the image at 100 percent.

2. Choose the Hand tool and pan to an area of critical sharpness:

 • If it's OK, just close the image.

 • If it's not, write down the camera number in the filename of the image to be zapped, then close the image and repeat these steps for the remainder of the open images.

3. Open the next 16 images and review all of the images.

4. Reopen Bridge and Cmd/Ctrl-click to select each image that has the number you've listed, even if it has somehow been duplicated in the meantime. After all, a duplicate of crap is still crap.

If you shot RAW, the job's much faster and easier (are you *sure* you need to shoot JPEG?):

1. Select about 16 images for each round. Once selected, press Enter/Return and they will all open simultaneously in Camera Raw (see Figure 3-14).

2. Double-click the Zoom tool in the Camera Raw dialog's Toolbar. Now, as you click the thumbnail for each individual image, it will be displayed cropped to 100 percent in the Preview window.

3. Use the Up and Down arrow keys to move through each of the files you've selected. As each image's magnified section comes up, you may want to use the Hand tool to pan to the area that should be critically sharp.

4. Press Delete/Backspace if you encounter an image that isn't sharp. A red X will appear (see Figure 3-14).

5. Make sure all 16 images are still selected. If not, double-click the Hand tool. Now all the images will be sized to fit inside the Preview window. Go through the images you marked for deletion one more time to make sure they don't contain something you may need to use in another image or that they aren't blurred in some way that actually adds to the image's emotional impact. If either of those is the case, you'll want to keep the image. Select the image that was marked for deletion that you want to keep and press the Delete/Backspace key. The X will disappear.

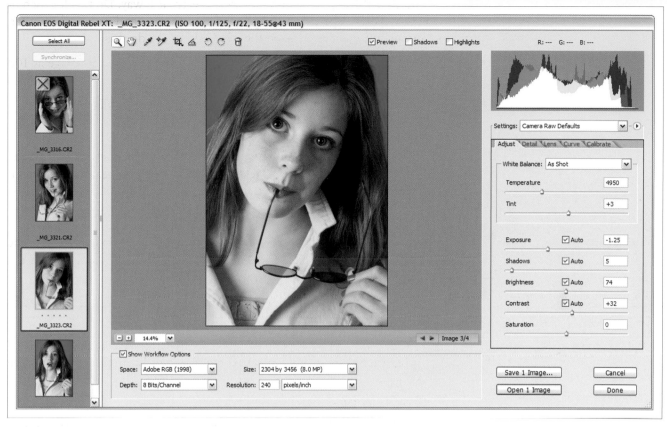

Figure 3-14. The Camera Raw workspace with multiple images selected. The red X in the upper corner of some indicates that they will be deleted when you close Camera Raw…if you haven't changed your mind.

Batch Rename the Images for the Shoot

We covered the general Batch Rename tool in Bridge earlier; now it's time to show the practical application of renaming all the images from a particular shoot. The goal is to name each image so that you know exactly which shoot and category it belongs to. Because you're limited to 33 characters in a filename and want to leave space for adding info to later versions, you will need to abbreviate the filenames.

Since there are almost always multiple images for a given shoot, category, and subcategory, most filenames will be unique in only one respect: the name given to that file by the camera. So I use the original filename as the last element in the reassigned filename. Figure 3-15 shows you a diagrammed example of a filename.

Figure 3-15. A diagrammed example of a filename.

The following is the routine for renaming images by category:

1. Select all the files in a given category and subcategory group. Include all the sub-subcategories in this same group. You'll be able to find these files by keyword.

2. Choose Tools→Batch Rename. The Batch Rename dialog will appear. You want to fill it in as shown in Figure 3-16.

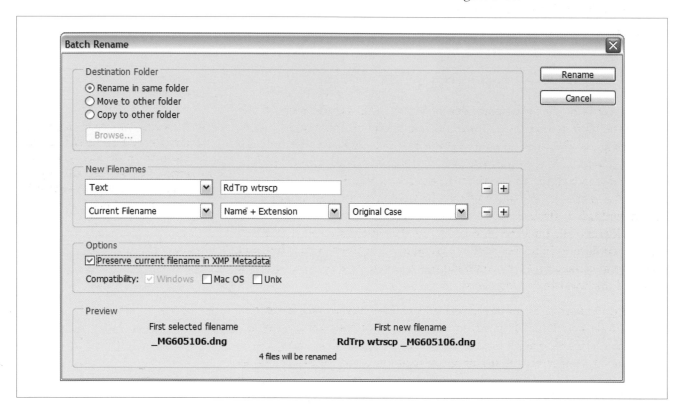

Figure 3-16. Using the Batch Rename dialog to rename your images by category.

3. Under Destination Folder, click the "Rename in same folder" button.

4. Under New Filename, choose Text from the first menu. In the field to the right, type the abbreviated name of the shoot. Then highlight that part of the name and press Cmd/Ctrl-C to copy it to the clipboard. Now you'll be able to enter the name of the shoot ahead of other category names by pressing Cmd/Ctrl-V. Add the category name for this file. Finally, click the plus sign at far right. A new set of menus and fields appears.

5. In the second row of menus and fields, choose Current Filename. In the center menu, choose Name + Extension. In the third menu, choose Original Case.

6. Under Options, check the "Preserve current filename in XMP Metadata" box. I also check all three compatibility boxes.

7. You will be able to see what your filename will look like in the Preview section of the dialog. Click Rename.

8. A dialog box pops up stating that the data will be written to a sidecar file, rather than the original. Since there's nothing I can do about this, I check the don't show again box.

Repeat this operation for each category in your shoot.

Add Metadata for the Record

By now, you already have some idea of how useful metadata can be. It records the settings used by your camera to take the picture, so by looking at the image in the Browser and clicking the Metadata tab and scrolling down to Camera Data, you can see the f-stop and shutter speed, ISO setting, focal length of the lens at the time the photo was shot, the maximum aperture of that lens, the name of the photographer, the date it was shot, date downloaded, flash used, metering mode, orientation, camera make, and camera model. Imagine how useful all that information—which you didn't even have to input yourself—is going to be in three years when you own several camera and lens combinations and you have no idea how you captured that award-winning photo.

But really, the usefulness of metadata starts with what the camera records. Camera Raw and Photoshop go on to record most everything they do, too. In fact, the image adjustments you make in Camera Raw only exist as metadata. The image processing program then takes the adjustment information in the metadata file and makes the adjustments to the thumbnails and to the image that opens in Photoshop according to those settings in the metadata.

As we'll discover in the next section, when it comes time to rank and label your images, Bridge records your ranking metadata as you enter it. However, when you want to record your emotions, purpose, or the character of the image, you have to make the effort to enter that data yourself. You can even enter information regarding the client for the image.

Adding Copyright Info

Adobe Bridge allows you to automatically add your personal metadata to any or all of the files that are currently open in a given folder in Bridge. Early on, while you're thinking about it, you should add your personal and copyright information to every photograph you've taken up until this moment. That information is needed for every image you shoot and can be made to

> **NOTE**
>
> *To make the type larger in the Metadata panel, choose Increase Font Size from its menu. It would be nice if you could do this for the Keywords panel, too, but nah!*

"travel" with your image files. You then have at least some assurance that you will be able to prove ownership of that image should someone later publish it without permission.

Adding personal metadata to your images is quite easy:

1. Open Adobe Bridge. There's no need to open Photoshop at the same time, so more computing power will be available to Bridge.

Figure 3-17. The New (file) dialog.

2. Create a new folder called Metadata Templates. Then open that folder. In Photoshop CS2, choose →New. The New dialog opens (see Figure 3-17). Since this file's sole purpose is to hold text data, there is no point in reserving space for a large image. So use a low-resolution setting and very small pixel dimensions. The exact figures really don't matter.

3. Save the file as *Yourname Copyright.psd* in a new folder you've created in your Photos folder called Metadata.

4. Open the file you just created in Bridge. Choose View→ Metadata. Scroll down to the IPTC Core heading. Enter the data for the following fields, but don't enter data for any other fields. You want to be sure you don't unintentionally overwrite any data later in this process. Here are the fields you should enter: Creator, Creator Job Title, Creator Address, Creator City, Creator State/Province, Creator Postal Code, Creator Country, Creator Phone(s), Creator Email(s), Creator Website(s), Copyright Notice, and Rights Usage Terms.

5. Save the file. A dialog will ask if you want to apply the metadata to the file. Click the Apply button.

6. Open the File Info dialog (see Figure 3-18) using Photoshop CS2. At the upper right, you will see the circled arrowhead that indicates a dialog menu. Click to drop down the menu, and choose Save Metadata Template. Name the template the same as the file, but there's no need for a file extension. Click Save.

7. Use the Bridge Folders tab to navigate to the folder where you just downloaded your files. Click the folder to open it. You will see the file thumbnails in the thumbnails window. Click in the Thumbnails window so that it's targeted and press Cmd/Ctrl-A to Select All.

8. Choose Tools→Append Metadata from the Bridge menu. A menu will fly out and you can choose the name of the file to which you saved the metadata. Next, a dialog will pop up asking if you want to append metadata to all the files. Click Yes.

9. Repeat these steps for every one of your pre-existing photo file folders. It's also a very good idea at this point to copy all your archived files to a hard drive and use this same procedure to add your author and copyright info to all your files. The longer you put it off, the greater the risk that your files will get lost or stolen, since someone may want to buy or license them and won't know who to contact. I think you'll agree that it's not worth putting this off any longer.

Figure 3-18. The File Info dialog box.

So far, you have only entered your personal information and your copyright information. You will be doing a very similar process later to add information that's pertinent to the shoot. When the time comes, I suggest you do

this by adding the data to your camera and copyright data. So be sure to keep the file handy that you used to enter this data in the first place. You'll want to rename copies of that file to the metadata for each subject or assignment category that you're likely to encounter.

Setting Metadata Preferences

The title of this section makes setting metadata preferences sound like a big deal, but it is one of the simplest operations in Bridge. Actually, you could get away with not even bothering. Still, the program will usually run faster and better if you do the following:

1. Choose Bridge→Edit→Preferences→Metadata or from the Metadata tab, click the Metadata menu (small arrow in upper-right corner), and choose Preferences.

2. The Preferences dialog will appear (see Figure 3-19) set to Metadata. Scroll down to Camera Data and *uncheck* the following: Software, Date Time, Image Description, and File Source.

3. Click OK.

Figure 3-19. Metadata Preferences.

Digital Photography Expert Techniques

Adding IPTC Core Metadata

You can manually add or change the metadata in an image at any time, so long as the metadata is assigned to the International Press Telecommunications Council (IPTC) Core. The IPTC Core is the portion of the prescribed keywords used in Photoshop XML; many other image management and digital darkroom programs have adopted these keywords.

To see or change the metadata, click the Metadata tab and scroll down to IPTC Core (see Figure 3-20). Click on any of the category titles that show a pencil icon on the right and a field will open where you can enter the data by hand. Again, be sure to collect a list for what could go into these fields so you don't enter similar keywords for the same thing.

> **NOTE**
>
> *It's a good idea to enter a title for any image you plan to use in a portfolio or web gallery. A good many programs that make web galleries, including Photoshop, can automatically label the image with its title.*

Figure 3-20. The categories for the IPTC core. You can enter these by hand if you like or you can apply them to numerous files automatically through a template.

Creating a Metadata Template

Metadata is added to whole groups of files in the same way personal and copyright metadata is added. The only difference is that you want to make a different template for each shoot. However, you'll probably never use exactly the same set of metadata again and you don't really want to have hundreds or thousands of templates. So after you've done a shoot that is typical of one of your categories, duplicate it using your computer's operating system (Finder or Explorer) and give the duplicate a generic name. Next time you do a similar shoot you can use the generic template that suits that type of shoot. Now all you have to do is enter the data that's changed in this particular shoot, such as keywords.

Here's the step-by-step procedure for adding metadata to files after the copyright and personal metadata has been added:

1. Open Photoshop and one of the images to which you applied the template for adding copyright metadata. As soon as the file is open, choose File→File Info. From the File Info dialog's menu, choose Save Metadata Template (see Figure 3-21). This time, save the template to a different filename that specifies the category of shoot that the new metadata will be added to. Make sure it's named after one of the major categories in your list for ranking images.

2. Add the metadata you feel is important to add to this *category* of images. *Do not* add any metadata that is peculiar to only a single image—it should pertain to the entire category. The idea is to enter as much data at one time as possible for as large a category of images as possible. You will want to add the following information for each of the primary categories in your list:

 Description

 Document title: The complete, unabbreviated title under the image when it appears in a slide show or in print. It is likely that several slight variations of the same image will have the same title.
 Author: The name of the person who wrote the title.
 Author title: Probably you, but could be an assistant, editor, etc.
 Description: This should be just enough for an explanatory caption.
 Description writer: The name of the person who wrote the description above.
 Keywords: Terms from your category list that pertain to this image. You can add new words, but if you do that you should also add them to your list. Then you will be able to reuse the same word for similar types of objects.
 Copyright status (menu): Choose from Unknown, Copyrighted, or Public Domain.

Copyright notice: Type the copyright symbol and year (e.g., © 2005) into Word, copy that to the clipboard and paste it into the proper field. This is a workaround since you cannot type a symbol in Photoshop.

Copyright info URL: The URL for the author's web site, e.g., *www. kenmilburn.com.*

Camera Data 1

All this data is automatically entered by your camera and cannot be modified.

Camera Data 2

All this data is automatically entered by your camera and cannot be modified.

Figure 3-21. The Save Metadata Template and the dialog for naming the saved metadata. Use a different set of metadata for each shooting category so you can use the set of templates over and over.

Categories

Category: Don't enter. These fields are no longer used in current IPTC core.

Supplemental categories: Don't enter. These fields are no longer used in current IPTC core.

History

Big blank page that you can fill with a descriptive paragraph or two.

IPTC contact

Creator: Your name, not that other guy's.

Creator's job title: Photographer, assistant photographer, whatever.

Address: Your business address.

City: Your town or village.

State/province: Just what it says.

Postal code: The zip code.

Country: Not the planet, silly.

Phone(s): As many phone numbers as you care to list.

Email(s): As many email addresses as you care to list.

Web site(s): As many of your web sites as you care to list.

IPTC content

Headline: Could be the same as title, but should be descriptive rather than emotional.

Description: Should be the same as the caption, or an alternative caption.

Keywords (be sure to separate each with a comma or semicolon): For consistency, these should be the same as the keywords in the Description above and come from your list.

IPTC subject code: These must be the official IPTC-sanctioned codes. (See list at *www.newscodes.org*.)

Description writer: Whoever wrote the description—you, an assistant, or the agency exec.

IPTC image

Date created: The date the information on this page was created.

Intellectual genre: These are meant for the IPTC listings at *www. newscodes.org*.

IPTC scene: These should be taken from the official IPTC listing of scene codes, found at *www.newscodes.org*.

Location: The one where you took the picture.

City: The one where you took the picture.

State/province: The one where you took the picture.

Country: The one where you took the picture.

ISO country code (menu): Codes are listed from all countries. Just choose the one where you took the picture.

IPTC status

Title: Same as the other title.

Job identifier: Codes that you invent for a particular job. Be sure to keep a listing of them, both printed out and on your computer(s).

Instructions: Notes on how the image should be processed, delivered, etc.

Provider: Person or organization who provided the image. If it's your photo, you're the provider. If it was a stock agency or someone else, make note here.

Source: Owner of the original copyright on this image.

Copyright notice: Create copyright symbol using these commands: Opt/Alt-Cmd/Ctrl-C (e.g., © 2005, Ken Milburn).

Rights usage terms: Where, how, and how many times the image can be published by this specific client (named here).

Adobe Stock Photos

This information should come with the photo when you purchase it.

Origin

Date created: When the photo was taken.

City: Where the photo was taken.

State/Province: Where the photo was taken.

Credit: Who's providing this image (probably you).

Source: Original copyright holder.

Headline: Short description of what's going on here.

Instructions: How to transmit or transport the photo to its destination, as well as any additional rights or usage info.

Transmission reference: Codes for identifying the job.

Urgency (menu): Ratings from 1–9: 1 is High, 5 is Normal, 8 is Low, and 9 is None.

Advanced

You have to take a graduate course for these.

Using Bridge to Find Images by Metadata Fields

The power of Bridge's Find command is a well-kept secret that is seldom even mentioned in other books. There's a reason for this: the location and name of the command make it look as though there's no difference between it and the Photoshop Find command. Ha! Wait 'til you see Figure 3-22—the dialog that appears when you choose Edit→Find from the Bridge main menu.

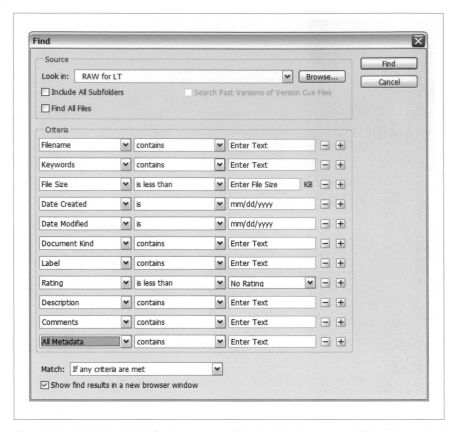

Figure 3-22. The Bridge Find dialog is reminiscent of the Batch Rename menu and features an amazingly powerful selection of options.

Although it's unlikely you'll ever search all the criteria shown, you can search on any combination of them. Note that you can search an entire drive if you check the Include All Subfolders box. Maybe someday you'll even be able to search multiple drives.

After you've entered your search criteria in the Find dialog above and clicked OK, you'll eventually see a new window that contains just those images (see Figure 3-23). It may be that you want to save that particular set of images as a collection so that you can quickly find the whole group. Then you can send them to the client, turn them into a slide show, or use the Image Processor to convert them to TIF, JPEG, or resized PSD for a different purpose or to turn them over to someone else, such as a publisher, client, or fine-art printer.

Figure 3-23. The Save As Collection opens as a new Bridge Window. Once you've saved what your search has gathered, the button changes to Edit Collection, and you can add criteria to your search or change the folders you're searching.

NOTE

Any time you add a keyword(s) that was also used to create the search, that image will automatically be added to the collection. No need to repeat the Find command or to use the Edit Collection button unless you want to add more keywords to the search criteria for that collection.

Entering Keywords

You can sort and search on metadata fields much more quickly than you can search through the thumbnails. One of the most useful things to search and group are descriptive keywords that you can add to the metadata by hand:

- To add keywords, make sure the Keywords panel is open by clicking its tab. If the tab isn't available in your current choice of workspaces, just check the Keywords panel in the View menu. You can see the Keywords panel in Figure 3-24.

NOTE

You can add keywords when you group and rank your files in Bridge or any time you think it might be helpful to add keywords to an image or a group.

Figure 3-24. The Keywords panel, with the keywords that have already been assigned.

- To add keywords to a pre-existing category:

 1. Click the Category you want the keyword to appear under.

 2. Choose New Keyword from the Keywords panel menu (click the little arrow at the top-right of the panel). Or Ctrl/right-click the Category heading. Or click the New Keywords icon at the bottom of the Keywords panel.

 3. Enter keyword in the new Keyword field that appears right under the category heading. Its name is Untitled Key, but it's highlighted so you can just enter any name you want. For consistencies sake, it's a good idea to use the IPTC list and your own lists that you made in Chapter 1 as the source for keywords. If you have to use a new word, be sure to add it to the list you typed on your computer.

- To add a new Keyword Set, follow the same options as above, but choose Keyword Set from whichever menu you pop up. Once again, use your existing list of categories and be sure to add to that list when you must create an entirely new name.

- To add Keywords to a group of files:

 1. Preselect the files you want to add the same keyword to. Presumably, since you are supposed to do what I tell you to do, you have already dragged files within a given category so that they're adjacent to one another. So all those files should have a number of their keywords in common. Because it's a lot faster to add keywords to all the files that will have them in common (as long as they're in the same folder), press Shift while clicking the first image's thumbnail, then go to the last image, press Shift again, and click on the last image.

 2. Scroll to other images that need the same keywords you're about to enter and press Cmd/Ctrl Click on each of the individual images. They will be selected discontiguously.

 3. Click the Keywords panel tab.

 4. Check any of the existing keywords that apply.

 5. Follow the instruction for adding keywords in the section above if you have new keywords that need to be added to these images. Be sure to check your keywords list and make sure to choose keywords from that list unless you've discovered a new category that simply can't be described by anything in your existing list. Then add it to both your existing list and to the new keywords.

> **NOTE**
>
> *You may wonder why I haven't suggested that you premake a list and then add the whole list to your Keywords panel. It's very important not to overcrowd your list, because you may end up adding a lot of keywords that aren't applicable to any images in your collection. When you try to sort for that keyword, you'll just be wasting time. Worse, you'll have to search through all the keywords you never use before you find the ones you do use.*

Ranking Images in Bridge

After sorting and adding metadata, the next thing you want to do in your normal workaday workflow is to give a permanent ranking to all your images. I rerank my images at this stage, now that all the trash has been eliminated. The reason: you make better judgments about image quality when there's less to consider.

Using the Light Table for Ranking

The first thing you want to do is go back to Light Table mode so that you can get the quickest overview and orientation as to what this shoot (folder) contains. Also, the idea here is that you're ranking so that you know what you really want to spend time working on and what to keep "just in case."

As soon as you have the files open in Light Tabel mode, drag the sizing slider until you get the smallest size thumbnail that isn't wasting space with a lot of info. At this stage, your images should already be arranged by category (see the "Organize and Regroup" section earlier in this chapter).

Figure 3-25 shows you the shoot in Light Table mode after you've added the first star.

Figure 3-25. The shoot in Lightbox mode after you've added the first star.

Go through each group quickly and click to put one star under all those images you think might be worthy of further use in any way shape or form. You're not trying to find the very best—just those you think you're most likely to use or market *sometime*. Don't include images that are exact duplicates (perhaps you shot them to make sure you got a steady shot or you bracketed and the shots are useless). They're going onto backup disk in a moment.

Once you've completed these steps, right-click in the Lightbox and choose New→Folder from the Context menu. Name the new folder with the prefix *Maybe*, then add the name of the current parent folder. Now, in Bridge, from the Unfiltered menu (why did they name it that?) choose Show Unrated Items Only. Now, what you see in the Lightbox is your new folder and all the images you didn't give a rating to. Select them all and drag them into the new Maybe folder.

Burn the Maybe folder to a CD or DVD, and label it clearly with an acid-free marker. Now erase the originals from your hard drive (they're just wasting space and slowing down your computer until the day, far-far away, when you need them). Put the CD in an acid-free glassine sleeve in a CD album. Make sure the album cover is clearly labeled with a marker. Stick on labels fall off, and you're not doing this for show. Finally, go back to the Unfiltered menu and choose Show All Items. Now you're ready for the next stage.

Of course, since you already have hundreds of shoot folders that you haven't organized at all, it would be a good idea to have your assistant follow this routine for all the pre-existing shoots.

Now we're going to take those one-star ratings and look for the images that deserve serious consideration since those are the ones on which you want to stake your reputation. Table 3-2 shows my list for ranking by stars. I save labels only for images that have been sold or exhibited, but we'll get around to that later.

Table 3-2. Criteria for awarding stars to images

# stars	Definition
1	Above average—may have a use or a market someday.
2	Candidates for royalty-free stock sales.
3	Show these in client presentation.
4	Chosen for consideration for sale. Add to Best of Directory for category.
5	Chosen for sale or exhibit.

This is an excellent list for general purposes, but of course you may have special considerations that suit the nature of your specialty or style. So feel free to edit and modify the list. Remember, though, you only have five ratings.

You can download this list from *www.kenmilburn.com/lists* or *www.oreilly.com/digphotoet*. Once you've downloaded the list, open it in your word processor and print it out so you can keep it next to your keyboard as you rank your images.

Start by using Bridge for opening the folder you're going to rank. You should do it in a mode that gives you as large a preview window as will fit your screen, with a thumbnails column to one side or the other. Personally, I prefer Ken's Workspace. You can download it from *www.kenmilburn.com/workspaces* or *www.oreilly.com/digphotoet*.

Ranking JPEGs

If you're working with JPEGs, make sure you do all your rotating in Bridge, as this rotates by adding instructions to Metadata and not by resaving and recompressing the file. Resaving JPEGs always means a progressively more destructive process each time the image is recompressed. If you need to open the image to get as large a version as you like, or because you need to crop or rotate, be sure to save the result as a *.tif* file. I say *.tif* because it's even more universal than *.psd*, it can be losslessly compressed (which is nondestructive), and it's easier to distinguish from versions that have been progressively manipulated in Photoshop or other programs.

Ranking RAW Files

If the shoot you are ranking was shot RAW, ranking your files is going to go much more quickly. You want to use the same basic procedure as used when collecting the trash. Use Ken's Workspace (*www.kenmilburn.com/workspaces)* and open multiple files. Follow the instructions in the "Using the Light Table for Ranking" section to throw out the trash when selecting, zooming in on, rotating, and cropping your files. As you click through the files, you can give your star rating to each. Just click the dots under the thumbnails until they show the correct number of stars. Better yet, as each image is selected and previewed, press Cmd/Ctrl-0–5 to assign the number of stars to that image.

If you want to straighten or level an image, choose the Level tool and drag a line that describes absolute horizontal or perpendicular in the rotated image. The image will rotate instantly and cropping handles will appear around it. If you want to do further cropping, just move the cropping handles until you see the crop you want. If you change your mind and don't want to rotate or crop, just click outside the cropping handles. The cropping marquee will disappear and the image will rotate back to its original position.

Choosing initial RAW settings

You're getting a preview of the next chapter here, because Camera Raw really helps in the ranking process with RAW files. At this point in your workflow, you've chosen the images that will be kept and that you will be presenting to your client. Chances are, the default automatic RAW settings that Camera Raw has assigned to your images already makes them good enough to show, but there may be some exceptions. Go to Bridge and from the Unfiltered menu choose Show All Items. Then look carefully at the three-star images that will be used for your client presentation. The first thing you probably want to correct before presenting your images for approval is color balance. If there are other settings in the Adjustments tab you want to correct, do that too. You may also, although it's not very likely at this stage, need to eliminate some noise or increase sharpness.

Once you've tweaked the default adjustments for the three-star image, you can easily apply them automatically to all the lower-ranked images. So why not do it now? It reduces the chances that you'll be embarrassed by the way those images look. It also speeds up your ability to present those images to secondary sales outlets, such as online print sales or low- or royalty-free stock photo agencies (see Chapter 12). You'll save a little time if you apply the settings to all similar images as soon as you've adjusted the three-star image (remember, that's the one you're going to present for consideration to a client, gallery, or whatever):

1. Click the Done button to save your settings. If you decide to apply the settings to the other images later, re-open the corrected three-star image and then click the Done button again. This places the settings for that image into the Camera Raw setting for the Previous file.

2. Select all the similar images. That should be easy if you've been following the workflow, because they're all positioned side-by-side.

3. Right-click on any of the preselected images to get the in-context menu. Choose Previous Conversion. Bling! All 36 (or however many) of the images in that same sequence show matching adjustments.

Streamlining Camera Raw

4

Camera Raw immediately follows image management (Chapter 3) in any workflow that aims to do as much nondestructive editing as possible before rendering the final image. The exception is if you just shot an extremely high-volume shoot, such as a sports event, or one with a digital camera that doesn't shoot RAW. In that case, just go straight to Chapter 7. One of the great benefits of working in the CS2 version of Camera Raw is that it adds quite a bit of power to your ability to adjust the image *before* it leaves Camera Raw. After all, the more brightness range data you have in your image when it enters Photoshop, the better your chances are for getting the exact interpretation you want at the end.

> **HOW THIS CHAPTER FITS THE WORKFLOW**
>
> ### Actual Processing Begins in Camera Raw
>
> This is the first chapter in which you actually process an image. That's perfect positioning for a book about nondestructive image editing; nothing you do in this chapter will destroy any of the original image data. The magic here is that all Camera Raw does is add instructions to the metadata that dictate how every bit of data recorded by the camera should look when it's opened in Photoshop. When you really need to go all the way back to the very beginning, you simply return to the original RAW file and change the settings in the RAW processor. Also, all Camera RAW data is recorded in 16-bit format, with the data itself typically occupying 10–12 bits. JPEGs contain a maximum 8 bits of data. So you're actually working with a positive image that has five to seven more f-stops of brightness range than the analog negative that's often suggested as its equivalent.

Save to DNG

One scary thing about shooting RAW files is that very few cameras shoot RAW in what I have reason to believe will become a long-lasting and universal format: Adobe's open source digital negative (DNG). There are several

reasons for this, such as the branding ego of various camera manufacturers. The danger is that we know ultimately all these proprietary formats will drop out of existence, either because of technological improvements, marketing considerations, or mergers and dissolutions of manufacturers. At that point, you have your files in a format that is no longer supported. So be smart: as soon as you download your images from the camera and have added the appropriate metadata (see Chapter 1), use Adobe's DNG Converter to convert all your proprietary files to DNG. I save these files in a subfolder. I also save them in a folder called "DNG backup." As soon as there are enough conversion files in the DNG backup folder to fill a DVD, I do just that. If you have a new camera that sports a new RAW format, make sure you've loaded the latest version of the DNG Converter from the Adobe site: *http://www.adobe.com/products/dng/main.html.*

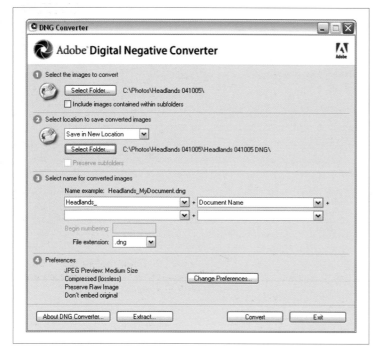

Figure 4-1. The DNG Converter dialog.

The DNG converter is very quick and easy to use. Of course it's annoying (and easy to forget) to perform any routine that's new to your work habits, but you'll be very glad you did. Even if you think your particular iteration of your camera maker's proprietary RAW format will *never* disappear, one more backup is just plain good insurance.

The DNG Converter can translate the entire download folder at once and gives you the option to save the DNG files to separate folders. If you choose to save to *.dng*, I recommend that you check only the Compressed DNG option (the compression is lossless, so why not save drive space?) and choose Medium as your JPEG preview size. You can see the "Save to DNG" dialog in Figure 4-1.

Here's the step-by-step process to save a DNG file:

1. Download the converter and create a shortcut for your desktop.

2. Download the files from a shoot, put them into the same folder, and follow the naming conventions suggested in the "Renaming Individual Files" section in Chapter 3.

3. Go to your desktop and click the Adobe Digital Negative Converter icon. The dialog in Figure 4-1 will appear.

4. Click the Select Folder button to choose the folder of files you want to convert. If you've (for some strange reason) already decided to create subfolders of files in other formats or put your rejects into a subfolder, you'll want to uncheck the "Include images contained within subfolders" checkbox.

5. Click the Select Folder button. Go to your parent folder for this shoot and create a subfolder with *DNG Backup* as the prefix and the name you've given the parent folder. So the folder name will be something like *DNG Backup Smith Wdng.*

6. Leave the third section of the dialog box untouched (you have already named your files, right?) so that it uses the current filenames with .dng added.

7. Stick with the preferences shown in Figure 4-1.

The rest all happens on its own, as if by magic.

If you forget to convert your camera's RAW files to DNG as soon as you download them, you can also save them to DNG with the Camera Raw Save button (but I don't recommend it). This also works if you have opened multiple files. Just complete the dialog in Figure 4-2 as shown.

Camera Raw has many major advantages:

Nondestructive editing
RAW files are read-only. Any image adjustment you make in Camera Raw can be deleted or readjusted at any time without affecting the information your camera originally recorded. The edits you create in any RAW processor, including Photoshop CS2's Camera Raw, are only recorded as metadata instruc-

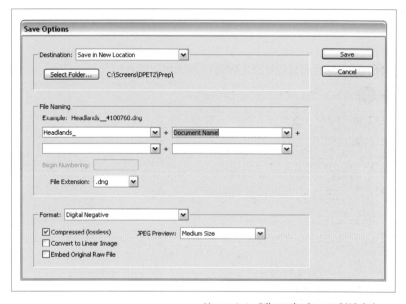

Figure 4-2. Fill out the Save to DNG dialog as shown but be sure to use a category name that's appropriate to the image.

tions as to how the picture should appear when it's viewed or edited in an image processor, such as Photoshop CS2. The actual pixel data remains unchanged. The only way you can destroy your original image would be to delete the file without backing it up. *Hopefully, you always back up your images to DVD immediately after downloading them to the computer.* This means that you can always recover when you need to create a different interpretation of the data.

No need for color balance adjustment in camera
Camera Raw lets you visually change the overall color temperature of your image, so you can choose not only from daylight and tungsten but also from virtually every color temperature and tint in between. Of course, if you do set color balance in your camera, you're likely to see an image that's closer to what you had in mind when you first previewed that image in Camera Raw, so there will be a little less work to do.

Five to seven f-stops of exposure latitude

Yes, you heard that right. Even if your image was shot two full stops over or under the "ideal" exposure, there's an excellent chance that you can rescue it by dragging a few slider handles—no one will ever know. How much latitude a given camera's RAW files actually contain will depend on how many bits of data were actually recorded. Only a few very high-end cameras actually record more than 12 bits of data in the 16 bits that are available to RAW files. By the way, just because you *can* be sloppy with your exposures doesn't mean you should be. If you expose properly, you can use that same latitude to extend the dynamic (brightness) range of your images so that you can produce highly detailed photos that closely approximate the range of brightness seen by the human eye. Figure 4-3 shows the same image adjusted to three different "exposures."

Figure 4-3. The same image adjusted (from left to right) to minimum exposure, Auto exposure, and maximum exposure. Note that none of these renditions contains significant "blocked" data.

Immense time-savings due to highly automated processing of multiple files

Photoshop CS2 Camera Raw actually provides you with the means to adjust a whole series of images at the same time (see Figure 4-4).

Easy elimination of "losers"

Camera Raw provides you with the means to quickly review a whole series of images at 100 percent magnification so that you can eliminate images that are slightly out of focus or slightly motion-blurred.

Digital Photography Expert Techniques

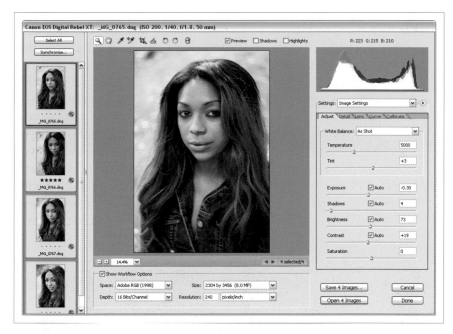

Figure 4-4. Camera Raw with a series of images from a portrait shoot that are all open at the same time. In this instance, all have been selected and Synchronize was turned on so that any adjustment affects all the selected images equally.

Ability to archive your RAW files to a nonproprietary format

Adobe has created a RAW file format—DNG—and made it available to all software publishers and camera makers. So, long after technology and changes in the industry have made the proprietary format your camera shoots obsolete, DNG format is likely to remain a standard.

Built into Photoshop CS and all later versions

You don't have to use your camera's supplied (and typically awkward or underpowered) program to render your RAW files. True, some proprietary and third-party RAW software (notably Phase One's Capture One and Pixmantec's Raw Shooter Premium) is even faster and more powerful than Camera Raw. However, the Camera Raw version in CS2 does a lot to narrow the gap, and you don't have to spend extra to get it.

Ability to open files in Photoshop in 16-bit mode

To put it another way, you can keep every bit of the data that exists after you've adjusted your image in Camera Raw. So if you want to make even more adjustments in Photoshop for dramatic effect, you're far less likely to see posterization in your images as a result. Posterization occurs when the adjustments you make "stretch" two specific levels of brightness and there isn't enough data in between to bridge the two new levels of brightness (see Figure 4-5). It's admittedly a bit hard to visualize what this means, but I'm sure you've looked at the Histogram

for an 8-bit image after it's been adjusted and seen a diagram that looks like Figure 4-5.

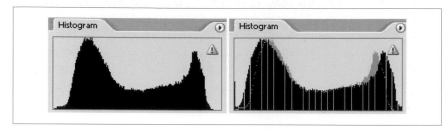

Figure 4-5. Posterization indicated by a "combed" Histogram (right) and the histogram for the same image when the adjustment is made from a 16-bit file (left). The space between the "fingers" in the Histogram is represented in the image as being of uniform color and brightness.

Added Curve control

With CS2, there's a tab in Camera Raw that lets you adjust contrast in specific brightness ranges within a given image, just as you can in Photoshop (see Figure 4-6). This capability is especially valuable to make a better first proof of your images for client and subject approval. The Curve dialog is a simplified version of the one in Photoshop. (Before using it, you should first make your image look as good as possible by using the settings in the Adjust tab.)

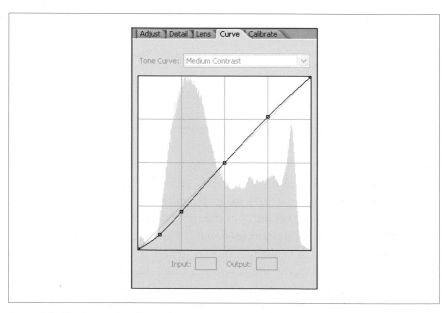

Figure 4-6. The Camera Raw Curve tab.

Auto adjustments option

Wedding and sports photographers often argue that shooting in RAW significantly extends processing time, making it difficult to respond to the immediate turnaround demanded by their publications and clients. Camera Raw now attempts to answer that objection by defaulting to "smart" Auto adjustments for Exposure, Shadows, Brightness, and Contrast. As a result of Auto settings, you have a good or better chance of having a publishable image right out of the camera as if you'd shot JPEGs.

Auto Adjustments Techniques

You can even bypass Camera Raw altogether by accepting the Auto adjustments and edit directly in Photoshop. In Bridge, select the RAW images you want to open and press Shift-Return/Enter or Shift-double-click the thumbnail. Whatever output options you or Camera Raw Auto set will automatically be used for any RAW images opened directly in Photoshop.

Auto Adjustments provide a reasonable preview of what your image should look like, so you don't have to do as much guesswork. As soon as you drag a slider to make a custom adjustment it will automatically replace the Auto adjustment and the Auto box will become unchecked.

Actually, there are a couple of quick ways to turn Auto adjustments off:

- Click any or all of the checked Auto checkboxes. Multiple clicks toggle Auto on/off.
- Press Cmd/Ctrl-U twice; the first time all auto adjustments will be turned on and the second time they'll all be turned off.

You can turn off the Auto settings or change the defaults so only your chosen few are automatically turned on. From a timesaving, quick turnaround standpoint, it's better to leave them on. However, I know some incredibly talented photographers who prefer to start with the settings all turned off so they're not prejudiced into thinking that there is only one way to interpret the image. Ah yes, the world is a wonderful place, full of options and mystery.

Leveling and Cropping in Camera Raw

We're almost all guilty (yes, even when using a tripod) of paying so much attention to the subject that we forget to carefully level the horizon line. Granted, tilted photos can sometimes be effective in making them look more spontaneous. However, most of the time tilted photos (especially if the tilt is only slight) just look unprofessional. Of course, Photoshop has some great tools for fixing this problem, but they are all destructive. For instance, you could tilt the top layer of the photo and make that layer from a flattened duplicate of the photo. However, if the original was a RAW file, that's a lot of wasted time. Straightening the RAW file can always be reversed because the data outside the crop is never deleted.

Leveling and cropping are so easily done that you may be wondering why you should even bother to think about doing it in Camera Raw. There's another very good answer: it's faster to turn around your work for client acceptance in a condition that makes it much more likely to be accepted.

Camera Raw features two tools in its toolbar that relate to leveling and cropping. The Straighten tool lets you level and crop in one operation. The Crop tool is strictly for those images that are already level, but need some degree of freeform cropping.

The Straighten Tool

Of the two, the Straighten tool is by far the coolest. Only some sort of photo robot is going to be able to keep all handheld shots perfectly level all the time. But all it takes to make them perfectly level is to drag the tool along a line (such as the horizon) that should ultimately be either perfectly level or perfectly vertical (see Figure 4-7). Zap! A new frame, already rotated to precisely the degree necessary and cropped to the maximum size possible after the rotation, is automatically placed around the image.

Figure 4-7. The Straighten tool allows you to level out the horizon.

Figure 4-8. The Preview Window after an image has been cropped and rotated.

Figure 4-8 shows what the Preview Window looks like after the image has been cropped and rotated. The file is rotated and cropped every time Camera Raw saves the image. You can change the size and proportions of the crop by dragging the marquee's handles. You can also rotate the crop (if there is room within the original image frame after resizing the crop) by placing the cursor outside the marquee and dragging.

Click the Crop tool, drag diagonally across the image, and release. You will see the Crop marquee and its handles. You can now resize by dragging the corner handles, reproportion by dragging the midpoint handles, or rotate by placing the cursor just outside the marquee and dragging in the direction of the desired rotation.

If you want to cancel the operation for either the Crop or the Straighten tool, select the tool and click outside the marquee. The image will simply return to its original state.

Understanding Camera Raw's Tabs

Camera Raw's functions are divided into tabs that were originally organized in order of workflow. However, when CS2 added new tabs, it simply added them sequentially. The most significant addition is the Curve tab, which should be used immediately after the Adjust tab. The sections below describe the features and functionality of each tab. They also discuss how workflow should be applied to each feature whenever that's a consideration.

Using the Adjust Tab Settings

The next step is to work with the settings on the Adjust tab (Figure 4-9). The settings on this tab are the most important and critical in Camera Raw. The one exception to using the Adjust Tab settings are situations in which you have already used the Calibrate tab to calibrate your camera, but because that is less commonplace and a bit more advanced we'll save the Calibrate settings for later (see "Using the Calibrate Tab"). Now, having said all that, let's just jump right in.

Adjusting white balance

White balance is a synonym for overall color balance. There are times when accurate white balance is absolutely critical and other times when color balance is purely subjective. White balance is critical if your assignment calls for absolutely accurate reproduction of a color in the photo. This might be the case if you were photographing a company logo or catalog items that came in a selection of specific colors.

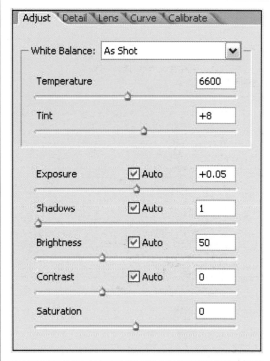

Figure 4-9. The Camera Raw Adjust tab, with the Auto boxes checked (on) is the default. If you wish to change an Auto adjustment, just drag the appropriate slider.

Whether or not you get that color absolutely accurately in the final output is dependent on much more than how precisely you set white balance in Camera Raw. You'll have to begin by having your monitor accurately calibrated. Otherwise, you will have no way to judge if your white balance settings are accurate when compared to the colors on the card.

Right now, we're focused on starting with accurate color rendition in the "color negative," which is the result of the Camera Raw output to Photoshop. The best and easiest way to do that is to shoot the first image of a series in a given set of conditions (camera, lens, light source, and nearby reflective surfaces) by placing an object that contains several levels of gray and all the

primary and complementary colors (Figure 4-10). Color cards must have absolutely accurate colors and gray levels, so purchase them from a reputable professional camera store. Color cards range in price from $30 to about $300. Oh, and if you're trying to match the color of a label, logo, fabric, or paint, it helps to have a sample of the actual item right alongside your monitor.

Whichever card you use, place it at the same level and lighting conditions as the main subject in the first shot in a series of similar shots. Do it again any time lighting conditions change. If you're shooting sports or news, just place one in a test shot as the first shot on each memory card.

Now, here's the easiest way to get close-to-perfect color balance:

1. Open the RAW photo in Camera Raw and click on the White Balance Tool icon—it looks like a gray eyedropper—in the Camera Raw Options Bar.

2. Place your cursor on the gray card in the Preview window image and click.

Bingo!

Figure 4-10. The Digital Gray Card.

> **NOTE**
>
> *Here's a little secret: you didn't need the colors in the color card to set white balance. However, you will need them when it comes time to set camera/sensor calibration to match a specific color in the image, such as that of the blouse in the catalog ad. The best reason to get a color card is to avoid having to carry two cards.*

Save the settings for each lighting condition you have measured with a gray card. That way, if you don't have the time or opportunity to place the gray card, you can look for the same conditions on your list and set the white balance to those conditions. Pretty clever, eh? Here's the step-by-step process on how to do this:

1. In Bridge, set up your workspace so that you see your metadata as you page through the images.

2. Look through your image catalog for a photo shot in the same conditions that was shot with a gray card.

Now, here's another little secret: even if you don't have a gray card, using the White Balance Tool (the gray eyedropper icon in the Toolbar) on anything in the picture that's close to medium gray will get you surprisingly close to accurate color balance. In fact, you'll often be startled how much better the image looks than setting the white balance by simply dragging the sliders.

Which brings us to the matter of setting white balance subjectively. If your objective is to set a mood or convey emotion, rather than absolute objectivity in rendering the subject, using the White Balance sliders is totally intuitive.

Figure 4-11 shows a model's face as it looked when shot in the camera and then after a subjective adjustment of the Temperature and Tint sliders.

Figure 4-11. A model's face as the camera saw the color balance (left) and the same pose after subjectively using the Temperature and Tint sliders.

To subjectively adjust Temperature and Tint, open the RAW image by double-clicking it in Bridge. It will open in Camera Raw. To give the image a warmer tone, drag the Temperature slider to the right. You'll notice the overall cast of the image becomes more yellowish-orange. If you want more of a nighttime look, drag the slider to the left and watch the image get "cooler" until it turns blue.

If your light source was fluorescent or if there were colors other than those of the main light source being reflected off nearby objects, you may have trouble getting exactly the color balance you want by using the Temperature slider alone. Fluorescent lighting has more green than conventional tungsten, daylight, or strobe. Drag the Tint to the right to reduce the green and add magenta.

The time of the day and the weather conditions you shoot in can also give you clues as to the most believable color balance. You can use the choices in the White Balance pop-up menu to automatically set the sliders to the settings typical of those conditions if you know what they were. Then, if you don't like the results, you can always further adjust the sliders to get the "feel" you want.

Adjusting exposure values

The balance of the sliders in the Adjust tab are for adjusting exposure, shadows, brightness, contrast, and saturation values of the image. The first thing you should do is set a black and white point for the image. This is done much the same way as if you were working with the Level command in Photoshop. Here are the recommended steps:

1. Check the Preview, Shadows, and Highlights boxes in the Camera Raw Toolbar. Now, bright red blotches will appear whenever your adjustments block highlights; bright blue will do the same for blocked shadows (Figure 4-12).

2. Drag the Highlights slider until the right foot of the Histogram just touches the right outside border of the Histogram box (see Figure 4-13). If this causes the image to look too dark, drag the slider to the right until red blotches start to appear. Don't let this happen to any greater extent than you can tolerate the total lack of detail in those areas of the highlights.

3. Drag the Shadows slider until the left foot of the Histogram just touches the outside left border of the Histogram box. If this causes the image to look too dark, drag the slider to the left until blue blotches start to appear. Don't let this happen to any greater extent than you can tolerate the total lack of detail in those areas of the shadows (Figure 4-14).

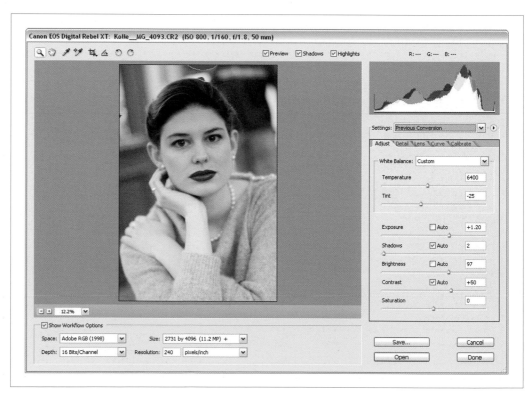

Figure 4-12. When the image was first opened in Camera Raw, the Preview boxes were all checked to make it obvious whether any highlights or shadows were blocked.

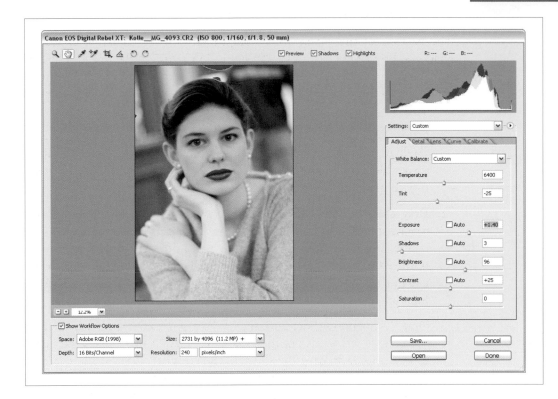

Figure 4-13. The Histogram adjusted so that no important highlights or shadows are blocked. Notice that the foot of the Histogram "mountain" almost touches down at the edges of the frame.

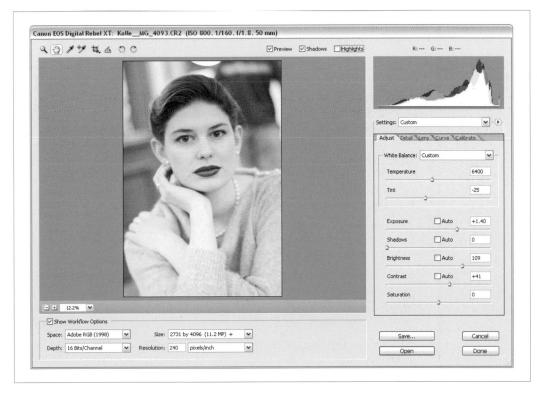

Figure 4-14. The sliders for Exposure and Shadows were adjusted to eliminate the blocked highlights and shadows. The Brightness slider then had to be adjusted to increase the overall image brightness.

NOTE

There are times when it's OK to block highlights and shadows to create a certain effect. But be sure that's the case and that you're not accidentally "uglifying" your hard work.

At this point, the image is adjusted so that, technically, it will display a full range of brightness values. If the overall image looks a bit too bright or too dark, adjust the Brightness slider. This slider adjusts the midtones. Make sure not to overdo it to the extent that blocked color blotches start to appear. If they do, either back off on the Brightness or move the Highlight and Shadow sliders as necessary to make the compensation.

Now you've got your basic exposure nailed. If you feel the image needs a bit more or less contrast, you can play with the Contrast slider. You can (and probably should) finalize contrast with the Curve tab (see the "Using the Curve Tab" section next), which will give you more control over the amount of contrast assigned to a given brightness range in the image. Using the Contrast slider is simply a matter of adjusting it to suit your visual preferences. Remember to leave all three Preview boxes checked so you can tell if your contrast adjustments start blocking highlights and shadows.

Whether to Check Auto on the Adjust Tab

If you're looking at your photos as Camera Raw automatically interpreted them, you may be wondering why you should make any adjustment at all. In the default Auto mode, Camera Raw is pretty good at giving you the same result you'd expect from a one-hour photo lab. This is a blessing because you can now turn around a whole RAW photo shoot to your client for approval with very little fiddling. So as I tell you about the correct workflow for adjusting the rest of the sliders in the Adjust tab, I'm going to be telling you how (almost 100 percent of the time) you can make the image look even better—and sometimes a whole lot better.

I recommend leaving Auto Adjust on as a default value—it gives you a starting place.

There is one danger to this: you can't always tell how close to perfect your original exposure was and, therefore, what needs the most adjustment. But all you have to do to compare the original exposure with the Auto exposure is press Cmd/Ctrl-U to toggle Auto settings on and off. When you turn Auto off, the images appear as they were shot. When you turn them on, the settings will go back to being the last ones you chose. So there's no chance that you'll inadvertently obliterate your painstaking adjustments.

When you're ready to "perfect" your image (for maximum efficiency, it's best to wait for client feedback so you don't have to do more work on all of them) use the following workflow:

- After client approval, make as many improvements as you can in Camera Raw because it's completely nondestructive.

- Go to the images that have been approved, press Cmd/Ctrl-U to turn off all the Auto checkmarks.

- "Custom" adjust the settings in the tabs to produce the best-looking image possible.

Using the Curve Tab

The next tab in the workflow is the one that goes out of order. The Curve tab's workspace is too large to fit within the Adjust tab, so it has to have its own tab—even though you're still adjusting. It really should have been positioned right after the Adjustment tab, but it's brand new, so it was simply tacked on near the end. You can see the Curve tab in Figure 4-15.

The Curve tab is just a simplified version of the Curves command in Photoshop's Image menu or in the Curves adjustment layer. There are some important differences:

- The contrast of individual color channels can't be adjusted in Camera Raw Curve.

- There is no Pencil tool that lets you draw a freehand curve.

- The curve adjustment can't be masked so that it is focused only on specific portions of the image.

- It can only be used once on the entire image.

So if the Curve tab isn't quite as powerful as the (nearly) equivalent command in Photoshop, why not wait until the image is in Photoshop? Well, there are actually several reasons:

- Creating the basic contrast curve for the image is completely nondestructive. However, to readjust it you have to return to the RAW image and reset the curve contrast. So you only want to use it here to control the contrast within overall brightness ranges in the image.

- The more basic you make this adjustment now, the easier it will be to add Curves Adjustment layers in Photoshop to control very specific brightness ranges (skin tones or skies, for example).

- You can immediately see how your curve adjustments affect the image's Histogram, so you know when you push the brightness of a certain range beyond its limits. Remember, too much brightness information in a specific range will push past the top border of the chart. Too little will leave a blank space in the Histogram. If the Histogram goes off the chart at either end, there is no brightness detail in either the whites (highlights) or blacks (shadows).

There are many ways you can construct a curve. The most basic curve is a linear curve (so called because it is simply a straight diagonal line from one corner of the Histogram to the other). By default, the Tone Curve menu is set at Medium Contrast. I find that I have more control over the tonalities that I want to see by choosing Linear and then performing the following

Figure 4-15. The Curve tab.

steps to adjust the curve (if you have a lot of experience with curves, you might want to skip the first two steps):

1. Choose Linear from the Tone Curve pop-up menu. Move the cursor to the very center of the diagonal line (where it intersects a grid point) and click. This point represents the exact midrange of the image.

2. Place a point and the other two intersections of the diagonal line. The one at the bottom represents shadow midtones; the one at the top represents highlight midtones.

3. To brighten a range of tones, click to highlight the point that represents that range of tones. You can drag it around, but your adjustments will be much more precise if you use the arrow keys.

4. Experiment with the placement of the dots until you like the way the image looks in the Preview window. If you've left the Preview boxes checked, you can also make sure that none of your Curve changes have caused blocked highlights or shadows.

Using the Detail Tab Settings

Many experts recommend using Photoshop to correct issues instead of using the Detail tab. If your goal is maximum image quality no matter how long it takes, follow that advice by all means. On the other hand, if you often find yourself in high-pressured situations, it's a great advantage to do your initial sharpening and sensor noise cleanup before you send it out of Camera Raw and straight to your client.

The Detail tab is immediately to the right of the Adjust tab. It is used to control sharpening and sensor noise (see Figure 4-16).

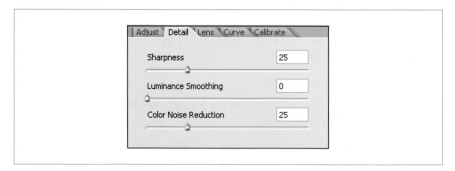

Figure 4-16. The Detail tab.

Sharpening

The Sharpeness slider is meant to be intuitive and interactive. However, you should be very careful to avoid over-sharpening, especially if you plan to do the Effects and Output sharpening that a good "workflow for perfection"

calls for. That's because sharpening sharpens sharpening. The result is overly contrasting edges and (worst case) added black shadow outlines and white halo outlines.

To avoid over-sharpening, sharpen at normal size in the Preview window. Then, before you save the image, double-click the Zoom tool so you can see a 100 percent preview. If you see even the hint of sharpening artifacts, back down on the sharpness slider.

Eliminating sensor noise

Sensor noise is something you're most likely to encounter if:

- You're shooting with a small sensor (point-and-shoot) camera.

- You had to elevate the ISO setting because you were shooting in low light or needed to capture speedy movement.

- You have a series of images with a lot of deep shadow detail that you needed to brighten.

Like Sharpening, eliminating sensor noise is something that can be done as well as or better once the image is saved to Photoshop CS2. However, if you only have enough time to process your image in Camera Raw before using the Image Processor to convert your files into TIF or JPEG to ship to your client, then Camera Raw's ability to clean up any sensor noise is better than none. And, once again, if you have the time later, you can always return to the RAW file and output an image in which you've turned off Luminance Smoothing and Color Noise Reduction.

Luminance Smoothing
> Works on the odd monochromatic clumps of artifacts that look a bit like film grain. It selects and blurs these lumps so they blend in with the rest of the image. Actually, as you might guess, you have to be careful not to overdo it, as this will soften the image, thereby "undoing" your sharpening.

Color Noise Reduction
> Gets rid of the wee color speckles that are the really distracting and upsetting part of image noise.

The amount and characteristics of noise that you get in your images will vary greatly. First, every camera model is different. Second, the smaller the sensor, the more likely you are to encounter noise. If you have an APS or larger size sensor, there will likely be no camera noise except at settings above ISO 400. In fact, some full-frame CMOS cameras and Foveon sensors may have no noise except when shooting very long exposures in the dark.

If the noise problem for a given image is extreme, you may just have to live with what you can reduce it to or buy a third-party noise filter such as Noise Ninja or Neat Image. The best you can do in Camera Raw is to do the best

you can. More often than not, that will be enough. To find and reduce the noise that may be in an image, follow these steps:

1. Double-click the Zoom tool. You'll be at 100 percent magnification.

2. Use the Hand tool to pan around the image until you find a dark to medium gray area of fairly uniform color (the smoother the better). You may want to zoom in a bit more. Do you see anything that looks like grain or little blotches of color? If so, you've got *noise* (Figure 4-17).

3. In the Details tab, drag the Luminance Smoothing slider slowly to the right. Be sure to release it every 1/8" so you can see the result. At the point where the grainy monochrome spots seem to loose their texture, stop. If you haven't lost any sharp edges, you're fine. If you have, back off a bit.

4. Are there any blotches of color that don't look like the natural texture of what you've photographed? If so, drag the Color Noise Reduction slider slightly to the right. When the color blotchiness is gone, you're cool—as long as you haven't fuzzed your image.

5. If your efforts to reduce noise result in more image softening than you find acceptable, you can try to reuse the Sharpening slider—but don't be surprised if you find yourself going 'round in circles. The same precautions outlined in the "Sharpening" section pertain here as well.

Figure 4-17. A 100 percent enlargement of a section of an image that shows pronounced noise.

Using the Lens Tab Settings

The Lens tab is used to minimize a digital phenomenon called fringing and the vignetting that occurs most noticeably with bargain-priced wide-angle lenses. You can see the Lens tab in Figure 4-18.

— **NOTE** —

These settings follow the same workflow advice as I gave earlier: if your goal is maximum image quality, no matter how long it takes, rely on the power of Photoshop. If you need a quick turnaround, it's best to make the photo look as good as possible before you send it out of Camera Raw and straight to your client.

Eliminating vignettes

We'll work with the settings for eliminating vignetting first just because they're dead simple and also because they can be used to create vignettes as well.

Vignettes are often the result of cheap optics or of the use of filters or lens hoods that are too small to cover the entire angle of view of the lens. They

Figure 4-18. The Lens tab.

tend to show up more in wide-angle optics—even more so if you have a camera with a full 35mm-size sensor. In extreme cases, you can spot vignetting when you see a gradual darkening around the edges of the photo. In Figure 4-19, I have intentionally exaggerated the vignetting to make it easier to see what it looks like.

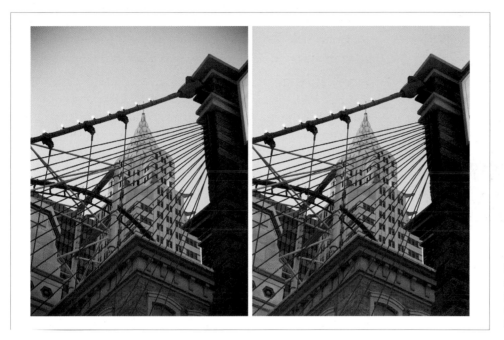

Figure 4-19. Noticeable vignetting caused by a fully zoomed out wide-angle lens. On the right, it has been corrected by the Lens tab's Vignette slider.

There are, by the way, two types of vignettes: dark-edged and light-edged. Moving the slider to the right makes the vignette lighter; moving it to the left makes it darker. If it's dead center (the default position), the slider has no effect at all.

If you have never corrected your edges for vignetting—probably because you didn't think it existed—take a few of your widest angle photos and try correcting them by dragging the vignette slider slightly to the right. If the corners brighten just enough that the whole image looks more "even," your lens probably has a slight amount of vignetting. The chances are particularly good if the lens is a 28mm or wider 35mm equivalent and has not been stopped down more than one or two f-stops.

Now, here's the interesting part: you may want to use this slider to *create* a vignette. After all, vignettes can be very effective in focusing viewer attention on the center of the image. Usually, I recommend doing that on a masked adjustment layer in Photoshop so you can turn the layer on and off to show your client (or yourself) the difference. However, if you want to save a layer and still do it nondestructively, here's your big chance.

When you're correcting a vignette, you usually want to keep it centered in the frame. However, when you're creating one, you may want to be able to

control the location of the center. However, you can't do that until you create the vignette itself. To make the vignette darker, drag the slider to the left. To make it lighter, drag it to the right.

Now you can move the center up or down. Simply drag the bottom slider and watch the vignette move until the vignette is positioned as you'd like it. You can see the result in Figure 4-20.

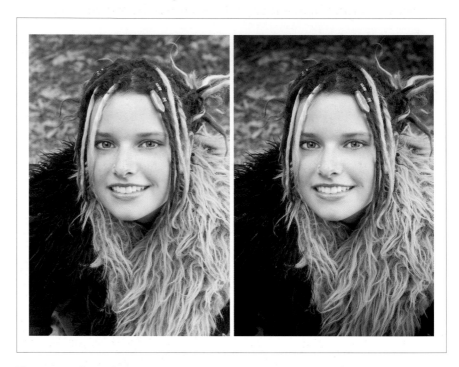

Figure 4-20. The result of creating a vignette.

Minimizing color fringing

Color fringing (aka chromatic aberration) comes in two flavors: Red/Cyan and Blue/Yellow (see Figure 4-21). Camera Raw, once again, isn't the most sophisticated tool on the planet for getting rid of this "fringe," but it's handy, nondestructive, and quick.

Once again, color fringing is a phenomenon you're most likely to see with small sensors, high ISO settings, and cheap optical construction. So if you can afford the best shooting gear, you won't encounter it much. If you do, here are the steps to get rid of it:

1. Select all the similar images that are likely to show chromatic aberration and open them at the same time in Camera Raw. Be sure to click the Select All button.

2. Double-click the Zoom tool. In the Preview window, all the images will be enlarged to 100 percent. Now, move the cursor to the middle of the

Preview window and click once more. You are now zoomed in 200 percent. Use the Hand tool to move the image around until you find some sharp, highly contrasting edges.

3. Oh, I almost forgot. You want to make sure your fringing isn't the result of over-sharpening. So before you go any further, click the Detail tab and take a look at the Sharpening slider. Make sure its slider is all the way to the left. If not, just put it there. Then go back to the Lens tab.

4. Now look carefully along your high-contrast, hard edges. Do you see any pure Red, Cyan, Blue, or Yellow lines that are parallel to those edges? If you do, you got fringing, baby. Don't panic—fix it.

5. If the worst fringe lines are Blue or Yellow (and they usually are), drag the Blue/Yellow slider to the left until the Blue disappears or to the right until the Yellow disappears. You won't see both of these colors. You might, however, see some Red or Cyan fringe lines. If so (you guessed it), move the Red/Cyan slider left to get rid of red fringe, or to the right to get rid of blue fringe.

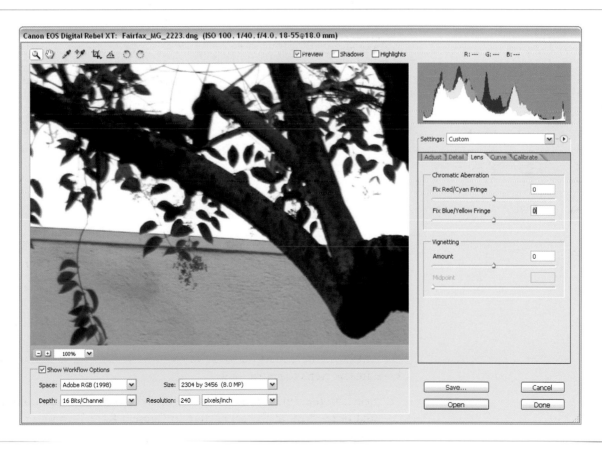

Figure 4-21. Red/Cyan (left) and Blue/Yellow (right) color fringing is easiest to spot along high-contrast edges.

Using the Calibrate Tab Settings

Camera Raw in CS2 has another new tab, Calibrate (Figure 4-22), which allows you to adjust the way your camera's sensor interprets color. You can adjust the color tint of shadows to make them more neutral by changing the green or magenta. You can also adjust how the sensor interprets each of the primary colors in respect to Hue and Saturation. You'll also learn to save those settings to reuse later or use on other images.

Figure 4-22. The new Calibrate tab.

One of the beauties of RAW file processing is that, for most purposes, you don't really need to calibrate your camera. This is because you have so much flexibility in interpreting the image in Camera Raw that the exact interpretation of the image can cover a huge range. The exception is situations in which you are shooting a product or scientific assignment in which a specific color must be reproduced exactly (e.g., the color and shade of clothing in fashion advertising or company logos when in a prominent portion of the photograph).

Before someone protests, it is true that Camera Raw is powerful enough to let you match colors without calibrating your camera. If your monitor has been calibrated to a very precise level, you could simply match colors by placing the object next to the monitor and then making adjustments in Camera Raw to match the color of the object. That's a good thing, because there will be times—such as when the client sends you a RAW file that you didn't shoot—when you have no other alternative. It is *desirable*, however, to calibrate your camera because it can save you hours of Camera Raw time. Besides, the more accurate your original exposure, the more latitude you have in interpreting that shot.

> **NOTE**
>
> *I've already mentioned using gray cards and color cards. If you're using only a gray card, don't expect your calibration to be good enough to accurately reproduce specific subject colors. However, your image will represent reality much more accurately and I'd advise saving the profile if you are likely to find yourself in that situation again.*

The tools you use to calibrate your camera sensor are in the Calibrate tab. These happen to be the same tools you'd use to subjectively change your camera's interpretation of color and detail. I'll give you procedures for using the Calibrate tab for both purposes.

To use the Calibrate tab to subjectively tweak the interpretation of individual primary colors:

1. Click the Calibrate tab. The Camera Profile menu will show only the current version of ACR that is installed. You should make sure you have only one version installed because Camera Raw can become confused trying to use a version that may not be current enough to read the RAW files for your particular camera and model.

2. One at a time, go to the two sliders for each of the primary RGB colors. If that color seems too overpowering, drag the Hue slider to the left. If you want it emphasized, drag the slider to the right. You usually want the Hue slider to give you the best compromise between the purity of that primary color and the amount of detail that you can see within it. Figure 4-23 shows the Hue of the Red in this image before and after adjustment.

Figure 4-23. From left to right, the image before any Calibrate adjustment and after the change of Hue in Reds, with lowered saturation in reds.

Getting and Installing Prebuilt Calibrations

The easy way to make sure that your camera's sensor(s) are making accurate interpretations of each of the primary colors is to download a Camera Raw calibration settings file from either your camera's manufacturer or—one of these days—from the Adobe site. The bad news is that unless you own a very high-end camera, such as a digital back for a medium or large-format camera, you probably won't find such a thing in either place. It's just a matter of time, however. In the meantime, calibration settings are likely to start appearing on enthusiasts' and well-established digital photography sites. Use your Internet search engine. Until manufacturers catch on, you'll have to calibrate your own camera (see "Making situational calibrations" next in this chapter).

But wait, there's more bad news: the only way to get truly accurate camera calibration is to calibrate for each camera, lighting, and lens combination that you're likely to use. This works best for a studio (or home studio) situation in which you can easily recreate the same lighting setup. Also, if the setup includes diffusers, reflectors, or backgrounds that may reflect a different light color temperature than the lights themselves, you'll have to calibrate for that shooting combination as well. The "Making situational calibrations" section tells you exactly how to go about making these calibrations. This will also help you set your white balance more quickly and accurately, even if you don't want to save the results as a calibration file.

3. Once you've adjusted the Hue of a given color, use the Saturation slider immediately below to adjust the intensity of the color until you like the combination of what you see.

Figure 4-24. A diagram of how your first camera calibration shot should be set up.

4. Check the moderately dark shadows, especially, in this case, those cast on the sheet. Are they completely neutral gray? If not, drag the Shadow Tint slider to the right to increase Magenta or to the left to increase Green until the shadow turns neutral. The procedure is the same if the shadows are cast onto colored objects, but it is hard to be as accurate. Since what you're doing at this stage is purely subjective, it's no big deal.

If you want to create a calibration for a particular camera and lens combination for use under particular lighting conditions, you must first take a picture in circumstances that are likely to be used in the same lighting conditions. For purposes of this example, you should shoot indoors using tungsten bulbs. Make sure there is no outside daylight coming in and that the tungsten bulbs are all of the same type. Don't mix traditional-type tungsten with the energy-saving fluorescent that has become so popular—they are likely to have very different color temperatures. Set up your shot with a white background. Figure 4-24 shows how each of these should be set up.

Here's how you use this setup to calibrate your camera for this lighting situation. If you use the color card in most of your other shooting at the beginning of any series, you will be able to check against the color card to calibrate the settings for this situation. Use the camera's information as recorded to metadata to note the time of day, year, lens, and camera. Looking at the picture itself will generally tell you about the conditions in which the photo was shot. So figure out how to incorporate all that information into a filename for the setting and save it. Of course, it will help if you know how to save calibration settings so you can apply them to any other RAW file. If that RAW file was shot in the same conditions, your rendition should be technically perfect, especially to ensure the accuracy of colors. I'll go over saving calibration settings next. Here's how you shoot the test shot to calibrate colors accurately for controlled tungsten lighting on a white background:

1. Set up your lights, background, and subject to suit the intent of the photo you're about to shoot.

2. Use one of those little business card easels or find some other way to prop up a color test card. It is best to have at least one 10 percent gray swatch and six 10 percent swatches of each primary and complementary color.

3. Shoot a test shot and take a look at the Histogram to make sure the exposure has enough detail in both Highlights and Shadows to just touch the ends of the Histogram mountain (see Figure 4-25). The amount of information at a given level of brightness will determine the location of the peaks of the mountain and needn't be of any concern.

NOTE

No two histograms for different subjects will look much alike, since a Histogram is a diagram of the number of pixels at 256 levels of brightness from black (left) to white (right).

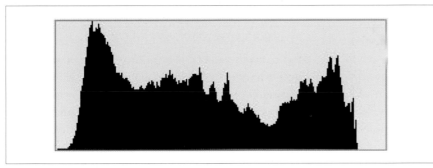

Figure 4-25. A typical histogram for a well-exposed image.

4. Load the image onto your computer and use Adobe Bridge to open it in Camera Raw.

5. From the Settings menu, choose Camera Raw Defaults.

6. In the Adjust tab, check all the Auto checkboxes.

7. Be sure to leave Saturation set at 0.

8. Click the Calibrate tab.

9. Place your color test card immediately alongside your instrumentally calibrated monitor (this is a must; if you don't have a monitor calibration spider, you can get the excellent ColorVision Spyder in its basic edition for $79 by shopping around online). If this is your first time instrumentally calibrating a monitor, you'll find it's very easy to do. Installing the software and following the instructions will probably take you no more than 15 minutes.

10. If you have a neutral shadow on a neutral background, choose the White Balance tool and click on it. If your shadows are on a colored background, drag the shadow tint slider until it looks just right. You probably don't want to move it so much that it noticeably changes any of the mid to bright colors in the image.

11. Drag the Hue and Saturation sliders for each of the primary colors until all the colors in the onscreen swatches exactly match those on the card. Be sure that both the monitor and the card are lit to the same level of brightness. If you have to shine a light on the card, make sure it doesn't hit the screen.

12. Once the colors match, you've got it. Now you need to save those settings (see the upcoming section "Saving and retrieving settings").

Making situational calibrations

Situational calibrations are made in conditions that you commonly encounter when shooting. Just be sure to have your color card in your camera case. When you arrive on the scene to shoot a situation, place the color card into the scene where it can be plainly seen and shares the same lighting as the subject you'll be shooting. When you're back at the computer, calibrate the shot you took and give it a name that can apply to similar situations when you don't have time to insert the color card in the shot. Then, when you're calibrating your shoot, you can just look for a settings title that matches the situation and apply that calibration to the new photos taken in the same condition.

Saving and retrieving settings

Saving calibration settings is no different from saving any or all of the other settings. The one difference is that when saving setting for calibration purposes, you should return all the other settings for all the other tabs to their default settings.

The only real tricks to saving settings are:

- Make sure they're stored in the Settings folder for the version of Adobe Photoshop you're using (CS2 or later or Elements 4).

- Come up with a system for naming these settings so they are coded in the camera, for the lens, light temperature, background color, and lighting setup. I try to put everything in a two-letter code and keep a chart in a Word or Excel document that fully describes each code name.

Then, follow these steps to save the settings:

1. Click the small diamond in a circle just to the right of the Settings menu. A drop-down menu will appear of commands for saving, exporting, and loading Camera Raw settings from all the tabs, including those you just made on the Calibrate tab.

2. Go to Preferences and make sure that the Save Settings menu is set to "Sidecar XMP files."

3. Choose Save Settings Subset. The dialog shown in Figure 4-26 appears. Be sure that Calibration is the only box checked. Then you can apply these saved settings to any image and only the Calibration settings will be affected.

Figure 4-26. The Camera Raw Preferences dialog.

Applying calibration settings to a collection

You can apply calibration settings to a whole series of images by opening them at the same time in Camera Raw. If you have more than, say, 16 images (the exact number depends on your installed RAM and on the size of the images), you may have to repeat these instructions for additional batches:

1. When you open multiple images, the first image is shown in the Preview window and the rest are shown thumbnails on the left side of the screen.

2. Click both the Select All and Synchronize buttons above the thumbnails.

3. Choose Calibration from the Synchronize menu in the Synchronize dialog and click OK.

4. Select the setting you just saved in the "Saving and retrieving settings" section from the Settings menu.

What if you have several hundred shots that you need to add the calibration settings to before you adjust the settings? Easy. Open one of those files in Camera Raw, apply the calibration settings and then click the Done button. Now, go back to Bridge, select all your files and then, in Bridge, choose Edit→Apply Camera Raw Settings→Previous Conversion. You may have

to drum your fingers for a few seconds, but all those images will have the calibration settings applied to them.

As you can see, it is possible to have dozens of calibrations for different lens, camera, and lighting situations.

> ── **WARNING** ──
>
> *Don't apply other Camera Raw settings before you apply these calibration settings—they'll be replaced by the default settings you saved with the calibration settings.*

Automating in Camera Raw

One great benefit of working in the CS2 version of Camera Raw is its expanded ability to automate the application of settings to numerous images at once. You can do this by applying the previous setting to an entire folder of images or to any highlighted image. Better yet, apply the settings to one image and then go back to Bridge and apply the previously used settings to any and all selected thumbnails or folders—all without ever even having to open Photoshop.

Winnowing While Processing Multiple Files in Camera RAW

> ── **NOTE** ──
>
> *One of the giant advantages in working with Printroom, Aperture, or iView Media Pro is that you can do winnowing at 100 percent magnification before you start processing.*

Winnowing is the process of sorting, classifying, ranking, and disposing of useless images. This should be done *before* you start processing. However, since the procedure is different when using Camera Raw than in Bridgee, I wanted to give it to you separately to avoid confusion. Camera Raw will let you simultaneously magnify all the images to any percentage of the original. Most handily, if you double-click the magnifier while Select All is in effect, all the images will be magnified to 100 percent. It is then very easy to move from one image to the next. Figure 4-27 shows the Camera Raw workspace as it should be set up while you are winnowing.

When you see an image that is unacceptably unsharp, hit the Delete key. The thumbnail will stay in place until you leave Camera Raw, but a red X appears in the upper corner of the affected thumbnail. If you change your mind about eliminating that image, simply click on the red X to deselect the image for deletion. You can zoom out by double-clicking the Hand icon. All the images will appear in the Preview window, scaled to fit. Now you can review the images for unacceptable characteristics, such as too much lens flare, an embarrassing facial expression, awkward pose, or the unexpected appearance of someone in front of the lens just at the "moment of click." Now that you've eliminated a lot of wasted file space and processing time, you can save even more time by adjusting whole groups of images simultaneously.

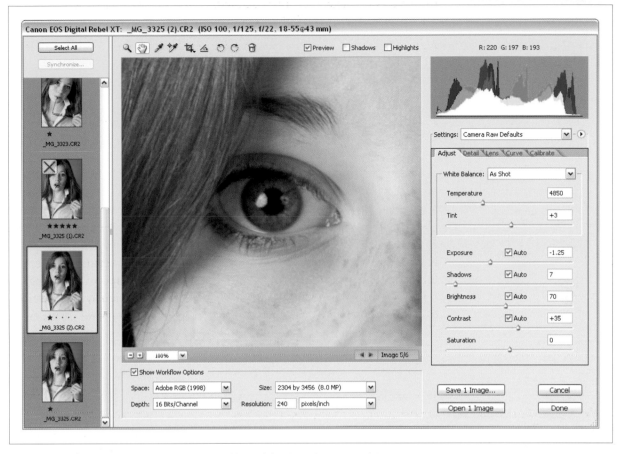

Figure 4-27. The Camera Raw workspace set up as I like it while winnowing.

Tweaking Camera Raw Adjustments in Sync

You had a taste of synching in the "Using the Calibrate Tab Settings" section earlier in this chapter. But the best part is that you can actually perform all the Camera Raw adjustments simultaneously on all of the open images:

1. In Bridge, select the thumbs of all the images you think should be adjusted the same way. These will generally be photos of the same or very similar subjects in the exact same location, light source and angle, time of day, and that were shot with the same camera and lens. When all the images you want to process have been selected, press Return/Enter.

2. The selected images will open in Camera Raw. Camera Raw is technically a Photoshop plug-in, so Photoshop will open first, with Camera Raw inside it.

3. At the top of the thumbnail column, you see two buttons: Select All and Synchronize. Click them both. You'll notice that all the thumbnails are highlighted to show they've been selected.

4. The Synchronize dialog will appear. Unless you want to apply only a subset of the settings to this group—for instance, you might decide later that you could improve on noise reduction and vignetting—simply leave all the boxes checked and click OK.

5. Make all the adjustments you want in the order you were given them.

6. When you're done making adjustments, note that the labeling of the Save and Open buttons has changed to reflect the number of files that are currently selected, minus those that have been selected for deletion. After making all the adjustments in Camera Raw, save all your images to Photoshop format by clicking the Save button. The Save dialog, shown in Figure 4-28, appears. Now is a good time to rename your images so that you can readily identify the subject and shoot.

Figure 4-28. The Save Options dialog.

7. Choose the folder where you want to save your PSD images. I like to keep them in the same folder as the RAW files so that I can use Bridge to move the adjusted PSD files immediately next to the corresponding original RAW file. This makes it very easy to know which images are ready for the client and which will need more work. In that case, choose "Save in Same Location." However, you can choose "Save in New Location" or use the Browse button to create a new subfolder.

8. Now comes the important part: naming your files logically. Because I organize my folders by client and shoot date, that is usually enough to identify the subject (see "Renaming Individual Files" in Chapter 3 for more on this). To change the name, highlight the words "document name" in the first filename field and enter the subject name. From the menu immediately to the right, choose Document Name. Other automatic renaming processes in Photoshop and Bridge also have a nearly identical dialog, so you'll get quite used to this automatic naming process.

9. Choose the file type you want to save to. Normally, you will want to save to the *.psd* format so you can continue editing in 16-bit mode for as long as possible and also to take advantage of layers—especially nondestructive Adjustment layers. Once you've done all that, press OK.

Converting Camera Raw Files to Other Formats

You can also use the Save button in Camera Raw to save as many files as needed to .*jpg*, .*tif*, or .*dng* formats. You can save all these images into most of the other popular file formats by choosing them from the menu. This is a good option if time constraints hamper how much work you can do on an image before sending it to your client for approval (most likely) or straight out for publication (in very tight deadline circumstances).

Applying Camera Raw Settings in Adobe Bridge

If you have more than the suggested 16 images to process simultaneously or just don't need to have all the files open as you process the first one, this is the fastest way to apply the same settings to any number of RAW files:

1. Open the first, best, or most typical of the group in Camera Raw and do all the processing recommended in this course.

2. Click the Done button at the bottom of the Camera Raw dialog. Clicking Done closes Camera Raw and at the same time applies all the settings you've made to the currently opened image(s).

3. Now you're back in Adobe Bridge. Simply Cmd/Ctrl-click each image to which you want to apply the last settings made in Camera Raw.

4. Ctrl/Right-click any of the selected images. From the resulting in-context menu (Figure 4-29), choose Previous Conversion. Since Camera Raw is closed, processing happens more quickly. And while it's processing you can do other things—such as selecting the next group of images you want to process.

> **NOTE**
>
> *As soon as you've processed multiple images in Camera Raw and come back to Bridge, empty your Trash/Recycle Bin to clear your available disk (and memory swapping if you're cramped for disk space) for the complex work of image processing.*

Figure 4-29. The in-context menu appears when you right-click on an image in Photoshop Bridge.

Using the Image Processor with RAW Files

You may want to save processed RAW format images to different file formats for different purposes. In fact, it's usually a very good idea to do this because you can automatically process all open files, selected files, or files in a particular folder for different purposes, such as:

- JPEG files destined for a web gallery to be used for client approval

- TIF images at full or enhanced resolution for printed publication or for delivery to the client (you probably don't want to give away your

trade secrets and send the client all the layers you use to adjust non-destructively).

- PSD (Photoshop) images to be fine-tuned and enhanced in your own "digital darkroom"

There are a couple of ways you can access the image processor (see Figure 4-30).

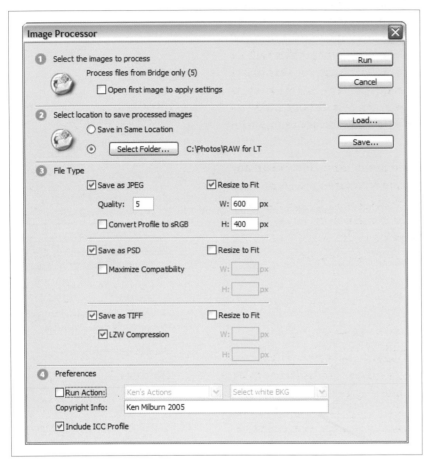

Figure 4-30. The Image Processor dialog.

- In Photoshop, choose File→Scripts→ Image Processor. Nothing needs to be preopened in Photoshop. The dialog will let you work on either all currently opened files or on the files in any designated folder.

- From Bridge, choose Tools→ Photoshop→Image Processor. If you have several files selected, the dialog states the number of opened photos to be transferred. If no image is selected, you can either translate all the images in the current folder or check the box labeled "Open First Image to Apply Settings." If the box is unchecked, all the images in the folder will be processed according to whatever adjustments have already been made in either Camera Raw or Photoshop. If it is checked, only the image(s) you choose after browsing will be processed.

After completing one of those steps, change the rest of the settings in the dialog according to the file format you want to translate to and how. But first, a close look at the dialog in Figure 4-30.

These are the rest of the steps for using the Image Processor:

1. In Section 2, select the location where you want the translated file to be saved. Regardless of where you save the translated files, each file format will be saved to a subfolder named after that format. The default choice is to have the "Save in Same Location" radio button active. If you want to browse to a different folder, click the Select Folder radio button, and click the Select Folder button to bring up a Browser dialog. Use that dialog to navigate, and pick the folder in which you want to place the translated files.

2. Image Processor will translate to any or all of the three file types at once. In Section 3, check the boxes for the formats you want to use. If you choose "Resize to Fit" for any file type, the files will be resized to fit within your designated dimensions while maintaining their original proportions. For JPEGs, you can choose the quality level by entering a number between 1 and 10. The lower the number, the faster files will load on the Internet. If you are saving JPEGs to be printed as proofs, select a quality level between 8 and 10. Finally, JPEGs destined for the Internet should be saved to sRGB color profile so they look more consistent on a wide variety of monitors. If you are saving to PSD, you will want to check the Maximize Compatibility box if those files will be shared with others who have different operating systems or versions of Photoshop and other compatible image processors. If you are saving as TIF, I recommend using LZW compression, since it is lossless and saves file space. The only danger LZW poses is very rare incompatibility with some programs.

3. You will rarely use Section 4, but it can be pretty jazzy. It can run any Action you've recorded on all the files you're translating. Keep in mind that it will run that Action on all the different types of files, which may be reason to designate only one file type for translation in Section 3. You can also enter copyright text that will be saved in the image's metadata; type "Copyright *Your Name Year*" in the Copyright Info field.

Differences in Camera Raw in Photoshop CS2 and Photoshop Elements 4

Perhaps the most important thing you need to know about processing your RAW files in Photoshop Elements 4 versus Photoshop CS2 is that nothing you do to a RAW file is permanent. So if you move up to the more plentiful and sophisticated features in Photoshop CS2, there's a chance that you'll be able to improve on what you could do with the same image in Elements 4. Figure 4-31 shows you the Photoshop Elements 4 Camera Raw interface.

If you're familiar with Camera Raw in Photoshop CS2, it's easy to see what most of the differences are. From left to right, top to bottom:

- There are no Color Sample, Crop, or Levels tools.

- You can't open multiple files in the same workspace, so you can't winnow and apply identical application settings to multiple files. Instead, if you open multiple RAW files at once, you have to do the settings for the first file, push any button other than Cancel, and wait until the Camera Raw workspace opens for the next file you selected. You can then apply the same settings as for the previous file.

- No option for saving settings, except as a default.

- There are only two settings tabs—Adjust and Detail—but they are identical to the same tabs in Camera Raw for Photoshop CS2.

- There are no Auto adjust boxes.

- There is no Show Workflow Options space, so you can't choose to assign a color space, change the output image size, or change the resolution.

- There is no 32-bit output option, only 8- and 16-bit.

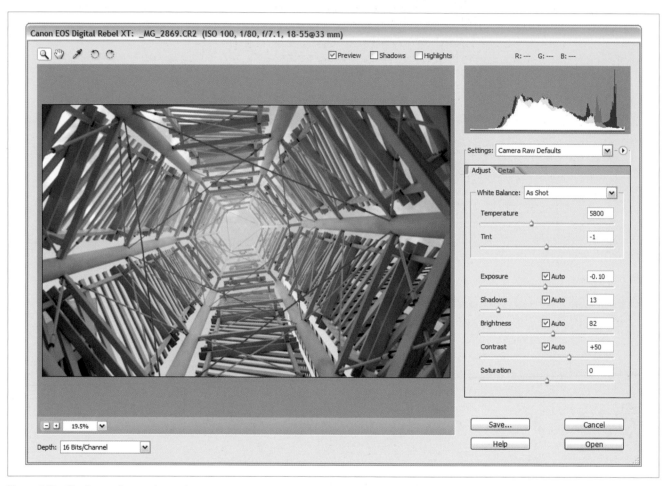

Figure 4-31. The Camera Raw workspace in Photoshop Elements 4.

The bottom line: I wouldn't use Photoshop Elements 4 for "bulk" processing of high-volume shoots with numerous variations of the same image. There is an alternative, however, if you're not quite ready to invest in Photoshop CS2: Raw Shooter Essentials (free) or Premium (only $100 and even more capable than Camera Raw CS2). You'd also have the option of using Adobe Lightroom or Apple Aperture. You'll find more on these alternatives near the end of this chapter. And Chapter 6 is all about Lightroom, which you will want to download as soon as a beta is available for your computer.

Opening and Adjusting Multiple RAW Files in Photoshop CS2

When you have multiple images that have the same exposure, brightness range, contrast, and color balance, you should open them all at once in Camera Raw. Then click the Select All and Synchronize buttons so the settings applied to any one of the images will apply to all of them. This situation especially applies to product, fashion, journalism, and event photography where many photographs are taken of the same subject to ensure capturing just the right "moment." You do not want to spend time adjusting each photo individually, since it could unnecessarily add hours to your processing time.

You have to start in Bridge to get into Camera Raw. If you jumped ahead to this chapter out of a rabid curiosity about Camera Raw, jump back to the "Applying Camera Raw Settings in Adobe Bridge" section earlier in this chapter and familiarize yourself with the steps you ordinarily take in Bridge. Then, if you're following my workflow rules as religiously as I dogmatically demand, you have already eliminated all the really obvious losers. You've also used Bridge's lightbox feature (choose Window→Workspace→ Lightbox) to physically place photos that should be adjusted in the same (or nearly the same) way next to one another. Once you've done that, processing efficiency demands that you open all the related files in Camera Raw at the same time.

You select a series of contiguous files by selecting the first file, pressing Shift, and then selecting the last file in the series. Figure 4-32 shows you the Bridge Light Table workspace after putting contiguous files together.

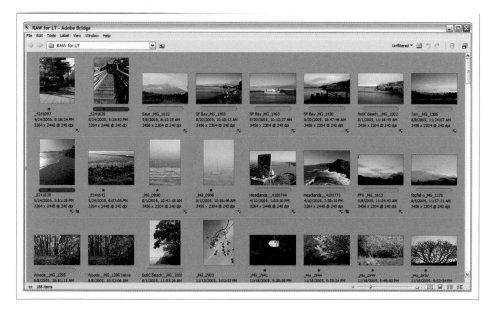

Figure 4-32. Using the lightbox workspace in Bridge, with similar images placed so that they are next to one another on the "light table."

Select a series of files that you haven't "lightboxed" into contiguous groups by selecting the first image, Cmd/Ctrl-clicking on another and then on all the files you want in that series. To simultaneously transfer those files into Camera Raw, press Enter/Return.

Adjust Similar Files at One Time

You can synchronize the open files so that when an adjustment is made to one, it is applied all. If you've opened 15 files, that means that you've saved 15 times as much as if you'd done each file individually. Doing this is a matter of:

Figure 4-33. The Synchronize dialog in the Camera Raw workspace.

1. Clicking the Select All button.

2. Clicking the Synchronize button. The Synchronize dialog appears, as seen in Figure 4-33.

3. Unchecking the boxes for the properties you don't want to synchronize.

4. Making the adjustments for the image currently in the Preview window. The images for all the thumbnails will be adjusted simultaneously for the selected properties.

If you are doing this for the first time, you probably want to keep all the boxes in the Synchronize dialog checked. If you just want to change a setting or two for a group of files that you've already adjusted, uncheck all the settings except those you want to change. If you only want to change one property for all the synchronized files, choose that property from the Synchronize menu at the top of the dialog. Now when you adjust any of the settings in any of the tabs, the same adjustment will take effect for all the images that are currently open, selected, and synchronized.

Ranking and Deleting

You should have already done all your initial ranking and winnowing (deleting) in Bridge. However, there's a big advantage to making your final choices after you open multiple files in Camera Raw: you can magnify all the images to whatever extent it is necessary to spot fatal flaws. The most persistent of these include minor blurring due to focus, camera shake, or forgetting to stop down enough to increase depth of field to the degree necessary. No matter how good the shots are in other respects, these shots are never going to be good enough (and don't fool yourself into thinking that you can recover them by sharpening).

Click the Select All button and then double-click the Zoom Tool icon. You'll still see the whole image in the thumbnail, but when you choose an image for previewing it will be enlarged to 100 percent in the Preview window. Grab the Hand tool and pan the image to the place where focus is most critical. As long as all the other images are still selected, they will be prepanned to the same location when you select them for previewing. Now you see approximately the same portion of the image when you preview each image using the arrow keys.

When you see an image that's technically unacceptable, just press Delete/Backspace. A red X will appear in the upper-right corner of the thumbnail. If you change your mind before leaving Camera Raw, select that image and press Delete/Backspace again. The red X will be gone. Don't leave Camera Raw until you're sure you want to delete the images in the Trash, because that's exactly what will happen. Of course, you could still open the Trash and drag any images back to the folder they came from. You just have to be able to identify them by their filename since your system's file browser may not read RAW files.

Using the Save Button

You *do not* want to click Save until you've done everything in Camera Raw to make the image look as much like the final image as possible. The result of your Camera Raw adjustments will become the Background Layer of your Photoshop file. This is because you want to avoid keeping track of multiple versions of a Photoshop file, which is because you can keep all the versions on layers inside the same file in *.psd* format. So when you have finished adjusting but need various versions for various purposes, automatically create a version for each of those purposes. You do that by turning off the layers you don't need for that version, exporting the result to all the sizes, color spaces, quality settings (if they are JPEGs), and sizes you need for the image's various intended purposes, and then number those versions.

At the bottom right of the Camera Raw dialog is the only button that doesn't record any settings or changes made in the current Camera Raw session. That button is the Cancel button. Use it when and if you come to a point where you just know you have to take a deep breath and start over from a fresh point of view.

Using Camera Raw for Creating Effects

Most of your adjustments in Camera Raw will be for changing brightness, contrast, and other overall characteristics (such as noise, sharpness, and vignetting) using a tool that is completely nondestructive. Most "effects" processing is terribly destructive, which is why it is placed toward the end of the book and workflow (Chapter 11, to be specific). However, there are

a few effects that you can at least begin in Camera Raw. After all, the more nondestructive processing you can do for an image, the better.

Making Multiple Exposures in Camera Raw

Now that you know how to use and make adjustments in Camera Raw, we've come to one of the more creative benefits of using the program—to use the RAW files' larger range of brightness as multiple exposures. There are basically two reasons you might want to do this: to create an especially interesting interpretation of the image by exporting the image as a particularly high-key or low-key interpretation (see Figure 4-34 and the next two sections of this chapter, "Increasing Dynamic Range by Making Multiple RAW Renditions" and "Increasing Dynamic Range Using the HDR Command") or to create exposures that can be combined to show detail in both the extreme highlights and shadows (see the two sections on HDR techniques later in this chapter).

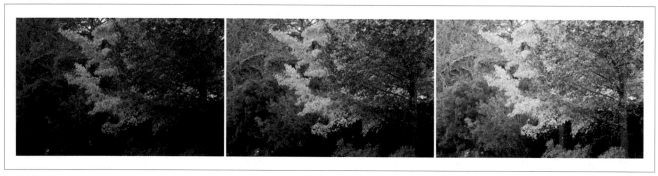

Figure 4-34. Three different "exposures" of the same image, all made approximately two f-stops apart in Camera Raw and opened in Photoshop. Of course, as long as you haven't obviously under- or overexposed the image recorded by the camera, the difference in exposure can be varied by as much as five f-stops in Camera Raw.

Increasing Dynamic Range by Making Multiple RAW Renditions

One of the great limitations of digital images is that present day printing methods ultimately force us to reduce our image data to 8 bits because that's all the printer can handle. So the ultimate dynamic range is somewhat less than that of film and we often suffer clipped highlights and shadows. Of course, there are various ways to get around that limitation. One of the best is to simply create different interpretations of the RAW file and then use a simple process to merge them together so that we get detail in all the shadows and all the highlights.

> **NOTE**
>
> *Most of the time, I actually prefer this method instead of Photoshop's HDR command (discussed in the "Increasing Dynamic Range Using the HDR Command" section next). With this method, you're not limited to static subjects because you're making a pair of interpretations of the exact same moment that, when combined, show pretty much all the brightness and tone that you could possibly see. Also, it is easier to previsualize and produce the end result.*

In Figure 4-35, I use a photo of a forest just because there's so much brightness detail in that type of subject, but the nature of the actual subject matter matters little. One thing you should be extra careful of is to watch your camera's Histogram to make sure that all the tones are inside it. The process is as follows:

1. Go to Bridge and open your image in Camera Raw. When you see the image in the Camera Raw workspace, press Cmd/Ctrl-U until all the Auto checkboxes are turned off. Then create a low-key exposure, but don't worry too much about keeping detail in the shadows. The overall image should look as though it's about two stops underexposed. The most important thing is to be sure that you see plenty of detail in the Highlights. When you like what you see in the Preview window, click Open. Your low-key image will open in Photoshop. Be sure to leave it open.

2. Reopen Bridge and reopen the same file in Camera Raw. This time, make the adjustments so that you see plenty of detail in the darker midtones and the shadows. These shadows are going to replace the shadows in the previous (low-key) interpretation you just made, so make sure they contain plenty of detail. At the same time, make sure that anything that needs to be black is black. The best way to do this is to turn on the Shadows preview box. You can see the results of both exposures in Figure 4-35.

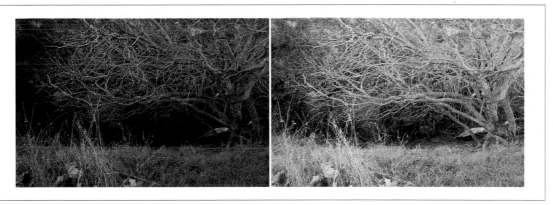

Figure 4-35. The low-key and high-key "exposures" of the same RAW file.

3. Click inside the overexposed or high-key image so that it's active and then choose Select→Color Range. The Color Range dialog appears (see Figure 4-36).

4. Choose Highlights from the Select menu. When the selection marquee appears, click OK.

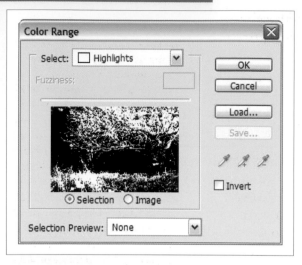

Figure 4-36. The Color Range dialog.

5. Choose Select→Feather. Enter a feather radius large enough to give you plenty of blending. I find that something around 150 pixels generally works best for merging markedly different dynamic ranges, such as we have here, but you will have to experiment on individual images to get the best result. If you select a feather radius that is too large, you'll lose a lot of detail in the midtones. If the feather radius is too small, you'll get very unrealistic halos around darker-toned objects.

6. Press Cmd/Ctrl-I to invert the selection and then Cmd/Ctrl-C to copy the contents of the selection to the clipboard.

7. Make the low-key image active by clicking inside it. Press Cmd/Ctrl-V to paste the contents of your selection layer into the low-key image. You can see the final result in Figure 4-37.

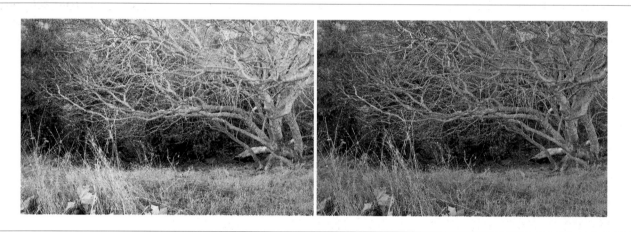

Figure 4-37. The Camera Raw Auto adjustment of the file (left) and the "fake" HDR result after the merge of both Camera Raw exposures (right).

Increasing Dynamic Range Using the HDR Command

Although you can create HDR files from other formats, they work best when created from RAW files, thanks to the extended range of data already in those files.

The exercise described here works best when you use a series of three to five RAW files taken two full f-stops apart. The camera should be on a tripod, you should use a remote shutter trigger (or cable release), and your subject must be still as a stone. You *must* not change the aperture or focus, so it's best to shoot in Manual mode for both exposure and focus and to shoot in RAW mode.

Once you've done all that, upload the pix to your computer. Although it's possible to process HDRs directly from the Bridge Tools menu, don't. You'll get much better results from the following sequence of steps:

1. In Bridge, select the images you want to merge, then press Enter/Return to open them in Camera Raw.

2. Click the Select All button to select the entire sequence. If you think there are too many in the set or that some exposures are too close together, press Cmd/Ctrl and deselect those you don't want to include.

3. Press Cmd/Ctrl-U once or twice until all the Auto boxes are turned off. You should now see a distinct one or (better) two-stop difference between the brightness of each of the thumbnails.

4. Leaving the chosen thumbs selected, click the Open button. Each image will open in a separate window in Photoshop.

5. In Photoshop, choose File→Automate→Merge to HDR. A Merge to HDR dialog that looks similar to the Camera Raw multiple exposure dialog will open. Be sure to click the Attempt to Automate box at the bottom if you attempted to shoot a handheld sequence. From the Use menu, choose Open Files. Click OK. Wait and watch.

6. After a few frames have popped up, they'll give way to a full screen dialog called Merge to HDR. (See Figure 4-38.) You'll see the images you

NOTE

If your camera can shoot a sequence two full f-stops apart in a bracketed sequence, you may be able to shoot an HDR sequence without a tripod (but you still need to be very steady when shooting). Be sure to put the camera in Aperture Priority mode to force the bracketing by shutter speed, rather than by changing aperture or ISO. It will help a lot if you can at least brace the camera against a lamppost, tree, or railing. At the very least, don't breathe or wiggle in the slightest. If you do risk handheld sequences, be sure to check the Auto-overlap box in the Merge to HDR dialog that opens when you choose File→Automate→Merge to HDR.

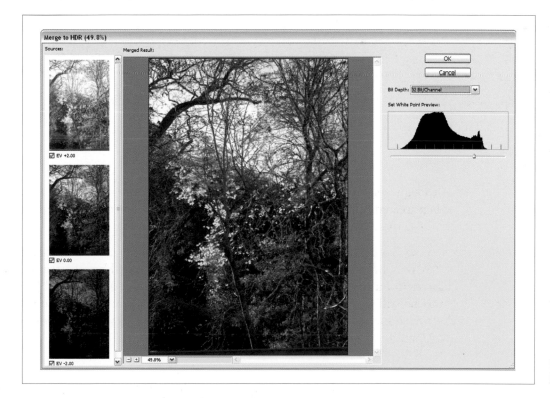

Figure 4-38. The Merge to HDR dialog.

NOTE

You can click the Browse button and browse for files to include in the merge, but there's no way to visually identify RAW files because there are no thumbnails.

picked fill the screen. On the left are the thumbs of the RAW images you picked just as the camera recorded them, with no adjustment. In the center, you'll see the results of the merge. On the right, you see a bit depth menu, a Histogram, and a slider. Move the slider until the overall brightness—and the white point—are exactly where you want them to be. Never mind if this image itself looks weak in the shadow tones. Leave the Bit Depth menu choice at 32 bits.

7. A new file opens that is titled Untitled HDR. If you want to save up your image for the day when you can actually make use of all that brightness information in some future version of Photoshop, save the file as a Portable Bit Map file.

Figure 4-39. The Exposure dialog.

8. You now have two choices for finally adjusting the file. If you want to adjust it in 32 bits, your only choice is Image→Adjust→Exposure. You can see the Exposure dialog in Figure 4-39. The Exposure dialog pops up. Drag the sliders until you like what you see and click OK.

If you want to use the usual adjustment commands, you'll have to convert the file to 16 bits. You can convert to 8 bits, but why throw out that much data when you've gone through the trouble to collect it? At least keep it to 16 bits until you've finished doing all your work on the file. Then you can make a copy, flatten the layers, and reduce the bit depth for publication without destroying all the work you did on the original, which you may want to change someday without having to do it all over again. Choose Image→Mode→16 bits. An HDR Conversion dialog appears, as shown in Figure 4-40.

Figure 4-40. The HDR Conversion dialog.

9. You now have several methods you can choose from to interpret the final version of the image. You'll probably find Exposure and Gamma

the most useful. The sliders are extremely sensitive, so start by getting the Exposure adjusted to something close to what you want as an end result. Now adjust the overall contrast with the Gamma slider. These are subjective adjustments, so just experiment until you like the results. You can see my results from the original images I shot in Figure 4-41.

Since you now have a standard 16-bit Photoshop file to work with, you can use any of the Photoshop commands to further enhance this image. Of course, some Photoshop commands and adjustments work only in 8-bit mode, so you should wait until you're further along in the workflow before applying those commands or you'll lose a large percentage of your brightness information.

Create a High-Key Version of the Image

High-key images are those that are very bright in tone and have few (if any) deep shadows. High-key interpretations of an image tend to look dreamy, glamorous, and idealized. That's one of the reasons they keep cropping up as a fad in fashion, female portraiture, and cosmetic ads. However, high-key images can be equally effective in creating a dreamy or foggy landscape or romantic wedding photo.

One precaution: any image that is destined to be interpreted as high-key should

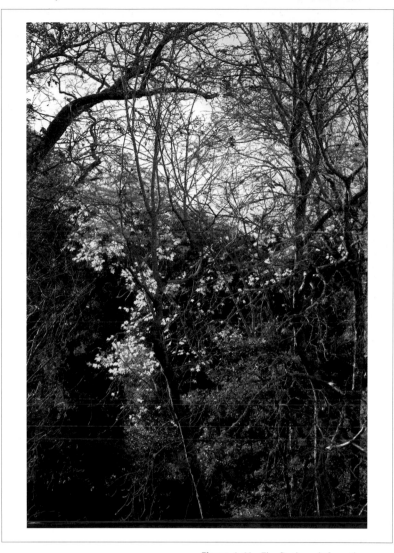

Figure 4-41. The final result from the Exposure and Gamma dialog. Of course, you'd crop out the railing, but not until further along the workflow.

be adjusted in RAW so that all the detail falls inside the borders of the Histogram. In other words, you don't want to see any more "blocked" detail—especially in the highlights—than absolutely necessary, even though you may decide it's appropriate when you finalize the adjustments in Photoshop. The Camera Raw Histogram should look something like the one in Figure 4-42. Of course, this is an ideal Histogram for virtually any type of RAW file exposure interpretation. But it's more important here because if highlight detail is blocked to begin with, there will be even more detail blocked when you use Photoshop to further interpret the image as high-key.

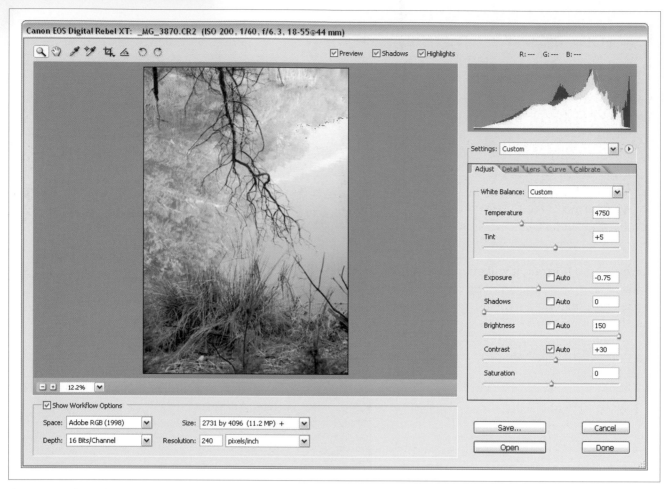

Figure 4-42. The ACR adjustments and Histogram of a high-key interpretation.

It would seem that the "no brainer" way to create a high-key version of the image would be to simply drag the Exposure slider far enough to the right. The problem with that is you push a lot of the brightest details, which are precisely the ones you want to keep, right off the edge of the Histogram. That means those highlights are blocked and you won't be able to see any detail in the area where it is most important to have it.

Now, let's try an interpretation that keeps detail in the highlights (although perhaps not as much as we'd have in a "normal" or low-key interpretation) and in which there are at least enough blacks to keep the image from looking like it was a mistake. Then, go to the Curves tab and select Linear from the Tone Curve menu. The Linear curve is superimposed over the image's Histogram. At the point where the Histogram reaches the greatest height (has the most pixels), click the tone curve directly beneath. Now, while watching the Preview window, raise the tone curve to the point where you get the high-key effect you are looking for. Figure 4-43 shows the before and after.

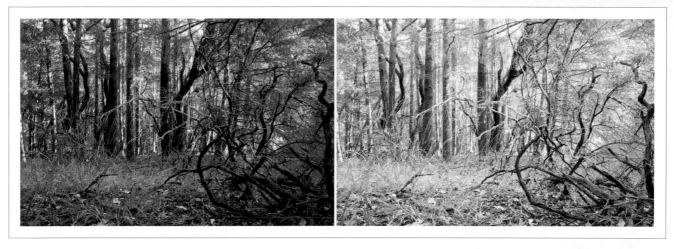

Figure 4-43. The before and after.

If the image is a portrait, it will often need some retouching in Photoshop—especially skin smoothing and lightening the shadows around the eyes—but the above high-key steps provide a much better start than you would be likely to get otherwise. The following are the steps normally required for this type of effect. After, I'll tell you what I did in Photoshop to improve these effects when applied to a portrait.

1. Open your image in Camera Raw.

2. Move the Highlight slider until the highlights are just touching the right foot of the Histogram.

3. Move the Shadows slider as far to the left as you can without pushing the shadows off the left end of the Histogram.

4. Move the Brightness slider all the way to the right. If a significant amount of the Highlight detail has moved off the end of the Histogram, look at the brightest tones in your image. If they lack detail that you'd like to see, drag the Highlight slider back to the left until you reach the best compromise.

5. Drag the Contrast slider both ways until you feel you've gotten the best effect that you can get from this particular image.

6. Click the Open button.

You will almost always want to do some further work on your high-key image in Photoshop. The main reasons are retouching, layer blend modes, and masked Adjustment layers, since none are available (yet) in Camera Raw.

In this portrait in Figure 4-44, there are still areas of the face that are in shadow and, as a result, aren't very flattering. In fact, they're even less flattering than in a normal tone portrait because the lighter skin tones contrast more noticeably with the shadows. After opening the RAW file you just

made in Photoshop CS2, open the Layers palette and click the New Layer icon at the bottom of the palette. A new layer will appear just above the background layer.

There are big advantages to burning and dodging with the Brush and an Overlay layer, rather than the burn and dodge tools. First, it has no effect on the original image's layer. So, if you goof, you can just paint that part of the layer 50 percent gray and then start over. Second, there's no loss of contrast or change of color balance in the burned or dodged areas because you are changing brightness with absolutely color-neutral tools. Third, you can "blend" the effect by changing the layer Opacity after the fact. To burn and dodge with the Brush and a 50% Gray Overlay layer:

1. Fill the new layer with 50 percent gray. Of course, this will hide your portrait momentarily, but choose Overlay from the Blend mode menu in the Layers palette and the gray suddenly becomes transparent.

2. Press D (for default) to set your foreground colors to black and white, then press X to switch your foreground and background colors so that White is the foreground color. Now you can dodge by using the Brush tool to paint in white. In the Brush Options, set Opacity to about 12 percent. Size the brush so it covers a bit less than the area you want to dodge and start painting into the shadows you want to lighten. Keep stroking (just as you would with the Dodge tool) until the area is as light as you like. In Figure 4-44, I did the following:

 • Created a large feathered brush to darken her hair slightly. To do this, I switched the foreground color to Black, lowered the opacity, and painted over the highlighted areas of the hair.

 • Created a new layer above the background layer to remove the wrinkles and skin blemishes nondestructively. But this time I selected the background layer. I also turned off the Burn and Dodge layer I just created (and any other layers that might have been added for whatever reason), leaving only the new, transparent layer and the Background layer visible. Next I chose the Spot Healing brush. In its Options bar, I make sure the Sample All Layers box is checked (clicking the box toggles the checkmark on and off). Now I "heal" all the spots. The Healing and Clone Stamp brushes will work the same way, but not the Patch tool. All the healing strokes appear on the new transparent layer.

3. Use a masked adjustment layer to lighten, darken, or change contrast or color balance to specific areas of the image. Select the area of the background layer you want to change. You'll want to soften the edge of the selection enough so that it blends smoothly with the other areas of

the image, so choose Select→Feather and then enter a number of pixels for the width of the transition from 100 to 0 percent opacity. Go to the Layers palette and choose the type of Adjustment layer you want to use.

For this example, I wanted to drastically lighten the blouse and background, so I selected both, feathered at 100 pixels, and then used a Levels Adjustment layer and dragged the Midtone (middle) slider to the left until those areas were bright enough to suit me.

You can see the result of both the Camera Raw and Photoshop CS2 steps in Figure 4-44.

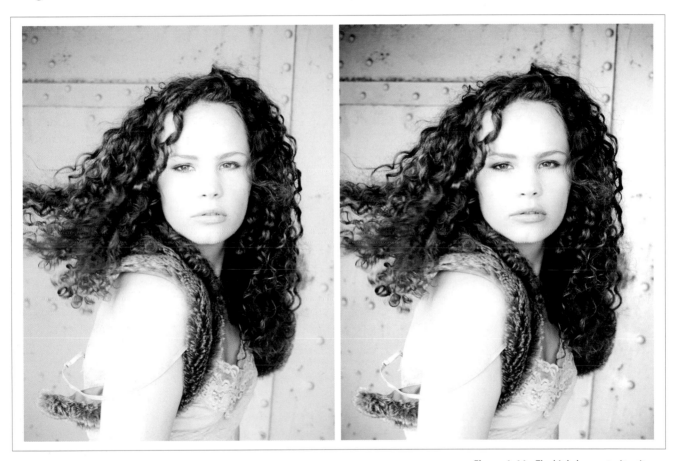

Figure 4-44. The high-key portrait as it came out of Camera Raw (left) and after further adjustments in Photoshop (right).

Creating a Low-Key Effect

In case you haven't already guessed, a low-key image is the opposite of a high-key image. That is, most of the tones in the image are in less than 50 percent of the overall brightness range. Low-key images tend to lend a more classic or somber effect. They're also used more often for masculine subjects

than for feminine. Think Rembrandt. Creating a low-key effect isn't just a variation on creating a high-key effect. After you've opened the image in Camera Raw:

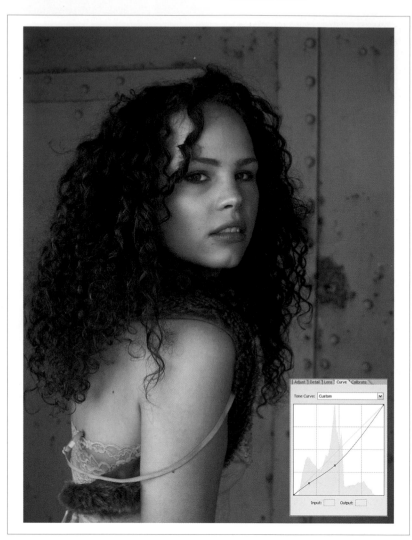

Figure 4-45. A tone curve for a low-key image. Yours will vary according to the exact levels of brightness in your image. Be careful not to let the peak of the Histogram move above the top side of the frame, as this will cause a loss of data.

1. Move the Highlights slider to the left until the highlights leave a bit of space at the right foot of the Histogram.

2. Move the Shadows slider a little to the right, cutting off a bit of the end of the Histogram.

3. Move the Brightness slider to the left. Take a look at the Histogram. If a significant amount of the Highlight detail has been cropped at the top, take a look at the brightest tones in your image. If they lack detail that you'd like to see, drag the Highlight slider back to the right until you reach the best compromise that you can.

4. Click the Curve tab and choose Linear from the Tone Curve menu. Now make a curve somewhat like that in Figure 4-45.

5. Click the Open button. Your low-key image will open in Photoshop.

You may need to repeat these steps for post-processing in Photoshop. You especially may need to burn in areas that were formerly very bright highlights.

Making a Black and White Image in Camera Raw

There are many ways to make black and white and other types of monochrome images in Photoshop—so many in fact that it could almost become its own separate science. Bet you didn't know you could do quite a decent job and do it a lot faster (although with slightly less flexibility) using Camera Raw.

Simply making an ordinary black and white comes about as close as possible to being a no brainer. After adjusting Shadows, Brightness, and Contrast to

your liking, simply drag the Saturation slider all the way to the left. Figure 4-46 shows the color and black and white renditions of the same photo after this treatment.

Figure 4-46. Left: a color portrait after adjusting Exposure, Shadows, Brightness, and Curves. Right: a black and white rendition of the same portrait made by simply removing saturation in Camera Raw.

You can do better than that, though. That is, you probably can but won't know until you try. There are two ways that Camera Raw lets you change the tonalities in the image. This is done in analog photography by choosing film or using filters that make the film more sensitive to different colors of light. You can do a similar thing in Camera Raw by changing the Temperature and Tint settings. You can then go one step further by changing the color sensitivities using the Calibrate tab. All of these actions will change the tonalities in the monochrome image without actually bringing any color back into the image. To create a black and white image:

1. Make the color version of the image look as good as possible in Camera Raw by using the steps described earlier in the Adjust Tab section.

2. Drag the Saturation slider all the way to the left (by the way, you can approximate a hand-colored process by removing *nearly* all the saturation; try entering -60 in the box).

3. With the Saturation at -100, move the Temperature slider back and forth until you're pleased with the new Tonal values. Figure 4-47 shows several different interpretations of the same image.

Figure 4-47. From left to right, the color temperature has been changed to 2,000, 4,000, 6000, and 8,000.

Toned Monochrome from Camera Raw

You can actually use the previous techniques to create a "look" approximating sepia- or blue-toned images, although they'll still have a bit of color in them. It's an especially good trick for a web site photo or to approximate it for client approval in a proof.

To create a sepia-toned image, drag the Temperature slider so far to the right that the whole image turns a reddish-brown. Now drag the Saturation slider to about -55.

To create a blue-toned image, drag the Temperature slider so far to the left that the whole image turns blue. Now drag the Saturation slider to about -55. The result is Figure 4-48.

Figure 4-48. Faux sepia and blue renditions of a portrait.

Digital Photography Expert Techniques

Nondestructive Layering

5

The secret to a good nondestructive workflow lies in a regular system of organizing layers and layering techniques. The objective of keeping the workflow layered is that individual layers can be modified without affecting other layers. One type of layers, Adjustment layers, are completely nondestructive. You can always readjust an adjustment layer's effect as long as it hasn't been blended with another layer by double-clicking on the icon that designates its adjustment type. When you do that, the standard dialog for that type of adjustment appears. Adjustment layers affect all visible portions of any underlying layers. You can also make them affect only a specific layer or group of layers by attaching them as a Clipping Mask to the target layer or group.

In this chapter

A System of Layers for Nondestructive Editing

Using Layer Options

HOW THIS CHAPTER FITS THE WORKFLOW

Adjustment Layers: The Key to the Nondestructive Workflow

This chapter is about how certain types of layers should be ordered and how you can use them to track exactly what you've done to your image. I'm not going to break down all the individual tricks that could be used on each of these layer types right here. This chapter covers the rationale for *why* the layers are placed in this order.

This seems to be the best place to objectively address a problem that many users have with using "too many" layers: use of disk space and RAM. Let's face it, some of your images will be approaching 300 or 400 MBs by the time they near the end of the nondestructive workflow recommended in this book. But there are several solutions to this problem, including:

- Add a cheap external hard drive to your setup. Buy the capacity of drive that will give you the lowest cost per megabyte. These days, it is about 30 cents per megabyte—the cost of a single CD.

- Create a LZW compressed and flattened version of the final image and let that be the only one that is permanently kept on your hard drive. To

do this, copy the layered file and move it to both CD/DVD and to an external hard drive. If you can't yet afford the hard drive, at least make the backup to a name brand CD/DVD and mark it with an acid-free marker. Don't use a standard marker or store your CDs in albums that haven't been certified as acid-free or archival.

> **NOTE**
>
> *Although it's good discipline to arrange your Photoshop editing workflow in the suggested order on the layers as they appear in the book, you do have the option of performing the work for a layer out of necessity and then moving it to its "proper" position later. After all, there will be times when you need to do the work that creates the most obvious results first to turn an image around as quickly as possible.*

A System of Layers for Nondestructive Editing

Table 5-1 lists the layer type for a given image's workflow if you applied everything that Photoshop can do. Of course (and thank Heavens), very few individual images will include each of these layer categories and even fewer could use all the processes that occur within them.

Don't use any of these layers unnecessarily—doing so will give you no advantage and will cause a little more destruction and use a little more disk space. The table is to be used as a guide to let you know where the layers belong in your workflow.

Table 5-1. Recommended layer structure for nondestructive editing

Layer name	Purpose	Advice
Background	This is either the JPEG or TIFF image as originally shot or the Camera Raw image as you've adjusted it. It could also be the result of merging several images, as done for HDR or panoramic composition.	Make sure you start with the best background image possible. Read the first four chapters of this book carefully and do all that it takes to get you here. Never make any changes directly to this layer; instead, make them on a duplicate layer.
Spot retouching	Quick retouching sufficient for client approval. Usually done before the rest of this process is completed.	Use only Healing Tools that have the Sample All Layers Option. Always keep (or move) this layer to a position immediately above the Background (main image) layer.
Burn and dodge	Modifiable layer. Can be enhanced after approval.	Never use actual Burn and Dodge tools for this layer. If needed, use them on an Effects layer.

Table 5-1. Recommended layer structure for nondestructive editing (*continued*)

Layer name	Purpose	Advice
Levels	Adjustment layer.	Use this layer to set black and white point and overall dynamic range.
Curves	Adjustment layer.	Use this layer to adjust the contrast of specific areas of brightness.
Targeted curves	Masked Adjustment layer.	Use this layer to adjust brightness and contrast for a specific portion of the image, such as a face.
Color balance	Adjustment layer.	Adjust overall color balance.
Regional color balance	Masked Adjustment layer.	Use this layer to color balance for a specific portion of the image.
Advanced retouching	Copy of flattened version of file as adjusted up to this point.	You can always return to this layer if you want to do even more.
Transformation	Copy of flattened version of file as adjusted up to this point.	The Lens Correction filter can perform several manipulations at once.
Compositing	Copy of flattened version of file as adjusted up to this point, as well as imported layers. Use Clipped Adjustment Layer(s) if needed.	Group all layers for composite so they can be turned off/on.
Effects	Highly destructive. Many effects are filters that work only in 8-bit mode. Additional layer for each effect.	Blending modes and Opacity is very important for mixing layers. One common effect is converting the image to monochrome or duotone.
Destructive editing	New, flattened layer for each destructive editing command. These include Auto Levels, Contrast and Color, Match Color, Replace Color, Exposure, and Equalize.	
Effects Sharpening*	Copy of flattened version of file as adjusted up to this point. Probably masked.	Could be several different masked portions of layers.

* Final sharpening must be done on a flattened duplicate of the image, preferably saved as compressed LZW. You should then add the color profile for the destination printer (see Chapter 12).

Layer Abbreviations in Filenames

Keep track of which layer you stopped on by adding an abbreviation to the filename. Table 5-2 shows the abbreviations I give to the filename to show how far along the layer workflow an image has processed. You could save a version of the image with each of these filenames, but that's overkill in my opinion. The idea here is that when you have to stop working to do something else, you know where you left off when you come back to the file.

Table 5-2. Suggested abbreviations for layer names

Layer	Add to filename
Background	*bkg*
Spot Retouching	*spot*
Burn and Dodge	*BrnDj*
Levels	*lvl*
Curves	*crv*
Targeted Curves	*tgt crv*
Color Balance	*clr bal*
Regional Color Balance	*tgt clr bal*
Advanced Retouching	*adv ret*
Transformation	*xfrm*
Compositing	*comp*
Effects	*fx*
Destructive editing	*destr ed*
Effects Sharpening	*fx shrpn*

You can perform different tasks within each of these layer categories. However, doing so doesn't often create as many layers as you might think—you won't do everything possible in Photoshop to every image you process.

What the Layers Palette Looks Like for All Stages

I thought you might find it helpful to see how a fairly typical landscape image's Layers palette might look after a complete run at the nondestructive editing workflow, which, in the end, is what this book is all about. You can also download a lower-resolution, copyrighted version of this image that is still in Photoshop format so you can experiment with turning the layers on and off, restacking them, and so forth. In Figure 5-1, the untouched image is on the left. The a finished version of the image is on the right. In Figure 5-2, you see the Layers palette as it was when the finished image was complete.

Figure 5-1. Left: the image just as it came from Camera Raw; right: the finished image.

Figure 5-2. The Layers palette after
processing the image in Figure 5-1 in
Photoshop CS2.

The Magic Action for Layered Workflow

It takes only minutes to record this "magic" Workflow Action, but if
you're too lazy, you can download it from from *www.kenmilburn.com*. The
magical part comes when you realize that you can include the layers in the
workflow for almost every image automatically. It also ensures that you'll
follow a properly layered workflow for at least the most basic steps. Figure
5-3 shows the Layers palette.

Figure 5-3. The Layers palette
after running the Workflow
Action.

> **NOTE**
>
> *Actually, there's nothing magical about this Action. My friend Doug Sahlin suggested it and I thought it a brilliant idea. So he said I could use it if I put his name in a prominent place in the book. Fair enough.*

To install the Workflow Layers Action:

1. Go to the folder you downloaded it to, select the Action, and press Cmd/Ctrl-C to copy it to the clipboard.

2. Navigate through your systems folders to Program Files→Adobe→Plug-ins. Once in the Plug-ins folder, press Cmd/Ctrl-V to paste the Action into this folder. If you have Photoshop on other machines in your office, repeat the process on all those computers as well.

To use the Workflow Action:

1. Use Bridge to open the image you're going to process. If the image is a RAW file, make sure you've preprocessed it in Camera Raw.

2. Open the Actions palette (Window→Actions) and click the small palette menu in the upper righthand corner. Choose Doug's Actions (he didn't invent them, just recorded them under that heading). Several new Actions will appear in the palette, which are self-explanatory. Choose Workflow Layers and click the Play button (forward arrow) icon at the bottom of the Actions palette.

3. Faster than you can blink, all the new layers will appear. Select the Background Layer and choose the Spot Healing brush. Make sure the Sample All Layers box is checked. Now spot out all the zits, trash, stray phone lines, and dust marks. The spotting will all appear on the clear layer just above the Background layer.

4. Select the Burn and Dodge Layer. If there are large areas that you want to brighten or lighten, select them with the Lasso tools. Then choose Edit→Fill and select a percentage of white to lighten or a percentage of black to darken. You can do the same for small areas by simply painting with the Brush tool set for a percentage of black or white.

5. Select the Levels layer. Double-click the Levels icon and the Levels dialog will open. Set the Levels dialog to your desired settings.

6. Select the Curves layer. Double-click the Curves icon and the Curves dialog will open. Set the Curves dialog to your desired settings.

Using Layer Options

You should understand all the options in the Layers palette for making layers "behave" in different ways. These options are employed when you click icons at the top of the Layers palette, as shown in Figure 5-4.

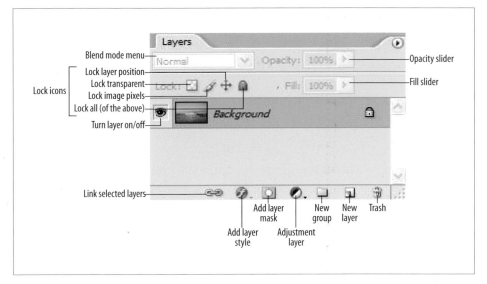

Figure 5-4. The Layers palette Options Icons.

What You Can Do with Adjustment Layers

Adjustment layers are one of the most important types of layers. Their big benefit is that you can adjust them at any time you like. For example, suppose your Curves adjustments look perfect when you apply them right after they come out of Camera Raw. However, after changing the Hue and Saturation on another layer, adding some brushstroke effects, and then adding an overall Solid Color layer, you then need to change the contrast in certain brightness levels of the original image. No problem—just double-click on the Curves icon in the Curves Adjustment layer and the Curves dialog opens to allow you to make any changes. You could even make some radical changes by changing the layers blend mode.

Adjustment layers are created by choosing them from the Adjustment layers menu at the bottom of the Layers palette. Adjustment layers do exactly the same thing as the commands of the same name under the Image→ Adjustments menu. The following is a list of each type of Adjustment layer on that menu and the basic purpose of each:

Solid Color

Brings up the standard Color Picker dialog and lets you pick any color in the palette. As soon as you click OK, the layer is filled with that color. You may then apply any of the Blend Modes to that layer for a blended color effect. You could also experiment with the Fill and Opacity sliders for even more variety. Try Darken, Lighten, Hue, Saturation, and Soft Light.

Gradient

Fills the layer with any gradient in the Gradient's palette. You can even make your own. The layer is opaque, but like Solid Color, you can use Blend Modes and the sliders to create a wide variety of effects.

Pattern

Fills your image with any pattern you've made or any of the dozens of patterns that come with Photoshop. Used with colored and textured paper patters, this can be a great way to make an aged photo. Use the Overlay mode. Also, feel free to experiment. Different colors in the image will blend differently with different colors in the patterns.

Levels

Ensures that the white, black, and midpoints of brightness range are set properly. You can also set color balance by adjusting individual channels. If this layer is masked, it can be used to control tint in specific areas of the image.

Curves

Controls contrast in specific ranges of brightness. Very useful when masked for setting contrast to targeted areas of the image.

Color Balance

Corrects color balance, unless you had a color or grayscale card in the picture (see the "Shooting a Calibration Target or Gray Card" section in Chapter 2).

Brightness/Contrast

Changes the layer or targeted area's brightness, darkness, and contrast but has very little control over interpretation. Can be useful as a quick way to darken or lighten an area, such as the periphery of a vignette.

Hue/Saturation

There are actually three sliders in this layer. Hue lets you interactively change the overall tint of the image. If you exaggerate the Hue setting, you can even create something that looks like a tinted photo. Adjusting Saturation affects the intensity of the colors; if you remove all saturation you'll have a monochrome. Lightness just makes the image lighter or darker.

Selective Color

Helps prepress folks adjust the amount of process colors to be dedicated to any primary color, which ensures the final output turns out as expected.

Channel Mixer

Creates special color effects.

Gradient Map

Creates various color effects. This is an amazing tool for creating psychedelic-toned color effects, monotones, and duotones. The effect you get is completely dependent on the gradient used. The tones on the left end replace the shadow tones, and those on the right replace the highlights. So, for instance, if you had a gradient that went from white to black, you'd get a negative image. You could vary tones with the smoothness of the gradient, too. Experiment with a few of the standard gradients. Then, based on what you learn, make and save some gradients of your own.

Photo Filter

The standard photo filters used in color photography, as well as some standard black and white filters. To get the same effect with the black and white filters as you would with black and white film, create a Hue/Saturation layer clipped to the Photo Filter layer, then drag the Saturation slider all the way left.

Invert

Switches the image from positive to negative.

Threshold

Sets a brightness point at which colors fall on one side or the other of the black/white dividing line.

Posterize

Lets you limit the number of shades of color and brightness in the image with a result that looks a bit like a hard-edged and flat-color poster.

Things You Can Do to Modify a Layer

There are many other ways you can change a layer or the way it affects layers below it.

Use the Merge Visible command

To create a flattened version of a layer, I usually duplicate the image, flatten it, copy the flattened image to the Clipboard, and paste that into the original version so that it becomes its own layer. That's one way to do it, but it's really just an old habit from days gone by. Here's a much more efficient procedure:

1. Highlight the top layer in the Layers palette.

2. While pressing Opt/Alt, choose Merge Visible from the Layers palette fly-out menu. When the new layer appears, it is a flattened version of the whole file.

Just be darned (I'm not allowed to swear) sure that you're holding down Opt/Alt when you do this. Otherwise, you'll flatten your entire image.

C'mon Adobe! There's already another command that flattens images. The only thing that requiring the Opt/Alt does is make it possible to mess up. But if you do mess up, don't panic; just press Cmd/Ctrl-Z immediately to undo the foolish thing you just did.

Apply Blend Modes

The Layers palette features 23 different Blend Modes (Figure 5-5). They're called Blend Modes because they cause the layer that's been assigned a Blend Mode to mix its colors with the immediately underlying layer in a specific way.

These are hard to describe, but Table 5-3 shows how the gradient in the Normal mode blends with the image in the upper left corner when each other Blend Mode is applied. Since this gradient contains all of the primary colors, you should get a good idea of what each mode does. However, there's no substitute for good old trial and error. Besides, the actual effect can vary considerably by dragging the Fill and Opacity sliders in the Blend Modes' layer.

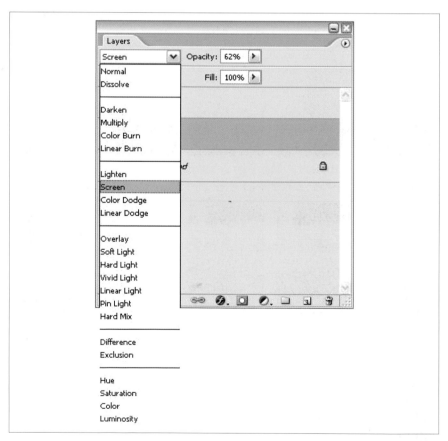

Figure 5-5. The Layers palette Blend Mode menu.

Table 5-3. Blend Mode examples

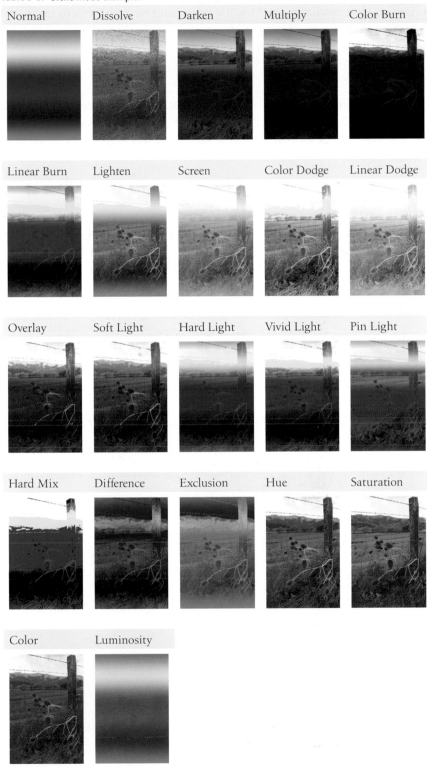

Set the Opacity field/slider

This slider, which is at top left of the Layers palette, always starts at minimum opacity. As you drag the slider to the left, the currently chosen layer becomes more and more transparent. You can also set Opacity to a percentage by entering a number in the field box.

Set the Fill field

At first glance, this slider seems to do the same thing as its older brother, Opacity—but it doesn't. If you set Opacity, you're setting the opacity of the blend mode. If you set Fill, you're setting the opacity of the colors in the fill layer. It's a very thin line, but there can be a very big difference in how Blend Modes treat a layer, depending on what the Opacity and Fill settings are.

Use the History Brush tool

The History Brush is very useful for restoring details from the original once you've imposed a layer effect, filter, or made an Extraction. It paints back either the original state of the image or a History Snapshot. History Snapshots are stored as invisible layers at the top of the History palette. You can create a snapshot at any time by clicking the Snapshot icon at the bottom of the History palette. All the same brush modes and styles that can be applied to the Brush tool can be applied to the History Brush tool.

Employ the Eraser tool

The Eraser can be extremely useful when you're working with layers and blend modes. If you want to "paint in" some transparency into the layer, you can preset the Opacity or Flow (same as Fill for a Layer) of the Eraser Brush. The Eraser can be used as a Brush, Pencil, or Block. In Brush mode, all of the regular brush settings are available to you.

Create a Mask

The Mask icon is at the bottom of the Layers palette. If you click it, it will add a mask to the current layer. If you already made a selection at the time you click the New Layer icon, it will automatically be masked by the selection. In most cases, you will want to "blend" the contents of the selection with those portions of the image that are outside the selection. You do that by choosing Selection→Feather and setting the number of pixels for the width of the feathering stroke. A "feather" is simply a black to white gradient that follows the path of the selection and is spread evenly from dark to light. Inside the selection, the mask graduates from black to 50 percent gray, and outside from 50 percent gray to white. In a mask, black is 100 percent opaque, while white is 100 percent transparent. You can see the effect of a feathered mask in Figure 5-6.

Figure 5-6. A mask feathered to 50 pixels.

Grouping Layers

There may be times when you want to make groups of layers as a part of your workflow. For example, there may be several masked Curve layers that affect different parts of the image in different ways. You want to keep all these layers together so you can move them or turn them off as a group.

Grouped layers differ from linked layers in that the entire group can be made to have a single characteristic, such as a Blend mode. In other words, the entire group can be treated as a single layer.

There are two ways to create a group, both are found on the Layers palette fly-out menu:

- To create a group from existing layers, press Cmd/Ctrl and click on each layer you want to have in the group. Then choose "Group from Layers" from the fly-out menu.

- To create an empty group, choose New Group from the fly-out menu. You can add new layers to that group at any time. Add a new blank layer by selecting the Group and then clicking the New Layer icon.

You can add an existing layer by simply dragging it to the Group layer where you want it to reside.

Layer Features That Arrived with CS2

On the rare chance that you're not fully familiar with layers or some of the new features in Photoshop CS2, here's a quick rundown.

Layer linking

Layer linking allows you to treat multiple layers as a single entity. So you can move or transform all the layers together into a new position or drag them into a new Group (see the section, "Grouping Layers"). You would want to transform linked layers if, for instance, you had already masked some Adjustment layers to affect targeted portions of the image so that the targeted areas remained proportionate. You can link layers temporarily by pressing Cmd/Ctrl and clicking all the layers you want to link together. If they're all next to one another, just select the top or bottom layer in that series, press Shift, and click the layer on the other end of the series. If you want to unlink layers, select those you want to unlink and click the Link icon.

Layer mask linking

Speaking of keeping masks in line with the image when you transform, make sure you link the mask to the image. Layer masks are linked by default, but you can unlink them by simply clicking the link icon that is in between the image or adjustment icon and the mask. Usually, it's the layer mask that's active (selected) by default because you will likely want to edit the mask by painting in it or adding a selection to it. If you want to make the image active, unlink the mask and then click the image. When either the mask or the image is selected, a black frame surrounds it so you can immediately see which is active.

Lock transparent pixels

If you have moved a portion of the image to a new layer or extracted the image from its layer, or have text or a shape on a layer, the area surrounding that shape will be transparent. By default, you can tell which parts of the layer are transparent because you see a checkerboard pattern through the clear parts of the layer. There will be times when you want to filter or fill a layer so that only the image pixels are affected. Whenever that's the case, click the Lock Transparent Pixels icon.

Lock image pixels

Clicking the Lock Image Pixels icon ensures that only transparent areas will be affected. Be aware that locking image pixels is destructive because if you fill the transparent area, it changes the pixels permanently (unless you Undo while that step is still in the History palette).

Lock layer position

Clicking this icon ensures that this layer will retain its position, which will keep you from accidentally bumping the layer out of position when using the Move tool.

Lock all

The Lock All tool doesn't lock all the layers—it locks all the locking options for the currently selected layer. Of course, you could lock one at a time, but why waste the time?

Nondestructive Overall Adjustments

The workflow organization of this book is about maintaining nondestructive editing in as many ways as possible for as long as possible. So when it comes to making post-RAW or non-RAW overall adjustments, you want to start by doing them with adjustment layers. That's because an adjustment layer doesn't actually do anything at all to the image itself. The adjustment layer simply passes on a text description to Photoshop to display the image in certain ways. You can even go back to that layer and change those instructions at any time. But, you say, what about all the Image→ Adjustments commands that are not available as adjustment layers? *Do not* use them until I tell you to, that's all. When that time comes, I'll show you a keyboard shortcut/Action alternative that will place the effects of those commands on their own layer, so they don't affect your previous work. Of course, there's no written law that says that you can't do these things in any order you like. On the other hand, the whole point of this book is to discipline you to sequence your work so you'll never have to recreate any more of an image than is absolutely necessary to make the desired change you want to make.

HOW THIS CHAPTER FITS THE WORKFLOW

Adjusting on Adjustment Layers

Once you've done your spot retouching and lightened or darkened (burned and dodged with the 50 percent gray layer), it's time to adjust your image. You'll probably want to make adjustments at this stage, whether you're working on top of adjustments you've already made in Camera Raw or starting from scratch, because your camera shot a JPEG or TIFF image. Also, if you made adjustments in Camera Raw, you'll be happy to know that there are even more overall adjustments that can be done only in Photoshop. This chapter only discusses the adjustments that can be done on adjustment layers because they are completely nondestructive. In Chapter 12, I'll show you how to make destructive adjustments on a separate layer.

The Basic Levels and Curves Routine

The best place to start, once you've taken your image past the RAW stage (or if you shot JPEG or TIFF), is with a pair of adjustment layers—one for making Levels adjustments and one for making Curves adjustments. Of course, you are wondering why on Earth you'd want to do that since you probably just made adjustments in Camera Raw. Well, one of the advantages of working with adjustment layers is that you can use the same adjustment several times on the same image. It may be possible that your image is so perfect right out of the camera or out of Camera Raw (or RAW Shooter, Capture One, Aperture, or Lightroom; see the Appendix) that there's no point in going any further. After all, one of the characteristics of a great artist is knowing when to stop. On the other hand, you don't want any more barriers than what your medium forces you to accept. I feel that I owe it to myself to try the tweaks—unless time simply doesn't allow it.

> **NOTE**
>
> *As I mentioned in Chapter 5, one of the things I've done to save you time is create an Action (actually it was Doug Sahlin's idea) that I call the magic Workflow Layers Action. You can download it from either the O'Reilly site (www.oreilly.com/catalog/digphotoet/) or from www.kenmilburn.com. Figure 6-1 shows the Layers palette (choose Window→ Layers) as the Action configures it. Load it. It will save you hours of time every month—or at least until you rerecord it with even more layers tailored to your own workflow. The rest of this chapter assumes that you are using it.*

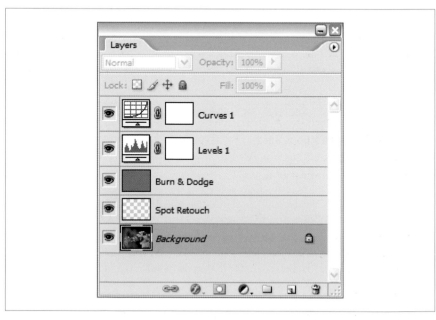

Figure 6-1. The Layers palette that the Workflow Layers Action produces. Assign this action to a key that doesn't conflict with anything you do often.

After opening your image from Bridge, use both the Levels and Curves commands to tweak the adjustments that either your camera or Camera Raw made to the original image. Levels are used to fine-tune the values in the three main areas of the image, much as if you made a simple S-curve in Curves. Then you can use Curves to tweak the contrast in two or three additional brightness ranges within that same image. Don't bother yet with masking these channels. Chapter 7 describes numerous techniques to create masks for layers and then use them to adjust very specific areas within the image. This is another step in the workflow called Targeted Adjustments.

Levels for Shadow, Highlight, and Overall Brightness

This is the Levels routine I use on all my images. When I finish, I know it is exactly as I want it. Then, if I want a certain effect, I can come back and modify this command as the interpretation I'm ultimately looking for begins to shape up.

1. Go to the Levels adjustment layer that was created by the Workflow Layers Action or any layer. Double-click its Layers icon.

2. Adjust each color channel individually. Don't make any adjustments in the RGB channel until the very end of this exercise. Press Cmd/Ctrl-1. The Red channel's Histogram appears. Look to see if the Histogram mountain "touches ground" at either end before it reaches the frame. If it does, move that end's slider (Highlight or Shadow) just barely to the left of the touchdown point. *Do not* touch the midpoint slider.

> **NOTE**
>
> *Don't perform Steps 2 or 3 if you used a color or grayscale card to match color balance in Camera Raw (e.g., for predetermined colors for catalogs or logos or because you wanted white balance to be correct regardless of subjective considerations).*

3. Repeat Step 2 two more times, once after pressing Cmd/Ctrl-2 for the Green channel and once after pressing Cmd/Ctrl-3 for the Blue channel. The colors in the image are now balanced. You'll probably be surprised at how much better it looks.

4. Adjust Brightness, Contrast, and Midtones by using the composite (aka RGB) channel's Histogram and sliders. Adjust the Highlight and Shadow sliders just as you did in the color channels. This is often not necessary because of the adjustments you just made, but if it is, follow Nike's advice and just do it.

5. Adjust the midtone slider to get the overall brightness you want. Don't even try to get the right look for a specific area of the image just because it's important. Not now—it's just not the right time. You want the overall balance to be right. Figure 6-2 shows the before and after of an image.

> **NOTE**
>
> *Make sure you exported your files from Camera Raw (or whatever application you use to process your RAW files) as 16 bits. In the last three or four chapters of the book, you may have to switch to 8 bit. However, in the meantime, you want to maintain as much data in the image as possible to keep posterization to a minimum for as long as possible.*

Figure 6-2. Before (left) and after (right) levels adjustment.

Curves for Adjusting Contrast in Specific Brightness Areas

Now is the time to get the brightness and contrast correct for the most interesting or decorative portions of the image. Which area this is will depend entirely on the picture you've taken and your interpretation of it. You may want to darken some blocked highlights, or increase the contrast in the midtones to make the subject of interest "pop" or to simply block some shadow detail in a specific area so that it doesn't cause a distraction. This will probably be easier to visualize if we start with an example. Figure 6-3 shows an image after it was treated with the Levels adjustment layer but before using the Curves routine described next. The right is the result of the Curves Layer adjustments.

Figure 6-3. The image after adjustment with the Levels layer (left) and adjustment with the Curves layer (right).

Here's the step-by-step process for changing the Curves adjustment layer for several specific areas of brightness in a given image:

1. Double-click the Curves icon in the Curves adjustment layer bar in the Layers palette. The Curves adjustment dialog appears (see Figure 6-4).

2. Place your cursor over the area you want to change and press Cmd/Ctrl. (I find that it's generally the mid-highlights and shadows that need a bit of added contrast, as well as some lightening or darkening.) The cursor changes to a dropper. Click while the dropper is exactly over the color you want to change. A spot will appear on the Curve line at the exact point that corresponds to the brightness level you picked. Leave it alone until you've picked another couple of areas that need changing.

3. Look at what you have. You will want to raise the points that represent the areas to brighten and lower the ones to darken. Check the Preview Box so you can see what you're doing. I find it is easier to change the position of points with the arrow keys because the changes happen in small and exact increments.

Figure 6-4. The Curves adjustment dialog as it appears when first opened.

As you raise or lower the points, notice that the contrast of areas between the two points increases as the Curve line becomes steeper. You may want to plot additional points to change the shape of the curve.

To isolate a point so that little changes on either side of its brightness, place two points on either side. This will keep the curve from moving. Figure 6-5 shows the Curves adjustment layer dialog as it looked after the adjustments from the right side of Figure 6-3.

> **NOTE**
>
> *With a little practice, you may know in advance what you want your curve to look like. When that day comes, you can save a lot of time by choosing the Pencil tool in the Curves dialog and simply drawing the curve freehand. It is usually a bit jerky, but you can click the Smooth button. The curve is still modified by clicking points and dragging them.*

Figure 6-5. The Curves dialog after making the necessary adjustments to get the results shown in Figure 6-3.

Adjustment Layer Advantages

You probably already understand this, but an adjustment layer actually doesn't make any changes to the layers below it. It simply gives Photoshop CS2 instructions on how the image should look and print. Adjustment layers have the further advantage of being readjustable at any time, as long as you haven't merged or flattened their layers (which you should only do when you duplicate the image and flatten it to purposely send an unmodifiable version to someone outside your company or personal domain).

If you're not yet familiar with adjustment layers, you'll find them listed on a menu that appears after clicking the New Adjustment Layer icon at the bottom of the Layers palette or by choosing Layer→New Adjustment Layer. The adjustment commands that are available on adjustment layers use exactly the same dialog as their Image→Adjustments menu counterparts. So if you know how to adjust without an adjustment layer, you also know how to adjust with one. Table 6-1 shows the specific adjustments that are available as adjustment layers.

Table 6-1. Available adjustment layer options

Levels	Hue/Saturation	Photo Filter
Curves	Selective Color	Invert
Color Balance	Channel Mixer	Threshold
Brightness/Contrast	Gradient Map	Posterize

The adjustments in Table 6-2 are available only as destructive adjustments, which I'll show you how to apply in a nondestructive way in Chapter 11.

Table 6-2. Available destructive adjustments

Auto Levels	Match Color	Equalize
Auto Contrast	Replace Color	Threshold
Auto Color	Shadow/Highlight	Variations
Desaturate	Exposure	

NOTE

All of the routines in this section assume that you have run the basic Workflow Layers Action described in the "The Magic Action for Layered Workflow" section in Chapter 5. If you skipped that chapter, jump back before going on.

What follows is an example of how each adjustment layer type might be particularly useful in a circumstance commonly encountered by professional photographers (remember, you don't have to be a pro to learn how to think like one). Whereas Chapter 5 described each layer's function, this chapter gives you the most practical applications for each adjustment layer. And this time, the layers are more or less in order of frequency of use. I say more or less because no two photographers' requirements are exactly the same. In fact, some of these commands may never be a part of your style. Still, it's good to know what your options are.

Levels Adjustment

Levels is the best command for ensuring that you have a full range of tones in your image. However, I have to give you a bit of a warning here: a maximum range of tones is not always best suited for every purpose. I have known photographers to make a career of styling their photos to have a unique look by forcing a very limited range of colors. On the other hand, the best artists are usually trained to create technically perfect art, so they know exactly why they are deviating. End of lecture.

The Levels command is also often used for setting white balance. There are a couple commonly used ways that should definitely be a part of your routine.

Setting technically correct white balance

You will need some part of the photo to be absolutely neutral in color. A grayscale card, black tires, or bleached coffee filters are all good candidates. These have to be the real colors of the neutral object. Don't try using a

Applying Adjustment Layers to Multiple Images

Since all of the adjustments in this chapter are targeted at all the image layers below the adjustment layer(s), you can easily apply these adjustments to multiple images. Prepare the first image in the series. Then, open half a dozen or so of the other images in the series at the same time by selecting them in Bridge and double-clicking. If they are Camera Raw files, I'm assuming that you've already followed the instructions for applying the same Camera Raw adjustments to all the images in the series (see the "Tweaking Camera Raw Adjustments in Sync" section in Chapter 4). I'll show you the routine for applying the Levels and Curves layers that are created by the Workflow Layers Action. If you've also created others for a particular group of images, just include them in the same Layers group.

Follow these instructions for applying adjustments to the series of images you want to adjust:

1. Group all the adjusted layers into an Overall Adjustments Group.

2. Open as many other images in the series as Photoshop can handle, given the configuration of your computer and memory. You should be able to open at least six at a time.

3. Keep the image you first adjusted and its Layers palette visible. Drag the other images into a stack on the right side of your screen.

4. Select the first image to make it active, and drag the Overall Adjustments Group onto the image at the top of the stack on the right. If you kept the Layers palette visible, you'll see the group appear in that image's palette, and the appearance of the image will instantly change to match the adjustment of the first image.

5. Click the Minimize Icon for the image you just dragged the Group to so that it will be temporarily out of the way.

6. Click the first image to activate its Layers palette, and drag that same group to the next image at the top of the stack. Repeat Steps 6 and 7 until all the images (other than the first one) have had the Overall Adjustments Group added to their Layers palettes.

7. Maximize the images one at a time that you added the Group to, press Cmd/Ctrl-S to save it, and then click its Close icon. Don't close the first adjusted image until you apply the Group to any of the other images in the same series that haven't been opened yet.

8. Open another six or so images and repeat Steps 4–8, if there are more images in the series.

If you already set white balance properly in Camera Raw, you don't need to do this.

Photoshop technique to make them that color—it won't work. Figure 6-6 shows the difference between the original image and the way it looks after this process.

Figure 6-6. The image as it was when opened and then after correcting white balance in Levels using the White Balance Eyedropper—first on the coffee filter to set white balance, then on the gray card to set exposure.

Follow these steps:

1. Select the Levels adjustment layer. (If you grouped it, you'll have to open the Group to select it. To open the Group, click the small gray arrow to the left of the Group folder in the Layers palette.)

2. Double-click the Levels icon.

3. Choose the Set Gray Point dropper and click on the neutral-tone object. I have to tell you one more time: the "neutral tone" had really better be totally lacking in color tint and be absolute gray, regardless how light or dark. Otherwise, your white balance will be surprisingly incorrect, rather than correct.

4. Adjust the midtone slider to the appropriate brightness level, if necessary.

If you didn't have time to include a gray or color card and there is nothing in the image that is absolutely neutral, there's still a process that ensures you have maximum brightness range from each color channel, as well as overall brightness range. The result is usually surprisingly good color balance and a much richer image than you might otherwise have expected. All of which

make it a good idea to use this process on any image that you haven't been able to color balance with a gray or color card. Figure 6-7 shows the before and after result of applying this process to one image.

Figure 6-7. The image as it was shot and then after color correction in Levels by using each color channel. Grayscale and white cards weren't used at all to make these adjustments.

Follow these steps to correct the color as shown in Figure 6-7:

1. Open the image from Bridge. If it's a RAW image, do the best you can in Camera Raw first.

2. Go to the Layers palette and double-click the Levels icon in the Overall Levels layer. The Levels dialog opens. Do *not* make any adjustments in the composite (RGB) channel just yet.

3. Press Cmd/Ctrl-1. You are now in the Red channel. If the Histogram "mountain" touches ground on either end before it touches the end of the base, drag the slider on that end until it touches the base.

 If the Histogram also touches ground before the other end, drag that slider until it touches the base. Figure 6-8 shows how the sliders should look. Do *not* move the midtone slider for any of the color channels at this point.

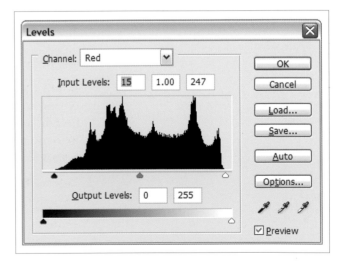

Figure 6-8. The Histogram in one color channel of the Levels dialog showing the sliders adjusted as recommended.

4. Repeat the color channel adjustment you just made for the Red channel for the Green (Cmd/Ctrl-2) and Blue (Cmd/Ctrl-3) channels, in that order.

5. Make the adjustment for overall brightness and contrast. Press Cmd/Ctrl-~ (tilde) to get to the RGB channel. Adjust the Highlight and Shadow channels in the same way as you did in the previous steps.

6. Adjust the overall midtone brightness. Drag the Midtone (center) slider until you like the overall brightness of the image. Normally, this is where you're done. However, sometimes you want to make some further subjective judgments to the overall brightness range and color balance. If that's the case for the image you're currently working on:

 a) To change the color balance, go to the channel that contains the color you most want to change. Drag the Midtone slider to the right to intensify the primary color or to the left to intensify the complementary color. For the Red channel, the complementary color is Cyan. For the Green channel, it's Magenta. For the Blue channel, it's Yellow.

 b) To change overall contrast, go back to the RGB channel and spread the distance between Highlight and Shadow to lower contrast or decrease the distance between Highlight and Shadow to increase the contrast.

Curves Adjustment

I can usually improve an image by changing the contrast within a chosen range of brightness. For example, sometimes I want to make the skin tones just a little lighter or find that it would be better if the sky were a bit darker. Please keep in mind that right now, I'm only talking about brightness areas that are predominant in a large part of the image and don't have to be isolated by masking. Masked channels come later in the workflow.

In case you don't already know, adjusting the contrast curve for a given range of brightness is easy:

1. Open the Curves dialog, press the Cmd/Ctrl key and the cursor will become an eyedropper. Click on the tone in the image that is the midtone in the brightness range that you want to adjust. A black dot will appear at precisely that brightness location along the Curve line.

2. Repeat the process for any other brightness tones you want to change.

3. Select each Curve line dot one at a time. For each dot, press the Up arrow key to brighten that tone or the Down arrow key to darken it. Press the Left/Right arrow keys to move that point to a different position along the curve.

If necessary, you can isolate the changes you are making to include only a given brightness range by placing double points above and below the curve point that you are moving. Figure 6-9 shows an image and its curve after changing the brightness and contrast of the midtones in the shadows to bring out a bit more detail.

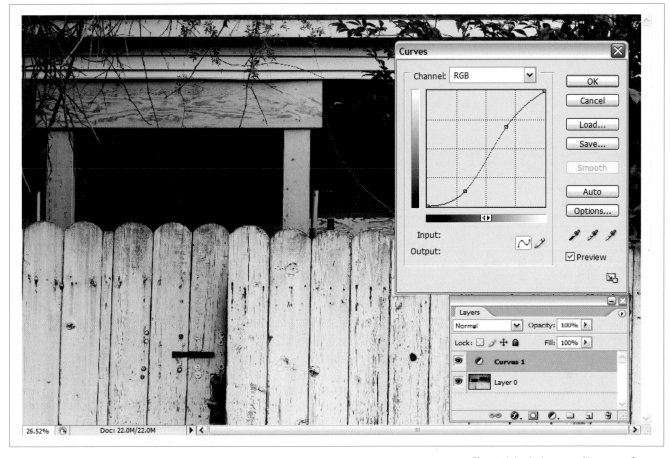

Figure 6-9. An image and its curve after changing the brightness and contrast of the midtones in the shadows to bring out a bit more detail.

The same Curves adjustment layer can be used to change the color tint of a particular range of brightness. Figure 6-10 shows the before and after of a portrait in which there is a tint reflecting from a nearby wall. This is something you couldn't do in Camera Raw, so doing it now is your only chance. You could use the Color Balance adjustment for this job, but you'd have to make selections to target the tinted area, so you couldn't apply the same layer to a series of images. This adjustment is particularly useful if the shadows or highlights are picking up the reflection of a nearby colored object, for example, a wall or sweater. Follow these steps:

1. Press Cmd/Ctrl-click in the image on an area that contains the brightness level you had in mind.

2. Place two anchor points on either side of the anchor point dot you just placed, leaving enough space between them so that your change "blends" with surrounding areas of brightness.

3. Go to the color channel most likely to make the change in tint. Raise the target anchor dot to intensify the primary color for that channel. Lower it to intensify the complementary color for that channel. You may need to use two channels to get or remove exactly the intended shadow tint.

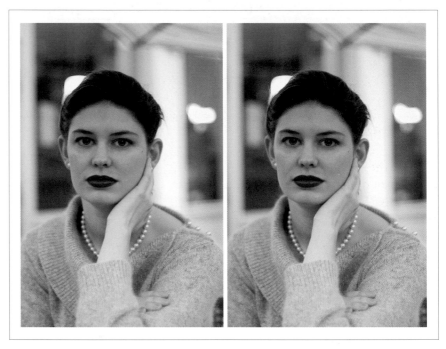

Figure 6-10. The before and after of a portrait in which there is a tint reflecting from a nearby wall that needed correction. See the orange highlight on the camera-left ear, top of the sweater, and on the highlighted rim of her face? There may also be times when you want to increase a tint for atmospheric effect.

Color Balance

Although the most accurate way to set color balance is to use a gray or color card with the Levels command (see "Levels Adjustment" earlier in this chapter), the Color Balance dialog is an excellent way to set color balance subjectively. For instance, suppose you shoot a landscape before sunset and the color balance doesn't feel right to you, so you use the Levels approach. Well, maybe it's better but still doesn't have a strong enough sunset feeling. Figure 6-11 shows the before and after of this scene.

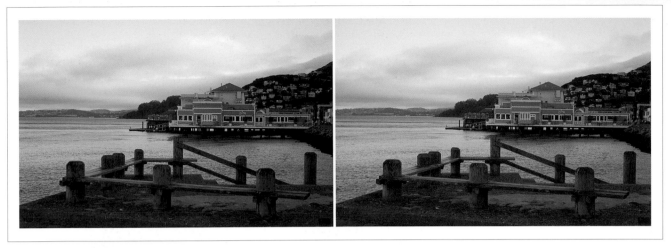

Figure 6-11. A landscape shot just before sunset that looks more like it was shot at 3 p.m. (left) until you "correct" it with the Color Balance adjustment layer (right).

Getting the subjective look I want is simply a matter of dragging sliders until I like what I see. Always start by correcting the color that most needs correction. Drag toward the name of that color to intensify the color or toward the name of the complementary color to diminish the influence of the primary color. The secret here (as it is for most adjustments) is to be sure the Preview box is checked. The settings that gave me the sunset feeling are shown in the Color Balance dialog in Figure 6-12.

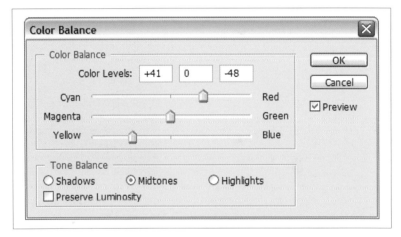

Figure 6-12. The settings for creating an orange sunset feeling. You could use the same method to warm or cool the atmosphere of any image.

NOTE

Many users prefer the Adjustments→Variations command instead of the Color Balance command because they can see the effect before the adjustment and can see several comparisons at once. However, until Adobe makes Variations work as an adjustment layer, the only way you can apply the command non-destructively is to create a copy of a flattened version of your file. To do that, highlight all the layers, then press Cmd/Ctrl-+ Opt/Alt-E. A new merged layer will appear and you can use the Variations command on that. Of course, you've added quite a bit more file size, and you can't try another Variation without repeating the whole process.

Hue/Saturation

The Hue/Saturation adjustment layer is most useful for two categories: hue and saturation (duh?). Seriously, most of the time you'll use both of the

NOTE

There is a script from Fred Miranda called Velvia Vision that gives you a number of versatile options for creating truly beautiful and authentic photos that feature highly saturated colors. Since this script costs a mere $25 and lets you preview the result before you apply it, I suggest you check it out (www.fredmiranda.com). There's more on Fred Miranda in Chapter 11.

dialog's sliders regardless of what your purpose is—you'll just use them differently. But I haven't yet told you what the two purposes are, have I?

Assuming your original image wasn't a JPEG, you might wonder why you'd want to change the saturation of colors in the image when you already had a chance to do it nondestructively in Camera Raw. Well, first, I suggest you only do it in Camera Raw when your camera or shooting conditions have simply dulled colors to a point beyond the norm. If you're doing it to stylize the image, you'll find it much easier to do different interpretations in Photoshop. You may even want to do these in a variety of Layer Comps (see Chapter 9) so you can present different interpretations to the client within the same file. Pumped up saturation can give your image the look of fantasy or romance. Take a look at the before and after images in Figure 6-13 to see what I mean to romanticize the image.

Figure 6-13. The image on the left would be considered a nice photo; the image on the right is saturated (with a lens blur effect added during the Effects processes described in Chapter 10).

Here's how the Hue/Saturation command was used to enhance the image in Figure 6-13:

1. In this instance, the image needed some adjustments with the Levels and Curves layers to bring up more detail in the darker areas of the picture and add color to the sky. So I raised the Curve in the darker shadows and lowered it in the top third of the highlights.

2. I clicked the Adjustment Layer icon and chose Hue/Saturation. When the dialog opened, I moved the Hue slider to +5 to favor the greens in foliage. Then I dragged the Saturation slider to +36.

Brightness/Contrast

The Brightness/Contrast adjustment layer can be useful for quick and dirty lightening, darkening, or contrast. It generally works best when you want to burn or dodge a small area of the image or the outside of a vignette by first masking a targeted area of the image. For other applications, it is much better (and less destructive) to employ the controls in Levels and Curves.

I don't like the old-fashioned elliptical vignettes much, unless I am intentionally dating the picture. Generally, I vignette to force the viewer to focus attention on central parts of the imaging by darkening peripheral stuff that could be distracting. To vignette an image:

1. Use the freehand Lasso tool to draw a loose loop around the edges of the image, as shown in Figure 6-14.

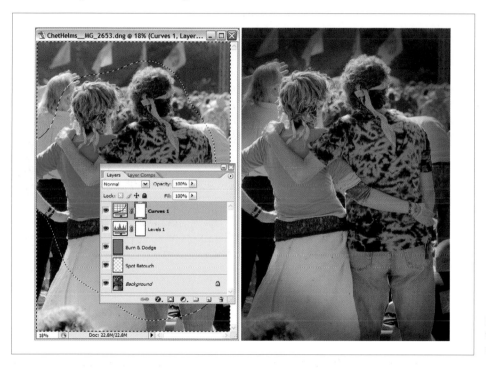

Figure 6-14. A freehand selection drawn to vignette less important areas on the outside of the image.

2. Feather the selection as much as necessary and then invert it. Make sure you keep the selection active.

3. Select Brightness/Contrast from the Adjustment Layers menu at the bottom of the Layers palette. The adjustment layer will appear. Be sure to move it above the Levels and Curves layers you've already created. Also, this is going to be a regional adjustment, so you may want to put it into a Regional Adjustments Group should you create more of same.

4. Drag the Brightness slider to darken the vignette as much as you like. You can also play with the Contrast slider. I often flattened the darkened part of the image to make it even less obtrusive.

Channel Mixer

The Channel Mixer has two primary uses: creating bizarre color effects and making stunning monochrome images (see the "Monochrome Effects" section in Chapter 10). Figure 6-15 shows you the difference between simply desaturating the image and using the Channel Mixer with the Monochrome box checked to mix colors in channels for the black and white tonalities that work best for a particular image.

Figure 6-15. On the left, a color image after using the Desaturate command; the image on the right is after the Channel Mixer is used.

Figure 6-16. A color image as first opened (left) and after treatment with the Photo Filter's 85 filter (right).

Photo Filter

The Photo Filter adjustment layer's name is a bit confusing. First of all, it's not found on the Filters menu. Second, its job is to emulate the glass filters used over the lens in traditional color photography. You can control the intensity of the effect by dragging the density slider. The filters that are emulated are: 85, LBA, 81, 80, LBB, and 82. You can also choose many straight–color overlay effects. You could achieve the latter with a combination of solid color layers and blending modes, but the Photo Filter adjustment layer is quicker and more interactive. Figure 6-16 shows the difference between an image that has simply been desaturated and one created with the Channel Mixer.

Solid Color

The only difference between this adjustment layer and simply filling an empty layer with any color from the color picker is that a Solid Color adjustment layer will let you change your mind by simply presenting you with the Color Picker dialog. A Solid Color adjustment layer, in conjunction with Blend Modes, opens all sorts of possibilities for special colorization and semi-toning effects. Using a solid layer on a black and white image creates an image "toned" in the solid color. In Figure 6-17 shows the result of using a solid color layer on a color image. In this case, the Solid Color adjustment layer was used with the Overlay Blend Mode at about 40 percent opacity. For more on using this technique, see "Changing an Object's Color" in Chapter 8.

Figure 6-17. The original color image (left) and the same image "toned" with a Solid Color adjustment layer in Overlay Blend Mode at 38 percent fill.

Selective Color

This is an amazing way to create color effects in a color image. You do it by mixing the primary CMYK colors (even though you're working with an RGB image) as they affect one color at a time. Figure 6-18 shows you the difference for just one such adjustment. The possibilities are literally infinite.

Figure 6-18. The original color image (left) and the same image (right) after using the Selective Color adjustment layer in one of an infinite number of combinations.

Threshold

Threshold divides the image into pure black and white. You can choose the luminosity value that makes the dividing line. This is a very easy way to make a selection that is darker or lighter than the Select Color Range command. Besides, it's interactive, so you can see what you're doing. You can then make a mask or selection from the result. You can fine tune that mask by painting on it or by modifying it in Quick Mask mode. You can also smooth the selection and then convert it to a pen path. Or you could stroke the selection to create particular edges. Another trick is to cut and paste the result of the Threshold adjustment into a mask channel and then use the Gaussian Blur filter and selections to feather the mask in varying degrees. See Figure 6-19 for a before and after example of adding details to highlights and shadows using this technique.

Figure 6-19. Specific areas of highlights and shadows were lightened and darkened by making masks with the Threshold filter.

> **NOTE**
>
> *You could use the Threshold adjustment layer to make corrections to the highlights and shadows that are nondestructive and readjustable. Make one mask for extreme highlights and another for extreme shadows. Then use each to mask a Levels adjustment layer. The highlights and shadows in Figure 6-19 can be readjusted and have an editable mask*

Gradient

This is a terrific function for creating bizarre color effects. I find that these effects can be extremely useful for making backgrounds for poster and album cover photos of entertainers. I'm sure you can find a million other reasons for using them (see Figure 6-20).

You can use any gradient in Photoshop's Gradients directory or any gradient that you make or modify and then save. The gradient automatically maps itself to brightness values and colors in the target image. If the gradient is monochrome, you get a monochrome image.

Figure 6-20. **The original image (left) and the same image with a gradient map used as a background for a glamour photo (right).**

Pattern

The Pattern function is pretty cool when you need to quickly create a textured background layer or when you need a pattern to use for creating a texture. Since patterns are often made to be seamless, you can easily make them small or large. They're also cool as backgrounds because they can be lit with the Lighting Effects filter (boy, would I love Adobe if they made that an adjustment layer), vignetted, blended with a gradient, or have shadows on them. You could also use the warp tool or project them onto a 3D shape to make them more credible as object surfaces. It would take a whole book to go into all the possibilities, but suffice it to say that Pattern can be a surprisingly versatile and helpful tool. You can see the result of using it and the Lighting Effects filter in Figure 6-21.

Figure 6-21. **A pattern layer (left) and result of using it as a background in conjunction with the Lighting Effects filter (right).**

Invert

Figure 6-22. A positive black and white image and its negative.

The Invert function reverses the tones in the image from positive to negative, as shown in Figure 6-22.

Posterize

Figure 6-23. A photo before and after posterization.

The Posterize function reduces the image to a number of colors specified in the resulting dialog box. Figure 6-23 shows an example of an image that has been reduced from full color to eight colors.

Using Blend Modes on Adjustment Layers

You may think that the adjustments you made to your image in Camera Raw may have made it unnecessary to go through the adjustments in this chapter. Never mind. Don't delete the adjustment layers created by your Workflow Layers Action until you've done everything you want to the image. You can mask either of those layers to use for a targeted adjustment (see Chapter 7) or use a Blend Mode with the layer.

Here's another good reason you shouldn't delete them: even when no adjustments are made in an adjustment layer, Blend Modes can have amazing effects on your image. And remember, because you did it with an adjustment layer you can experiment all you want. I will show you the three that are most useful, each in a before and after on the same image. Remember, you can vary these effects considerably by adjusting the Opacity and Fill sliders for the adjustment layer.

Luminosity

Neutralizes color shifts, as shown in Figure 6-24.

Figure 6-24. An image before and after adding a Curves layer in Luminosity Blend Mode.

Screen

Creates a high-key effect, which is especially useful for creating a dreamy mood or adding glamour to a female portrait (see Figure 6-25).

Figure 6-25. An image before and after adding a Curves layer in Screen Blend Mode.

Multiply

Creates a low-key effect, which is especially useful when you want to create a classical or dark and creepy mood (Figure 6-26).

Figure 6-26. An image before and after adding a Curves layer in Multiply Blend Mode.

Changing Hue/Saturation

When the image interpretation you're after is all about color that goes beyond what you're likely to shoot in the original and exists only in your imagination, it's definitely time to think about the Hue/Saturation adjustment layer. This is once instance where it's especially useful to have the nondestructive nature of an adjustment layer on your side. This command makes it possible to boost the intensity of colors far beyond anything your screen can see or a printer can print. So before you even start to use it, turn on the View→ Gamut Warning command, especially if you plan to boost saturation rather than reduce it.

As you probably know or will see as soon as you open the dialog, changing the intensity of colors isn't all this dialog does. It also lets you change the overall Hue or color balance of the image. Yet another slider lets you change the brightness of the image's midtones and is especially worth giving a try when you want to bring the image back into gamut by sacrificing brightness for color intensity. One again, keep the Preview box checked so that you can use these sliders interactively.

When to Change Saturation

If you've made your shot in dull or foggy lighting conditions, increasing saturation may be the way to bring the image back to life. Or sometimes you just want to increase the impact of a colorful subject, such as a punk hairdo or an iPod billboard (see Figure 6-27).

Figure 6-27. A colorful image before and after having its color saturation enhanced.

Granted, the Figure 6-27 is an exaggeration. Fujifilm discovered sometime ago adding saturation to the colors of nature often adds to the appeal of an image. Forests look greener, wild flowers pop, and skies are bluer.

On the other hand, if you turn on Gamut Warning and start seeing solid gray blotches in the brightest colors, the Hue/Saturation adjustment layer should be your first choice for rescue—although anything that turns down brightness or desaturates color can be a candidate. Just lower the Saturation or Brightness. (You can even try changing the color balance, although that's likely to produce a result that is unacceptable.)

Mapping Hue/Saturation to a New Color Model

The Hue/Saturation adjustment layer can be used to completely remap the colors in the image. This can often be a wonderful punk or fantasy effect. Note that there are two color spectrum ramps at the bottom of the Hue/Saturation dialog (Figure 6-28). If you go to the Master menu (above the sliders) you will see the names of all the adjustable color ranges. Choose one and the lower color ramp will become bracketed; this will allow you to adjust the bracket to widen or narrow the range of colors. Then, as you move the Hue slider the colors within that target spectrum are remapped.

After playing with the possibilities for a while, try changing the Opacity and Fill of the Hue/Saturation layer. You can also try painting black or dark gray into the Layer Mask to bring portions of the image back to the original colors. In the before and after image in Figure 6-29, all of these adjustments have been done in the righthand image.

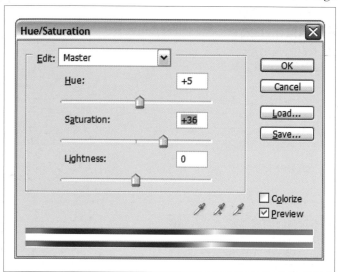

Figure 6-28. The Hue Saturation dialog.

NOTE

You can use the eyedropper in the Hue/Saturation dialog to pick a color to transform instead of choosing a more general color from the Master menu. This is a good way to change the color of the sky from red to pink, for example. With a bit of masking, you could even use it to change the color of an object, such as a car or shirt.

Figure 6-29. In the after image, the colors for yellow have been remapped by moving the Hue slider. Also, details in some of the shadows, such as the interior of the closest sailboat, have been brought back to life by masking them from the effects of the Hue/Saturation adjustment layer.

Color Balance Techniques

It's often hard to adjust color balance correctly because one part of the image is lit by a different color of light than another. I'm not talking about changing the color balance of a specific area but correcting all the areas of the image that were lit by a light source of a different color than the main light source. Examples of this would be colors reflected from walls, clothing, or tablecloths. Another common example would be a portrait taken by window light. The highlights might be lit by daylight and the shadows by the tungsten bulbs lighting the interior.

Using a Color Balance Adjustment Layer

The Color Balance adjustment layer is nondestructive, but not all that controllable when it comes to color balancing a specific brightness range in the image. You can choose whether the adjustments affect highlights, midtones, or shadows. You can also check a Preserve Luminosity box so the brightness range doesn't change as you make your adjustments.

In Figure 6-30, I've rebalanced the highlights so that the skin tones are warmer in the highlights, while the rest of the image has retained the original color balance. The end result is that the picture looks even more romantic.

Figure 6-30. On the right, the Highlights radio button was turned on and the Yellow slider increased by about 25 percent. Notice the warmer tones in the highlight areas and especially in the models' faces.

Using the Curves Adjustment Layer for Color Balance

I don't usually think of Curves as a way to adjust color balance, but you and I both should. It's too easy to forget that you can pick a single color channel from the drop-down menu on the Curves dialog and apply the curves to that color. This allows you to easily increase or decrease particular ranges of color. If your purpose in changing color balance is to set a different mood, changing small areas of color in the image can do it. It's also a good device for correcting colors in a limited spectrum in the image that might be caused by reflections or stray light. In Figure 6-31, the reds in the tree bark and the green of the vegetation and moss were both intensified in their own channels of the Curves layer.

Figure 6-31. The original image (left) and the same image after disproportionately changing color in two of the channels.

Levels Adjustment Layer

The Levels adjustment layer is also a good way to control color in a single channel. Again, you just choose the desired channel from the pop-up menu on the Levels dialog box. You can also control the range of that color a bit more accurately by moving the Highlight, Shadow, and Midtone sliders to limit the range of colors that will be affected in each channel. Figure 6-32 is an example of the sort of fantasy effects that can be created this way.

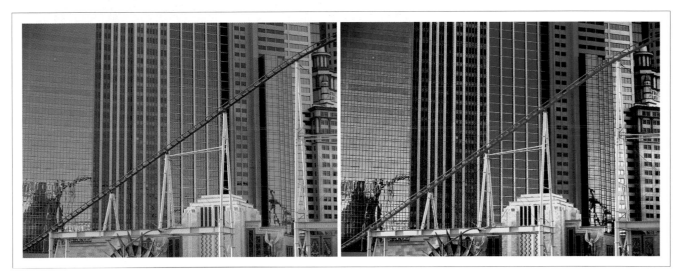

Figure 6-32. In the after image, each color channel was limited to about one-third of its normal brightness range. The adjustments were totally arbitrary.

The Auto Commands in Levels

If you followed my recommendations for adjusting the Levels adjustment layer in the Layers Workflow layers by adjusting each of the color channels individually, you have already come pretty close to attaining perfect color balance. If you haven't, I strongly suggest you go to the "Levels for Shadow, Highlight, and Overall Brightness" section of this chapter. There is a quicker way to do this, which is totally destructive: by using the Auto Color command in the Image→Adjustments menu. Of course, nothing in Photoshop is quite what it appears to be and if you look carefully at the Levels dialog you'll see a button labeled Auto. The default for this command is to do exactly what Auto Color does by clipping each channel Histogram at its minimum and maximum values. In fact, you can easily incorporate that adjustment into the Workflow Layers action so that this button is clicked as soon as the Levels layer is created. Now, when you're really in hurry, you'll have all your images auto color corrected. Figure 6-33 shows the result of clicking the Auto button using the default Enhance Per Channel options. To change the defaults, click the Options button.

NOTE

Levels can be used to correct or subjectively change the overall (midtone) tint of the images channel by channel, just as you do when using the Color Balance command. Go back to the individual color channels and drag the midtone sliders. Be sure to have the preview box checked so that you can see the result.

Figure 6-33. A subtle but dynamic change in the color balance using the Temperature and Tint sliders in Camera Raw compared to using the Auto button in a Levels adjustment layer (right).

When to Use Hue Instead of Color Balance

Since both Hue/Saturation and Color Balance adjustment layers change the overall color balance of the image, you may wonder when to use one instead of the other. Use Hue/Saturation when you want to:

Figure 6-34. An image as it came out of Camera Raw adjustment (left) and using the basic workflow layers in conjunction with the Hue/Saturation adjustment layer (right).

- Color balance a CMYK image for fine-tuning output to offset printing devices (see Chapter 12).

- Create an effect that changes one set of basic colors to another. See Figure 6-34 for another example of this.

- Change the color balance or a range of colors and add or subtract saturation.

- Subdue the effect by lowering the opacity or fill of the adjustment layer.

Applying Color Balance Techniques to Other Images

If you shot a series (or what Aperture calls a "set") of the same image in the same lighting conditions and are post-processing them in Photoshop according to the recommendations so far given in this chapter, it's very easy to apply all that work to the whole series.

1. Keep the first image that you processed open, along with its Layers palette.

2. Go back to Bridge and make sure all the other images in the series had those same settings applied to them. If not, open the first image in Camera Raw, then click the Done button. This registers the settings for that image as the last settings that were made. Go back to Bridge.

3. Highlight all the images in the series and press Enter/Return. They will all open in Camera Raw simultaneously. Click the Select All button. Now, from the Settings menu, choose Previous Conversion.

4. Make sure all the thumbnails are still selected and click the Open button. All of the images will open in Photoshop.

5. Select the first image and make sure its Layers palette is open. Select all the adjustment layers (they all have that adjustment layer icon at the left end of the Layer Bar. Choose Make Group from Layers from the Layers palette menu.

6. Drag the adjustment layer group to each of the other images in the series. You will see all of the adjustments happen automatically.

Making Destructive Adjustments on the Layers

There are a few adjustments on the Adjustment menu that don't have adjustment layer correspondents. As a result, they are among the more destructive operations that one can perform. However, that doesn't mean you can't use them. You do this by creating a layer on which you can perform destructive editing (this will save space, since you seldom need more than one or two of these for a given image). When you need to do a lot of destructive editing, you'll want to create even more layers using the following method:

1. Drag your Background layer to the New Layer icon at the bottom of the Layers palette. This will duplicate it to the top of the palette. Drag it down to just above the original background layer.

2. Highlight all but the background layer and press Cmd/Ctrl-Opt/Alt-H. A new layer that looks like the background layer with the overall nondestructive adjustments will appear at the top of the stack.

3. Select the top layer and rename it Destructive Edits. Figure 6-35 shows how the Layers palette should look at this stage.

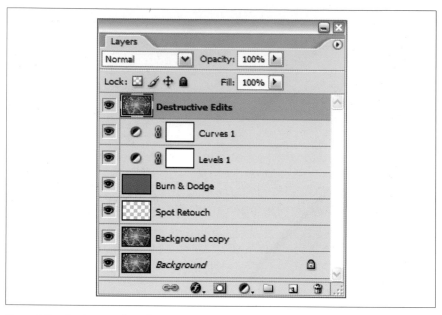

Figure 6-35. The Layers palette showing the basic Workflow Layers with the addition of a merged layer that combines all the initial adjustments.

The following are the commands in the Image→Adjustments menu that have no adjustment layer counterpart, along with a description of what each does, and before and after illustrations that show the effect of the adjustment:

Auto Levels

The Auto Levels command adjusts each channel individually to the highlight and shadow clipping points that you specify in the Auto Color Options. The white point for each channel is then set to 255. This command sometimes causes surprise color shifts, which you then have to correct using one of the color correction techniques covered earlier in this chapter. Or, you might Undo (Cmd/Ctrl-Z) and try the Auto Contrast command instead.

Auto Contrast

This command does the same thing for the RGB channel as the Auto Levels command does for the individual color channels. The effect is to "idealize" the overall image contrast, without affecting color cast.

Auto Color

Auto Color arbitrarily and automatically resets the color balance by setting the gray tone at 128 for all three channels. Highlights and shadows are clipped at .5 percent. Figure 6-36 shows the same image "auto-corrected" by Auto Levels, Auto Contrast, and Auto Color.

Figure 6-36. The same image, left to right, untouched, the auto-corrected by Auto Levels, Auto Contrast, and Auto Color.

Desaturate

This is an automatic command. The result is a crummy black and white image. You're much better off to use the Channel Mixer nondestructively (see the "Channel Mixer" section earlier in this chapter). However, there may be a time when you're in a heck of a hurry.

Changing Auto Color Options

To change the Auto Color options, which affect all three of the above adjustments, open either the Levels or Curves adjustment layer and click the Options button. You will then see the dialog in Figure 6-37.

Under Algorithms: Enhance Monochrome Contrast is the equivalent of the Auto Levels command; Enhance Per Channel Contrast is the equivalent of the Auto Contrast command; Find Dark

Figure 6-37. The Auto Color Options dialog.

& Light Colors is the equivalent of the Auto Color command. Options for target colors and clipping can also be set. If you check the Save as Defaults checkbox, then when you click Auto in either the Levels or Curves dialog it will perform whichever of the three auto-equivalents you've set it for. *Yes! That means that you can perform all three of the above operations nondestructively.* You just have to remember to set these options first.

Match Color

Uh, not sure what this command thinks it's doing. It should be called "make a mess of a batch of images for which you're trying to match color." It actually works pretty well if you have a series of images (remember, series means same subject and surroundings) in which lighting conditions change. The trouble arises if there are large areas of very different color, such as a red wall behind one subject and a blue wall behind another. In that case, I prefer to make color adjustments for each image while all the images are open, so that I can compare them directly. More importantly, you can then use adjustment layers and go back and tweak each image until you have a really good match. This can be very important when you're going to use several very different images in the same publication, particularly if they're going to be on the same page or screen.

Replace Color

This command brings up the dialog in Figure 6-38. It allows you to replace one fairly solid color in the image with another. It can be a great way to change the color of clothing in a catalog or to change the color of all sorts of things in a fantasy photo taken to illustrate a children's book

Figure 6-38. The Replace Color dialog.

or a comic book. Click the eyedropper at the top of the dialog to pick the color you want to change. Click the color swatch at the bottom of the dialog and use the Color Picker to pick the color you want to change to or drag the Hue slider until you see the color you want in the swatch. Chances are that you'll only see a change in part of the area you want to recolor. Since you're making this change on a duplicated layer, if you want to further isolate the change, you can erase any color changes you don't want to keep.

Shadow/Highlight

This is a command is hard to live without unless you have an assistant and a budget for portable strobes and reflectors. Otherwise, when you're shooting outdoors in sunlight, you will have either blown-out highlights or blown-out shadows. The "Opening Up the Shadows" section in Chapter 7 shows you some nondestructive workarounds to this command. However, this dialog makes corrections fast, easy, and interactive. To keep it nondestructive, create a merged layer at the top of your stack (see instructions at the beginning of this section). Shadow/Highlight is one of the newest commands in Photoshop. It does an excellent job of providing an absolutely shadowless fill-flash, while also allowing you to restore seemingly blocked highlights or tone down images that were too close to a light source. Figure 6-39 shows the before and after image—along with the dialog that made it so.

Figure 6-39. The result of using the Shadow/Highlight command and the associated dialog.

You have quite a bit of flexibility with the end result produced with this dialog. There's really nothing mystical about it—just drag the sliders until you get what you like. When the dialog opens, the adjustments you made the last time will still be in effect, so you may not have to make any adjustments at all.

Exposure

This adjustment and HDR images are discussed a great deal more in the "Using Photoshop's Merge to HDR Script and the Exposure Command" section in Chapter 11. After all, the Exposure command was really invented for readjusting the appearance of an image after it has undergone a Photoshop CS2 HDR Merge command. These images have a gamma of 1.0, as opposed to the 1.2 gamma typical of an Adobe RGB 1998 image. The HDR images are typically 32-bit images as well, but you can output a 32-bit image from Camera Raw. Exposure will also work with 8- and 16-bit standard images. It just works differently than the other adjustment commands since there are three eyedroppers: White sets the white (brightest) point in the image, Black sets the midtone with which the Offset slider works, and Gray sets the Gamma point for the Gamma slider. Once you've set those points, the dialog has three slider controls:

Exposure

Adjusts mostly the brighter half of the tonal scale, although shadow tones may be somewhat affected.

Offset

Darkens mostly shadows and midtones.

Gamma

Sets the width of the dynamic range for the image.

You can get some very strange results from this command. If you're looking for a unique "look" for an image or want to play with black and white results, I suggest you try it. Figure 6-40 shows the dialog; Figure 6-41 shows the original and two different results on a color image.

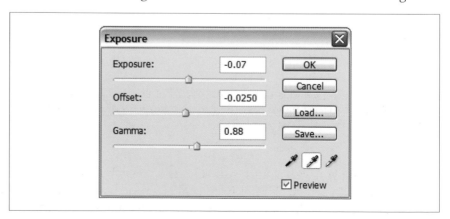

Figure 6-40. The Exposure dialog.

Digital Photography Expert Techniques

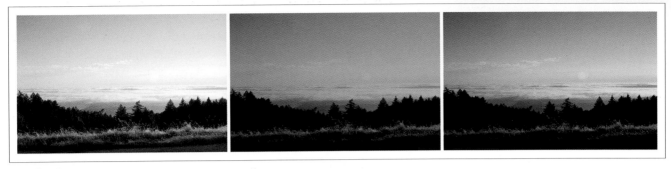

Figure 6-41. The image at left is the original interpretation, followed by two separate adjustments.

Equalize

Equalize is an automatic command with no settings dialog. It flattens the Histogram, so all levels of brightness are the same intensity. It's especially worth experimenting with in conjunction with the Fade command or the equalized layer's Opacity slider. Furthermore, if you use a nondestructive layer, once you balance the effect by using layer opacity you can erase areas that have been overly affected and end up with some beautiful results. I love the Equalize command for dramatizing existing skies. Figure 6-42 shows an image untouched by Equalize and another in which the image was equalized and then painted back in with the History brush or faded out with the Eraser.

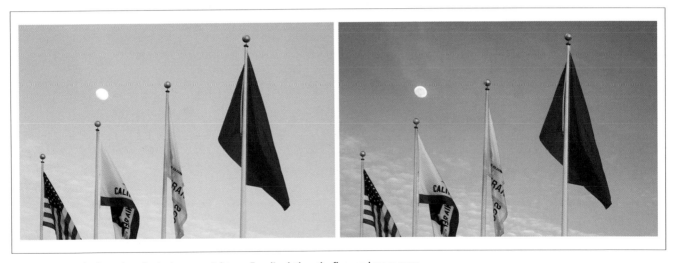

Figure 6-42. A duplicate layer in the image at right was Equalized, then the flags and moon were selected, feathered, and erased. Finally, the equalized layer's Opacity was reduced to about 30 percent. The result? A much more interesting sky.

Variations

Variations are a visual means of adjusting color balance and exposure. It works only with 8-bit images. When you choose Image Adjust Variations, the dialog shown in Figure 6-43 appears. Be sure to check

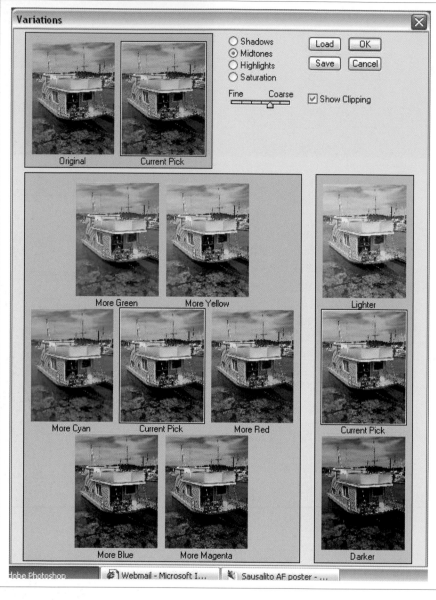

Figure 6-43. The Variations dialog.

the Show Clipping box to insure that your choices aren't blocking or oversaturating colors. Drag the Fine Coarse slider to the first notch to the right of Fine to insure that your choices won't overdo it. Then all you hve to do is click the thumbnail(s) that seem to improve your image.

Each time you click a thumbnail, it adds its effect to the Current Pick square. Note that you can change the effect in Shadows, Midtones, or Highlights separately by clicking the radio button for that brightness range. You can also affect the intensity of the saturation of any of the prime colors. Finally, you can change the overall lightness or darkness of the image by clicking the Lighter or Darker thumbnails. When you're happy with what you see, click OK.

Making Targeted Adjustments

There's not a big difference in the procedure for making adjustments when you're making targeted adjustments. The difference is primarily in how you adjust a specific area without losing or jeopardizing the totally nondestructive work that you've done up to this point.

Much of the success of regional adjustments depends on your ability to make the mask that restricts your adjustments to one or more very specific areas of the image. Of course, you could make an adjustment directly onto the image by using any of the adjustment commands after you'd made a selection. But then that adjustment becomes a permanent part of the image, destroying whatever was previously in that area. So you really want your selections to do one of two things:

- Mask an adjustment layer so that it will only have an effect on targeted portions of the image. This is the option you should use—except when it is impossible.

- Create a separate layer for adjustments that have no adjustment layer equivalent.

In this chapter

Tips for Using Selections

Using Layers to Make Targeted Adjustments

Creating Effects with Targeted Adjustments

HOW THIS CHAPTER FITS THE WORKFLOW

Direct Your Adjustment to a Particular Spot

This chapter isn't about how to make an adjustment. You learned about that in Chapter 6. It's about the various ways to "aim" those techniques at enhancing a particular part of the subject in such a way that those adjustments stay both intact and isolated. You'll also learn about making selections to create masks for those layers. And you'll learn a lot more about how to modify a layer mask to change the exact area and blending of a targeted adjustment.

NOTE

I assume you have some knowledge of Photoshop and the basic selection tools such as the Marquee, Magic Wand, and Lasso tools.

Tips for Using Selections

Of course, a big part of targeting specific areas of the image for adjustment is knowing how to most effectively and credibly isolate that portion of the image. It's important that the isolated portion blend smoothly with the rest of the image so that your adjustments look natural in all respects. It's also important to make sure that the adjustment is accomplished in a nondestructive way.

Checking Alpha Channels

Any time you spend more than 10 minutes making a selection, it's a good idea to save that selection so that you can recall it if you decide to make more changes to that same image (choose Select→Save Selection). The saved selection takes the form of an alpha (transparency) channel, which will be bundled with the file only if the Alpha Channels checkbox in the Save As dialog is checked. The downside of saving each selection is that it increases the file size by approximately one-third from the original RGB file. So you don't want to save alpha channels if you won't be using them again for a final version of a file or for a file that has to be optimized for the Web. So it's a good idea if, before you save the final version of a file, you open the Channels palette and take a look at the alpha channels. If you won't need them in the future, drag them out of the palette and into the trash at the bottom of the palette.

Making Accurate Selections Easier with Brightness/Contrast

You can use the Image→Adjustments→Brightness/Contrast... control to make your selections easier. Duplicate the layer you're selecting, boost the contrast so that the Magnetic Lasso can see the edge clearly, and make the selection. Then you can save the selection as a mask (alpha channel) and throw away the duplicate "contrasty" layer.

Sometimes you'll have to select an object whose edges are a lot less contrasty along different segments of the profile you want to trace. In that case:

1. Make two or three duplicate layers, as seen in Figure 7-1.

2. Turn off all but the lowest layer.

3. Choose the Magnetic Lasso and trace the edge that has the most contrast between it and the background. When you get to the end of that portion of the edge, double-click so the selection is closed from the beginning of that portion of the edge to the end. Save the selection, but leave it active so if you accidentally drop it, you can retrieve it.

Figure 7-1. The selection as it looks after tracing one adjusted layer and then selecting another.

4. Throw away the layer you just traced and turn on the (or one of the) other layers and repeat the step above, only this time trace the edge with the most contrast in this rendition of the image. It shouldn't take you more than two or three of these layers to end up with a fully selected image.

5. Use the Selection→Save Selection command each time you trace a layer.

6. Throw away all the duplicated layers after you to trace them.

7. Use the selection to target your image; an extreme example of this is shown in Figure 7-2.

> ── **NOTE** ──
>
> *To easily duplicate a layer, select the layer you want to duplicate in the layers palette, press Cmd/Ctrl-A to select the whole layer, and then press Cmd/Ctrl-J to lift it to a new layer.*

Figure 7-2. The targeted selection was raised to a new layer and a new background was substituted.

Making a Mask from the Image

There will be times when you want to use the image itself as a mask, especially if its edges are really complex. There are a couple of ways you can do this:

- Convert the image to black and white and then make what you don't want included in your selection black and what you do want gray or white.

- Knock out the image using a program or plug-in made for the purpose. You can then make the mask by locking the transparency on its layer, filling it with black, then cutting and pasting the image into an alpha channel in the Channels palette.

Making a selection from a black-and-white image

If you're going to make a mask from a photo, you will want to photograph the subject against a background that contrasts with it as much as possible. This is one of the best techniques for flying hair or skylines full of trees and trellises. The image in Figure 7-3 is a pretty good example.

Figure 7-3. The selection as it looks after tracing one adjusted layer and then selecting another.

Once you've made a mask from a black and white image using the Threshold adjustment, you might want to use it to darken or equalize the sky. You could also use it for isolating a color effect or for compositing in a sky from another day or location. You could also use the same technique for a fashion shot or head shot that is crying for a new or inaccessible background. (For those specific techniques, see Chapter 9.) What we're going to do here is nondestructively create a mask from the photo, then add interest to the sky using an adjustment layer made from that mask. Here's the procedure for making a mask from a black and white image using the Threshold adjustment to pick a hairline or a skyline.

1. Open the image you want to make a mask from. Make sure it's one in which there's a distinct difference in brightness and colors from the part of the image you want to keep and the part you want to mask.

2. Choose Image→Duplicate. You are simply going to use this image as a mask so there's no need to save or rename this duplicate since you will put the whole thing back into the original image. In the meantime, we can run some commands on it that we don't want to keep with the original for space-saving reasons.

3. Pick a color channel that shows the greatest contrast between the foreground and the mask. Open the Channels palette and click on each of the color channels. You'll see how each of the channels handles brightness for that area of the image. Figure 7-4 shows this image's Red, Green, and Blue channels in that order.

Figure 7-4. Red, Green, and Blue color channels for the tree image.

4. Choose the channel that makes the foreground the darkest and the background area the lightest. The closer to white, the better. In Figure 7-4, that would be the Blue channel.

5. With the Blue channel selected, double-click the Zoom tool to get 100 percent magnification. Press and hold the spacebar and use the resulting hand tool to pan around the image until you find the smallest and lightest detail that you want to leave unmasked.

6. Choose Image→Adjustments→Threshold. You'll see the dialog shown in Figure 7-5. Drag the slider from side to side until that small detail is black but absolutely no larger than it was in the original image. Now you have your mask. Click OK. Now be sure to pan around the mask, keeping it side by side with the open image. There's a small chance you incorrectly judged from the wrong section of the image when you had it magnified. That usually happens in the area where the background is lightest. If there's a discrepancy, just repeat the procedure until your mask looks like a perfect match. It's easier than it sounds.

Figure 7-5. The Threshold dialog adjusted exactly as it should be for our mask.

7. Press Cmd/Ctrl-A to select all, then Cmd/Ctrl-C to copy the mask to the clipboard.

8. Open the original image and then open the Channels palette (you may have it already open). Click the New Channel icon at the bottom of the palette. The new channel will be named Alpha. Make sure it's the selected channel and the press Cmd/Ctrl-V to paste your mask into it. The mask is now in your image and it has been saved. Be sure to now choose the RGB channel in the Channels palette.

Figure 7-6. **The result of using the Hue/ Saturation adjustment layer on the masked sky.**

You can now do anything you like to the sky without affecting the rest of the image at all. One of the most useful things you can do with the mask (if you're going to use it for a targeted adjustment layer) is to load the selection (you may want to name its channel something like Skyline Mask), then choose the adjustment you want to make from the Adjustment Layers menu in the layers palette. I chose the Hue/ Saturation adjustment layer. I used the sliders to darken the sky, increase saturation, and change the Hue of the sky. The result is shown in Figure 7-6.

Another useful trick in a situation like this is to simply darken the sky. You can raise the selected sky to a new layer and then put the new layer in Multiply Blend Mode. You can keep darkening the sky by duplicating the Multiply layer multiple times.

Making a selection from a knockout

In a sense, a knockout (something extracted from the rest of the image) is a selection. That is because knockouts always rest on their own layers and everything else on that layer is transparent. So anything you do to the knockout will be separate and distinct from the rest of the image. Still, there are reasons you may want to knock out a portion of the image just to use it as a selection:

• To create a shadow, glow, or lighting effect that outlines the selection.

- To make more instances of the same object without having to extract them all. You can simply use the selection made from the knockout to raise the image to another layer.

- To make one object appear to cast an effect, such as a reflection, onto another.

It's pretty easy to make a mask from a knockout. The trick is to make the best possible knockout (see the "Homemade Backgrounds" section in Chapter 10). The only difference here is our purpose in making the knockout. Once it's been made, you have an object—often with very complex edges—floating on a transparent layer. Figure 7-7 shows a knockout of a thistle on the lefthand side. The right of the same figure shows a mask made from that knockout.

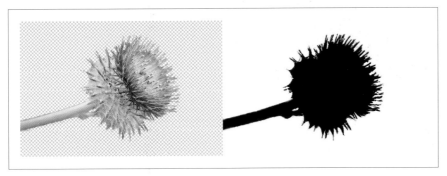

Figure 7-7. A knockout (left) and the mask made from it (right).

To make the mask from the knockout:

1. Duplicate its layer.

2. Click the Lock Transparency icon (the one with the checkerboard background) in the layers palette.

3. Choose Edit→Fill from the main menu. In the Fill dialog, choose Black from the Use menu and leave the other settings at their 100 percent defaults. Click OK.

4. Create a blank layer behind the black silhouette, fill it with white, and then select both layers. From the layers palette menu, choose Merge Layers.

Figure 7-7 shows your results. If there are any artifacts left over from the knockout, simply use the Brush tool with black or white paint to get rid of them. Figure 7-8 shows how two separate adjustment layers were used to dramatically reinterpret the image's subject and background, thanks to the use of one simple mask.

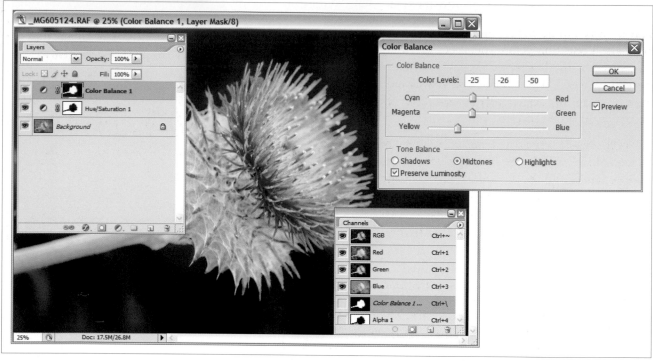

Figure 7-8. The thistle's colors have been dramatized and the background's hue and lightness have been changed completely by using a mask made from a knockout.

Using Layers to Make Targeted Adjustments

You may have already figured this out from the Chapter 6, but not all adjustments can be made with adjustment layers. So you make the adjustment nondestructive by simply merging the layers up to this point into a new layer that is used solely for making that targeted adjustment. There are many other instances in the course of employing the "Milburn Method for Nondestructive Editing" when you will want to do the same thing. Each time one of those instances arises, use the techniques described in this section.

Lifting a Selection to a New Layer

You already know the keyboard shortcut that raises a selection to a new layer, but it's easy to repeat in case you've forgotten it: Cmd/Ctrl-J. Be sure you've selected the layer in the layers palette. This makes a copy of what was inside the selection so you can always restore the target portion of the image to its original state by simply deleting or clicking the Eye icon in the layers palette to turn it off.

You can also save the selection before raising the targeted area to a new layer. Then you wouldn't have to make several selections when you want to raise the same portion of the image to perform a different adjustment on each.

Making a Layer Mask from a Selection

A layer mask can be created either before or after you create the layer. If you make a selection before you select a new layer from the Adjustment Layers icon at the bottom of the layers palette, that layer will be automatically masked. If you create a new layer and later decide you want to mask it, create the selection you want, then click the Mask icon at the bottom of the layers palette.

If a layer mask is already in existence for a layer (because you clicked the Layer Mask icon in the layers palette *before* you make the selection), you'll see an icon to the right of the layer's image or purpose icon (Figure 7-9). If that icon is all white, you can create a mask by making a selection, inverting it, and then filling with black or—if you want the mask to only let in some of the background image or effect—a shade of gray.

Figure 7-9. The Layer Mask shown in the layers palette.

> **NOTE**
>
> *You may want to go back through your layers once you've finished composing, compositing, and adjusting an image. If you have no reason to keep all of a layer, select what you don't need and delete it. You'll save a wee amount of disk space. However, be aware that it's not worth the savings if you think you'll ever need more of that layer should you modify or replace its mask. "Empty" layers can be a good reminder that there's more that need to be done later. This can be handy if you need to get a "good enough" version of the image to the client or subject before you continue to work on it.*

Layer Mask Pros and Cons

Like just about anything in life, there's an upside and downside to using layer masks:

- **Pro:** Just in case you might wonder why you should bother with a layer mask instead of just retrieving a saved selection, well that's what this book is all about. If you use a mask on an adjustment or to make a partial layer, you can change the settings or the effect on that layer without affecting the whole image. You could even adjust the partial layer nondestructively simply by adding a clipping mask to it. Such adjustments can always be changed at any time during the remaining construction and adjustment of the image.

- **Con:** All the adjustment layers will take up a somewhat larger amount of disk space. Of course, derived partial layers will add a significant amount to file size, but not as much as if you had to work with the whole layer.

Using Blend Modes on Regional Adjustment Layers

As we saw in Chapter 6, the Blend Mode function in Photoshop provides nearly endless possibilities. How a given Blend Mode is applied to an adjustment layer will depend on both the type of adjustment layer and the settings that are being used. Suffice it to say, it never hurts to try the following steps because you can always come right back to where you started. Meantime, you may create a miracle. Once you've created your masked adjustment layer and made the settings you desire:

1. Drag the Layer's palette tab up to the palette doc, but make sure to then click the tab so that the palette is extended.

2. Choose the Move tool—*but don't move anything.*

3. Cycle through all the Blend Modes. Press and hold the Shift key while tapping the + key.

You may not end up using the results of any of these experiments, but they're very quick to do and you may find a happy surprise.

Using Multiple Adjustment Layers

You can make specific kinds of adjustments at any time. One of the absolute best things about using adjustment layers (as if you don't already have enough reason by now) is that you can aim and overlap them in endless combinations of location and Blend Mode.

Moreover, by stacking adjustment layers, you can often create effects in multiple areas of brightness or color. I can exert extremely precise control over contrast within a masked portion of the image by using multiple Curves layers—all with the same mask but with different portions of the curves adjusted differently. To look at this more closely, I've constructed a mask for the street-crossing crowd that's used for three stacked curves layers in Figure 7-10.

Figure 7-10. The crowd in this scene has been adjusted with one Curves layer at left, two in the middle, and three in the right image.

If you stack adjustment layers that are about contrast, rather than color balance, it's a good idea to put them all in Luminance Blend Mode so that they don't change the color balance of the image.

Creating Effects with Targeted Adjustments

There are a number of special effects that you can create with targeted adjustments. This section suggests a few and you can take it from there.

Adding Colored Light

There are numerous ways to add colored lighting effects, but most of them involve using commands on the filter menu that are more destructive than the operations recommended in this chapter and at this workflow stage. However, you can do just about anything you want to do for a colored lighting effect

by using a combination of the Solid Color adjustment layer, the Opacity and Fill sliders for that layer, and by painting some layer masks and using a Blend Mode or two. Moreover, you can do this to create coloring effects in different colors and in different parts of the image.

Admittedly, these effects aren't as slick or easily predicted as a great many third-party color effects filters. However, this method is non-destructive, doesn't require another layer (which doesn't mean you may not find reason to want one), and doesn't cost you extra bucks. In Figure 7-11, you see an image as I processed it in Camera Raw alongside an image treated with three color effects layers, each with its own mask.

Figure 7-11. An image with Camera Raw processing (left) and after applying three masked Solid Color adjustment layers (right).

Opening Up the Shadows

One of the most useful adjustments in Photoshop is Shadow/Highlight. It often does a better job of fill flash than if you had actually used simple fill flash. Fill flash has a tendency to cause red eye , create very deep and unnatural looking shadows just under the chin and nose, and usually overexposes the subject while underexposing the background. However, we'll have to save the Shadow/Highlight command itself for Chapter 11, as it makes dramatic changes to the image that can't later be dismissed or readjusted.

Besides, although it works quite well most of the time, there are other times when you might be happier with the results from other techniques, namely threshold masking, a masked Curves layer, or the use of Screen Blend Mode. You could even combine these techniques.

Threshold masking

I already mentioned threshold masking earlier in this chapter and discussed it as a way to brighten specific areas of brightness in an image in Chapter 6. Brightening shadows is another very good use for threshold masks. It's not as quick and easy as using the Select Color command (see the "Select color" section below), but has the advantage of allowing you to decide the level of brightness to start the masking. Here's how you do it:

1. Duplicate the file you want to mask and flatten its layers. Leave both the original and duplicate files open in Photoshop.

2. Choose Image→Adjustments→Hue/Saturation. When the Hue/Saturation dialog opens, drag the Saturation slider all the way to the left. Your image is now grayscale. This step isn't absolutely necessary, but does help you to judge the level of brightness.

3. Choose Image→Adjustments→Threshold. The Threshold dialog appears, as seen in Figure 7-12. Note that the slider is turning every-

Figure 7-12. The Threshold dialog.

Digital Photography Expert Techniques

thing black that is 75 percent gray because I didn't really want to lighten any midtones in this image.

4. Select everything and copy it—press Cmd/Ctrl-A, then Cmd/Ctrl-C.

5. Select the original file and open the Channels palette (Window→ Channels). Click the New Channel icon at the bottom of the palette. A channel named Alpha will appear and it will be selected. To place your mask in that channel, press Cmd/Ctrl-V. Since you actually want to mask the shadows, press Cmd/Ctrl-I to invert the Alpha channel. Now click the Make Selection (circle of dots) icon.

6. Choose Select→Feather and enter a small amount (4–10 pixels) of feathering if you expect your adjustment to be slight or a large amount (80–200 pixels) if your adjustment is going to be drastic. The idea is for your adjustment to blend with the surrounding image without showing obvious edges or haloes.

7. Click the RGB channel, then open or go to the layers palette and choose an adjustment layer that will let you control Brightness and Contrast. You should experiment to see whether Brightness/Contrast, Levels, or Curves works best for your purposes. Be sure the preview box is checked in the dialog so you can visually set the effect as you want it. If you want to turn off the marching ants (the pulsing dashed line around your selection), press Cmd/Ctrl-H.

> **NOTE**
>
> *One of the nicest and most controllable ways to darken nearly blown-out highlights is to select them, lift them to a new layer using the old Cmd/Ctrl-J trick, and put the new layer in Multiply Blend Mode. If the highlights are now too dark, just lower the Opacity or Fill of the layer. If they're still not dark enough, duplicate the Multiply layer as many times as necessary.*

If you want to darken the highlights a bit, go back to the duplicate image, press Cmd/Ctrl Opt/Alt-Z until you're back to a full-scale grayscale image, then use the Threshold command to mask just the very brightest highlights. Copy the result to a new Alpha channel in the original image, make a mask, feather it, and use your favored Brightness/Contrast adjustment layer to bring down the highlights. You can see the before and after results of lightening shadows using this method in Figure 7-13.

Figure 7-13. Note that the shadows have been filled regardless of their distance from the camera, just as they are when using the Shadow/Highlight command.

Select color

You can often emulate extended ranges simply by selecting the highlights or shadows and then using a duplicate layer in Multiply or Screen Blend Modes or an adjustment layer. Unlike making a mask from a Threshold adjustment of a duplicate file, your selection will be either shades that are brighter (highlights) or darker (shadows) than 50 percent gray.

There are two ways to select highlights or shadows:

Use the Channels palette

In my opinion, this is the easiest way to select highlights or shadows. Open the Channels palette (which, if you're working on regional adjustments, is a good idea to keep open) and Cmd/Ctrl-click on the RGB layer. The highlights will be immediately selected. If you want to select the shadows, just invert the selection with Cmd/Ctrl-Shift-I.

Use the Select Color Range adjustment

Choose Adjustments→Select Color Range. In the Select color dialog (see Figure 7-14) choose either Highlights or Shadows. I always choose Highlights and then simply invert the mask with Cmd/Ctrl-Shift-I.

Once you have your highlights selected, you can invert the selection to make a shadow mask, if that's the area you prefer to work on.

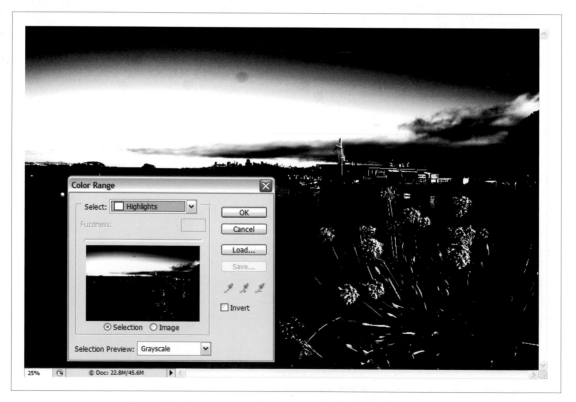

Figure 7-14. The Select Color Range dialog with Highlights chosen from the Select menu.

Using the Color Range Selection to Adjust Midtones

You will often find it useful to use the Color Range dialog to select midtones. For instance, in the example shown in Figure 7-15, I darkened the sky and the river by selecting Highlights, lifting them to a new layer, using the Multiply Blend Mode and then duplicating the layer. I then discovered that I wanted to lighten the shadows in the ridges and some other tonal qualities in the landscape. So I selected the shadows by inverting the selection made with the RGB Channel technique, lifted it to a new layer, and then opened the Color Range dialog again. This time, I clicked the eye dropper on one of the darker areas in the image. Then I used the Fuzziness slider to narrow the selection to just the areas I wanted to brighten and click OK. I feathered that selection by 80 pixels and then used a Curves adjustment layer with a Clipping Mask to brighten the shadows and add contrast to them.

Figure 7-15. The HDR image on the right was created from the image from Camera Raw at the left by using the Select Highlights routines for the sky and river and the Curves method to lighten shadows and add contrast to the foreground.

Curves

If the image you're working on just needs some minor brightening, darkening, and contrast changes, make your mask by whatever method seems best—including those previously mentioned. Then open a Curves adjustment layer and attach it to the portion of the image that you lifted from the selection. Add a Clipping Mask to the Curves adjustment layer by choosing Create Clipping Mask from the layers palette menu. Make your curves so that they affect the area of brightness you want to affect. If you want the effect to also lighten the overall selected area, try either the Screen or Lighten Blend Mode.

Screen Blend Mode

You can often lighten an area by simply selecting and lifting the selected area to its own layer, then placing that layer in Screen Blend Mode. This is a technique I often use for high-key portraits, but it can be useful for lightening all sorts of areas.

Don't Forget the Eraser

There are many times when one of the techniques in this chapter works almost perfectly, but simply affects some areas of the image that are fine without the effect. Eraser to the erasecue! Be sure to lower the Eraser's Opacity in the Options bar, so that you can build and blend with the Eraser by "scrubbing" the portion you are erasing. Scrubbing is the act of keeping the pen or the right button pressed as you stroke so that you gradually erase (or burn, dodge, or paint if you're using those tools) until you see only as much or as little of the effect as you wanted to create.

Repairing the Details

8

This chapter covers all types of image "repair" and the tools you'll need to restore and retouch images in a variety of situations. We'll first cover some basic tools used for all types of repair and then get into specific techniques for image restoration, glamour, portraiture, architecture, still life, and scenic subjects.

> **NOTE**
>
> *There are some procedures, such as using a high-key glow effect for a glamour portrait, that may be considered retouching but (from a workflow perspective) are really special effects. Those procedures are covered in Chapter 11.*

In this chapter

General Repair Toolkit

Specific Types of Repair Projects

HOW THIS CHAPTER FITS THE WORKFLOW

Limit Destruction to a Retouching Layer

Retouching, when done on the image itself, is totally destructive of any area that it affects. For that reason, you should do all the retouching on at least one separate retouching layer. You already started one of these in the "The Magic Action for Layered Workflow" section in Chapter 5 for spot retouching. What you'll be doing here, when the discussed techniques are necessary, is creating new individual layers for more specialized techniques and then grouping them so they are easy to find, move, rearrange, and blend. It is also done at this time because you need retouch at the earliest practical stage. First of all, you need to do it for quick client turnaround and before you or the client decide to do more "refined" destructive procedures. Second, the changes you are most likely to want to make for purposes of reinterpretation are those that follow this procedure in the workflow. Remember, one of the purposes of an organized workflow is to ensure minimum time waste when an image needs to be reinterpreted.

General Repair Toolkit

Certain tools and commands are part of what I like to call Photoshop's "Repair Toolkit." These included the Healing tools, the Clone tool, the History brush, the Replace Color tool and command, and a technique for copying entire selected portions of the image.

Healing Tools

Another headline for this section might be "Using Spot Retouching Tools." But I'm calling it Healing Tools because the most efficient tools are found in the sub-menu of the Healing Brush tools. One of these is a brand new tool called the Spot Healing brush.

The first thing you want to do when you're about to use the Healing tools is to create a blank layer immediately above the layer you're about to retouch. When you are about to use the Spot Healing Brush, Healing Brush, or Clone tool, check the Sample All Layers box in the Options bar for those tools. Then turn off all the other layers. After you've checked Sample All Layers and made a new layer, your retouching strokes will all appear only on that one transparent layer. Now you can erase those strokes and make a new one if you make a mistake. You also have the option of reducing the effect of your retouching by decreasing the opacity of the healing layer.

I placed the above tip in another publication at one time (frankly, I don't remember which one) and got an email saying, "Yes but what if you don't want to change the opacity of all of the retouching evenly?" That's a very good question that has a simple answer: put the Lasso tool in Add mode and select all the spots you do want to change the opacity of. Then press Cmd/Ctrl-X to cut them from the current retouching layer and then Cmd/Ctrl-V to paste the contents of that selection to a new layer. Then change the opacity of the new layer.

Spot Healing brush

The beauty of the Spot Healing brush is that it's a big time-saver. Size it to cover the target spot or zit by pressing the [(left square bracket) to make the brush smaller or] (right square bracket) to make the brush larger) keys and click. Photoshop fills the surrounding area with its texture—provided you made the brush size too big. How do you know

Quick Switching Between Tools in the Same Menu

Each of the tool sets in the Toolbox has a letter assigned to it. To find out what that letter is, pass the cursor over the tool. In the case of the Healing Tools, the letter is J and for the Clone stamp tool, the letter is S. To switch between tools in the same category, just press the letter repeatedly. Also, in Edit→Preferences→General make sure you check "Show Tool Tips" and uncheck "Use Shift Key for Tool Switch."

Figure 8-1. On the left, you see skin defects. Thanks to the Spot Healing brush, there are none on the right.

when you've made the brush size too big? Look carefully at the ex-spot and see if it's been filled with the surrounding texture. If it hasn't, just undo (Cmd/Ctrl-Z) and switch to the Healing brush tool (see the "Healing brush" section next). In Figure 8-1, I have intentionally exaggerated the spots and blemishes that you can easily fix by tapping them with the Spot Healing brush. That's exactly what I did to the figure on the right.

Healing brush

There are some areas that are too big for the Spot Healing brush to handle, or at least to handle very well. You could deal with these areas pretty well with the Patch Tool, but it won't sample to another layer—at least not until some future version of Photoshop. So thank Heaven for the Healing brush. The Healing brush lets you set an anchor point to tell it what texture to use in the patch, then it always blends that texture into any area you paint with the Healing brush.

There are two options for how to use the Healing brush—Sampled and Pattern. Most of the time you'll want to use the Sampled button in the Options Bar. Pattern is only useful if you want to replace an area with a pattern. The difference between doing that with the Healing brush and the brush is that the Healing brush brings in brightness and colors from the surrounding areas. You can get some really interesting effects with this when you want to replace a cluttered background or texture an object in a still life.

Patch tool

The Patch tool lets you select relatively large areas of the image that need to be hidden or subdued. Simply use the tool to draw a free-hand marquee around the area you want blend with the surrounding area and then drag that selection to an area that contains the same texture you want inside the "patched" area (see Figure 8-2).

To use the Patch tool as nondestructively as possible:

1. Make a selection around the area that you want to patch that is large enough to contain the target area for the patch. The target area is the place where you want to drag the marquees. Once that selection is made, press Cmd/Ctrl-J to lift it to a new layer. Figure 8-3

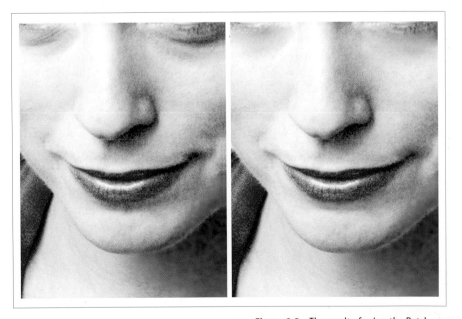

Figure 8-2. The result of using the Patch tool on matching areas—in this case the bags and wrinkles under the eyes.

shows how that area would look to produce the result shown in Figure 8-2.

2. Click to activate the Source radio button in the Options Bar. Leave all the other options at their default.

3. Once you've set your options, make a selection just as you would with the Lasso tool. You'll get the same type of marching ants marquee.

4. Put the cursor inside the selection and drag it to a portion of the image that has the pattern or texture you want to blend into the area that was originally selected.

5. Use the Edit→Fade command to lessen the effect of patching. The Patch tool is so good at doing its job that it can produce an unrealistic or overly idealized result. If you're patching a pair of matching characteristics, I often find it better to click the Add option so that you can patch multiple areas at once. Then, when you use the Fade command, both selections are faded to exactly the same degree or with the new layer selected, just reduce its Opacity (drag the slider to the left) until you see the effect you want.

Figure 8-3. An area of the image lifted as a layer so that patching can be done nondestructively.

There are times when you may want to see detail inside a patched selection. If you have done the patch in its own layer, as suggested above, then it's easy to do. Just use the Eraser tool in Brush mode to erase portions of the patch. If you just want the Eraser to "fade" its result into the original, lower its Opacity in the Options Bar. In this example, you could restore one or two of the lines if you thought that made the subject look more realistic (e.g., if you were asked to make a business portrait rather than a glamour portrait).

Fencing off Healing

Miraculous as the Healing tools are, they're not perfect. If you're healing an area that is too close to a contrasting area, Photoshop will simply give up trying to figure out what the clone texture should be and will produce anything from a black blob to a vignetted or "ghosted" picture of a nearby area. Figure 8-4 shows you such a result.

When you are in this situation, there are two options. One I already suggested—raise the area to be patched and patch from to a new layer. Since the patching then takes place on the new layer that has been cut out of the original layer, there are no neighboring pixels that can confuse the patch tool.

The other option, in case you're working on a multipurpose retouching layer and making several patches, is to use the Lasso tool to make a selection that will "fence off" the area within which you plan to patch or heal (see Figure 8-4). Just be aware that this second technique works only with the Spot Healing and Healing brush—not with the Patch tool. Imagine that you

> **N O T E**
>
> *I have used a portrait to show how the Patch tool is used because it's most often used for retouching portraits; in general, portraits get more retouching than anything else. However, you can just as well use it to restore the texture and color of a section of graffiti painted wall or cracks in the pavement of a roadway.*

want to eliminate a hole in a wall next to a door. Leave the door *outside* the selection so that Photoshop doesn't try to consider it in the texture and color that belong within the patch.

Finally, you're less likely to "smudge" your retouching with the wrong neighboring pixels if you make your stroke parallel to any contrasting pixels that border the area to be healed.

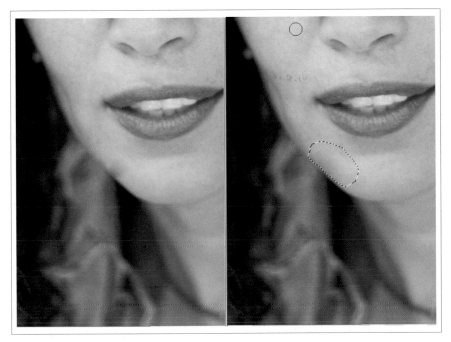

Figure 8-4. The Spot Healing brush tried to incorporate texture information from the area of the photo that you see under the cursor circle in the image at right. At the right, after fencing off the area with the Lasso tool, the shades are blended properly, but the Add Noise filter had to be used to match the grain of the rest of the image.

Cloning

The Clone tool is simply a brush that copies edge-blended portions of an image from a designated source area to a designated target area. In fact, if you need to do this to a large area, see the "Copying Areas" later in this chapter.

In the image in Figure 8-5, there was a pipe running the length of the creek, a tree trunk invading the left edge of the composition, and a blue plastic tarp. All of those elements made the scene look less idyllic and woodsy. So I used the Patch tool to remove the sections of the pipe that crossed the water and the Clone tool to "paint over" the tree trunk, tarp, and sections of the pipe that crossed the leaves. All of this was placed on a separate transparent layer, which I made by first selecting the entire section of the image that needed retouching, turning off all the other layers, and making sure the

Clone Stamp had the Sample All Layers option turned on. This placed all the Clone Stamp's strokes on the duplicated layer as well.

Figure 8-5. The pipe was healed out of the water and cloned out of the leaves and rocks. The tree trunk was cloned away, as was the blue tarp.

NOTE

You can clone from one portion of the same layer to another portion, from one layer to another in the same image, or from an entirely different image whose window happens to be open at the same time. Just be sure to select the layer or image you want to clone from first, and then click the Anchor point. Next, select the image and layer you want to clone to and drag.

When you clone, you have to make a choice in the Options bar as to whether the Anchor point will be Aligned (if checked) or not. If it's aligned, the anchor point travels with the brush. Imagine the pickup point as being at one end of a stick and the repro point as a brush at the other end of the stick—whatever gets "sucked up" at one end of the stick gets "sprayed on" at the other end. This is the way to reproduce a whole portion of an image in another section of the image.

If the Anchor point is not aligned, the Clone tool will keep copying the portion of the original image to the repro point that's the same size as the brush.

Clone Detail from Another Photo

Maybe it would've been a great shot if your model had straight teeth, perfect forearms, or didn't blink. Or maybe you just really want the hat in one image to appear with the costume another as in Figure 8-6.

Details in one photograph can be painted in another with a Clone Stamp brush on a superimposed and transparent layer. There are several advantages to painting on a layer. First, you can blend that layer with the underlying layers by changing the Opacity or Blend Mode. Second, you can alter the exposure and color balance of the layer so that the painted-in detail matches the originals (or, if you have Adobe Photoshop CS, you can even replace the color by using the Replace Color brush). You can also use the Free Transform command (Cmd/Ctrl-T) to reshape or rotate the item so that it appears at the natural-looking angle, size, and perspective. Perhaps most important of all, you can use the Move tool to drag the contents of the new layer so that you're cloned object ends up in exactly the right place.

Figure 8-6. The client wanted the hat in this picture to appear with the costume in another picture.

This method is most likely to work if the object or characteristics that you are transferring from another photo are inside the silhouette of the same part of the subject. That is, it's much easier to add or subtract muscle tone from *inside* the silhouette of an arm, chest, or stomach. If you actually have to reshape the subject, see the "Punch out the paunch" section later in this chapter. Of course, you can combine both of these methods.

Here's the typical workflow:

1. Scale or transform the area inside both images that you are cloning to and from to exactly the same size and orientation. As mentioned previously, it's best to cut and paste the information you're incorporating onto a new layer in the target image, temporarily reduce its layer transparency so that you can see through to the target image on the layer below, and then use the Free Transform command to scale the "incoming" image properly.

 Decide which parts of your image could be improved. Do you need a better-arching eyebrow, a more elaborate piece of jewelry? Make a list so that you can deliberately find or make the images to clone from. You'll need photos with the required detail photographed at the same camera angle and perspective, and with the same lighting and resolution. If you don't have any, you'll have to shoot new photos. For example, if it's jewelry you want, put the piece on a mannequin and set up or find lighting that's the same as the original.

2. Open both photos side by side. Copy the photo you're going to clone from (the source) to a new layer in the photo you're going to clone to (the destination). To do this, press Cmd/Ctrl-A to select all, then Cmd/Ctrl-C to copy to the clipboard. Activate the target image's window and press Cmd/Ctrl-V to paste the photo to a new layer. In the Layers palette, place the new layer (from the source image) above the target image layer.

3. Use the layer palette's Opacity slider to make the new layer blend with the target image, and use the Eraser tool to brush away any unneeded portions of the imported layer.

The biggest problem with this method is matching the texture of the original with the texture of the image you borrow from. This is typically not an issue with eyes or clothing accessories, but skin is another matter altogether. If you have to transfer a tattoo, or some muscle tone, or a different nose, use transparency in the new layer. If you're using Photoshop CS, it's also a good idea to use the Healing brush and anchor it on the original layer, then stroke *around* the parts of the transfer that show bare skin. The Healing brush will transfer the texture from the anchor point without transferring the original details. Don't try this on the focal area you've transferred because the Healing brush will blur it; instead, do it only on the surrounding skin.

If that approach doesn't work for your particular image, try using the Eraser tool on the new layer to reveal the skin in the original layer. Be sure to feather your Eraser brush and set its opacity low enough that your strokes will blend the new layer with the target image.

Recalling History

There's so much going on in Photoshop that it's easy to overlook some features that you could probably use many more times a day than you actually do. For me, one of the most useful features that I tend to overlook until it's too late is History. History, as referred to in Photoshop, is really two features: the History palette and the History brush.

The History palette lets you record any state of an image so that you can recall it at any time that you screw up. I often workaround this by making backup copies of various states of an image. I'm getting over that habit, slowly but surely. The problem with too many backup versions is that over time it becomes harder and harder to find the right image—even if you've labeled them conscientiously. I'd rather keep lots of layers in the same image. You can't save a Snapshot, but a Snapshot is nothing more than a flattened version of the image the way it looked at the moment the snapshot was taken.

Snapshots are useful for keeping a temporary image from which to "paint" an effect. For instance, imagine what you could do in an image by seriously oversharpening it and using the History brush to paint over small details that you really wanted to make pop, e.g., the edge of a blade, the iris of a model's

eye and her lashes, or the collar of a fur coat. Just run your favorite sharpening command or filter, take a Snapshot, and press Cmd/Ctrl-Z to undo or go back to a History state before you did the sharpening. Now you can paint in the details you wanted on a clear layer above the image. If the client later wants a little less sharpening effect or wants to use a Blend Mode—no problem. Apply the client's request to the layer onto which you painted the History information.

You can use the same technique to brush in localized adjustments. For instance, you could make the whole image much lighter and higher contrast and then use the History brush to paint in shadow details or small details on objects that would otherwise have been lost. Figure 8-7 is an example of such an image.

Here's the step-by-step routine I used to make Figure 8-7:

1. I ran the Workflow Layers Action so I could burn, dodge, and heal nondestructively.

Figure 8-7. In the righthand image, notice the area around the hair, eyelashes, and fur that were painted in from the History snapshot after sharpening the image on the left. Since it would have been bad to teach you to oversharpen the image, you'll have to look very carefully to see the difference in the sharpening of an image this size—but it would certainly be important in a full-page ad.

2. I then duplicated the Background and Retouch layers, placed them above the original layers, selected them both, and then chose Merge Layers from the Layers palette menu.

3. I selected the new merged layer and named it High Key Curve & Sharpen. I then gave it a curves adjustment that dramatically brightened the entire image as well as dramatically increasing contrast.

4. I ran Smart Sharpen and really cranked up the sharpening levels.

5. I chose Window→History to open the History palette, scrolled up so I could see the Snapshot bars, and clicked the Snapshot icon at the bottom of the palette to record the change that I made in the merge layer. Then I clicked the box next to the Snapshot I just took so that the History Brush icon appeared in it. This lets you know which Snapshot the History Brush will paint from.

6. Back in the Layers palette, I turned off the merged layer, clicked on the Retouch layer and then used the History brush to paint over the model's hair, fur, the iris of her eyes, brows, and lashes.

> **NOTE**
>
> *Be sure not to throw away or add any layers before you use the History brush. Otherwise, the cursor will appear as a "no" icon and a dialog tells you that a corresponding layer is missing. Also, make sure you don't click the Image icon in the Snapshot bar. The whole image will change to a Snapshot and you'll lose all your layers. You'll probably be really upset if that happens.*

Copying Areas

Sometimes, cloning large areas just takes too long unless you use a very large brush. Very large brushes are more likely to accidentally pick up details you don't want. Also, you can transform (resize, stretch, or rotate) Clone tool strokes. So you can't make the pattern disappear off into perspective. The solution is to select a large area that you want to use to cover another portion of the image, feather the selection so that it will blend, and lift the contents of the selection to a new layer (press Cmd/Ctrl-J). Choose the Move tool and drag the new layer into the exact position where you want it. If appropriate, you can transform the contents of that layer to resize, rotate, or give it perspective with the Transform tool. You can also mask the layer if you need to shape it to fit a boundary. Just switch to the layer that contains the boundary, use the tool that seems most appropriate to select it, select the new texture layer, and click the Mask icon in the Layers palette. In Figure 8-8, it was more efficient to do a combination of copying areas and cloning. After the major areas were copied, their layers were merged and the Clone Stamp was used to blend any seams leftover from merging. The pier was extended one section at a time by copying the same lifted layer over and over again.

Figure 8-8. Note the layer stack at far right. Several of these layers were merged from other layers to allow cloning over seams and from merged layers.

Changing an Object's Color

You can recolor objects simply by selecting them and then filling the selection (Edit→Fill) with the Foreground Color. Of course, you have to choose the color you want from the Color Picker before you issue the Fill command.

Rather than just selecting the item, as I mentioned, it's a good idea to lift the object whose color you want to change to a new layer. By doing this you preserve the precolored original on the background layer and isolate the object so that you don't accidentally recolor the surrounding objects.

In fact, in catalog photography it's often a good idea to make copies of that layer so that you can have a different color object on each layer. Then when you need to output a file that shows the object in that color, you turn off the other layers instead of having to color over and over again.

Figure 8-9 shows a dress by Kashi Stone Designs that comes only in an off-white natural hemp. However, we wanted to see what some of the items might look like if they were dyed different colors. Since we'd already shot the entire line in the style shown at left, I simply used the Extract filter to knockout the model so that there was no change of overlapping the background. We didn't need to isolate the skin or hair, since they weren't the same color as the dress. We simply set the Color Replacement brush in Contiguous mode, lowered the Tolerance to about 20 percent and painted away. It took less than 10 minutes to recolor the dress.

The New Color Replacement Brush

If the object you want to recolor has areas of color intermingled with the color you want to replace, such as a garment that shows through between strands of hair, it's a good idea to use Photoshop CS2's new Color Replacement brush with Contiguous selected in the Options bar. Place the cursor in the area of color that you want to replace and scrub to paint. As long as you've set the Tolerance low enough, you won't recolor colors that are different from the color you clicked on. You may have to experiment a bit with the Tolerance setting. If you see the Color Replacement Brush recoloring areas you don't want recolored, press Opt/Alt and click to choose the color of the object you accidentally colored and re-color it.

Figure 8-9. The dress on the right was recolored using the Replace Color brush.

Specific Types of Repair Projects

The subsections in this section describe an oft-encountered retouching situation in which some specific routines can save time and angst.

Restoring Youth to Photographs

No, this section isn't about glamour retouching. It speaks to restoring the youth of keepsake and collector's images that are beginning to fail the ultimate test—the test of time. The problems with old and worn images most frequently fall into the following categories:

- Spots
- Fading
- Discoloration
- Stains
- Scratches
- Cracks

Most of the retouching required for restoration can be done with the Healing, Spot Healing, and Clone tools. They should always be performed with all image layers turned off except the image being retouched and a transparent layer meant to show retouching strokes. Place the transparent layer immediately above the layer of the image being retouched. If you later create or lift other layers from the main image, place them above this retouching layer. All retouching that uses the Healing, Spot Healing, and Clone tools should be done with the Sample All Layers box checked on the Option bar.

If the entire image has faded, then it's mostly a matter of restoring the original color and contrast, with Photoshop you can make it look pretty decent, pretty easily. Open the scanned image, duplicate it, copy the duplicate, paste the copy into the original file as a layer, and then use the following techniques as they apply to your image:

- Restore the overall color and contrast of the image before you fix any of the regional problems, such as spots and stains. Otherwise, your spot and stain correction may show up even more and in a different color. Of course, you probably won't have the original to compare, but you can do a pretty realistic job by following the Levels adjustment procedure described in Chapter 6. Figure 8-10 shows the image before and after color and contrast correction using that method.

- Remove stains by using the Replace Color tool. Just be careful to stay within the area that belongs to the color that you are replacing. If the stains have dark or faded borders, or if they have darkened or lightened

Figure 8-10. The aged and faded original on the left has had color and contrast restored with the Levels adjustment layer.

the image, you will have to do more. Most of the time, however, you can just remove the stain by using the Replace Color tool.

- To lighten some areas that are darker than others due to the stain, select each one. It is important to be very precise in making the selection. Once you're confident that is the case, feather the selection as needed and then raise the selection to a new layer (yes, that's Cmd/Ctrl-J again). Now use the Brightness/Contrast adjustment to match the brightness and contrast of the area(s) that were formerly discolored.

- If the outside perimeter doesn't quite match the brightness of the underlying layer, use the Burn and Dodge tools (not a Burn & Dodge layer unless it turns out to be a much tougher job than you expected). Figure 8-11 shows the results of the last three actions.

Figure 8-11. Most of the work of stain removal can be done with the Replace Color brush, the Brightness/Contrast Adjustment, and a bit of burning and dodging.

- Remove smaller stains by painting in the surrounding area and textures with the clone tool.

Figure 8-12. Tears are cleaned with the Clone and Patch tools. Occasionally, you'll use the Healing tools to clean up small goofs.

- Clean up all of the small spots with the Spot Healing tool. Occasionally, a spot or smudge will be too close to a contrasting color. So you may find it easier to clean up with the Clone tool than to fence off the spot with a selection before healing it. If you get a border artifact, immediately undo and try one of the other techniques mentioned here.

- Most tears and cracks are easy to clean up by anchoring the Clone tool and dragging it along the path of the tear. Make sure your brush isn't much larger than the width of the tear or crack. Also, be sure to re-anchor the tool if the path of the tear changes direction. Figure 8-12 shows the end result of cleaning up the spots.

Glamour Tips

Most people want to look as irresistible as possible in photographs, but we all have our flaws. Unfortunately, the high-resolution digital cameras and lenses that most pros are buying today will record these flaws with unforgiving accuracy. In glamour photography, this can be a real issue.

Now look at Figure 8-13. What a change! The following tip makes use of the Healing and Clone brushes and the Patch tool that we described earlier and also discusses some filters and settings that can soften the look of a portrait and diminish skin flaws more or less automatically. You'll also see how to use layers to lessen the effect of the retouching tools by changing the opacity of the retouched duplicate layer.

When you're glamour retouching, be very careful not to overdo it. For instance, if you set the Spot Healing brush at too large a size, you will end up with some very pasty-looking, almost posterized, skin tones that can make your subject look more mannequin than human.

Figure 8-13. A bevy of glamour retouching techniques has been used on the image on the right.

Smoothing skin

One of the best ways of smoothing skin is to simply take your time using the Spot Healing brush and make sure you zap all the blemishes. However, skin sometimes photographs a lot more textured than it looks in real life and Spot Healing all of it can take hours.

There are several means of smoothing rough or heavily textured skin. The problem is that most of them involve blurring the image in one way or another. That can be a fine technique for a dreamy or glamorous look, but it's not always what we're after.

There's one technique, however, that involves blurring but doesn't actually blur any details. You select and send the skin tones to a duplicate layer, blur the skin tone layer by about 6 pixels (the exact number will depend on the overall pixel size of the image), erase any of its areas that contain critically sharp elements, such as the eyes, and then put it into lighten mode. You still have a sharp image, but the blurring has obliterated all the little dark specs and creases. If there are still blemishes left over, at least you have fewer of them that need to be zapped with the Spot Healing brush. Figure 8-14 shows an example of this technique in a before and after. None of the other techniques in this chapter have been applied to the righthand image.

Figure 8-14. Look carefully and you'll see that all the small, time-consuming blemishes are gone. Now there are only four or five areas you might want to heal. If this weren't a glamour portrait, you probably wouldn't even want to do anything more.

Figure 8-15. Before and after our list of eye enhancing techniques have been applied.

Credible eye emphasis

The eyes are the focus of the image and there are a few things you almost always want to do to emphasize them (see Figure 8-15). However, take care applying these changes; you don't want the image to look unrealistic or overly made up. Obviously, you'd want to do far less of it in a business portrait, for instance, than in a cosmetic ad. The following are some techniques to emphasize the eyes in an image.

Use the Patch tool to remove bags or circles under both eyes

Make sure to select a large area around both eyes and lift it to a new layer so you can do your patching nondestructively. Be sure you have the Patch tool in Add mode so you can patch

both eyes at the same time on lifted layer. Then use Edit→Fade to keep the effect of the patching at a realistic level.

Whiten the whites (and the teeth while you're at it)

Be very careful not to overdo it. I usually use the Dodge and Burn layer to do this. An alternative would be to choose the Burn and Dodge layer in the Layers palette, make a selection around the areas you want to whiten, and then fill them with a percentage of white. If you've over- or underdone it, undo and then change the Opacity in the Fill dialog after repeating the Edit→Fill command.

Darken the pupils and outline the iris

This is done just like whitening, but use Black instead of White on the Burn and Dodge layer.

Lighten the iris

This is one of the few times when I prefer to use the Burn and Dodge Tools on the original layer—or, if you've already lifted the eye, on the lifted layer. Then the irises will look better when you sharpen them.

Lengthen lashes

I also do this on the layer that was lifted to do the sharpening. I simply use the Burn tool at about 50 percent Opacity with a very small brush. If you have a pressure-sensitive tablet, it will help a lot to stroke very lightly so you get hair-thin lashes. You could paint in Black, but that is often overkill and the Burn tool just darkens the existing colors, so the result looks much more natural.

Sharpen eyebrows and lashes selectively.

This is done on a separate layer, which you can also use as a retouching layer if you need to use the Spot Healing brush. I find it very easy to mask the area I need to raise to a new layer by clicking the Quick Mask icon in the Toolbox then choose the Brush tool. Then make sure the Brush Hardness is only about 80 percent (pull down the Brush menu in the Options bar), and that the Mode is Normal and the Opacity is 100 percent. Then I paint over the areas shown in Figure 8-16.

Figure 8-16. Painting a Quick Mask over the parts of the eyes that need sharpening.

Moistening, smoothing, and highlighting lips

Lips, especially in fashion, glamour, and pin-up photos, can be very important in setting the desired mood. Oddly enough, they seem to make the model seem more relaxed and attentive. Go figure. Before you moisten the lips, there are a couple of techniques you should consider doing first:

Figure 8-17. Look, Ma…no cracks.

Smooth cracks in lips

One of the reasons models tend to go for lip gloss is to keep their lips from cracking since it makes them look harsh and stressed. Lip gloss also makes their lips look moist and saves us from all this work. If they didn't bring or use their lip gloss, don't despair. Just use a small brush size with the Spot Healing brush and stroke over each crack (see Figure 8-17).

Highlight lips

Once you've removed cracks from the lips, the highlights may seem diminished. Not to worry. Just use a wide (in relation to the width of the lips) brush at max softness and paint about 10–15 percent white onto the Burn and Dodge layer (see Figure 8-18).

Figure 8-18. On the right, a bit of glow added to the lips.

Now here is a trick that is downright inappropriate for some images, such as business portraits, guys, and young girls. I think you get the idea. On the other hand, it's a great way to moisten lips as well as give a "juicy" look to many things. The secret lies in a little-used filter that's been with Photoshop over the long haul. In fact, it's used so little, you'd think they might have dumped it by now. This is how I use it to moisten lips and maybe even dampen the surface of a street:

1. Select the lip or lips you want to moisten using the Quick Mask mode at a 100 percent, and about an 85 percent Hardness Brush. Size the brush appropriately and paint over the lips.

2. Click the Standard Mode icon in the Toolbox and then press Cmd/Ctrl-I to invert the selection, then Cmd/Ctrl-J to lift it to a new layer.

3. Choose Filter→Artistic→Plastic Wrap. You'll see the Plastic Wrap dialog. Check the Preview box and lower the settings until the image looks interesting. It always produces an overdone effect for what we're trying to do, so don't throw up just yet. Instead, just click OK.

4. Immediately choose Edit→Fade. In the dialog, scrub the Opacity slider (probably all the way down to about 10 percent) until you like what you see. It should look something like Figure 8-19.

Figure 8-19. Moistened lips.

High- and low-key techniques for glamour shots

When it comes to getting a viewer's attention, it's all about the drama. One way to create this drama is to give the image a different look, such as deviating from the usual striving for a full range of brightness and just go for the brightest or darkest tones. Doing this also seems to set a definite mood. If you shoot RAW, I've already shown you how to get as high- or low-key as possible outside of Photoshop (see the "Using Camera Raw for Creating Effects" section in Chapter 4). Generally, though, you'll want to do some fine-tuning in Photoshop. And if you chose not to shoot RAW, you'll want to use similar adjustments in the Levels adjustment layer as you would have used in Camera Raw to at least get the tonalities in the image into the high-key "ballpark."

Now I'll explain the tricks you can use to get the same effects in your own images. Here's the step-by-step for a low-key rendition:

1. Make sure you output the image from Camera Raw using low- or high-key settings—see Chapter 4. You'll probably be more pleased with the end result because you're starting with all your tones in the right basket,

so to speak. Basically, what you want to do is lower the Exposure, then raise the brightness so that you can see more detail in the midtones. Don't raise the Brightness so much, however, that you loose the low-key effect. Drag the Shadow slider all the way to the left so you can see as much detail in the shadows as possible.

Figure 8-20. The workflow layers for the low-key image, before I renamed Layer 1 Skin Smooth.

2. Open your image in Photoshop and run the Workflow Layers Action. You can see the Workflow Layers and one I added as the Layers palette appears in Figure 8-20.

3. Optional: If there are any highlights in the background of the image that you don't want to be any brighter, use the Lasso tool to make a selection that fences them out, then feather the selection. This is more likely to be the case if you're working with a portrait than with a landscape.

4. In the Levels layer bar, click the Mask icon (which currently contains no mask). You'll see a frame appear around it. Now click the Mask icon at the bottom of the Layers palette and the selection you just made now masks the layer.

5. Double-click the Levels adjustment layer's Levels icon. The Levels dialog will open and the adjustments you make will be masked so they affect only the area within what was formerly your selection. The Histogram is probably pushed off the left end and hits the ground well ahead of the Highlights slider's arrow. Move that arrow to where the highlights start to rise significantly.

6. Smooth the skin as explained earlier in the "Smoothing skin" section of this chapter. Because the skin tones (or the midtones in another category of images, such as landscapes) are so much darker than normal, blemishes have a tendency to be especially noticeable.

7. Spot retouch as required.

8. Select the Levels command. There's already a mask in the Levels adjustment layer, but there's nothing in it. Select the mask (a frame appears around it when selected) and then use Edit→Fill and select Black from the menu in the dialog. There will almost always be areas of the image that have become too dark to show much detail. In this case, it's the area around the model's eyes. Burning and Dodging isn't really appropriate for these areas because you not only want to change the brightness of the area, but the contrast within it as well. There even will be times (this isn't one of them) when you want to change the color balance at the same time.

9. Choose the Brush tool, set the color to 100 percent white, set the Brush's Hardness to about 75 percent, and paint into the dark areas in

the image. It will appear that nothing is happening, but if you look at the Curves adjustment layer's mask, you'll start to see little white specs appearing where the mask should be.

10. Make a Curves adjustment that will brighten the eyes (or whatever else you want to brighten). Double-click the Curves layer icon, make sure the preview box is checked so you can see what's happening, and adjust your "too dark" areas to your liking.

11. Use the Burn and Dodge layers to adjust areas that are too dark.

Figure 8-21 shows the end result.

The high-key version of the same image will look like what you see in Figure 8-22 on the right.

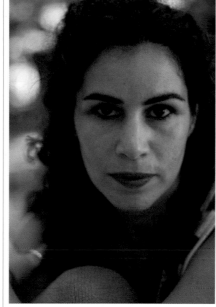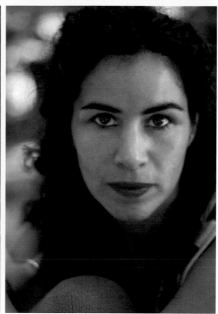

Figure 8-21. The portrait as it looked after modifying the low-key image as it came out of Camera Raw.

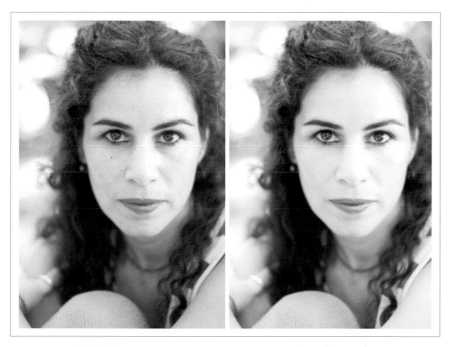

Figure 8-22. The high-key version of Osher's portrait on the right. On the left, you see the image as it looked straight out of Camera Raw.

Here are the steps that took me to that high-key image:

1. In Camera Raw, I dragged the Exposure slider as far to the right as I could without blocking any highlight in the skin tones. There are some blocked highlights in the background, but they seem to simply add to the atmosphere in the image.

2. In Photoshop, I ran the Workflow Layers Action. I immediately went to the Levels layer and dragged the Midtone slider to the right to brighten the skin tones even more. If you're starting here because you didn't have a RAW shot, use the Levels adjustment layer to get a high-key result similar to the one on the left of Figure 8-22.

3. I performed the smooth skin layer action.

4. I used the Burn and Dodge layer, mostly to take out the intense shadows under the eyes, but also to further lighten skin tones in the hand and shoulders and to darken the knee just enough to see some color and texture. I also burned to darken the color of her lips a bit.

5. I used the Curves layer for a gentle S-curve that raised overall contrast just a touch.

Using Multiply and Screen modes

Two favorite attention-getting tricks in photography, especially glamour, involve creating a high- or low-key version of the image, duplicating the layer, and then using Screen mode for a high-key result or Multiply mode for a low-key result. This technique is most useful when you want to lighten or darken the image without losing as much highlight and shadow detail as you would by simply using a Levels or Curves command. This technique works so well that I often simply use it instead of the adjustments. It also works extremely well when you want to brighten or darken only masked areas of the image. To lighten or darken the image using Screen or Multiply Blend Modes:

1. Select all the layers that make up the current version of the image and drag them to the New Layer icon. This will duplicate them and the duplicates will stay selected.

2. From the Layers palette menu, choose Merge Layers; now you now have a flattened version of the image as the top layer. If you want a higher-key version of the image, choose Screen from the Layers palette Blend menu. If you want a lower-key version of the image, choose Multiply from the Layers palette Blend menu. Figure 8-23 shows both effects on the same image.

Using Diffuse Glow Filter

One technique that has become almost too popular is the use of Photoshop's Diffuse Glow filter or third-party filters such as Andromeda's ScatterLight filter. I've seen it used to "define the style" for certain gallery and portrait artists.

Digital Photography Expert Techniques

Figure 8-23. The original image (left), with a Screened layer (middle), and with a Multiply layer (right).

> **NOTE**
>
> *There are a couple of ways to further adjust Multiply and Screen layers and they usually are used in conjunction with one another. You can interactively reduce the intensity of the effect by lowering the Opacity slider. To increase the intensity of the effect, drag the screened or multiplied layer to the New Layer icon in the Layers palette. This will double the intensity of the effect, so you'll probably need to use the Opacity slider.*

Portrait Enhancement Tips

The techniques for enhancing portraits are much the same as for glamour, but more realistic. Use the same techniques for smoothing skin and brightening eyes and teeth, but be careful to keep it realistic. Men, specifically, should look more "weathered" especially if they're in outdoor or sports businesses.

Re-lighting for emphasis

From a workflow point of view, lighting effects are more in a category of special effects than of retouching. There are several ways you can "re-light" a photo to make it more interesting, to make it stand out from the background, or to make it a more natural match when combined with other photos. Check out Chapter 9 for lighting methods suited to compositing and Chapter 10 for a number of lighting effects that are traditionally applied with special effects filters.

There's one useful re-lighting trick that can be done using the Burn and Dodge layer—or a "lighting" layer that is also a layer filled with 50% gray in Screen mode. Best of all, thanks to this gray layer technique, you can modify your results endlessly without any damage at all to the Background Layer (the original image).

The differences between these techniques and those done on the Burn and Dodge layer are that you'll be using a larger brush and often limiting your lighting effect by adding a selection or layer mask.

Earlier in the "Moistening, smoothing, and highlighting lips" section of this chapter we brightened lips in an image using a certain technique, which is really a junior version of something I call the Glow technique (see Figure 8-24). You can use it to give depth and a kind of shininess to almost any type of subject. Since glamour is one of my specialties, I'll show you how it's often done with a face—though the same technique could be used in a car or liquor ad.

Figure 8-24. A low-key portrait out of Camera Raw (left) and a glow stroke or two on a Burn and Dodge layer (right).

Here's all it took to produce that magical glow:

1. After you made the low-key interpretation of your RAW file, open it in Photoshop. If you must shoot JPEG, simply underexpose for about a stop and a half and then work a bit with Levels and Curves adjustment layers to get the dramatic tonalities you really want. In this instance, you see the result on the left in Figure 8-24.

2. Apply any necessary healing techniques on the Retouching layer in your Workflow layers.

3. Brush glows into place (may take a bit of practice); if there are large areas, such as the Highlights on the face that you really want to make glow, draw that area with the Pen tool (see Chapter 9). Edit the resulting path so that you have a very smooth-edged shape in which to center the glow.

4. Convert the path to a selection. Open the Paths palette and click the Make Selection icon. You have a selection. Choose Select→Feather and enter a moderately large number of pixels so that the glow blends smoothly. Press Cmd/Ctrl-H to hide the selection whenever you want to see what you've done, then press Cmd/Ctrl-H again to toggle it back on to position your brush.

5. Press D to make the color swatches turn to the default Black and White, then press X to make White the Foreground Color. Choose a large, soft brush and paint inside the feathered selection. If you feel you've overdone it, paint 50 percent gray back onto the Dodge and Burn layer and try lowering or raising the Brush Opacity and then do it again. Drop the selection (Cmd/Ctrl-D) when you're satisfied with what you've done in that area.

 If you want to make some other areas glow a little, try using a brush for smaller areas. Just be sure to undo quickly if you don't like the results of a stroke. Practice makes perfect.

Of course, you can easily do the same thing in reverse to bring up shadow areas in an image. It can be a good way to add mystery to the shot. The steps are the same, except you press X to change the Foreground color to black.

Killing eyeglass glare

People who wear eyeglasses can be tough to photograph in bright sunlight or with flash—especially on-camera flash. If you have a photo with glasses and there is hardly any detail, you may have to do a fair amount of hand-painting. If you can plan ahead, be sure to take several pictures of the person without their glasses and with their heads at different angles and tilts—there's a pretty good chance you can match up an eye from another

photograph. In the photo in Figure 8-25, the subject's left lens caught the reflection from a sunstruck window on the other side of the street. (Actually, that's bull. I made the reflection from a combination of filters because I didn't have any other shots I could use to demonstrate this process.) To correct eyeglass glare:

1. Place the photograph with the eye in it on a separate layer above the original layer. Temporarily reduce the transparency of that layer to around 50 percent. You're reducing transparency to scale and position the "replacement" eye.

2. Make sure the new layer is still selected and press Cmd/Ctrl-T. You'll see Transform handles appear on the corners and midpoints of a thin frame. Move the new layer so that the eye is positioned immediately above the flared eyeglass frame.

3. Drag a rectangular marquee around the area that contains the eye so that the frame leaves a fair amount of room around it. When it's in place, press Cmd/Ctrl-Shift-I to Invert Selection, then press Delete/Backspace. Since the eye layer contains little more than the eye, it won't take up a lot of extra memory and transformations will be much faster.

Figure 8-25. Luckily, I had the subject pose without his glasses, too. Good thing he wasn't driving the motorcycle.

4. Place the cursor just outside one of the corner handles. The cursor will turn into a curved, double-headed arrow. Rotate the eye so that it's in the same position as the eye that was flared out. Since the original eye is somewhat blocked by the flare, zoom out to make sure the position of the new eye has the proper orientation.

5. While the Transform marquee is still in place, proportionately scale the eye so that it matches the size of the original eye. Scale proportionately by pressing Shift and dragging a corner handle. You must be very precise about sizing the new eye to match the other eye, or the image will look downright scary.

6. Drag the Opacity slider until the new eye is the same brightness as the old. Remember, it's supposed to look like it's behind glass, so it shouldn't be as bright or as contrasty as it originally was.

7. Change the brightness and contrast of the new eye by using a Brightness/Contrast adjustment layer and Clipping Mask on the eye layer.

8. Blend the edges of the new eye with its new background. If you have one, use a pressure-sensitive tablet for this and check Shape Dynamics in the brush presets. This will let you interactively broaden or narrow your brush by varying the stylus pressure, so you can more easily shape the erasure. Be sure none or very little of the flare shows through. Figure 8-26 shows the end result.

Figure 8-26. The results of the steps taken above (right). Looks pretty natural, eh?

Punch out the paunch

Subjects will almost always want to see an image of perfection. For example, the subject in Figure 8-27 really wanted her picture to look more like the photo on the right. If there's even a hint of a chubby thigh, oversized derriere, or saggy upper arm, you're likely to have an unhappy subject.

Figure 8-27. From certain angles, especially using the wide-angle lenses that are so popular in fashion, certain parts of people appear to gain weight. On the right, the Liquify filter has been used to remove those extra pounds.

If you suspect that you'll be dealing with this problem, shoot your subject in the studio against a seamless backdrop using a knockout color. This way, you can easily knock out the subject's silhouette without having to worry about cloning in background. You can then use the Liquify filter to reshape the person's silhouette. If your shooting situation forces you on location, you can still use one of the more sophisticated knockout tools, such as Extract or the more versatile Corel Knockout 2. It will just take a bit more time and effort to clone the background over the parts that were formerly hidden by the subject's shape. That's what I did in the example shown in Figure 8-27.

Here's how to slim down your subject:

1. Decide how extensive the changes need to be. If just one small area needs work, clone it into a carefully made selection on the original layer. For a bigger job, you should start by duplicating the background layer and then using the Extract filter or one of the knockout plug-ins

(Ultimatte AdvantEdge and Corel Knockout 2 are my favorites) to isolate the subject onto its own layer.

2. Use the Pen tool to carefully outline the area(s) you want to whittle away from the body. Be sure you have the Paths option chosen in the Options bar. You want to draw a path that's outside the main shape of the body.

3. Convert the paths to selections by clicking the Convert to Path icon at the bottom of the Paths palette (see Figure 8-29). Save this path (Select→Save Selection) just in case you need it again in the future.

4. If the subject's edges were a bit soft in the original, you will want to keep them that way. Feather your selections just enough to soften the edges very slightly. Often, feathering by one pixel is enough.

5. If your subject is on its own layer, press Delete/Backspace. The contents of the selections will evaporate. If the subject wasn't knocked out of a plain background that you are substituting with another, keep the selection active to protect the subject and use the Clone Stamp tool to clone in the surrounding background details. Of course, the less detail filled the background, the easier this will be.

6. To "light" the edges you trimmed so they seem rounded rather than flat, recall your selections by choosing Select→Load Selection. If you're lighting with a highlight, brighten the selection on the shadow side. If you're lighting with a shadow, lighten the selections on the highlight side. Feather your selection enough to make the drop-off in lighting look natural, and use the Brightness/Contrast command to adjust the highlight or shadow edge's luminosity.

7. Fine-tune the edges of the lighting fall-off with the Dodge and Burn tool, since the edges of the lighting are likely to be a bit too regular.

You can't always plan ahead, but if you know you're going to have to do some trimming after shooting on a set or on location, try to remember to take a shot of the setting in the same light and at roughly the same time as you shot the model. Then, if you have a really tough time cloning in the background, you can just knock out the model and substitute the unpopulated background. If you are careful to adjust the brightness and color balance of both layers so that they look like they belong together, it should all look perfectly natural.

If it turns out that you don't need the saved paths after you've finished your retouching, it's a good idea to delete the channels to save file space. Open the Channels palette and drag the selection channels to the trash can at the bottom right.

Architecture Tips

Although you can buy (or rent) digital camera backs that will work on traditional view cameras, even most of today's pros are only able to afford DSLRs. So being able to correct perspective in-camera just isn't affordable. Neither is correcting the barrel distortion that tends to occur when lenses are zoomed in to accommodate the widest angle of view.

Lens correction

From a strict workflow standpoint, lens correction should be done at the same time as other full-screen special effects. Just make sure you duplicate your image file, flatten it, and copy it to the original image file on its own layer. That way the destructive processes that you're about to do will be on a separate layer. If you have to redo this, just throw out the layer that contains your last attempt, then duplicate, flatten, and copy again.

There are three facets to lens correction: perspective correction, pincushion, and barrel distortion. You can use Photoshop CS2's new Lens Distortion filter to correct all three—and more. You can remove any chromatic fringing that you didn't get in Camera Raw or that you haven't been able to clean our of a JPEG image. You can rid yourself of the vignetting that often occurs

Figure 8-28. You have to look closely, but in addition to the obvious perspective distortion that resulted from tilting up with a 28mm equivalent lens, there is a slight amount of barrel distortion and vignetting in the original image.

when you use very wide angle lenses—a common practice in architectural photography. You can also crop and resize your image to fit the original space. Figure 8-28 shows an image that has all these problems and the result of fixing it with the Lens Correction filter.

Here's how the corrections to Figure 8-29 were made:

1. After opening the image in Photoshop, and making other corrections, I duplicated, flattened, and copied the duplicate image. Then it was pasted into the original image, where it became a new layer, which is the target layer for this technique. Be sure it remains the selected layer for the remainder of this exercise.

2. I chose Filter→Distortion→Lens Correction. The result was the dialog you see in Figure 8-29. This dialog lets you combine a number of corrections that, before Photoshop CS2, had to be made with separate commands, interfaces, and even third-party filters.

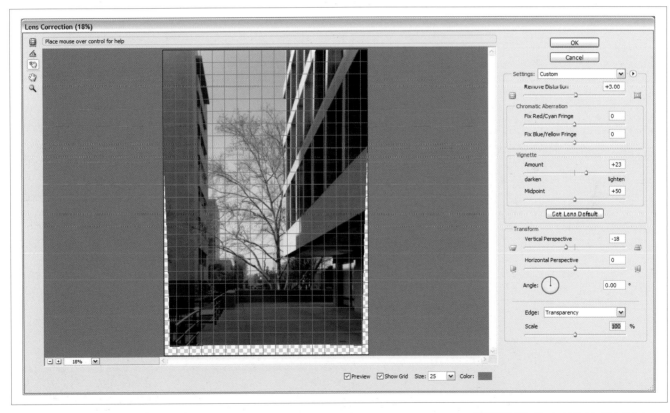

Figure 8-29. The Lens Correction dialog, as it appeared after all distortion corrections were made. As a finishing touch, you would want to correct any camera tilt with the Angle icon and drag the Scale slider to push any transparent areas outside the limits of the picture.

3. I removed the vignetting that is often caused by racking out a zoom lens to its widest angle. As is often the case with this type of image, the vignetting wasn't all that noticeable. But when removed, it makes a big improvement in the apparent quality of the image. I dragged the Vignette Amount slider to the right until the corners brightened

just enough. Be very careful not to overdo it or you'll have a reverse vignette.

4. The next easy correction is the barrel distortion that also happens when zoom lenses are zoomed out to wide angles. How much of this distortion exists will depend on the focal length of the zoom, the size of your image sensor, the aperture used (wider is more), and the quality (which often translates to cost) of the lens. In this case, you had to look at the grid to really judge the distortion. That's hard to do before you've corrected Horizontal and Vertical perspective (camera tilt and swing), but you can do it better on an image that hasn't already been distorted.

5. This image needed no horizontal correction, but there was noticeable keystoning of the vertical lines as a result of having to tilt the camera upward to get the right perspective. Once again, this adjustment is totally interactive—just drag the slider until you like what you see.

6. This photo was shot on a tripod with a level, so there was no side-to-side tilt. If the photo you want to correct does have side-to-side camera tilt, correct it by placing the cursor on the tip of the Angle dial and dragging until the image looks more or less level. This dial is a bit over-sensitive, so you have the option of typing an exact angle in the field to the immediate right of the Angle icon. Also, you'll have more control if, after clicking inside the icon, you keep the button down and drag your cursor some distance from the icon before you start dragging from one side to the other. You'll be able to make your adjustment with much higher resolution.

Vanishing Point

Vanishing Point is a new tool in Photoshop CS2 that allows you to magically clone in perspective so that, if you want, you can completely repaper a wall or repeatedly copy a window to a whole row or column (or both) of windows. Although it's another one of those programs within Photoshop, much like the Extract and Liquify Filters, Vanishing point is amazingly quick and easy to use. And, like those other filters, the way it works implies that you should do it later in the workflow process. Like Liquify and Extract, this program is covered in depth in the "Vanishing Point filter" section in Chapter 9.

Still Life Retouching Tips

In this chapter, I'll discuss only a few things that you might want to do to enhance the appearance of the objects in a still life. I'm going to show you a few techniques you should consider at this stage by using a simple still life of some pottery.

Adding water drops

Believe it or not, you can make water drops out of Photoshop even when you don't happen to have any glycerin around the studio. Frankly, I recommend glycerin because it's cheaper and faster. But I don't recommend putting glycerin on your computer. So here's the deal: draw some water drops in different shapes with the Pen tool and then turn them into a selection by clicking the Make Selection icon at the bottom of the Paths palette. Lift them to their own layer. Make another layer and fill it with a radial white-to-gray gradient, then use the Layer Styles icon to turn the water drop into three dimensions, with a glow on the highlight side and a translucent shadow on the opposite side. In Figure 8-30, you can see the water drop and the pen path, along with the Layer Styles palette and the settings used.

Figure 8-30. The Layer Styles palette and a water drop made with it. Be sure to use the same or similar settings as shown here.

Make a variety of water drops in different sizes and shapes. Make them about twice the size that you're ever likely to need them. That way, you won't have to remake the set because you'll always have enough resolution. Keep the water drops in their own layered file so if you need them, you can just open the file alongside the target image and drag their layers to the target image. If you're really wise, turn them into Smart Objects.

Then you can transform a single water drop in many different ways and do it completely nondestructively. Of course, you could do the same thing with bugs, butterflies, flower petals, confetti, etc. Many of those images are available as stock photos. Figure 8-31 shows the same product shot, before and after being covered with water drops.

The first water drop was placed by dragging the water drop layer shown in Figure 8-30. It was then transformed to the desired size and proportion and copied and placed a few times. All the water drop layers were then merged and the Opacity of the merged layer adjusted to about 40 percent.

Adding glow lighting

This technique is the same used in the "Re-lighting for emphasis" section earlier in the chapter. However, there's one more thing to add when it comes to still life images: put the glow inside a pen path made selection, just as I did on the model's shoulder earlier in this chapter. The reason is that the objects in still life photos are generally much less "organic" than other types of subject matter. The glow or shadow will look a bit unnatural if it also doesn't contain a geometric shape. Also, the brightest part of the highlights in geometric forms are usually very obvious and geometric, so either use the Fill command when you're putting white or paint onto the Burn and Dodge layer.

Adding lighting from behind translucent objects

This also follows the same technique as a glow, with some exceptions: if the translucent objects have a textured shape, you'll have to make selections to match each of the texture shapes. You'll have select any shapes that are inside the translucent object if that object is something like a glass of iced tea. Your best bet is to backlight the object when the picture is taken. Then you can add a bit of glow later if you like.

Figure 8-31. A photo of a glass of water decorated with handmade water drops.

Enhancements Later in the Workflow

Some of the things you're most likely to want to do to enhance still life or product photos will be found much later in the workflow due to their highly destructive nature. Simplifying the background is something you will likely do most frequently for still life photos. One of the primary reasons for shooting still life is to show a product and you won't want anything distracting from it. In fact, you usually don't want anything at all around that product. If you can't shoot it in a circumstance where you can set up a tabletop studio, perhaps the best option would be to simply knock it out.

If you have to do that for an object such as a teddy bear, it is best to use the Extract filter (see the "Using the Extract filter" section in Chapter 9). However, most products are machine-made and have very smooth and regular edges. I find it much easier to knock them out by using a vector path made with the Pen tool. In fact, even when it's not perfectly accurate, you can easily edit it by dragging the anchor points and re-adjusting the curve handles. Chapter 9 covers the use of the Pen tool pretty extensively, as well as shadow casting if you have to emulate a seamless edge or just want to make

the product look like it's actually sitting on something (see the "Lighting and Casting Shadows" section in Chapter 9).

Most of the work done for "retouching" scenic images is covered elsewhere in this book for workflow reasons (see the "Using Blend Modes on Regional Adjustment Layers" section in Chapter 7 and "Where to Find the Pieces for Your Collage or Montage" in Chapter 9). In those chapters, you'll learn to bring out detail, contrast, and to put skies and other elements into the image to "correct" the composition or to add interest to an otherwise empty landscape—or sky. The Vanishing Point filter, which can be very useful for doing things such as extending a grassy meadow over a pile of garbage, is covered in the "Vanishing Point filter" section in Chapter 9. Also, you'll want to make generous use of HDR images and the various techniques that can be employed to put them together. You'll find a technique for making an HDR image from multiple RAW exposures in the "Increasing Dynamic Range by Making Multiple RAW Renditions" section in Chapter 4. You'll also find HDR covered thoroughly in Chapter 11.

Collage and Montage 9

This chapter is all about compositing. Compositing, in the context of this book, is the art of montage and collage. Montage is "seamless" compositing that creates an image of a time, place, space, or person that never existed in reality. Collage is the art of putting together multiple images in such a way that their borders are obvious. I'll start with collage because it's such an easy process and illustrates so clearly the basis of compositing. Then I'll talk about techniques for making composites seamless, which is the art of montage.

Before we really get going I want to stress that, ethically, I only approve of montage techniques that are a matter of art or illustration. Montage techniques have no place in news publications, except where it is emphatically stated that they were created to illustrate an idea rather than fact. Figure 9-1 illustrates the difference between montage and collage.

Figure 9-1. The difference between a collage (left) and a montage (right). The collage is simply a collection of photos from the San Francisco Love Parade of 2005. The montage looks like a single photo, but the photo of the lady hula-hooper and the photo of the crowd were taken from different frames.

NOTE

You may think that montage is too time consuming or expensive to use very often. However, this art needs be no more complicated than adding clouds to a dull sky or placing some people or animals in the foreground of a scene to give it a better sense of context and place.

HOW THIS CHAPTER FITS THE WORKFLOW

The Whole Is Greater Than the Sum of Its Parts

As you probably guessed by now, a nondestructive image editing workflow—once you're past the image management, winnowing, and RAW adjustments stage—is all about layering techniques and organization. A big part of that organization is keeping the order of layers so that they are created bottom-up—from the least to most destructive. This chapter is about creating images that are pieced together from two or more separate photos—especially when the photos are combined in such a way to make the viewer think the photo is real. The practical applications range from illustration to creating locations that were previously out of reach. To keep your workflow nondestructive during this stage, be sure to make your composite a layer group above the background image. And be sure to keep each of your knockouts in its own layer group along with the layers for shadows and other effects.

Where to Find the Pieces for Your Collage or Montage

The problem with composites is that you don't always have immediate access to the photos that you need at the time the image is put together. And the trouble is other people's photos (as all pros know) can't be used for commercial purposes without express permission and probably some payment on your part. The first thing that comes to mind is stock photos. In the past, traditional stock agencies concentrated on the big money markets. That's fine if you're doing an ad that has a budget for stock photos. But what if you're just creating an illustration for an internal brochure or for an illustration on a small client's web site?

Collecting Your Own Stock Photos

In the course of your daily business, keep your eye out for objects and props that you could possibly use in your own stock photos. For one thing, you should take a photo of the sky every time it looks interesting. Collect all types of clouds, sunrise, and sunset shots. Shoot the sky every different seasons of the year. The most common use for montage is placing an interesting sky into a scene that was taken when you didn't have time to wait

for just the right time, season, and weather. You might also consider puppies, flying planes, flying birds, cyclists, skateboarders, and people viewing something.

Here are some guidelines for collecting your own stock:

- Try to shoot subjects against a contrasting and uncluttered background.

- Shoot in conditions that produce few, if any, shadows or reflections. It's much easier to add highlights and shadows to simulate the lighting that predominates in a background photo than eliminate them. This topic is covered in the "Lighting and Casting Shadows" section later in this chapter.

- Shoot the subject from several angles and distances. You will want to match angle and distance when you place the images in the target montage.

- Put the objects into their own category folders or "collections" and give them uniform category keywords so you can find them quickly when you need them.

Using Adobe Stock Photos

Adobe now includes its own stock photo library in Photoshop CS2 (and all other CS2 applications). Make sure your computer is online, open Bridge, and choose Edit→Search Adobe Stock Photos. Adobe represents most of the major commercial stock photo agencies and you can use a keyword to search through all of their libraries. Thumbnails appear in the window just as if they were on your own hard drive. Right-click on an image and you get an in-context menu to download a low-resolution comp of any image at no charge. The comp images aren't at a high enough resolution for commercial print purposes, but they're large enough to fill a full screen. So you could make a low-resolution image of your background photo and then incorporate the comp into it as a test before you commit to buying the photo.

Figure 9-2 shows how easy it is to search for stock photos in the Bridge interface. Now, the only problem is that if you're just looking for a bird to fly through your sky or a mouse to peer out of your kitchen cupboard you may find these prices to be more than you'd care to pay. On the other hand, if the alternative is to take the time to go make the photo yourself, you'll find most of these prices quite affordable. You can always check the price without having to go through a major process by highlighting the thumbnail of the image you're interested in and clicking the Get Price button. A dialog will appear that displays the full range of price information. If you want, you can even then download the photo right there on the spot.

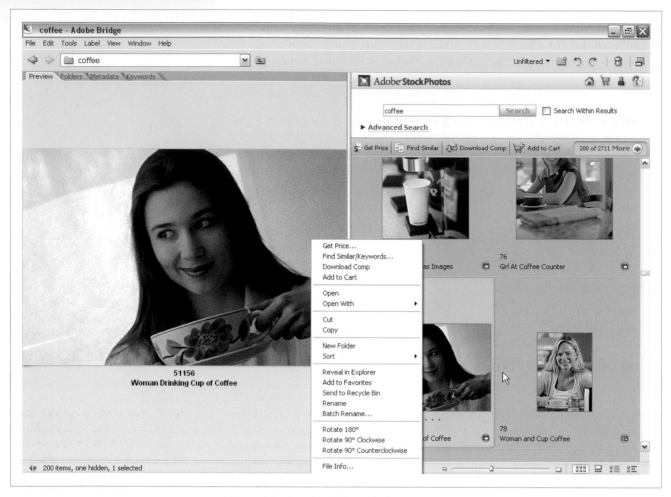

Figure 9-2. Browsing Adobe stock photos in Camera Raw.

There are also many very affordable—and sometimes, even free—stock agencies popping up on the scene. The following are some that I find very useful. These agencies are also good outlets for your own photos—especially those that would otherwise be surplus.

iStockphoto (www.istockphoto.com)

This large and heavily advertised stock agency charges between $1 and $20 for images, depending on their physical size. For most collage purposes, you'll be paying less than $5. O'Reilly authors often use iStockphoto when they simply don't have time to take the photo needed to illustrate a given point. (I may even resort to that myself before this book is done.)

Shutterstock (www.shutterstock.com)

This site has about half a million photos in all categories. You buy a subscription for a limited time and are then able to download as many images as you need. There is a limit, however, of 25 images on any given day.

Inmagine PhotoSubscribe (www.photosubscribe.com)

This is the subscription service for Inmagine, on of the largest stock agencies. There are numerous subscription plans, for example you can buy by collections, by the month, or by the year. There's also a collection of pre-knocked out images for lower prices so if you find the image you want, at least you won't have to spend the time doing the knockout work yourself.

Making a Collage

Putting individual pictures together in such a way that they create a feeling or tell a story is relatively easy. The main hurdle is collecting the photos you feel will tell that story. If you have to collect them from existing pictures, start by collecting as many as possible, then use Bridge to Light Table and winnow them. Pick the shots that do the most to tell the story you want to tell.

If you are photographing a scene to turn it into a collage, think in terms of long, medium, and close-up shots. You want have as many perspectives as possible. For example, if your collage was intended to be a poster of a farmer's market, it might help to include a long shot of the venue. That long shot might even become a background over which all the other photos are imposed. Then you want to photograph both the prepared and the freshly picked foods. And, of course, you want some of the colorful or well-known participants in this event.

Now you can start putting your collage together:

> **NOTE**
>
> *Before you make a collage, it's a good idea to make sure you've done all the workflow steps that image is going to require. Duplicate and flatten the original before bringing into the collage. Otherwise, you could end up with hundreds of layers in the composite photo.*

1. Decide roughly how many images wide and how many images high you want your collage to be. Then decide what the full resolution width and height of the collage will be. Divide that width and height by about two-thirds of the full-resolution. Then you will know how many images you'll need for the entire composition.

2. Assign a five-star rating on that number of images in Bridge. From Bridge's Unfiltered menu, choose Show 5 stars.

3. Add a keyword that designates the name of the poster. (This will make it easier to find the same collection of images should you move onto to Lightroom, Aperture, Capture One, or some other image management program.)

4. Open Photoshop and choose File→New. The New dialog opens. Enter the width and height you want your final project to be and then complete all the other entries as shown in Figure 9-3.

Figure 9-3. The New dialog for creating a new, black background for a collage.

5. Start putting together your collage. Go to Bridge; only your five-star images should be showing. Press Cmd/Ctrl-A to select all. Now scroll down to make sure you haven't also collected folders and unrelated files from other Adobe CS applications. If you have, press Cmd/Ctrl-click on each of the strays to take them out of the collection. Now press Return/Enter to open all the five-star files in Photoshop.

6. Drag each image onto the New background one at a time. The background will probably be larger than you want it to be, but that's a good thing—it's much better to maintain fidelity by scaling down. Choose the Move tool and drag the new layer to the approximate location where you want it to be.

7. Press Cmd/Ctrl-T. A Transform marquee will appear around your image. If you want to resize it proportionately, press Shift and drag a corner handle. If you want to rotate the image, place the cursor just outside a corner handle. When the cursor changes to a curved double-headed arrow, drag from side to side and watch it rotate. The further you drag from a corner, the more precisely you'll be able to rotate.

8. To crop the image, make a selection in the shape you want to fit it inside of. Then invert the selection (Cmd/Ctrl-Shift-I) and click the Mask icon at the bottom of the Layers palette. The layer mask is always a good idea

in this application because you can modify it to show more or less of the image once the whole composite is arranged. Also, it's very easy to make a new mask without having to reload a new image.

9. Repeat Steps 6–9 until all of your images are in place. If you want to hide one image behind another, go to the Layers palette and just drag its layer further down in the stack. You may have to do this several times to get all of the images in the right stacking order.

10. Since you usually want all the outside images to be direct attention to the center of the collage. Often, you can do that by flipping the image horizontally. To do that, choose Edit→Transform→Flip Horizontal.

> **NOTE**
>
> *If you do a lot of collages, you may want to use the Shape tools to cut out images in certain shapes. You can even invent your own shapes and draw them with the Pen tool or in Adobe Illustrator. If you do it in Illustrator, you'll have to import the shapes into Photoshop (see Photoshop Help if you don't know how to do that).*

Photoshop Features Especially Useful for Making Montages

Making montages can be much more complex than making collages because the bits and pieces of photos that make up the whole have to look as though they were all photographed in the same place and at the same time. That is, the angle of lighting of objects in the background photo has to match in the lighting of the imported objects. So does the color temperature, the perspective, and the angle of view of each imported object. To make matters worse, it is often impossible—or at least impractical—to find photos that are an exact match. This section will show you some Photoshop features that help you credibly fake the appearance of the matching photo. Especially notable among these features are the new Warp and Smart Object.

The Smart Object Advantage

Smart Object is a new feature in Photoshop CS2 that can go a long way toward minimizing the horrendous degree of destructive editing that traditionally occurs when combining photographs. The basic idea of the Smart Object is that one image can be used in multiple documents or places in the same document without ever really being there. The Smart Object is simply stored in its own file (which acquires a PSB extension) and mathematically referenced to as the needed changes in appearance happen when that image appears in another place. Moreover, there's no limit to the number of other places in which it can appear. You could, for instance, have a whole flock of birds flying across a sky in different sizes and rotational and

NOTE

Smart Object maintains this nondestructive editing capability as long as you don't change the bits in the image, which presently only can happen by converting the layer back into a bitmap or changing the original image's bitmap. Operations that can occur only on a rasterized or bitmapped image include most filter effects, painting on the image, and changing the adjustments in the image itself. However, when it comes to making adjustments or adding effects, you may be able to simply add a Blend Mode or adjustment layer to the Smart Object as a Clipping Layer, so that you don't have to affect the Smart Object itself.

transformational attitudes. Even after all this, nothing has really happened to the original image of the bird.

I know—it sounds too good to be true. Figure 9-4 shows one portion of one Smart Object that has been combined into a sort of supernatural kaleidoscope. All of the pieces of this kaleidoscopic image are layers derived from the same Smart Object.

Warping a smart object

Another new feature of CS2 that can have a positive impact on making composites (whether they be collage or montage) is a new Options Bar choice for Freeform Transformations that allows you to actually warp the shape of the image. Click the new Warp icon on the right side of the Options bar and you'll be switched to warp mode. You can see the Freeform Transform Options Bar in warp mode in Figure 9-4.

If you want the Smart Object to originate at the same size as its original image, just choose the original image and copy its contents to the clipboard. Then open the target image and paste (Cmd/Ctrl-V). Open the Layers palette, right-click on the pasted layer to show the in-context menu, and choose Group Into New Smart Object. Now, press Cmd/Ctrl-T to Transform the object and scale it to the size in which it will be used most often in the new image. The next two sections will show you how this image became a part of a completed montage.

Figure 9-4. Warping the Smart Object into the desired shape.

Making a Montage with a Warped Smart Object

In Figure 9-5 I put together several versions of the image on the left, resulting in the kaleidoscope on the right.

This is how you make a kaleidoscope montage:

1. Open the original of the image or images that you want to use as Smart Objects. This can be a Camera Raw image that you've opened in Photoshop, as long as it wasn't saved as a Photoshop file since the collage will reference the RAW image. Your collage will remember the Camera Raw settings that were used in the Smart Object.

2. Open the background image for your montage and paste in the clipboard image.

Figure 9-5. On the right, a kaleidoscopic montage made from four Smart Objects, all derived from the photo at left.

3. Go to the Layers palette and right click on the new layer. From the resulting in-context menu, choose Group into New Smart layer.

4. While the new layer is still selected, press Cmd/Ctrl-T to go into Free Transform. Scale the image to the size you want it to be by pressing Shift and dragging a corner handle.

5. Once the image is the right size, and while it's still in Transform mode, click the Warp mode icon. You'll now see a grid around the layer's image with 12 control handles. If you drag on any of these, a curve control handle will appear. In this instance, I dragged the handles into the positions you see in Figure 9-6. You can drag the curve control handle to stretch the image in the direction you drag it. Also, if you drag inside any of the nine grid sections you can warp that portion of the image

uniformly. In this example, I dragged the handles into the positions I wanted. When you like what you've done, press Return/Enter or click the Commit icon in the Options bar.

Figure 9-6. Drag the handles to your desired shape.

6. Copy this layer three more times. Use Free Transform to rotate each layer 90 degrees and then drag the result so that the foot of the branches is in the dead center of the image.

7. To create a background the normal way—by knocking it out—would force you to rasterize each layer. Rasterization would then disqualify it as a Smart Object. So, to work around that place each layer in a Blend Mode that causes the background to be revealed. In this example, Multiply works quite well.

Knockout Knockouts

One thing you must almost always do when adding objects to a background photo is to seamlessly remove the object from its background. Making believable knockouts is mostly a matter of knowing which selection tools to use and which technique to use for a given subject type. Table 9-1 gives you the basic guidelines to follow.

Table 9-1. Extraction Tool Guidelines

Subject type	Command or technique
Complex edges, e.g., flying hair, feathers, transparency	Extract filter or third-party knockout tool, such as Ultimatte AdvantEdge or onOne Mask Pro 3
Soft edges, transitional edges	Extract filter
Manufactured objects, fruit	Pen or Magnetic Pen tool
Large areas of solid color, such as skies and walls	Select→Select Color
Wiggly edges	Magnetic Lasso

> **NOTE**
>
> *If the knockout is a combination of the above subject types, you will need to use software such as the Photoshop Extract filter, Ultimatte Advantage, onOne Mask Pro 3, or Fluid Mask from Vertustech.com*

Manual knockouts and transitional edges

If the edges are smooth and geometric, you want your selection edges to be equally smooth and geometric. To select these edges, especially for a knockout, you should use the Pen tool as much as possible. You're probably already aware that the Pen tool draws geometric shapes called vector curves. These originated in drawing programs. Not only do they draw perfectly smooth edges, but these forms can be edited quickly and with a great deal of precision. They can also be stored with the file and in far less memory than the bitmapped edges formed with any of the selection tools, such as the Lasso. Figure 9-7 shows a selection drawn around a manufactured object and the resultant knockouts.

Figure 9-7. The selection on the left was made with the Pen tool. Note that this path can be easily and precisely reshaped by dragging either the control points or the curve handles. At right is the resultant knockout and montage.

Here are the steps taken to make this selection:

1. Choose the Freeform Pen tool from the Pen tools menu. In its Options bar, check the Magnetic box. Click the inverted arrow just to the right of the shape icons and choose the Freeform Pen options shown in Figure 9-8. Also, make sure the Add mode is checked.

2. Drag carefully along the edge of the shape you want to select. Absolute precision isn't necessary at this point and speed is essential. On the other hand, don't be blatantly sloppy. Be sure to close the path.

3. Zoom in to 100 percent and then use the Hand tool to follow the path. Choose the Select Path (white) arrow just above the Pen tool and click on the path so that you can see the control points. Use the white Direct

Selection tool to select and drag a point you want to move. When you do, its control handles will appear, protruding on either side of its anchor points. Drag the anchor points to align the path with the edge you are selecting. Then use the control points to shape the curve (see Figure 9-9).

Figure 9-8. The fit resolution options for the Magnetic Pen tool.

Figure 9-9. A close up of the curve path showing anchor points and control handles.

4. You may need to edit some of the points. If you have too many points, you can remove the extras by choosing the Subtract Point Pen (it has a minus sign next to its icon) and clicking on the unwanted point. If you want to make a corner point from a curve point, choose the Convert Point tool and click the point. If you use the Convert Point tool to click and drag on a point, a new Control Handle will appear in the direction you are dragging.

5. Make sure the Paths palette is open and save the path (from the Paths palette menu, choose Save Path). When the dialog opens, enter a name for this path.

6. Convert the path to a selection and feather it slightly so that you'll have an edge that blends with the image you are going to composite it into. If it's a hard-edged object like the one in Figure 9-9, keep the feathering to a small number of pixels. Depending on the overall size of the item, 1–5 pixels should do.

7. Invert the selection (Cmd/Ctrl-Shift-I) and press Delete/Backspace. The image outside the selection is now transparent. Save your image. When

you want to place it into an image, open your knockout image at the same time. Press Cmd/Ctrl-A to select all, then Cmd/Ctrl-C to copy it. Activate the target image's window and press Cmd/Ctrl-V to paste it into place. See the section "Matching a Knockout to Its Background" later in this chapter for instructions on sizing, lighting, and shadow casting.

> **NOTE**
>
> *Sometimes you'll have an object that is transparent or semi-transparent inside its boundaries. You'll have the most control over the blending and shape of this transparency if you add a blank mask to your knockout layer after the knockout has been placed into the target image. Use the Magic Wand to select the transparent area in the layer and click the Mask icon. Your shape will be masked. Now select the mask (a frame appears around the mask in the Layers palette) and use the Brush tool to paint white inside the mask as appropriate. You will get as much transparency as the opacity of the white paint you use allows.*

Regardless of the technique used, if the surface of what you knockout is even slightly reflective, you will probably have some traces of the original background color around the edges. This reflected color is easily eliminated. Choose the Brush tool and choose Color from the Options bar's Mode menu. Go to the Layers palette and click the Lock Transparency icon. Press Opt/Alt to momentarily convert the Brush to an Eyedropper and click in an untinted portion of the item to pick up its color. Now, just brush over the reflected color from the old background. When you place the same knockout into a target image, you can do that same thing, but this time pick up the color from the layer that will be the background image. You can see the result of the re-coloring in Figure 9-10.

Using the Extract filter

The images that are really tough to knockout are those that are in a complex background, have highly irregular edges (flying hair), or very soft edges (semi-transparent or blurs). Fortunately, Photoshop 7+ comes with a tool called the Extract filter, which improves with every new edition of Photoshop. It's not the most sophisticated of the knockout tools, but you don't have to pay extra for it. And most of the time, with a little practice, you can do a credible job of making the knockout. The lady

Figure 9-10. This cutout was made with the help of one of the Frames Custom Shape tools. You could also use Layer Style to bevel the edges of shapes and to cast shadows.

with the hula-hoop in Figure 9-11 was knocked out with the Extract filter. Figure 9-12 shows you the original image and the resultant knockout. To do this:

1. Open the image you want to knockout and immediately choose Image Duplicate. There's no hot-key for this, so make yourself an Action to do this and then assign that Action a hot-key that you're not using for anything else. You should always duplicate any image that you're going to do very destructive things to so that you can use the messed-up image as a layer without destroying the original.

2. Since the Extract tool won't extract from the background layer of an image, in the Layers palette, double-click the background layer of the duplicated image. When the New Layer dialog appears, enter knockout and the subject name as the name of the new layer.

Figure 9-11. The subject was knocked out with the Extract filter.

3. Make sure the Knockout layer is still selected and then choose Filter→ Extract. The Extract dialog shown in Figure 9-12 appears. Double-click the Zoom tool to make the preview window show the image at full (1:1) resolution.

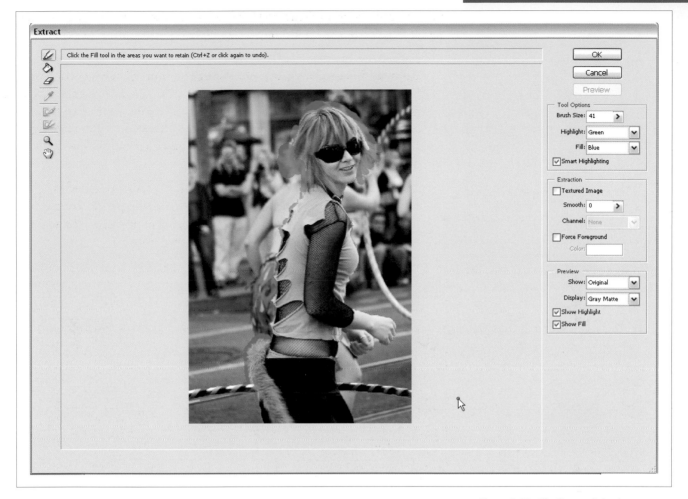

Figure 9-12. The Extract dialog box.

4. Choose the Highlighter tool (aka the marker) and make the brush size large enough to cover the flying hair while keeping one-third or less of the marker color inside the portion of the image that should be kept. You should always follow this one-third rule when selecting "transitional" (fuzzy or fly-away) edges. Pan around so that you cover all those transitional edges first. Once you've done that, make the brush size just large enough (press the square bracket keys: [to get a smaller brush and] to make it larger) to cover any slightly fuzzy edges and check the Smart Highlighting box.

5. Choose Gray Matte from the Display Menu in the Preview Options. This will temporarily place a neutral gray background behind the preview image so that you can more easily see what edge corrections need to be made.

6. Choose the Fill (bucket) tool and click inside the Highlighter selection. It will fill with blue. If the blue fills the entire image, you have a space in your Marker selection. Simply zoom in to 1:1, press the spacebar to pan, and pan around until you find the gap(s). Then use the Marker to fill

them in. Then use the Fill tool again. Repeat until only the area inside the marker is filled with blue.

7. Click the Preview button. You will see Figure 9-13, which clearly shows the goofs made by the Marker selection. You can either try a new Marker selection or use the cleanup tools. The cleanup tools are those that have a tool in front of a Mask icon. The Brush cleanup tool erases edges with some intelligence. Press Opt/Alt to make it replace instead of erase. The Marker cleanup tool smooths and cleans up edges. It either does a great job or really messes things up. If it's the latter, quickly press Cmd/Ctrl-Z to undo and use the Brush cleanup tool.

When you're cleaning up edges, it really helps to switch background colors. Then you can see all the colors that need cleaning up, whereas grays may not be visible against gray, etc.

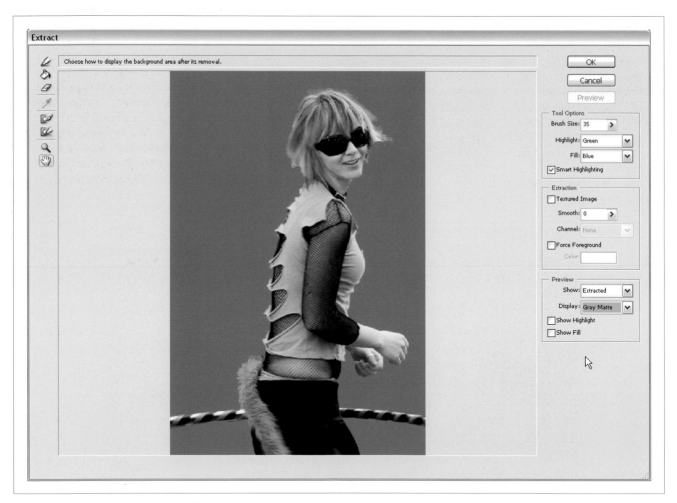

Figure 9-13. Extract in Preview mode, so you can easily see what needs cleaning up.

8. Once you've finished your cleanup, click the OK button. You see the result in the righthand image in Figure 9-11.

Third-Party Compositing Tools

There are a couple of tools that make parts of the compositing process much easier.

The first tool, onOne Mask Pro, originally made by Extensis, was recently acquired by onOne. Mask Pro is a third-party plug-in for Photoshop that does quite a good job of knocking out both smooth and fuzzy-edged images. Available for both Mac (Universal code yet to come) and PC at a reasonable $199.95, it is quite versatile for its price. If you've lit the background evenly enough and in such a way as to minimize reflections, you can knockout almost anything in a totally realistic way.

There are two main tools for designating what should be kept and what should be thrown away: Marker and Eyedropper. The Eyedropper tool is best used when you have a plain-colored background. You simply click the three or four most different shades in the background and foreground. You then use a Magic Brush tool to remove all the colors that should be thrown out. It's an excellent tool for removing a colored background from a portrait or a furry animal. You can see in Figure 9-14 how well it separated the teen model's hair from the background. The beauty of this technique is that, because you don't brush inside the object to be kept, there's no chance of knocking out details that are the same color as the background.

The Marker tool works best when you have a complex background and object that contain many colors. It's similar to the technique used in the Extract tool. Use the Green Marker to designate the area to be deleted and the Orange Marker to designate the area that will be kept. You then use the Magic Bucket to click in the area that will be knocked out. As you can see in the toolbox in Figure 9-14, there are also numerous tools for cleanup. To find out more, go to *www.ononesoftware.com*.

The second tool is Ultimatte AdvantEdge, which is designed strictly for removing matte green and matte blue (aka green screen and blue screen) backgrounds. You have to shoot in a studio to use these backgrounds. The other piece of bad news is the cost of this plug-in: $1,495. That's roughly twice the price of Photoshop CS2 at full retail. Yet an amazing number of pros buy this package. Why? Because it does a perfect or near-perfect job of knocking out even the most complex images from their backgrounds. Furthermore, you can do it in seconds. Pretty much all you have to do is open the image you want to knock out in the plug-in, click once on the background, click a button telling the program to process, and then watch for a miracle. To find out more, go to *www.ultimatte.com*.

Figure 9-14. The onOne Mask Pro interface showing a portrait that is being knocked out with the Eyedropper and Magic Brush tools.

Using the Select Color command

When you want to knockout a solid color background but you're having trouble getting exactly what you want from the programs mentioned above, give the Select Color command a try. It's right in Photoshop and won't cost you a penny extra. The main secret to getting what you want is learning how to judge the setting of the Fuzziness slider. Find a photograph that has been taken against a reasonably solid color background and open it in Photoshop. Then:

1. Choose Select→Color Range. The Color range dialog, shown in Figure 9-15, will appear.

Figure 9-15. You can see that the main portion of the selection is well defined, although you'll want to use Quick Mask Mode after the selection is made to "paint over" details inside the selection that you don't want selected.

2. Choose the method of color selection you want to use from the Select menu. I don't have room to show you that menu here, but your choices are: Sampled Colors; any of the primary RGB colors or their complements, highlights, midtones, or shadows; and Out of Gamut. For making knockouts from solid color backgrounds or taking out monotone skies, the best choice is usually Sampled Colors.

3. Choose Quick Mask from the Selection Preview menu. You'll now be able to see exactly what is selected when you drag the Fuzziness slider. You'll also see the orange quick mask superimposed over your image.

4. If, in the preview window, you still see areas of color that haven't been selected, choose the + Eyedropper and click on those colors until everything you want is selected.

5. Drag the Fuzziness slider as far to the right as you can without letting the Quick Mask cover any of the image that you want to knock out. The most important thing is to get the edges right. You can always fix the Quick Mask after the fact, as I'll show you in a second.

6. When you have the Fuzziness and the selected colors just right, click the OK button.

7. You'll see a selection marquee appear on your image. You will probably want to mask some of the interior details in this selection, so click the Quick Mask icon in the Toolbox. The orange mask will re-appear on the image. Press D to make sure your foreground color is pure black and the background colors is pure white.

8. Choose the Brush tool and set its Opacity at 100 percent and its Blend Mode to Normal and paint over any interior details that aren't fully masked. If the image you're masking is as geometric as our example, you can just make a selection inside its boundaries the then choose Edit ›Fill ›Black. In Figure 9 16, you can see what the fully masked image looks like in Quick Mask mode and what the resulting knockout looks like.

9. Save your knockout, duplicate it, and drag the duplicate into a layer in your composite image.

Figure 9-16. Using Quick Mask mode to knock out this building.

Matching a Knockout to Its Background

Hopefully, you have already collected the images you're going to include over the background image in your composite. Of course, if it's a collage, matching the background is probably pretty easy. In all likelihood, you won't even see a background. If you do, just make sure it's a color that flatters the images you're pasting on top it. Also, make sure it's not lit or patterned in such a way that it detracts from the images, rather than enhancing them. Since that sort of thing is always very subjective, it's hard to give you more specific advice than that.

On the other hand, if you're making a montage, there are lots of "gotchas" to pay attention to if you expect your end result to really look as though the photo actually happened, rather than being cut and pasted together.

Matching Exposure and Color Balance

The first thing you want to do is open the images at the same time and match exposure (brightness and contrast) and color balance. Here are the steps for this stage of the workflow. It may seem strange, but you'll want to do all the above-mentioned adjustments within the image. So just start by dropping each image and its layers onto your background image.

1. Go to the Layers palette and place it right alongside your composite image. Double-click the Hand tool to make the image fill as much of the screen as possible so that you can easily distinguish one image from the other.

2. Name each layer for the subject of its knockout. This ID process is important because you will be doing a lot of work with layers and layer groups in this compositing workflow. So you want to be able to easily find the objects you're looking for. Also, you're going to be attaching a number of other layers to each of these images and you want to group all those layers so they can be easily identified and changed as the client requests.

3. Make your color balance and exposure adjustments. To keep complexity to a minimum and to save space, try doing all of this with Levels adjustment layer. Be sure you attach each of these adjustment layers to their respective images with a Clipping Mask (right-click on the layer and choose Make Clipping Mask). You'll find the recommended Levels routine in the "Levels for Shadow, Highlight, and Overall Brightness" section in Chapter 6. At the end of that routine, don't go back to the color layers to adjust color balance until you've made the initial exposure adjustments for all the images.

4. Adjust the Levels for all the channels, the RGB channel, and overall brightness for all the images, then go back to the Levels adjustment layer for each image. Double-click the Adjustment icon and the Levels

dialog will appear for each image. From the Channel Menu, choose the channel whose color will contribute the most to correcting the color balance to most closely match what you want as the overall color balance for your composite image. In other words, you want the color balance of your knockouts to match that of the background image. (If you're making a collage, you'll want the color balance of the images to match one another. However, the easiest way to do that is to use one image as the image to which you want to match all others.)

WARNING

Don't use the Match Color command for this job. More often than not, you'll be very unhappy with the results.

5. Repeat the step above for each of the other images.

6. Match exposure for all the images. You've already pretty much done that with the Levels adjustment layer by adjusting the Midtone slider in the RGB channel. However, you may need to have control over contrast in some areas of the brightness range, so add a Curves layer to those images that need it. Be sure to use a Clipping Mask on that layer to attach it to only the specific image you're adjusting. Make the Curves adjustments as you've been instructed in the "Curves for Adjusting Contrast in Specific Brightness Areas" section in Chapter 6.

7. Repeat the step above for each of the other images.

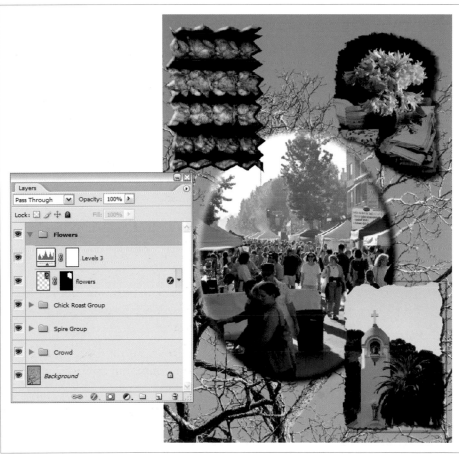

Figure 9-17. Because it's a collage, it's easy to exaggerate the effects and to show what layer effects do for a collage. In a montage, the subject matter, scale, and edge blending would be the only differences.

Figure 9-17 shows how the layer structure looks at this stage of the workflow—not taking into account any other layers you might have created in making each of these images before they were included in the composite.

Lighting and Casting Shadows

One of the hardest things to keep consistent between imported objects and the background photo is the hardness/softness of shadow edges and the predominant directions of primary and secondary lighting. If you're lucky enough to have the time to specifically shoot the objects you'll be importing or to specify assigning them to others, make sure the photographer knows the time of day, year, and location that the background photo was made. The photographer or his assignee should also take along a copy of the background photo when shooting objects to be added. That way, you can at least position the subject in regard to the lighting, put up a scrim if the light needs softening, or move the subject into the shade if the original was taken on a cloudy day.

Back to reality. All too often, it's just impossible to control all those elements when the picture was shot. So what you have to do is to imitate lighting and perspective in Photoshop. Following are some steps that will be helpful in most instances:

- Shoot the incoming photos in flat lighting as much as possible. That is, in the shade or on a cloudy day. If you have the time and the manpower, it's also a good idea to use a soft reflector so that there are no deep shadows.

- Take the photo from the same distance and angle at which it will be seen in the photo.

- Create a new layer above the imported object, fill it with 50 percent gray (Edit→Fill→50 percent gray), then change the Blend Mode of the gray layer to Overlay, then add highlights by painting in white on the gray layer. Add shadows by painting in black on the gray layer. Experiment with the softness of the brush and the Opacity of the paint to create a believable intensity of highlights and shadows.

- To correct perspective (it only works if the photo was shot at something at least close to the right distance and angle), select the layer for the incoming object and then choose Filter→Distort→Lens Correction. The Lens Correction dialog performs many tricks to correct lens distortion. All you want to do at this point is to fool with the Vertical Perspective and Horizontal Perspective sliders and the Angle dial (to rotate the image as needed). The sliders are rather self-explanatory, but you should know that the further you drag the cursor away from the angle ring after click on the approximate angle, the easier it will be to change the angle in precise increments.

Fixing Focus

There will be times (but definitely not always) when you want to change the focus in the background image in a montage to approximate a more shallow

depth of field. Doing so tends to emphasize the subject and is especially useful if you're placing a head shot against a new background. Figure 9-18 illustrates that point.

If the subject is grounded (appears to be standing or resting on a flat surface) or appears to be near another object that will be in sharp focus, you will definitely want to use the Lens Blur filter (Filter→Blur→Lens Blur). The Lens Blur filter allows you to simulate depth of field by keeping the area nearest the subject in sharp focus while blurring the objects that are far away from the subject considerably more. Figure 9-18 shows the result of using the lens blur filter on a composited object.

Figure 9-18. A montage using depth of field simulated by the Lens Blur filter. Notice that objects closer to the model are in sharper focus than those far away. On the left, the image as it would have appeared without the Lens Blur filter.

Here's how to use the Lens Blur filter to blur the background:

1. Make your knockout and place it in the background image.

2. Light the knockout to match the lighting in the background image, as instructed in the previous section.

3. Make an alpha mask that protects the areas you want to keep sharp and then "graduates" to the area(s) that you want to blur. You can skip this step if nothing in the picture is on the same plane as the subject. For instance, in a head shot you rarely see any part of the model touching the objects in the background.

4. Make a new layer at the top of the layer stack. Make a selection of the areas that you want to keep in focus. Then feather the selection (Selection→Feather) so that it graduates from black to clear over as much distance as it's going to take to keep the nearer objects relatively sharp compare to the farthest objects. The area in which the farthest objects reside should be pure black. In this image, I also used black and gray paint to paint over areas that weren't in the primary plane of focus, such as the leaves overhead and the park bench. The park bench is medium gray to ensure that it wouldn't be as out of focus as more distant objects.

Figure 9-19. This focus mask was painted onto a new, transparent layer after the knockout image had been placed.

5. When you've finished painting the mask, turn off all the other layers and select the entire image (Cmd/Ctrl-A). Open the Channels palette and click the New Channel icon. A new channel, titled Alpha 1 will appear. Name this channel Lens Blur. While it's still selected, press Cmd/Ctrl-V to paste the mask into the channel. You can see the resultant mask as it looked over the background in Figure 9-19.

Notice that in Figure 9-19, I also painted a little spot of black at the bottom of the image. I'd have done the same at the top of the image, but the need to mask the leaves would have hidden the spot. If there's nothing but transparency at the top and bottom of the layer, the mask will be centered in the alpha channel when you paste it in. Once it's pasted in, simply use the Eraser tool to remove the black spots.

6. Make sure the background image's layer is selected. This is where you use the Lens Blur filter. Choose Filter→Blur→Lens Blur. The Lens Blur dialog appears, as seen in Figure 9-20.

7. Choose Alpha 1 from the Source menu and click the More Accurate radio button. The Hexagon Shape usually imitates the diaphragm shape in most DSLR and 35mm cameras. Set the Blur Radius for the amount of blur you want to have. Click the Gaussian radio button. Once you've done all that, just click the OK button. You can see the result at the beginning of this exercise in Figure 9-18.

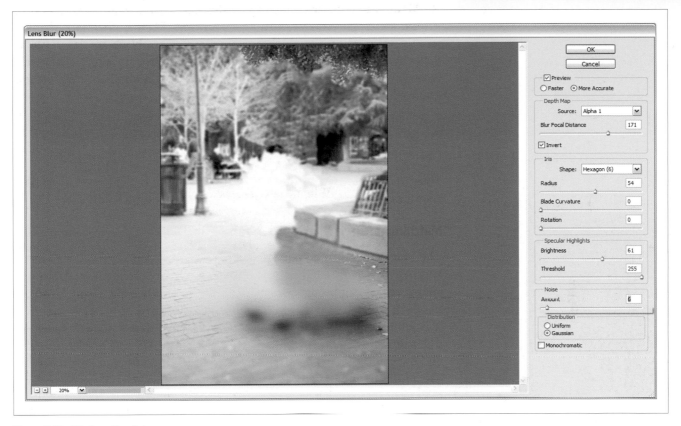

Figure 9-20. The Lens Blur dialog.

Matching Perspective

Matching the point of view and distance from which the background image and the knockout(s) were shot is best done at the time of shooting, especially if the knockout object is three-dimensional. If you have the opportunity to do this, make sure you have approval on the background image first and make yourself a print of same. If you're good at searching the stock sites and your own library of images, you should be able to tell whether you've found knockout objects that will look natural in the background setting.

I once assisted a photographer who wanted to shoot a proposal for a series of car ads. We could rent the car for long enough to get a number of shots of it, but didn't have the budget to take it on location with us. So we took along my car. In every location where we wanted to show the car that would be in the ad, we took a shot of the scenery with my old junker in place of the shiny, sexy new car. Then I drove my car out of the scene and we reshot it without the car. So when we rented the car, all we had to do was take it to an empty baseball stadium parking lot. We held up the print of the scene with my car in it and then positioned the camera in respect to the new car so that we'd be shooting it from the same distance and angle and at

approximately the same time of day. The end result was so believable that the agency simply paid for the finished product and ran the ads pretty much as they were shot and processed. We also ended up getting several other assignments from the same agency for fashion shoots in which the desired location was too remote to make it affordable to send an entire crew and group of models there.

If you simply can't do all that, at least you can do some perspective matching by using either one of two Photoshop tools—Free Transform and Lens Correction filter.

You can also match the perspective of flat or nearly flat objects such as floor tiles, mirrors, pictures, or grass by using the Vanishing Point filter.

Matching perspective with Free Transform

The Free Transform command (Cmd/Ctrl-T) is the easy way to give perspective to a flat object on a layer. I find it especially useful for playing a very simple trick: simulating a seamless background when there was no studio handy. The photograph of Kashi Stone modeling one of her famous outfits was photographed outdoors on a grassy Marin County hillside. Later, we did a series of shoots on white backdrops, but Kashi was too busy sewing and fitting models to take part. So I used the Extract filter to knock her out. Then I did the following:

1. Created a new, empty layer beneath the Knockout layer.

2. Made a rectangular selection and feathered it by 70 pixels so that it would gradiate from white to gray to white. I filled the rectangle with light gray then dragged the selection to the next position (making sure the New Selection Icon was selected in the Options bar) with the Rectangular Selection tool and filled it again until I had what looked like a striped background or curtain (see Figure 9-21).

3. Once all the stripes were made, I made a new Rectangular selection that covered the bottom portion of the image. I then feathered that selection by 100 pixels so that the stripes would "bend" when I transformed the rectangle to make a perspective transformation.

 To make this transformation, you will need some space all around the image. Double-click the Hand tool to fill the screen with the image window. Choose the Zoom tool, press Opt/Alt and click in the center of the image. Each time you click, the image will become progressively smaller until you have all the room you need. You can also drag the corner of the window so you have more room from side to side.

4. To make the perspective transformation, all I needed to do was press Cmd/Ctrl-T, then press Cmd/Ctrl and drag each of the corner rectangles directly out to the side and equidistant from the original position.

5. I wanted to "light" the background so that Kashi actually looked like she was standing there and so that the part of the background that was on the floor was slightly darker. I created a new layer above the background layer, made another feathered rectangular selection, filled it with a light gray, and then used the Multiply Blend Mode so that the layer below would show through.

6. I needed to "anchor" Kashi with a shadow. I made a new layer, made a freehand selection under her feet, feathered it by 120 pixels, and filled it with a 35 percent gray. I then changed that layer to Multiply mode. I also used Free Transform to stretch the right side of the shadow so that it was cast further to the right than to the left. Finally, I used the Burn tool to really darken the areas immediately under her foot and the coat.

> **NOTE**
>
> *An excellent way to make non-seamless walls and floors is to use the Patch tool. Just make a selection around the edges that should be seamless and then move it onto the floor. This technique works best when the patterns in the floor and wall aren't too pronounced or too different from one another.*

Figure 9-21. You can see how the selection rectangle feathers and how the Transform marquee takes it into account. A variation on this technique could also be done with Vanishing Point.

Lens Correction filter

This filter is discussed a bit more in the "Lens correction" section in Chapter 8. It's perfect for correcting any tilts you might have forgotten to correct in Camera Raw, for getting rid of vignettes and lens distortion, and

for correcting the overall perspective. I particularly like the way it lets you correct perspective by rotating the image both left and right and top to bottom, which allows you to visually fine-tune the results. Another use is for creating backdrops. In Figure 9-22, I created a wall on one layer and the floor on another and used the Lens Correction filter to position the wall and floor in separate operations.

Figure 9-22. The back wall and the floor were from separate photographs and perspective-corrected with the lens distortion filter. The floor then needed further perspective correction using Free Transform.

Vanishing Point filter

Vanishing Point is one of the coolest new features in Photoshop CS2. It is especially useful for architectural photography and cleaning up flat surfaces. It is also great at letting you redecorate by adding new doors, windows, or paintings—all in perfect perspective. Figure 9-23 shows the before and after of one such situation. Pay attention to the workflow, this feature is anything but intuitive. Figure 9-24 shows you the images I started with and the image I ended with. Obviously, I was just fooling around to make a point. I'll leave it up to you to do the serious stuff.

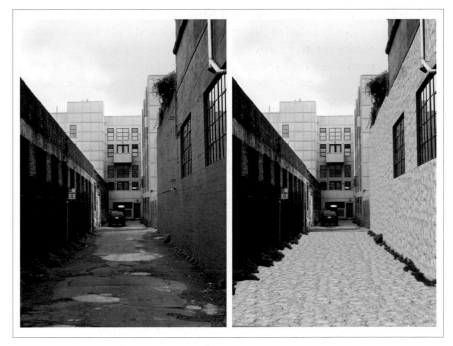

Figure 9-23. On the right, you see this alleyway as it has been "bricked" in Vanishing Point.

Vanishing Point works by having you set a perspective grid for all the flat surfaces in your image into which you're going to place perspective.

- If you want to do that according to the workflow laws set by yours truly, first duplicate and flatten the background image. If you don't do that, you'll find this process unrecoverably destructive.

- Minimize the destruction by putting the Vanishing Point stuff on its own layer. So as soon as you've duplicated and flattened the image (and closed the original image so you don't accidentally overwrite it), open the Layers palette and click the New Layer icon. A new blank layer will appear.

- If you're going to "perspectivize" an image from an outside source, open it, duplicate it, then flatten and re-size the duplicate so that it's close to being the size in the final image. Also, if that object is a flat object (that's the only kind that will work) that was photographed from an angle, use Lens Correction to correct its perspective. Once you've done all that, press Cmd/Ctrl-A to select all, Cmd/Ctrl-C to copy it to the clipboard.

- If your target image will use outside images in this effect, you'll have to open them in a separate window, select the portion of the image you want to use, and copy it to the clipboard (Cmd/Ctrl-C). Be sure you don't do anything to replace that image in the clipboard before you're ready to use it. Just in case you do, keep that image open so that you can repeat pasting it to the clipboard if you need to.

Whew! Alrighty! We're finally actually ready to use Vanishing Point. Make sure the new layer is the one selected, not the background layer. What you see should be the background image, the Layers palette and the image you're going to use to surface a portion of the background image.

1. Open the image you're going to use on the surface of the background image. Press Cmd/Ctrl-C to copy it to the clipboard.

2. Choose Filter→Vanishing Point. You'll see the image in the Vanishing Point interface, shown in Figure 9-24, except the perspective grid won't be in place.

Figure 9-24. The image in the Vanishing Point interface.

3. Choose the Create Plane tool in the toolbox. It looks like a perspective grid. You're going to draw a perspective grid that looks like the one in Figure 9-25. Click to set the first point, drag to set the next corner, then the next. In this image, I used the four corners of the window to keep the perspective correct. If you make a mistake, *do not* press Esc! It'll just drop everything you've done up to that point and return you to the original image.

4. If you've laid out the original plane properly, it'll be blue. If it's not geometrically correct, it'll be red. Use the Edit Plane tool (arrow) to move the corner points until the grid is suddenly blue.

5. Stretch the grid up the gray wall on the right. Just grab the center right handle and pull it up the wall. When you get to the edge of the image, change the direction of the grid to lie flat along the white part of the image that contains the incoming picture(s). Then, go back and stretch the bottom of the grid straight out until it reaches the bottom of the image.

6. Press Cmd/Ctrl-V once the Grid is in place. The image you're using to resurface your image will appear. Be sure to place it in an area of the image that you're not resurfacing. The image will be selected as soon as you paste it. Press Opt/Alt and drag the contents of the selection onto the perspective grid. As soon as you do, the image will transform itself to the correct perspective, regardless of which plane you drag it to.

7. Be sure to keep the Marquis tool selected. This time, make sure you've chosen On from the Heal menu. Place the cursor inside the selection and press Opt/Alt again and immediately drag your surface image to the next location. Keep repeating this step until your entire grid is filled. In this image, I've created a brick wall and driveway. You can see the result in Figure 9-25. Click the OK button and you will return to Photoshop.

Figure 9-25. The bricked wall.

8. Now choose Select→Load Selection→*Whatever You Named Your Mask*. When the selection appears, go to the Layers palette and click the Mask

icon. The original windows and the vegetation that was growing along the intersection of the walls will all reappear.

Matching Size

When you composite one photograph into another, the image(s) added to the background image should always be at the same resolution per inch as the background image—or higher. You may be able to get away with images that are slightly too small, but otherwise the image is going to lack detail and contain too much noise. Figure 9-26 shows you a background image with an incoming knockout superimposed on it in a new layer on the left, after resizing but before sharpening and noise matching. On the right, you see how the image looks after it's been resized and the noise level reduced.

Figure 9-26. The truck on the right looks like it's been here all along, thanks to noise matching, color balancing, sharpening, and shadow casting.

Because you often have to downsize composited objects to give them the right scale in regards to their location in the background, you'll probably lose much or all of the noise (the equivalent of grain in film) that was originally in the image. Always do this when the object is on a separate layer from the background. It's also a very good idea to duplicate the original layer and then hide it beneath the background layer. Then, if you're asked to add more or less noise, you can delete the layer to which you added the noise, pull duplicate the original layer, and make a change. No need to search around to find the original, re-do the color matching, etc. After you've transformed the image down to the size where it fits realistically into the composition, you will generally need to do two things: match image noise and re-sharpen. Both should be done with tools that let you see both the knockout and the background superimposed over one another and should have a preview option so that you can match sharpness and noise visually.

NOTE

If you have multiple images that need to be added in and resized, you may be able to save disk space by pasting one or more of the originals onto a transparent layer. Then, should you need to remanipulate one of the originals, you can simply select that one subject and lift it to a new layer with our workflow's most useful shortcut keys: Cmd/Ctrl-J.

This is the routine to re-size, sharpen, and match noise for the image in Figure 9-27:

1. Open the background and knockout images at the same time. Cut and copy the knockout image's layer, then Paste it into the background image where it becomes a new layer.

2. Free Transform (Cmd/Ctrl-T) the knockout to fit the size, angle, and perspective you want it to have. Ideally, you should have to reduce its size or keep it the same size, rather than enlarge it.

3. Create the shadow: duplicate the layer and then drag it below the original. This is going to be the Shadow layer. Lock the layer's transparency by clicking the Transparency Lock icon near the top of the palette. Choose Edit→Fill→Black. You now have a black silhouette of your knockout.

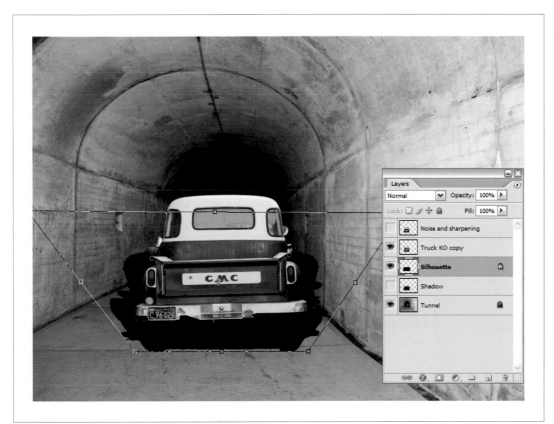

Figure 9-27. The Transform command used to cast the shadow as the light from the front of the tunnel would cast it.

4. Now transform the shadow silhouette layer so that the shape of the truck is projected away from the source of the light. In this particular shot, the light source has to be behind us because the truck is in a tunnel that's lit by sunlight. You can see how I shaped the Transform marquee in Figure 9-27.

5. Make a gradient selection for the entire image. This is going to allow you to make a shadow that becomes more diffuse as it recedes from the light source. To do this, go to the Channels palette and click the New Channel Icon. A black channel named Alpha 1 will appear. Rename it Truck Shadow. Now choose the Gradient fill tool, a rectangular fill, and a black to white gradient. Fill the channel with the black to white gradient, spreading the gradient portion as far as possible.

6. Return to the Shadow Layer and turn off all the other layers so that you can clearly see what you're doing. Choose Select → Load Selection. In the Load Selection dialog, choose Truck Shadow (or whatever you've called the layer and channel you're turning into a shadow). Drag the resultant marquee so that its lower line (which happens to be the center of the gradient) is slightly below the bottom of the shadow silhouette.

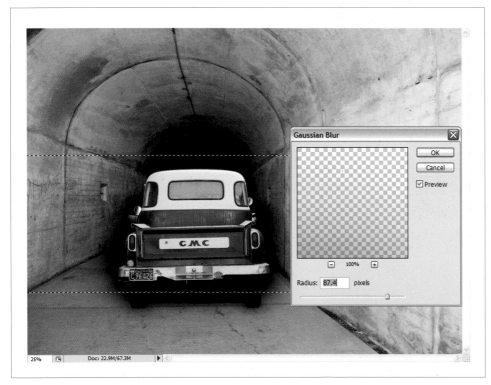

Figure 9-28. The Gaussian Blur filter has been used in conjunction with a feathered selection to make the shadow diffuse over distance.

7. Use the Gaussian Blur filter to soften the edges of the shadow, while the gradient mask makes the shadow more diffuse as it is projected further from the light source. For that reason, you want to diffuse the whole thing to an extreme so that it can graduate to that extreme. You may have to reapply the Gaussian blur filter several times to blur it enough for a realistic effect. In Figure 9-28, you see not only the marquee line mentioned in the step above, but the Gaussian Blur dialog and the preview of the result.

8. Match color balance, noise, and sharpen the downsized image to match the sharpness of its surroundings. Choose a Color Balance adjustment layer. When its dialog opens, don't do anything, just click OK. Then, while the layer is still selected, right-click and select Create Clipping Mask.

9. Match the noise and sharpening. Double-click the Zoom icon so you can see detail clearly. Now match the noise. Choose Filter→Noise→Add Noise. The Add Noise dialog, shown in Figure 9-29 appears. Drag the Amount slider to the left. You will probably need a very small number, so when you get the grain structure that comes closest to matching the Background image, type in the exact percentage you think is most likely to work. When you've got it, click OK.

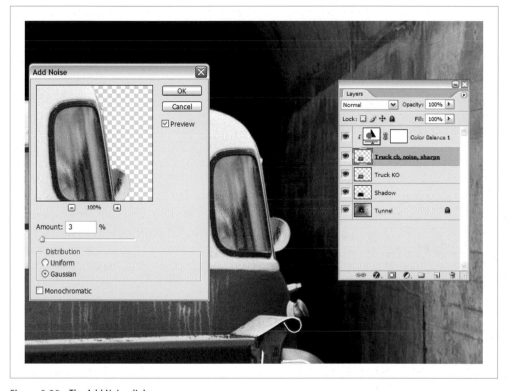

Figure 9-29. The Add Noise dialog.

10. Add the sharpening to the same layer or—if you're concerned that you might have to sharpen to a different degree later—copy the noise matching layer first and put it on top of the stack. Then choose Filter→ Sharpen→Smart Sharpen. The Smart Sharpen dialog will open, as shown in Figure 9-30. Choose the settings you see in the figure. You need to be careful not to oversharpen because you will have to do final sharpening for the printer you are using and that could cause dramatic oversharpening.

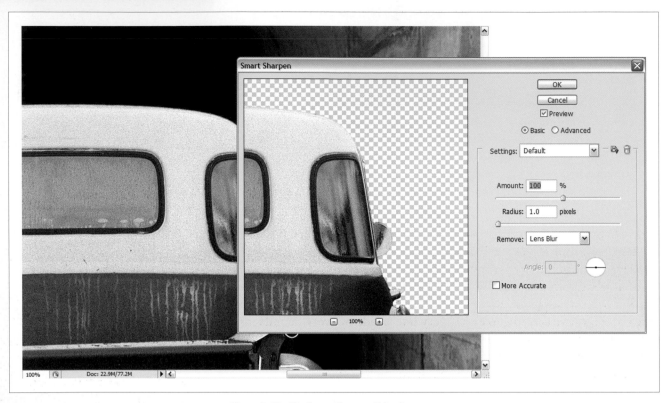

Figure 9-30. The Smart Sharpen dialog box.

Creating the Wow Factor 10

This chapter is about special effects, such as art and photo filters, warping, and Liquify, Lens Flare, and Lighting Effects filters. Also included are a number of scripts, both free and third-party that let you imitate some of the special films, over-the-lens filters, and processing routines that have been traditional in silver-halide (film) photography. The one thing we won't make the room for here is trying to cover every filter made by every manufacturer or even every single filter in Photoshop. This chapter is about effects for photographers, since they're the focus of this book and because no book has room for everything in or that can plug-in to Photoshop.

HOW THIS CHAPTER FITS THE WORKFLOW

Destruction Is Inevitable

Most, but not all, of the effects in this chapter will destroy the original image, which is why they come so late in the workflow. Besides, you probably want your special effects to affect everything that the image needed up to this point. Before you do pretty much anything in this chapter, there's a hotkey that you should drill into your head: Cmd/Ctrl-Opt/Alt-E. Before using it, convert your Background layer to a regular layer, then select all the layers you've created up to this point and press that key hotkey: Cmd/Ctrl-Opt/Alt-E. All the layers will be copied and then merged to become a new layer at the top of the stack. You can now do any destructive thing you want to that layer. If you know you're going to use several effects and don't want them to react directly with other effects, simply make several copies of the effects layer before you begin—or repeat the Cmd/Ctrl-Opt/Alt-E trick when the time comes. After that, even if you forget to undo until even History can no longer save you, all you have to do to return to where you were (before you found something you tried in this chapter didn't make the cut) is turn off or delete the merged and copied layer. Then you can merge and copy an unaltered version with a few keystrokes and try again.

Organizing Your Layers to Apply Effects

Here's the routine you should employ for organizing your layers for applying effects to an image you haven't already been processing. If you have already done considerable processing, use the Cmd/Ctrl-Opt/Alt-E hotkey to create a new unified layer and then apply these steps to that result:

1. Open the image to which you want to add effects.

2. Run the Action called Workflow Layers that you were introduced to the "The Magic Action for Layered Workflow" section in Chapter 5. Temporarily turn off all layers except Spot Retouch and the Background. Then do any cloning, healing, or spot healing needed to touch up the image, making sure to check the Sample All Layers box in the Options bar for those tools. Then turn the other layers back on.

3. If you need to add any composite layers, add them now. You'll usually want to place these layers between the Burn and Dodge layer and the Spot Healing layer so that all the layers above can affect the entire composition. However, your composite item could have its own workflow layers in a Group.

4. Use the Burn and Dodge, Level, and Curves layers as appropriate.

5. Make the Background layer an ordinary layer by renaming it.

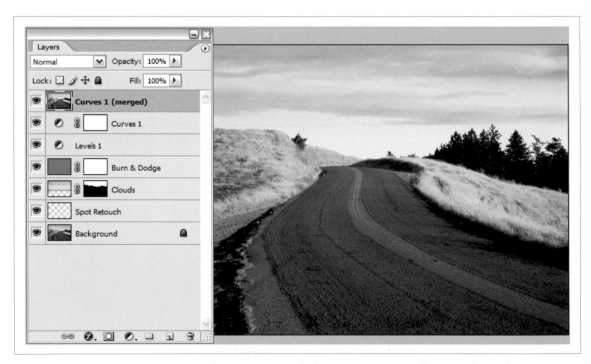

Figure 10-1. Merging all the layers before creating an effect in the Layers palette at left. You should also rename the merged layer for the effect(s) you're going to impose on them.

6. Select all the layers and press Cmd/Ctrl-Opt/Alt-E. The image you have been working on will appear as a flattened layer at the top of the layer stack. Be sure to create any layers for any of the processes in this chapter on top of and from this combined layer.

The end result will look something like Figure 10-1.

Applying Filter Effects

The most commonly used type of effect is probably filters. These include all the highlighted items in Figure 10-2 on Photoshop's Filter menu, plus any third-party filters you might have installed. You can either apply these effects filters one at a time, apply different filters to different layers, and then use Blend Mode, Fill, and Opacity to mix them, or use an interface that mixes them for you.

Figure 10-2. The filters in the menus that are highlighted are totally destructive, as are those in the top section. The other menus are mostly photographic processes that are typically a little less destructive and are usually used in a different layer set or group that usually falls just below the highlighted effects in the layers hierarchy.

Using the Filter Gallery

Photoshop comes with a host of special effects filters. With the advent of the Filter Gallery in Photoshop 7, there are actually an infinite number. That's because the Filter Gallery will allow you to combine many of the Photoshop filters in any combination of intensity and blend mode. Figure 10-3 shows the original image and one at the end of the routine that follows.

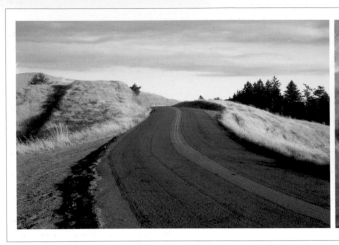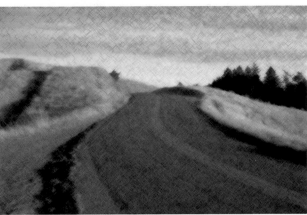

Figure 10-3. The figure on the right shows an effect that is the result of applying several filters at once.

1. After you have a merged and flattened layer that is a copy of all the work you've done up to this point, select that layer and duplicate it by dragging it onto the New Layer icon at the bottom of the Layers palette.

2. Choose Filters→Filter Gallery; that interface shown in Figure 10-4.

Figure 10-4. The Filter Gallery dialog. Click the folder for any of the effect categories in the center column, then the thumbnail for the filter you want, and you'll see the controls for that filter in the right hand column. To add the effect of more filters, simply click the New Filter icon.

Digital Photography Expert Techniques

Actually, when the interface first opens, you see a 1:1 section of your image in the Preview Window. This is a good way to see the detail in the effect, but I prefer getting an overall view first. To do that, click the down arrow just to the right of the Zoom percentage menu and choose Fit in Window.

Not every Photoshop filter will work in the gallery, but at least one or two from most of the categories will. The categories are listed in the center column. If you click the down arrow for any category, you'll see thumbnails of the effect that are in that category. Click a thumbnail and the gallery will immediately process the image with that effect. This process takes patience, so if you're going to process full-frame filters a lot, invest in a quad 64-bit processor and as much RAM as your computer and budget can take.

3. Select the filter that looks like it might be the effect you're looking for. As soon as you've seen enough of that effect rendered to get an idea of the result, drag the sliders for that effect so that those individual properties give you a more fine-tuned result.

4. Click OK any time you satisfied with the results, but you can also experiment with combining a number of filters. Click the New Filter icon (it looks like the Layers palette's New Layer icon). You'll see another copy of the previously chosen filter in the stack. You could set separate settings for this iteration of that filter or you can choose any other filter thumbnails to replace it.

5. Make the adjustments for the new filter, then add yet another or not. Quit whenever you feel you're ahead. You can also rearrange the order the filters are in by dragging them to a new place in the stack. The cumulative effect can differ quite a bit, depending on the sequence in which the filters are applied.

6. When you're pretty sure your image has had enough, just click OK. Have a cup of coffee or a good stiff drink. Hope you like what you get.

Frankly, I find that I can do the job faster and more flexibly by simply duplicating the combined layer several times, running a different filter on each, and then blending the layers using different opacities and Blend Modes (especially Multiply). Besides, I can then change the combination of effects later.

Blurring Memories

We pay so much to get the best and sharpest lenses, the highest resolution sensors, and top-rung software such as Photoshop and Lightroom, but then we spend even more money to blur all that sharpness. That's because too much detail often detracts the viewer from seeing the part of the image that we want seen. Sometimes too much sharpness just becomes motionless or static. Sometimes too much sharpness just doesn't convey that soft, silky

> **NOTE**
>
> *Because of the speed issue, you may want to select only a portion of your image before opening the gallery. You can then run this whole process on just that section of the image. When you like what you see, click OK. Then press Cmd/Ctrl-Z to Undo. Then choose Filter→ Filter Gallery from the very top of the Filter menu—not the one further down. It will then repeat everything you did to that little section you were experimenting on.*

"I'm in *love*" feeling. So, to make money, sometimes we have to destroy at least some of the sharpness that we spent so much time and money to get.

Lens Blur

The most photographic of all the Photoshop blur effects is the one that imitates what happens when you intentionally keep the lens aperture as wide as possible to minimize depth of field. We used to use the Gaussian Blur filter for achieving that effect after the shoot, but it's a bit time consuming to use feathered selections and multiple applications to create a truly photographic look. So after listening to a lot of photographer's whine (Adobe's good at listening), Photoshop CS introduced the Lens Blur filter. Figure 10-5 shows an image shot with a relative high shutter speed and small aperture. Although the model is definitely sharper than the rest of the image, the rest of the image is just too sharp to keep our attention focused on him. To make matters worse, the rest of the image was taken from another photograph and blurred slightly with the Gaussian Blur filter—Lens Blur filter to the rescue!

Figure 10-5. Applying Lens Blur to the background helps get our eyes back on the subject.

This is how the Lens Blur filter works best:

1. Do all the layer stuff to the image and then follow the routine in the "Organizing Your Layers to Apply Effects" section at the beginning of this chapter so you end up with a merged layer that reflects all your

adjustments, retouching, burning and dodging, and anything else you might have done.

2. Select the area you want to keep in focus. Because there's usually some softness toward the edges of any image that has a shallow depth of field, I like to place the image in Quick Mask mode and then simply paint the mask into place, as shown in Figure 10-6. When I'm done, I click the Standard mode icon and a selection marquee appears.

Figure 10-6. The Lens Blur dialog settings used to get the result seen in Figure 10-5.

3. Be sure the Portrait (merged and copied) layer is selected and click the Layer Mask icon in the Layers palette. You will see the layer mask appear alongside the image icon. It will be selected, so be sure to click on the image icon to make it the target of your next step.

4. Choose Filter→Blur→Lens Blur. The Lens Blur dialog, shown in Figure 10-6, opens.

5. Check the Faster box in the upper-right column of the Lens Blur dialog. Then choose Layer Mask from the Source menu.

6. Drag the Blur Focal Distance slider until the background seems blurred just enough. Because of the way you made the mask, the edges of the mask silhouette are a bit sharper than the immediate foreground, which is due to the fact that you used that large, feathered brush.

7. Under Iris, choose Hexagon or Octagon as the Shape of the opening in the Iris.

8. Drag the Iris Radius Slider to the right if you want to create an even more noticeable blur effect. It's the equivalent of using a wider aperture for a more shallow depth of field when shooting.

9. If everything looks good to you now, zoom in to 100 percent and go back up and click the More Accurate radio button so it's on. Now look carefully and you'll notice that, regardless of your camera's resolution, there is more image noise in the foreground than in the blurred background. If you want the picture to look natural, you'll have to restore that noise, but don't overdo it. Choose Gaussian as the type and then drag the Noise slider ever so slowly to the right until you get a good match.

10. You're done. Click OK.

Gaussian Blur

The Gaussian Blur filter is the old standby for blurring most anything. It's been around so long that surely anyone reading this book has been there and done that. Just be sure that when you use it on part of an image, you do it inside a feathered selection that will let the effect blend from sharp to blurry. Also remember that you'll want to match the noise in the image.

In Photoshop CS and later, there are quite a few variations on Gaussian Blur that will give you some special effects. The procedures and cautions for using them are the same as for other types of blurs. Here's a brief description of each of them.

Shape blur

You can choose from several shapes that act like diaphragm shapes in a lens blur and control their size. Sounds neat, but I haven't found a lot of important difference between them. Feel free to experiment and let me know if you discover anything super useful.

Smart blur

I'm not sure I get the difference between this and the Surface Blur filter. Smart blur blurs every thing inside an edge, but keeps the edges sharp (see Figure 10-7). The blurring is controlled by Radius and Threshold sliders. Radius controls the amount of blur. Threshold controls the difference in brightness that will be considered an edge within which all the pixels will be blurred. You can also choose to show nothing but the edges or superimpose the edges over the image. Showing nothing but the edges creates a nice mask for sharpening only the predominant edges, so you might find it well worth experimenting with.

Figure 10-7. Here you can see the Smart blur dialog and the effect that these setting produce on the macro photo of this flower.

Surface blur

Surface blur is identical to Smart blur, except that it doesn't have the Quality and Mode menus. It's the perfect tool for quickly smoothing surfaces, especially in glamour photos. Select the area you want to smooth and lift it to its own layer. If there are interior details that need to remain sharp, you can fix that later. Just run the filter (Filter→Blur→ Surface Blur) on the lifted layer and adjust the sliders so you see just the right degree of smoothness. Click OK. Then use a feathered brush for the Eraser tool and erase through the smooth layer to the sharp details below it. As a finishing touch, use Filter→Noise→Add Noise to match the noise in the "unsmoothed" portion of the image. You can see the result of having done all this in Figure 10-8.

Figure 10-8. Notice that the noise in the grainier portion of the image has been matched in the image on the right in the areas which have been "smoothed" by blurring.

Motion Blurs

There are so many motion blur filters that it's hard to keep track of them all. They all do the same basic thing: give the viewer the feeling are seeing an object captured while it was traveling at high speed—so high that even a shutter fast enough to keep everything else in the image sharp couldn't keep the traveling object sharp.

I often find that it helps more to put a motion blur filter on an object that's been knocked out, even if that object originated in the same photograph and was just lifted from the photo. Otherwise the background smears as well as the subject. The result isn't quite as believable as when you blur a knocked-out subject, even if you've placed a selection around the image to be blurred. Figure 10-9 shows an example of both techniques so you can see the difference.

Figure 10-10 shows you the same object blurred with a third-party filter, Andromeda's Velociraptor, and a stroboscopic blur made in Photoshop, just to give you some idea of other ways to make a motion blur.

There's also the Motion Trail filter in Alien Skin's Eye Candy 5: Impact (Figure 10-11). This is one of the most versatile motion blur filters because it will let you have the blur trail the object or start at its leading edge. You can also make the trail curve, taper, and change its opacity. All of this is done with sliders, so it's easy to see the effect before you apply it.

Figure 10-9. On the left, the photo of the biker as it was shot. On the right the same photo after knocking out the biker and duplicating the knocked out layer to apply the blur.

Figure 10-10. Blurred with Andromeda's Velociraptor.

Figure 10-11. Both motion blurs were created with Eye Candy 5: Impact's motion blur filter. On the left, the blur starts trailing outside the selection or knockout. On the right, it starts on the leading edge of the selection.

Radial Blurs

There are two kinds of radial blurs in the Photoshop Filter→Blur→Radial Blur menu—Zoom and Radial. The Zoom blur gives the viewer the feeling of moving in fast on the subject. It got its name from the fact that if you zoomed a video camera manually at very high speed and then looked at a frame captured midzoom, it would look a lot like the result in the Zoom mode of the Radial blur filter. The Radial blur filter gives you the feeling that the subject has been captured while spinning at a high speed while sitting in the center of a high-speed turntable. Examples of both are shown in Figures 10-12 and 10-13. Each of these figures is followed by a short description of how each effect was achieved.

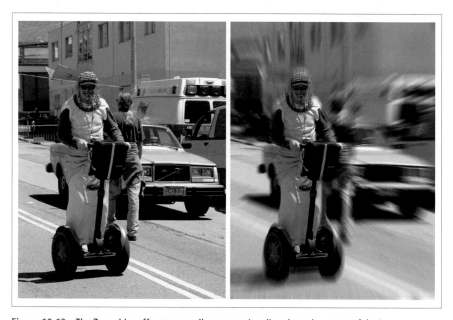

Figure 10-12. The Zoom blur effect moves all our attention directly to the center of the image.

The problem with making the Zoom blur work for you is that it wants to blur everything from the center out. More often than not, I want to see what I'm zooming in on. So I make a duplicate layer over the original, select the duplicate layer in the Layers palette, center the zoom, set the dialog settings that I like with the Preview box checked, and click OK. Then I take a *big* eraser brush, set it at 100 percent Opacity and make sure the brush is feathered to the max. Then, using a pressure sensitive pen, I erase through to the original image where I do not want the image to be blurred.

Usually, a feathered selection works well with the Radial blur when it comes to keeping intact the portion of the image you want to keep sharp. However, it didn't work very well for this thistle in Figure 10-13, thanks to its thorns. So, once again, I duplicated the image and then brushed through the radial blur duplicate with the eraser tool.

Figure 10-13. Radial blur.

What to Do When the Filter Doesn't Let You Center the Blur

The problem with blur filters is that they often blur just the thing you want to emphasize by blurring the rest of the picture. That's not always the case, but it is with all of the pictures in this blur section. The standard operating procedure (SOP) for avoiding this is to place a selection around the portion of the image you want to keep unblurred and then feather it so that the blurring graduates into sharpness when it comes to the image itself.

Another problem is that radial blurs are sharpest at the center of the blur. Most Radial blur filters will let you move the center of blur (is there really such a term?) so that you can position it where it works best. All of the fil-

ters used for the illustrations in this section provide some intuitive means of letting you do just that.

If you run into a Radial blur filter or effect that prevents you from centering the blur, just increase the size of the Canvas. Make a duplicate of the layer you want to blur and position it so that the center of the image is the center of the blur. Then run the filter. Then move the layer back to its original position by reducing its Opacity to 50 percent and drag it into place. Zoom in to 100 percent (1:1) and make sure that the details are perfectly registered atop one another in every direction.

Satisfaction in Liquefaction

Ever since Live Picture went away and left us stranded for a really good fictitious imaging tool, illustration photographers have been making do with Photoshop's Liquify filter. Liquify lets you treat any shape as though it were made of modeling clay. Have a client who's a bit on the heavy side? No worries. Liquify is Photoshop liposuction. Want to turn a person's face into a caricature? Liquify is marvelous for making ear-to-ear smiles and bug eyes have never looked so buggy. Figure 10-14 shows you a pair of familiar pets, before and after liquefaction.

Figure 10-14. The grins and bug eyes on the dogs' faces.

Like everything in this chapter, Liquify is maximally destructive, so do anything you plan to do with it on a new layer. Here's how I made clowns of the dogs:

NOTE

At the bottom of the dialog is a checkbox called Show Backdrop. Check it if you want to see layers in the same image. You can choose All Layers or a specific layer and whether you want the other layer to appear in front or behind the Liquify layer. If you use a knockout, you can display the originating layer beneath the Liquify preview. That way, you can tell how well your distortions of the knockout will fit into the background. You can also tell whether or not you need to clone background into the part of the image that the knockout was "lifted" from.

1. First, knowing that I didn't want the Liquify filter to affect anything in the image except the dogs, I placed a selection around them that ended at the leash. I had no intention of modifying anything below the leash, either. When you then choose Filter→Liquify, the Liquify dialog opens. As you can see from Figure 10-15, the Liquify dialog is another one of Photoshop's applications within an application.

 You could use a grid over the image to help you visualize how much and where you've distorted the original. The grid is called the Mesh. To use it, just check the Show Mask box. You can choose the Mesh's color and size from menus.

 When the dialog opens, the red color designates the area masked by the selection. You could paint a mask around the edge with the Freeze tool or erase it with the Thaw tool. Both are just above the Hand tool in the Toolbox. Masking protects areas from being distorted by the other Liquify tools so that you don't smear parts of the image unintentionally.

2. I wanted to make these cute little dogs to look silly, so I bulged out their eyes by sizing a brush just slightly larger than what I wanted the eyes to become. Then I centered the cursor over the eyes and pressed until the eyes were the size I wanted. Be careful not to press for too long.

The thing you're bloating won't get any larger than the brush (unless you move it), but the program will keep pushing the center out toward the edge until there's no more detail left in the center. I've applied sunglasses using that technique.

3. To make the ears larger, I used the Thaw brush to open larger spaces in the mask. Then I used a very large brush for the Bloat tool and made the ears expand to fit the mask. You could also use the Push to the Left tool. It pushes to the left when you drag upward and to the right when you drag downward.

4. The smirk on the dog's lips was made by dragging the Forward Warp tool to push up the ends of their mouths.

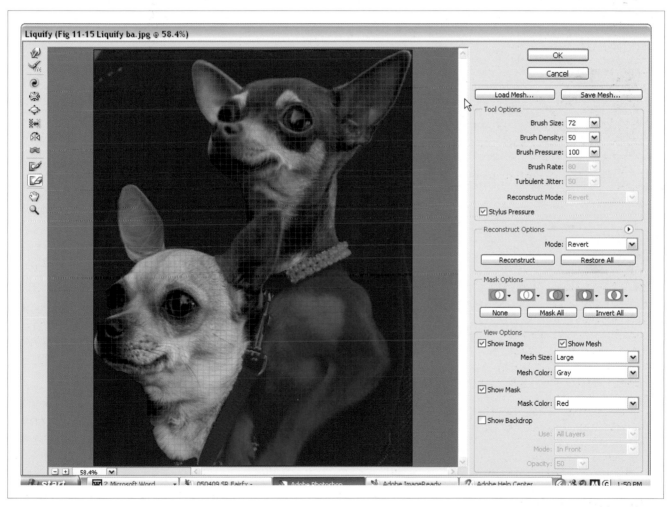

Figure 10-15. The Liquify dialog after selecting the dogs. I have already come pretty close to the final effect using nothing more than the Bloat and Push tools.

Using the Warp Tool

We've already covered the Warp tool a bit in Chapter 9 in the "Warping a smart object" section. You can do exactly the same thing by simply choosing Edit→Transform→Warp. No dialog appears, just the Warp marquee over the image itself. This can be an excellent tool for making an image, logo, or tattoo fit a fairly simple geometrically shaped object. All you have to do it drag inside the grid cells to make the shape bend. You can drag any of the cell corners or borders to make the image swell in some places and narrow in others. When you're done, select the target object (or the target portion of that object) and then use that selection as a layer mask for the portion of the layer you warped. That's exactly what was done to make the photo on the left fit the bowl on the right in Figure 10-16.

Figure 10-16. You can see how dragging the Warp tool's grid makes the pattern look as though it actually fits the bowl.

Using Lighting Effects

In this section, I'm talking about lighting effects, such as spotlights and lens flares projected onto a background or inside a selection. I'm not talking about redirecting the lighting falling on a subject to match it to the background in a montage, that process is covered in Chapter 9 in the "Lighting and Casting Shadows" section.

I use lighting effects a lot for lighting the backgrounds of portraits and product shots that were originally shot on green screens. I have also used them in the form of lens flare filters and for simulating lens flare caused by shooting directly into a lighting source such as the sun or a spotlight.

Speaking strictly from a nondestructive point of view, you should make a separate layer for your lens flares. However, I often mix them on the same layer as my lighting effects, just to save hard drive space.

Using the Lighting Effects and Lens Flare Filters

The Lighting Effects filter casts light onto an image originating from three types of light sources: Omni, Directional, and Spotlight. Directional places a wide beam across the image. Omni is a circle of light radiating equidistantly from the center handle. Spotlight is adjustable and can produce virtually any kind of a beam. The Lighting Effects filter lets you add these to an image in any arrangement, and at any size. You can brighten and dim the individual lights, as well as the overall room light. You can also imitate placing colored filters over the lights. One of the coolest things is that you can use the Lighting Effects filter to texture the entire layer you're lighting. The direction of the shadows on the texture will depend on the light that is affecting that part of the texture. Figure 10-17 shows a portrait before and after application of the Lighting Effects filter.

Figure 10-17. A portrait before and after application of the Lighting Effects filter.

Once again, this technique is highly destructive to the layer to which you apply it once you click the OK button. So be sure to keep a hidden duplicate layer somewhere in the image in case you have to make a change, which will prevent you from doing everything over to create that layer, even if all it amounted to was spending the time it took to find and qualify the right image.

The Lens Flare filter simulates what would happen if you pointed several different types of lenses at a very bright light source that was aimed directly at the camera. I often use it to simulate exactly that when I want

to dramatize a sunset photo or a rock performance with spotlights in the background. Often, when you actually include bright lights in the shot, some important portion of the image is flared out. With the Lens Flare filter, you can position the flare(s) exactly where they most benefit the subject and the composition.

To save a bit of space in this book, I combined both techniques on the image in Figure 10-17. Lighting effects are almost always (but not necessarily) on a pasted-in background behind a knocked-out subject. You can see the subject and the background before the lighting effects on the left side of Figure 10-17. Here's how the whole thing is done.

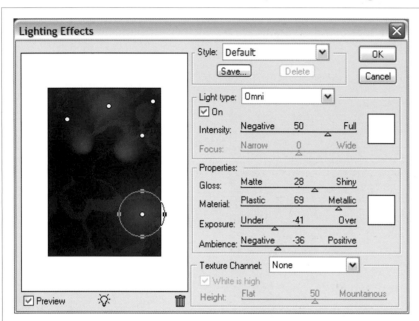

Figure 10-18. The Lighting Effects dialog remembers what you did the last time you used it so you can go back and make changes if you don't like what you see when you click OK. Also, if you check the Preview box, you'll see the results of your adjustments on the image itself.

1. Duplicate the layer that is the background image for the knock-out, just in case you irretrievably mess it up with lighting effects and need to start over.

2. Start with lighting effects if you're going to apply both Lighting Effects and Lens Flare. I find it usually makes it easier to decide where to put the lens flare. Choose Filter→Render→Lighting Effects. The Lighting Effects dialog appears, as shown in Figure 10-18.

The Lighting Effects filter may look frighteningly complex if you're new to it. Knowing a few things will likely make it much easier. First, you can have as many light sources as you want. To introduce a new light source, drag the Light Bulb icon into the image in the Preview window. You can relocate it with the cursor any time you want. If you decide you want to get rid of a light source, just drag it to the Trash icon.

— **NOTE** —

If you want to take the easy way out, the Style menu contains seventeen pre-made lighting configurations. You can often save yourself a lot of time, especially if you are new to this, by browsing through the premade style until you find the one closest to the effect you're looking for. You can still change all the variables for any of the lights. And if you find an effect that you especially like, you can save it so that it can be recalled any time. Click the Save and Delete buttons.

3. Choose the size and shape of your light sources. To make the light source into an Omni, drag the side handles until the light's marquee is a circle. To make it a Directional light, increase the diameter of the circle

and then drag the end of the marquee until the oval is several times longer than it is wide. When you drag in a new light source, it's always the same type as the last one you used. To change it to another type, choose another type from the dialog's Light Source menu.

4. Adjust the Intensity and Ambiance sliders first—they are the most important. Intensity refers to the relative brightness of the currently chosen light source. Ambiance controls the overall brightness of the background.

5. Experiment with the Exposure slider. Exposure lightens or darkens both the lights and the overall image simultaneously. It's very helpful to let you match the brightness of your background to the brightness of your image.

6. Experiment with the Gloss and Material sliders to get the background shininess that you like.

7. Match the noise in the background with the noise in the image.

> **NOTE**
>
> *You can also choose any of the image's channels as a texture channel. However, you have to place a monochrome image into an Alpha channel first. You can create a bump map from any photographic pattern, such as a close-up of a piece of fabric or of a tiled floor or by simply painting a texture into a blank file. Whatever is white in the bump map appears to be higher, while darker tones appear to be lower. Figure 10-19 shows a monochrome bump map on the left and how its result looks in the Lighting effects filter on the right.*

Figure 10-19. Left, a bump map made from nighttime neon; right, the bump map applied in the Lighting effects filter.

— **N O T E** —

*In "real life", lens flare is caused when a very bright light source is aimed direct-
ly at the lens. Unless that light source is very narrow and highly focused, it will
cause a backlight rim around the foreground object (such as people). So if you
really want the lens flare effect to be realistic, try selecting and then feathering
the foreground objects. Use that selection as a mask for an Adjustment layer
and use the adjustment (Levels, Curves, Brightness/Contrast) to brighten the
background so that a rim of light appears around the foreground objects.*

Making Your Own Lighting Effects

You can create your own lighting effects with a mask that lets the light
through in varying degrees of opacity, then using it to mask an adjustment
layer. In Figure 10-20, the adjustment layer mask is on the left and the lit
subject is on the right.

Figure 10-20. The lighting mask (left) and
the result on the subject (right).

I did this by creating a blank layer above the layer I want to light, then used
the Lasso tool to select the area to light the brightest and filled that area
with pure, 100 percent Opacity White. Next, I used the Brush tool to paint
areas of progressively lighter gray around the white areas. To smooth every-
thing out and blend the shades of gray, I blurred that layer with a Gaussian
Blur filter. I turned off all the other layers and copied the image to the
clipboard, then opened the Channels palette and clicked the New Channel
icon to create a new Alpha Channel. I selected that channel, pasted in the
Clipboard contents, clicked the RGB channel to go back to the Layers pal-
ette, and dragged the lighting layer to the trash. Next I opened the Curves
adjustment layer. The Brightness/Contrast adjustment layer is OK when
you're in a hurry, but Curves will give you a lot more control.

Homemade Backgrounds

If you do much work with knockouts, chances are you will need some eye-catching backgrounds for them. Of course, many applications for knockouts, such as catalog advertising, require a white—or at least, solid color—background so that there will be as little interference as possible with the surrounding advertising copy. On the other hand, I've done whole fashion shoots knowing that there simply wasn't the budget for either location shooting or fancy backgrounds. Anytime I'm out scouting around with my camera, I'm looking for backgrounds for realistic situations, but sometimes you just want an eye-catching look. Sometimes you want to suggest an atmosphere that doesn't really exist.

I don't know if anybody would buy it, but you could write a whole book on the possibilities for creating your own backgrounds. One way is to use a lighting mask like the one I described above and create interesting shapes to cast highlights and shadows on a solid color background by using a masked adjustment layer. In this instance, I used shapes from the Animals collection provided in Photoshop. Shadows were created by inverting the original layer and then changing its mode to Multiply and then reducing the opacity of the layer. You can see the result in Figure 10-21.

Figure 10-21. These shapes were used to create a lighting effect. On the right, you see it applied to a solid color background. Of course, it could be applied to a background of any color or texture, even a photograph.

Using Pattern Maker

Pattern Maker makes a whole layer of a seamless texture from a selection you made from another layer or photograph. It's a good way to make a background for an image whose natural background was too complex. Because this new background is taken from the original background, the color balance and exposure of the background are much more likely to match. Be sure to make a merged layer of your entire image before you run this process. You will select the pattern area from this merged layer.

The following process is typical of the process for this making a new background for an object knocked out of the same photo that the background pattern is derived from. Figure 10-22 shows an example of the before and after of this effect.

Figure 10-22. The original image is on the left. Although it's a stronger image as it stands, the jacket that was being sold in the ad was getting too much competition. Furthermore, there wasn't room for type.

1. Open the image for which you want to create a new background. Create a new layer, which is merged from all your existing layers that becomes the top layer.

2. Knockout the portion of the image you want to make the new background for.

3. Use the Rectangular Marquee to select a portion of the original image to make a good background pattern; areas of the image that are textured, such as stone walls or hedges, are usually the best candidates. On the other hand, there's no harm in experimenting if you have the

time. Anyway, when you've chosen the area you want, press Cmd/Ctrl-C to copy its contents to the Clipboard.

4. Create a new transparent layer immediately above the Merged Composite layer. Now select that layer in the Layers palette. Name the layer Pattern Maker Bkg.

5. Choose Filter→Pattern Maker. The Pattern Maker dialog will open (see Figure 10-23). There will be nothing in the preview window yet, but when you're done, it will fill with the pattern you've made.

Figure 10-23. The Pattern Maker dialog.

6. Click to check the Use Clipboard as Sample box. Set the Width and Height just slightly smaller than your marquee. You may have to open the Get Info palette to see what the Marquee size was and then translate inches to pixels. Alternatively, you could just make a good guess, however if you set the size larger than the sample, you'll get a seam in your pattern. Choose 3 from the Smoothness menu. This determines how much "wraparound" you get on the edges of the selection so that it will be harder to spot the seams between the tiles in the pattern. Experiment with the Sample Details slider setting.

7. Click the Generate button to see what your settings will produce. You'll quickly see the result. If you don't like it, try a different original selection or different settings, or try different Offsets. When you like what

you see after pressing the Generate button, click OK. You'll see your original image with the knockout floating above the new background.

The subject was leaning against a wall, so I transformed the background so that the texture projects out toward the viewer. I also create a shadow for the knockout and used a Lighting effect on the back wall.

Colorization Effects

There are about a million different ways to add cool color effects to your images, whether those images are black and white, color, or effects processed. Actually, I've never had time to count the ways, but you can divide them into two major techniques: Layer Blend Modes and Brush-on Blend Modes. I'm sure that a little imagination on your part will give you ideas on how to modify and combine these into many other different looks. Traditional toning techniques, such as sepia and duotone are covered later in this chapter. The three techniques discussed here are:

- Hand-coloring or tinting
- Color Layer overlays
- Pattern overlays

Once again, as is typical in this chapter, you should start by copying all your layers and merging them into one. We'll apply these effects to that merged layer or its derivatives to keep the original state of your image intact.

Figure 10-24. One of the advantages of hand tinting is that you can make anything any color you like. There's also a mood of surrealism or fantasy.

Hand-Coloring or Tinting

This is done in traditional photography by chemically sepia-toning a print that's been made intentionally less contrasty than usual because the application of colors tends to give us a darker impression of that image. In case you can't already guess, I'm going to show you the Photoshop equivalent of how to do that same thing. These same techniques can be applied to many different types and looks of images. You could, for instance, use a cross-processed effect (see the "Cross Processing" section later in this chapter) and then intentionally add to the somewhat bizarre look by painting with the brush in any of the Blend Modes. Anyway, back to reality. In the tradition of this book, Figure 10-24 shows you a standard black

and white interpretation of an image and the result of sepia toning and hand-tinting it. To hand-color an image:

1. Merge and Duplicate your channels according to the routine in the "Organizing Your Layers to Apply Effects" section at the beginning of this chapter.

2. From the Layer palette, choose a Channel Mixer adjustment layer. When the Channel Mixer dialog appears, click to check the Monochrome box. Then use the sliders to get the tonal mix you want.

3. Now you want to lower the contrast just slightly, so that the upcoming sepia tone won't mix too strongly with the colors. From the Layers palette, choose a Curves adjustment layer. Click to place a dot in the lower portion of the curve diagonal and then press the up arrow keys several times until the shadows are as light as you'd like them to be. You can see the image and the curve I used for it in Figure 10-25.

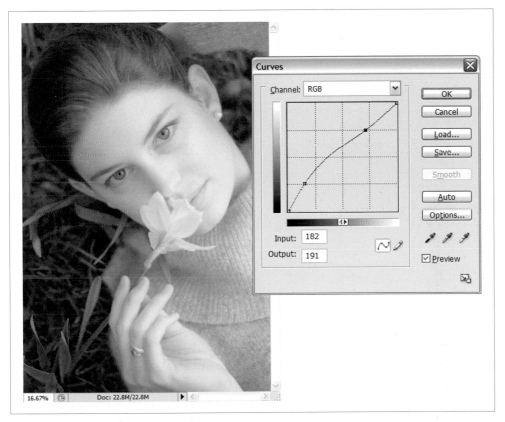

Figure 10-25. You may want to adjust the tones in the monochrome interpretation of the file with a Curves adjustment layer.

4. Select the merged layer and the two adjustment layers you just created and make a new merged copy of that layer at the top of the stack by pressing Cmd/Ctrl-Opt/Alt-E. This is the layer you're going to sepia tone.

5. Choose Image→Adjustments→Photo Filter. The Photo Filter dialog, seen in Figure 10-26, appears. From the Filter menu, choose Sepia. If you check the Preview button and drag the Density slider, you can watch the image until it attains the density you want. When you're there, click OK.

NOTE

This filter can be used to tone your image in any color of the rainbow. Click the Color radio button and then the Color Swatch. Use the Color Picker to pick any color or shade you like. The rest of the procedure is the same as described here.

Figure 10-26. As you can see, the Density slider was moved up to create the level of sepia color that you see in this image.

NOTE

If you create a new Burn and Dodge layer (neutral gray fill in Overlay mode) above your image, you will have an easier time lightening and darkening areas of the image as you try putting in the colors.

6. Choose Image→Duplicate and then zoom out so that the image becomes small enough to keep to one side. You're going to use this image to pick up colors that you want to take from real life. You'll also want to choose Window→Swatches so that you can keep the Swatches palette handy for quickly picking color.

7. Choose the Brush tool. In its Options bar, choose Color from the Blend menu. Of course, if you want to see some really interesting and bizarre effects, you could choose some of the other modes. What the heck, it's your picture and your time, right?

8. Choose the colors that are appropriate for a particular area of the photo and paint them in. You'll have a much easier time of it if you have a pressure-sensitive pad, such as the Wacom Graphire. Don't be afraid to take liberties to gain effect.

Color Layer Overlays

Some of the most delicious effects can be created simply by placing colors on an empty layer and then using Blend Modes to have them affect the original layer. If you're interested in photographic illustration, seriously consider the possibilities in this one effect. The illustration in Figure 10-27 shows one simple technique that can be used with myriad variations.

Figure 10-27. The original image is on the left. On the right, the two colors of brush strokes were made on a transparent layer, blended with the Gaussian Blur filter, and the layer was placed in Hue Blend Mode.

Here's how the image you see on the right in Figure 10-27 was created from the original you see on the left:

1. I clicked the New Layer icon in the Layers palette to make a new layer above the original. (If it took several layers to make your original, make a composite layer and start from there.)

2. I made a fairly large brush and selected foreground and background colors that I felt could convey the feeling of an imaginary sunrise or sunset. I made a shape I liked of the first color, then switched the colors (press X) and filled the empty area with the Paint Bucket tool. I could also have filled with a gradient for a somewhat different effect.

3. I choose Filter→Blur→Gaussian Blur and cranked the slider all the way to the right, then clicked OK. As you can see, this made the two colors blend smoothly over a wide area.

4. All that remained was to pick the right blending mode. That choice is rarely the same for any two layers, given the difference in the color and content of the two layers. In this case, the mode I chose was Hue.

5. I was really happy with the result, but couldn't stop experimenting. So I made another copy of the original layer. Then I used Select→Select Color to select all the blue in the sky and deleted it. I then chose Outer Glow from the Layer Effects menu and also experimented with some of the other sliders in the resulting dialog in Figure 10-28.

Figure 10-28. These are the settings I used for the Outer Glow Layer Style used on the layer that contained the silhouette of the branches.

> **N O T E**
>
> *Nik Color Efex is a third-party filter that will automatically create hundreds of color effects that you can use with your images. This software comes with some Wacom tablets, but they can be purchased separately as well. If you want to check it out for yourself, download a free trial copy from* www.niksoftware.com.

Pattern Overlays

You can get some really nice effects by simply blending layers with two different subjects on them. It's so easy to experiment and so much fun—and much more productive than playing solitaire while you're waiting for that call from the agency. What I'm going to suggest here, however, is a slightly more predictable variation on that same idea. Simply create a solid color layer and then use either the Pen or Shape tool to make an object that, if repeated, would become a pattern. In this instance, I used a 50 percent gray layer fill and then filled it again with a pattern. I then put the resulting layer in Multiply Blend Mode and reduced the Opacity of the layer. Finally, I used a Curves adjustment layer to increase the contrast and exposure of the end result. Figure 10-29 shows you the original image and the color-blended result.

Figure 10-29. A pattern layer overlain on a photograph could use many variations on Blend Modes.

NOTE

The pattern in Figure 10-29 wasn't made with the Pattern Maker filter, but by the much more predictable old-fashioned Photoshop method; I created a solid color layer and placed an image inside it. I then used a square Rectangular Marquee to select it and chose Edit→ Define Pattern. After naming the pattern in the resultant Pattern dialog, it became part of the currently chosen pattern library. I then created a blank layer and chose Edit→Fill. In the Fill dialog, I chose Pattern from the Use menu. The pattern then seamlessly filled the entire layer, thanks to the fact that its background had no pattern.

Photo Filters

The Photo Filters command in the Image→Adjustments menu is a means for making a sepia-toned image but it is also a way to make toned images based on all the primary RGB colors and their complements. But the Photo Filters command's most real and important function is imitating the glass color-balancing filters traditionally used in film photography for warming and cooling the image (see Figure 10-30).

Film Effects

The following effects are traditionally done to film, but they've become popular in digital photography precisely because they bring back the nostalgia of film. They can also separate a picture from a bunch of run of the mill images.

Figure 10-30. Each of the Standard Photo Filters, applied to the same image at 25 percent.

Velvia

Fujifilm made its mark with the famous Velvia film, endearing itself to many photographers for bright, vivid colors. By far, the best way I've seen to create this look is a very affordable (would you believe $25?) automation script from Fred Miranda (*www.fredmiranda.com*). However, you can do an only slightly less impressive version of the same thing by using the Hue/ Saturation adjustment layer. Just move up the Saturation slider by about 30 percent and then tweak with the Hue Slider (see Figure 10-31).

Figure 10-31. On the right, Fred Miranda's Velvia Vision provides lots of latitude for tweaking color saturation and extending dynamic range.

Cross Processing

Cross processing is a term used in traditional darkroom photography for processing film of one kind (e.g., Ektachrome) in the chemicals usually used for processing another kind of film (e.g., Kodachrome) or paper. The results can vary quite a bit, depending on the specific combination used, but generally end up looking somewhat like the image in Figure 10-32. To apply this technique to your image:

1. If your image has a normal or flat tonal range and quiet colors, you'll probably want to change that. Add a Curves adjustment layer and boost the contrast. At the same time look for areas of tonal brightness you might want to change. If you find any, press Cmd/Ctrl and move the cursor to the spot in the image you want to brighten or darken and click. Then press the up arrow key to brighten or the down key to darken.

 If your image's colors are particularly intense, brighten them with a Hue/Saturation adjustment layer by dragging the Saturation slider to the right.

Figure 10-32. The original image (left) and the result after simulated cross processing.

2. Duplicate the image (Image→Duplicate) because you need to convert it to Lab color, which will flatten it. Now choose Image→Mode→Lab Color.

3. In the Channels palette, select the B channel and choose Image→Adjustments→Levels. When the Levels dialog opens, drag the Shadows slider to the right until it reads "77" then click OK. Then repeat this step for the A channel.

4. Select the Lab channel. You'll probably notice that your image is quite blue (see Figure 10-33). Press Cmd/Ctrl-A to Select All, then Cmd/Ctrl-C to copy the selection to the clipboard.

Figure 10-33. The Lab version of the image after adjusting the A and B channels.

5. Select your original image and press Cmd/Ctrl-V to Paste the blue Lab image into your RGB image as a new layer. Put the new layer in Overlay mode. Add a Hue/Saturation adjustment layer and move the Hue slider until you see the cross-processing colors you want. You'll end up with something approximating a cross-processed image.

Aged Film

There are several filters on the market that will create an aged film effect, but unless you do this a lot, it's probably going to be tough to justify the cost. After all, it's not that hard to do a reasonably credible job in Photoshop. You can see the result of the exercise that follows as it was applied to Paddy O'Connor's photo in Figure 10-34. It will work equally well when you want to create an old-fashioned look. To give an image an aged look:

1. Duplicate and merge your original layers (of course). Rename the duplicate Aged Film.

2. Open a Curves adjustment layer. Grab the bottom left of the curve line and drag it up until the whole image fades, especially in the blacks. Then drag the very top of the curve line to the left so that you block up some of the whites.

3. Open a Color Balance adjustment layer and add a bit of yellow and green. At this point, your picture should look as though it spent a few years in the sun.

4. Optional: You could also use a Burn and Dodge gray layer to add some lightening and darkening if you're trying to make it look as if some areas of the image had faded from more light than others.

5. Adding a bit of noise to the image tends to make it look a bit older as well. Before you do that, make a merged composite layer and add the noise (Filter→Noise→Add Noise) to the composite layer. That way, you can turn it off, blend it, change its opacity or blur it slightly just to tweak the variations on the age effect.

Figure 10-34. The picture on the right definitely looks as though it's been around for a while. If you want to make it look even more damaged, you could print it, mistreat it with creases, tears, and scratches, and scan it or take a picture of it.

Solarization

In the liquid darkroom, one of the all-time classic processing effects was solarization. It was done by giving the image half the development time, flashing the image with white light while still in the developer, then continuing development in the normal way. The result was that the image was half negative and half positive. More accurately, the image was part negative and part positive, depending on when and for how long you flashed the white light. The process for simulating that effect in the digital darkroom is

even more flexible, depending on the Blend Mode used, whether you change the exposure of the blended layers that make up the effect, and whether you do about a million other things. Of course, the most important of all these things is the tonalities in the image you're processing. Figure 10-35 shows the original and the result. The process to create this effect is as follows:

1. Open the image you want to solarize and duplicate it. All the steps in this routine will be performed on the duplicate to protect the original.

2. Press Cmd/Ctrl-J twice to make two duplicates of the image.

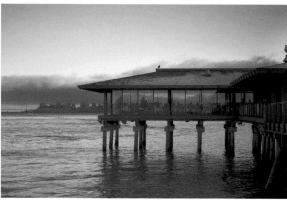

Figure 10-35. Although the photo on the left is well-exposed and adjusted, the "solarized" image on the right projects an "artier" feeling.

3. Select the top duplicate image (Cmd/Ctrl-A) and copy it to the Clipboard (Cmd/Ctrl-C).

4. Open the Channels palette and click the New Channel icon. A new Alpha Channel will appear at the bottom of the palette. Press Cmd/Ctrl-V to paste the image into the Alpha channel.

5. Go back to the Layers palette and select the top layer. Invert it (turn it into a Negative) by pressing Cmd/Ctrl-I. Now add the Alpha Channel to that mask and invert it, too. Choose Select→Load Selection and choose Alpha 1 from the menu in the Load Selection dialog.

6. As soon as the selection appears on the image (you're still on the top layer, right?) press Cmd/Ctrl- Shift-I to invert the selection (rather than its contents) and click the Mask icon in the Layers palette to add a new mask to that Layer. You'll notice that the mask is a Black and White negative of the original image.

7. Select the second layer from the top and add the Alpha 1 channel.

8. Group all these layers and drag the group to the original image. Name the Group Solarization. Your image layers should look like those in Figure 10-36.

Figure 10-36. The Layers and Channels for the solarized image for this exercise.

> **NOTE**
>
> *Frankly, the easiest and best method I've found for Solarization is in the Nik Color Efex filter set. You have a choice of either black and white or color solarization and four different methods for each. These filters come in several different sets and edition at different prices; go to www.niksoftware.com for more information.*

Monochrome Effects

You may have already noticed that when you see the rare black and white advertising photo, your attention is drawn to it immediately. In an over-saturated world that has become typical of digital photography, a simple monochromatic statement stands out more than ever. Well, black and white isn't the only monochrome technique. Some of the others are even more rare and attention-getting.

Infrared

One of the most charming effects you can get is infrared. Wedding photographers love it because a couple in traditional wedding garb running through a grassy hillside or forest look as though they've floated into a living dream. Their skin tones are absolutely smooth and all the vegetation is a snowy white. Moreover, although there are special filters for it, you can make an Action of this routine that will automatically convert any image you shoot to infrared. And because the Action uses adjustment layers, you can go back

after the fact and readjust the effect as you like it. In Figure 10-37, you see the color photo from with the infrared on the right was made.

Figure 10-37. The original image (left) and the monochrome infrared result (right).

You'll get the most dramatic results from a digital color image with highly saturated tones. You might even try the Velvia effect I suggested earlier in this chapter, as I did for the image on the left in Figure 10-37. Here's how to turn that image into the infrared result you see on the right:

1. Select all your layers and copy and merge the copies into a single layer at the top of the layers stack (Cmd/Ctrl-Opt/Alt-E).

2. Duplicate the merged layer by selecting it in the Layers palette and then pressing Cmd/Ctrl-J.

3. Change the Blend Mode of the Infrared layer to Overlay.

4. Name the duplicated Merged layer "infrared."

5. Go to the Channels palette and choose the Green channel. Use the Gaussian Blur filter with the Uniform box checked, to blur the green channel by someplace between 10 and 20 pixels. You'll decide the amount of blur to use based on the resolution of the image and your subjective feel for how "glowy" you want this infrared interpretation to look. This process is very destructive of the Green layer, but you can always duplicate the merged layers layer and try again. Wouldn't it be nice if we had a Blur adjustment layer? Ditto for Smart Sharpen.

6. Now use the Channel Mixer to make it look like infrared. Choose Channel Mixer from the adjustment layer palette. When the Channel Mixer dialog appears, check the Monochrome box, darken the Red and Blue channels, and then drag the slider for the Green channel all the way to the right. You can see the Channel mixer as it should be set and the result of how it made the original image look in Figure 10-38.

7. Now if you compare the original image to the finished one, you can see that this one is a bit dark. All you have to do to change that is to lower the Opacity of the Infrared layer until you like what you see.

Digital Photography Expert Techniques

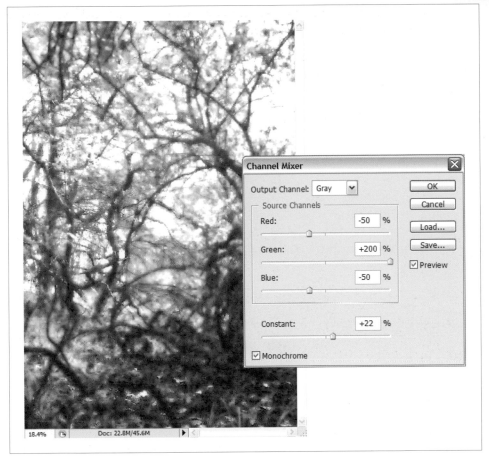

Figure 10-38. The Channel Mixer settings used for the infrared effect.

Duotones

Duotones look like enriched mono-chrome images because the highlights are printed in one color and the shadows in another. Photoshop lets you choose either colors from a standard color book or colors from the color wheel, so the possible interpretations are literally infinite. There's also a separate Curves control for each of the colors and adjusting these can have considerable influence on how much each color contributes to the final mix. In Figure 10-39, you see an

Figure 10-39. The image on the right is made from a mix of a light yellow for the highlights and one of the Pantone blacks.

NOTE

The process here is to make a duotone for a special effect look, but you will convert it back to an RGB image for printing purposes. Duotones (and more) are also used to mix spot colors that are being used for printing the rest of the page and the exacting mechanics for doing this are outside the scope of this book. Consult with your offset print shop.

original color reportage portrait and the final result of turning it into a duotone.

Here is the six-step program for making duotones:

1. Duplicate your image and keep the original open. Otherwise, the process you're about to undertake will obliterate your layer structure.

2. Convert your duplicate image to monochrome by using the Channel Mixer. There's no point in using it as an adjustment layer because the duotone processing will automatically flatten the image anyway.

3. When you've got the best-looking black and white you can get, choose Image Mode Grayscale and then immediately choose Image Mode Duotone. You'll see the dialog in Figure 10-40. Be sure the Preview box is checked. You definitely want to be able to choose your colors and curves interactively by being able to see an instant preview.

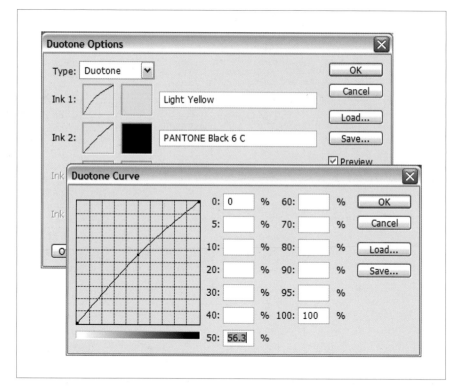

Figure 10-40. The Duotone Options dialog box.

4. The most full range duotones are said to use the lighter shade of color on top and the darker shade on the bottom of the dialog. So change the default Black for the first color to whatever the light color you want to choose should be. You do that by clicking in the color swatch. The color picker will appear instantly. Pick the color and shade you want to use

and click OK. Do the same for the second color swatch. When you like the result of the two colors you picked, you're very close to done.

5. Click the Curve box to the left of the color swatch. It's just a square with a diagonal line across it. You'll want to do this for each of the two colors. Start your experimentation by clicking in the center of the curve and dragging it up or down to make that color brighter or darker in the overall interpretation of the image. When you're happy with this, you're done with the duotone part. Just click OK.

6. Convert your image back to RGB, then copy it to the clipboard (Cmd/Ctrl-C) and select the original image and paste the duotone in as the top layer. Done de done done.

Sepia (or Any Other Color)

The sepia tone image you'd use for hand-tinting would be a bit weak and flat on its own—at least, for most subject matter. That's not a problem though. You can use the Monotone Option in the Duotone dialog to create a monotone in sepia or any other color. Pick the color from the color wheel. If you want a full range of tones, you'll want a dark shade of that color. It can also be a good idea to use the Levels adjustment layer on the result, so you can really get down to the blacks you want. In Figure 10-41, shows the result of converting the color photo taken by Paddy O'Connor from color to a blue monotone. Be sure to convert the image back to RGB before printing.

Figure 10-41. A dark blue was chosen from the Color Picker as the color for the monotone on the right.

Sharpening

The very last thing you want to do in your workflow is sharpening. In fact, you will likely want to do two different kinds of sharpening at the very end: effects sharpening and detail sharpening. Of course, you you've already done some sharpening to correct the resampling to bring your camera's Bayer Pattern color matrix back to assigning a specific 8- or 16-bit shade of color to each pixel in the image—initial sharpening. Hopefully, you were very careful not to overdo that sharpening. If you did, there will be some jagged and/or haloed edges. That's not a pretty sight. In fact, it can be downright disgusting.

You don't want to do any sharpening between then and now, either. Otherwise you'll have some of your processes softening the image and

others sharpening it and you'll never be able to find the most reasonable compromise.

So why do we want to do two types of sharpening now? Well, one of them isn't really sharpening. It's just a very dynamic illusion of sharpening—effects sharpening. The other is real image sharpening, but done in such a way that only important edges are sharpened and so that edge artifacts are either minimized or eliminated.

Effects Sharpening

Effects sharpening uses the combination of a few Photoshop manipulations to make small and similarly colored details—such as strands of hair or leaves of grass in a landscape—pop (see Figure 10-42). I'm sure you've seen prints that make people's jaws drop because of what seems to be a small detail rendered with exquisite sharpness. Chances are excellent that what you really saw was an image made by someone who understands effects sharpening.

Figure 10-42. On the right, effects sharpening using the Overlay Blend Mode and High Pass sharpening. The end result makes it seem that you could feel the texture if you rubbed your fingers across it.

Here's the super-simple routine for doing effects sharpening:

1. Start by not looking for any sharpening filters. Usually, you want to sharpen only the parts of the image that have the most detail so those

areas will draw more attention. Start by putting a feathered selection around those areas you want to "super sharpen." In Figure 10-42, those areas were the tree branch and the weeds protruding from the lake.

2. Press Cmd/Ctrl-J to lift the feathered selection to a new layer.

3. Make sure the new layer is still selected and then choose Overlay as its Blend Mode. The colors inside the selection will suddenly look eerily oversaturated and too contrasty, but don't worry about it.

4. Double-click the Zoom tool to enlarge your image to 100 percent. Choose Filter→Other→High Pass. The High Pass dialog will appear, as seen in Figure 10-43.

Figure 10-43. The High Pass filter dialog.

5. Be sure to check the Preview button because you want to adjust the Radius slider according to what you judge to be the best effect in the image window. When you like what you see (and there are no halos) click OK.

Using Smart Sharpen

Until Photoshop CS2 came along, with the new Smart Sharpen filter, I had become addicted to using a couple of third-party filters for preprint sharpening. Frankly, I still prefer them in some images. However, Smart Sharpen is such an improvement over the Unsharp Mask filter that I often find it's quicker and easier to use it than the competition.

Before you do any overall sharpening of an image, make sure you convert your Background layer to an ordinary layer, select all the existing layers, and then press Cmd/Ctrl-Opt/Alt-E to merge them all and send the merged result to the top layer. You can see the resultant layer stack in Figure 10-44, along with the image that resulted.

Figure 10-44. Overall sharpening using the Smart Sharpen filter.

Special Purpose Processing

11

This chapter is about three highly useful techniques: image stitching, extended dynamic range images, and photopainting. All of these techniques can extend your marketing and creative capabilities significantly. They have also helped quite a few photographers establish a unique look and style. Best of all, none of these techniques absolutely require any special equipment—unless you consider a tripod to be special.

> **HOW THIS CHAPTER FITS THE WORKFLOW**
>
> ## Use Duplicates for Complex Projects
>
> All of the processes in this chapter should be performed on a duplicate of one or more images that you've brought to this stage. Two of the three processes discussed here actually require multiple images (or multiple interpretations of the same image). For that reason, you may want to go back and re-interpret the contributing images so that they'll match or blend to maximize the desired effect for one of these processes. You'll learn how to easily do that without compromising what you've already done to the contributing images. Having said all that, there are some exceptions to the duplicate image requirement. Panoramas and Photoshop HDR images that are taken directly from RAW files don't really need that backup, since the RAW files themselves are indestructible.

Stitching Images for a New Point of View

One of the best ways to catch a viewer's attention is with a panoramic view of a subject, whether it is a close up of a beached whale body or a view of the Grand Canyon. One of the reasons for this is that panoramas have become much easier to create since digital photography has come along because there's no requirement for an expensive specialized camera. Also, you don't need to use an expensive, super wide angle lens on a large format camera to get a large, high-resolution image.

Without changing its look much at all, Photoshop's built-in panoramic stitching software has become much more versatile and much more accurate with

each new version of Photoshop. My one argument with it is that it doesn't always blend the images together as invisibly as I'd like, but I'll show you a way you can usually work around that, too.

Taking the Best Shots for Panoramas

Once again, these images will turn out best if you plan ahead and capture the best content before you even get to Photoshop. Before I get into the details of how to make the Photomerge subprogram work, you need to know that there are some special techniques required for shooting a panorama if you expect the end result to look anything but amateurish:

Get a tripod or pan-head that will let you rotate your camera on the absolutely level

> If your tripod twists, rocks, or slants as you pan from one side to the other, the image will have to be cropped quite a bit. Furthermore, you may have to take the extra trouble to align the images manually after placing them on separate layers. You can get away with cheap and flimsy tripods when shooting single frames by just making sure the camera doesn't shake when the shutter is depressed or while the shutter is open. When you shoot panoramas, you want to make sure the camera doesn't rock and roll between exposures.

Rotate the camera on its optical axis

> Special pan heads made for shooting panoramas make it possible to mount the center of the optical axis directly over the pivot point of the tripod thread. Panoramic heads that allow you to mount the camera vertically are best, since there are more photos for a given area of arc. This makes for cleaner stitching and higher resolution.

> The optical axis is not the tripod thread. It is the exact point at which the image becomes inverted from left-to-right and top-to-bottom as it passes through the lens. Rotating on this axis is especially critical if there are objects, such as railings or plants, in the foreground of the image.

Put a level in your camera's hot shoe

> Then you can make sure the panorama is not tilting as you rotate. Just rotate the camera as far as needed for the panorama you want and make sure the level bubble doesn't change position.

Use a wide angle lens

> This isn't a strict rule, but your panorama will require fewer stitches and will show more of the scene from top to bottom. On the other hand, the lens shouldn't be so wide angle that it has lots of barrel distortion. Someplace between 21mm and 35mm in focal length generally works well.

Be very careful not to zoom in between shots

Zooming means that Photoshop also has to try to figure out how to rescale the image and you may have to do it manually or you may have to crop the final image more than you'd like.

Overlap each shot by about 30 percent on each side

If you're lucky enough to have a "rule of thirds" grid that fits over your preview monitor, it's much easier to judge overlapping. Also, many panorama pan heads have adjustable click stops that alert you when you've rotated exactly the right amount. If you're thinking that a panoramic head is worth the investment, you're right—you'll have much better luck in creating successful stitched panoramas.

Keep your exposure consistent from frame to frame

Do not use any of your camera's automatic modes. If you do, the exposure will change from one frame to the next. This makes it much harder to blend the frames smoothly from one frame to the next. Instead, put your camera in spot or center metering mode, aim the camera at the most important part of the panorama, and take a reading. Then switch to M(anual) mode and compensate the exposure reading you got from the auto reading so that the f-stop is around f-11 for the best compromise between depth of field and sharpness.

> **NOTE**
>
> *More expensive lenses can be stopped down as low as f-16 without loosing significant sharpness. Also, thanks to their exaggerated depth of field, pocket cameras can be excellent for panoramas, but only if they provide access to manual exposure.*

Rotating at the optical axis

If the panorama you're shooting requires that you stay right on the optical axis as you rotate, get a panoramic pan head that works with any camera. I can use my panorama head either on my pocket camera or DSLR.

Set up the camera and the pan head in front of two vertical objects that are a few feet apart. I usually do this in the studio with two light stands. I place the stands so they're centered in the frame. Then I mount the camera on the panorama head (*not* the tripod's pan head, but the accessory shown in Figure 11-1). Typically, the optical axis is going to be about one-third the distance between the tripod thread and the outermost end of the lens. Then I put the camera and the panorama head on the tripod and aim and level the camera so that the closest light stand (or other vertical object) completely blocks my view of the other. Then I rotate the camera. If, as I rotate, I begin to see the second lamp stand, I'm off-axis.

Keep testing by moving the camera back and forth on the panorama head until no amount of rotation reveals the second object. After a few times doing this, you'll become instinctively good at it. If you always use the same fixed focal length lens for your panoramas, you'll only have to do this once per camera, provided you mark and label its place on the panorama head. If you use a zoom lens at varying focal-lengths, you'll have to do it every time you set up a shot or make sure nothing in the scene is ever any closer than 10 to 20 feet away.

One more thing: you want to orient the camera vertically in respect to the direction of the panorama whenever possible. This means higher resolution from the top to the bottom of a strip, less rotational distortion from frame to frame, and smoother blending from frame to frame. The diagram in Figure 11-2 illustrates this.

Figure 11-1. Diagram of optical axis test setup.

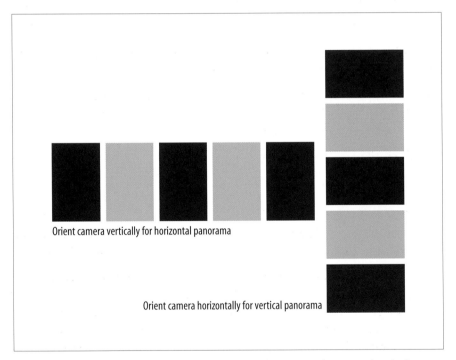

Orient camera vertically for horizontal panorama

Orient camera horizontally for vertical panorama

Figure 11-2. If you have a panoramic pan head that allows the camera to be mounted vertically over the optical axis, you will get smoother and more precise stitching in vertical panoramas.

One Dimensional Versus Two Dimensional Panoramas

The panoramas that most of us are used to looking at consist of only one horizontal row of images. However, Photomerge will now let you stitch vertically as well a horizontally. So you can have a panorama that consists of multiple rows. You will need to drag most, if not all, of the images into place. Figure 11-3 shows you the images used to make a 1D panorama and the completed panorama after it has been stitched in Photomerge. A 2D image would have one or more rows of images above and below that center row.

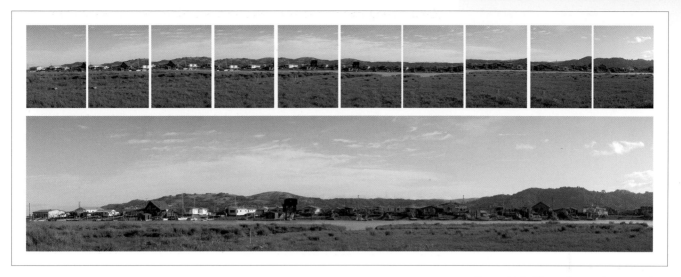

Figure 11-3. The component images and complete panorama.

Here's how to stitch a 1D panorama in Photomerge (start with Step 1 if you shot your panoramic in RAW format; if you didn't, go to Step 4):

1. In Bridge, select all the images for the panorama and press Enter/Return. They will all open in Camera Raw. Select the thumbnail for the image in the middle. Keep it selected.

2. Click the Select All and Synchronize buttons. When the Synchronize dialog appears, look to make sure that all the boxes are checked and press Return.

3. Choose the image that's closest to center and make your RAW adjustments. You have just ensured that all frames will be processed the same way, so click the Open button. All the images will open in Photoshop.

4. Choose File→Automation→Photomerge. A small Photomerge dialog appears with the names of all the files that are currently open in Photoshop. If you see any that you don't want to include in the panorama, select them and then click the Remove button. If you handheld the panorama shots, uncheck the Attempt to Automatically Arrange Source images button. Otherwise, leave it checked and press Enter/Return or click OK.

5. The Photomerge application dialog will appear, looking something like what you see in Figure 11-4. If you left the Attempt to Automatically Arrange Source images button off in the previous step, the photos will all be arranged in the window at the top. If you checked the Automatically arrange box, they'll look like the best Photomerge can do at automatically arranging them. Actually, there's no harm in letting Photomerge do it automatically all the time. If you don't luck out, you can always drag the images into the frames bar at the top and then place them yourself. You can even press Cmd/Ctrl-T to correct perspective on

an image if you can't quite get the edges of objects to match. You can also click the Rotate tool if you tilted the camera too much as you were panning.

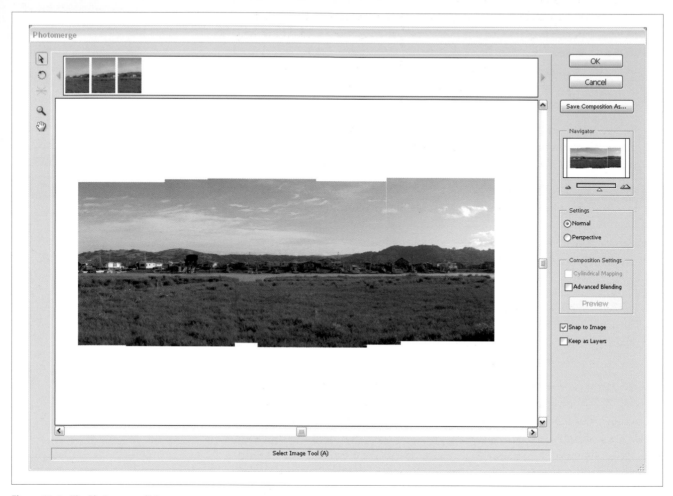

Figure 11-4. The Photomerge dialog.

6. You can try the Advanced Blending if you like. Frankly, most of the time I find it makes a big mess. Thankfully, you have to click Preview to see what it does and if you don't like the result, you can click an Exit Preview button.

> **NOTE**
>
> *If you're having trouble with getting interframe blending to look smooth, check the Keep as Layer box. I can often make very smooth blends after the image opens in Photoshop with each image on a separate layer. I just choose the Move tool and Cmd/Ctrl-Opt/Alt-click the portion of the image that's on the layer I want to fix. Then I choose the Eraser tool and a very large and soft brush to do my blending. If that doesn't do the whole job, I'll blend seams or get rid of shadows with the Clone tool after flattening all the layers.*

Here's how to stitch a 2D panorama in Photomerge:

1. Shoot the frames as suggested above. If shooting in vertical orientation doesn't show enough of the scene from top to bottom, you may have to add a row or two above. Use playback mode on your camera and move back to the first shot in the series. Line up your view find frame with that frame and then tilt the tripod up just enough so that the top and bottom frame overlap by about 30 percent. Be sure to lock down the height of the camera's tilt and then shoot another row of images just as you shot the first.

2. When you load the frames, you probably won't want to have the program stitch them automatically. Instead, put the middle row together first, then the one above it, then (if there is one) the one below it.

3. Again, if you're having trouble with blends, check the Keep as Layers box and try a bit of hand retouching and layer blending.

Vertical Versus Horizontal Panoramas

We usually think of panoramas in the horizontal, but imagine needing to shoot a tall building from just across the street. You simply don't have room to back up far enough to get the whole building into the picture. Besides, even if you could, you might not have enough resolution in a single frame to make the six-foot tall poster you'd like to make of that building. It's time to shoot a vertical panorama.

It's tougher to find a panorama pan head that rotates vertically on the optical axis, although some can be used that way, especially since you want to shoot the vertical with the camera in a horizontal (landscape) position. The good news is that most verticals don't require more than a few frames. If you pan vertically more than about 45 degrees, chances are the end frames won't show anything more than blank sky or pavement. Staying on optical axis is tougher, but the chances are better you won't have foreground objects to worry about. Also, as long as you know what the limitations are, the better your chances for success at working around them.

I've often found myself in situations where I needed to show something like an office building or a waterfall and simply didn't have time to set up a tripod. So I've just been very careful to stand absolutely rigid and to shoot the middle image first. I then tilt up twice by about 20 degrees and take a shot with each tilt, then go back to the center and tilt down twice. Because I know there's a good chance of error and I'm shooting digitally and not "wasting" film, I shoot this same sequence at least twice—maybe four times. Then I have a much better chance of finding the three to five images it will take to make my "vertirama." The stitching procedure is the same. However, if automatic stitching doesn't work, try placing the images yourself. Also check the Save as Layers box. The image in Figure 11-5 required that I do both to keep from getting "double exposures" in the tree trunk on

the left and for the head of the guitarist. The problem was easily resolved by saving as layers and then doing my own blending with the Eraser tool.

Figure 11-5. You could get this same shot with a very wide angle lens, but you'd probably also get more barrel distortion and about 70 percent less resolution.

Matrix Stitching for Super High Resolution

Did you know that as long as your subject doesn't move, you camera has unlimited resolution? Just do what you've been doing previously in this chapter, and then stitch the pieces together. There's one instance where the method of shooting described won't work, however: when you're shooting 2D artwork for very large and very high-resolution printing or for use on something like a billboard.

The trick here is that you have to keep the camera parallel to the artwork for each of the shots in the stitch. In other words, you are shooting pictures in rows and columns and with the camera at the same distance from the subject in each of the cells of that matrix. To do this:

1. Mount the artwork on a flat wall and light it by placing two very soft (to minimize spectral reflections) light sources (umbrellas or lightboxes are my favorites) equidistant from the center of the image.

2. Use a polarizing filter to minimize the chance of any lighting "hot-spots" on the 2D artwork. In any case, don't shoot that artwork from behind glass unless you have no other choice.

3. Place a strip of tape across the floor at exactly the distance from which you'll be shooting the art and make sure that the strip is absolutely parallel to the surface of the artwork.

4. Set up to shoot the center row of the artwork. Take each shot after moving the tripod or (better) camera stand.

5. Go back to your original start position, raise the camera (preferably with the tripod's center post) so that it frames the top portion of the image, and then repeat the procedure for the top row. When you've finished that, go back to the start position, lower the camera for the bottom row, and repeat the side-to-side shots.

6. Open all the shots in Photoshop and choose File→Automate→ Photomerge. The Photomerge dialog opens. Make sure Open Files is the menu item already chosen from the Use menu. If that's not it, change it. Click OK.

7. The Photomerge dialog will open and, believe it or not, the program will automatically merge all three rows perfectly, as long as you've followed the instructions for shooting (Figure 11-6).

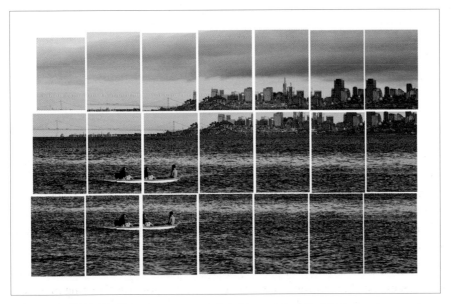

Figure 11-6. This is how Photomerge arranged all the images automatically.

8. You may notice a couple of white streaks (Figure 11-7). Those could be retouched, but one hates to fool with another's masterpiece if you're

being hired by a museum, gallery, or artist. However, when I checked the Save as Layers box, those lines disappeared and all I had to do was flatten the image.

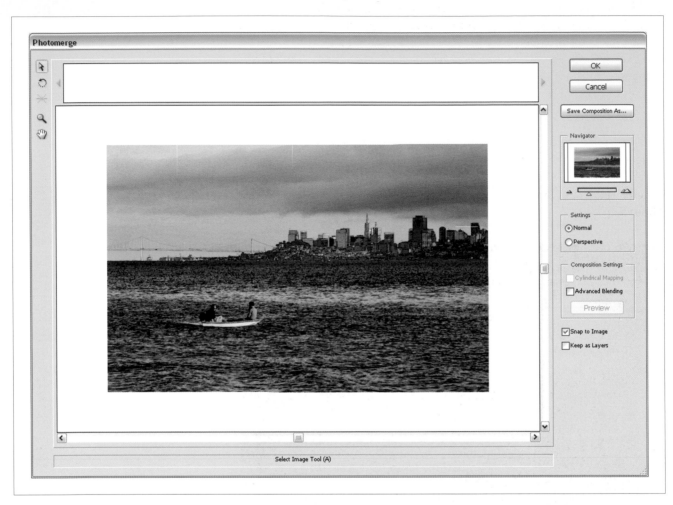

Figure 11-7. The final Photomerge image.

Making a Montage with Photomerge

You can make a montage with Photomerge and save quite a bit of time. Just open all the images you want in the montage, according to the previous processes in this chapter. Be sure to uncheck Snap to Image. Then position and rotate the images as you like and then do one of two things: check the Advance Blending box or the Keep as Layers box. If it's the former, you'll get a strange blending of all the images. If you keep as layers, you'll be able to resize and transform the individual layers, give them layer styles, do you own feathering, and use any of the layer Blend or Style modes.

Extending Dynamic Range

We've already covered some techniques for extending dynamic range (HDR) in Chapter 8, however, here's the skinny on three different ways to do it. You'll find all of them useful for different reasons. HDR images are, or can be, a bit outside of the normal workflow. They are often used as the background layer of an image in which you are going to make further adjustments.

The Basic Manual Method

You can make your own EDR image from any two (or more) flattened images. Ideally, these will have a couple of different f-stops of exposure difference. Figure 11-8 shows an EDR image composed by exporting two different exposures from Camera Raw, then combining them manually in Photoshop.

Figure 11-8. Two different exposures of the same Camera Raw file were used to get the beautifully balanced image on the right. There is immense detail in both extreme highlights and shadows. Also, there's much less noise in the shadows and color shift than when using the Shadows/Highlights command on this same image.

Camera Raw images have such a huge dynamic range that the human eye can't see it all. I So I use the Camera Raw adjustments to create that part of the dynamic range that is visible to make the picture look as much as possible like what I want it to look. But sometimes—particularly in highly textured landscapes with big skies—I want to simulate a much wider range, so that I can see detail in just about everything.

One of the big advantages of using two Camera Raw interpretations is that there's no need to worry about moving subjects and you don't need a tripod. That's because the content of both images is exactly the same in every respect except brightness range interpretation.

The technique I use is to create two interpretations of the same image. I can easily create exposures that are as much as two stops apart if I'm working with a 12-bit image, often more. Even a 10-bit image will give me the equivalent of two exposures that were made 1.5 steps apart. Here's how it's done:

1. Select the image whose range you want to extend in Bridge and press Enter/Return to open it in Camera Raw.

2. Make adjustments that will allow you to see all the detail you want in the highlights. Although it's wisest to be careful to exposure so that you don't absolutely block highlights, you'll be amazed at how much you can "bring back" if you drag the exposure slider until the highlight end of the Histogram is inside its frame. Then adjust the other sliders so that you still get as much overall detail as possible without affecting the highlights. When you're done, click the Open button.

3. Go back to Bridge. Your image is still highlighted, so press Enter/Return again. The image reopens in Bridge. Make your adjustments so that all the darker areas of the image show a reasonable amount of detail. When you're done, click the Open button.

4. When the brighter exposure opens, copy and paste the entire image into the darker image. Label the layers Highlight and Shadow for future reference.

5. Open the Channels palette and press Cmd/Ctrl-Opt/Alt and then click on the RGB channel. Everything brighter than 50 percent gray will be selected. Now you have to decide about feathering. I always run a test to see how minimal or no feathering will look. Just hit the Backspace/Delete key and then press Cmd/Ctrl-H to hide the marquee or Cmd/Ctrl-D to delete it. If the image looks good, rename it to reflect the stage it's been through and save it.

6. If the image looks solarized or the highlights and shadows don't blend naturally, press Opt/Alt-Cmd/Ctrl-Z several times until you get back to the original, undeleted selection. Now choose Select→Feather and enter a pixel radius of around 200 pixels. The exact radius will depend on the resolution of your image. The criteria: if you see a halo when you delete the contents of the selection, go back and feather over a larger radius. Otherwise, you're done.

The Miranda Scripts for Merging Two Images

Fred Miranda, a photographer based in Los Angeles, has put considerable time into developing a whole series of scripts for digital photographers. These

routines are either in the form of Actions or, more recently, converted to Adobe Scripts that run under the File→Automate command. Figure 11-9 shows the image as it was originally exposed by Camera Raw and after the merge of one image that Camera Raw exposed for the detail in the falls and another that was exposed for the details in the trunks of the redwoods.

Here's the process for Fred Miranda's DRI Pro script (see Figure 11-10):

1. Shoot or Camera Raw process a pair of images that are about two f-stops apart. When you process or winnow them, be sure to name them and to indicate in the name which image is over- and underexposed.

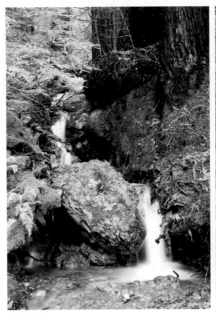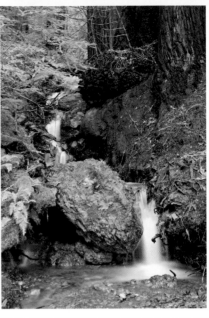

Figure 11-9. The auto-adjusted Camera Raw image and the result of merging two Camera Raw exposures in DRI Pro (right).

2. In Photoshop, choose File→Automate→DRI Pro. The DRI Pro dialog, seen in Figure 11-10, will burst upon you.

3. Click the Browse button for the underexposed image. Use your OS's normal file navigation system to locate the file and select it.

4. Click the Browse button for the overexposed image. Use your OS's normal file navigation system to locate the file and select it.

5. Click the DRI Options button. It makes the right guess most of the time. If you see a highlight halo around the highlight objects in the resultant image, simply press Cmd/Ctrl-Opt/Alt-Z until you get back to the dialog and then click the DRI Radius Tweak button. You'll then need to choose a radius from the Choose Blending Radius menu and may have to repeat this operation several times until you find the right radius.

Figure 11-10. The Fred Miranda DRI Pro dialog, ready to rock.

Using Photoshop's Merge to HDR Script and the Exposure Command

The most advanced method of creating a combined high or expanded dynamic range image is the Photoshop HDR command, which was greatly enhanced in CS2. It combines images mathematically into a 32-bit image whose dynamic range far exceeds anything that your sensor could record or that your eye can see.

Shooting for HDR

Shooting for an HDR image so you get the best result requires following a few rules. Don't auto-bracket unless you *have* to handhold the shot. Besides, auto-bracketing only works on cameras that let you shoot at least three shots, and HDR prefers five to seven shots. If you want to use auto-bracketing, you have to use a camera that gives you at least a full f-stop between bracketed shots. You must also be able to auto-bracket with the camera in A (Aperture Priority) mode. *Never* change f-stops or ISO settings between bracketed shots because the depth of field and noise must remain consistent between shots.

> **NOTE**
>
> *There isn't much point in shooting RAW files for HDR interpretation unless you just want to open up your interpretation options. It's easy to shoot seven frames for an HDR at one stop apart without using a significant portion of the space on your memory card. If you try to HDR multiple RAW interpretations, the program will just tell you there's not enough dynamic range. If you combine JPEGs—particularly if there are five or more—they will be combined into a 32-bit file that potentially has far more dynamic range than a single RAW file.*

Here's what I recommend you do almost all the time: put the camera on a tripod and use a cable release or remote. Take an Aperture Preferred spot meter reading from a gray card and note the settings. Set the camera in manual mode. Now, set the aperture the same as it was set for the Aperture Priority shot. Set the shutter three settings slower than the reading recommended. Now shoot, reduce the shutter speed by another full stop and repeat four more times.

If you want to apply HDR to a scene that doesn't move too quickly but may not remain static long enough for the routine suggested above, then use a camera that lets you bracket at least three shots at least one full f-stop apart. Place the camera in Aperture Priority mode and set your aperture to give you the desired depth of field. Then set the camera to do a bracketed sequence, brace yourself, and let the camera fire all three shots. Different camera models vary wildly in their bracketing versatility. There's a fair chance your camera may not meet all these qualifications.

> **NOTE**
>
> *One of the giant advantages of using the Merge to HDR command is that you get the same benefit you get from other HDR merging methods—less noise due to the fact that the images are stacked atop one another—so grain from one layer fills in empty spaces between grains in other layers.*

Merging to HDR

Using the Merge to HDR command seems complex at first, but is actually quite easy. You can do it from either Photoshop (Automate→Merge to HDR) or from Bridge (Tools→Photoshop→Merge to HDR). Open three to seven images at the same time (or select them in Bridge). A simple dialog appears that lets you browse to choose the files you want to merge, Open File, or a folder of images. You can then opt to click a box that offers to Auto Align the files. If you handheld your bracketed shots, I suggest you check this box no matter how careful you were to keep the camera from moving. Figure 11-11 shows three images that were shot with a Canon Rebel XT's Sequence button turned on and with the bracketing set to +/- two full stops. On this camera, the sequence is limited to three shots when in auto-bracket mode. The camera was set in Aperture Priority mode so as to keep the depth of field consistent. You should never change your aperture when bracketing for HDR images, whether you're going to use this brilliant new script or use either of the methods described above.

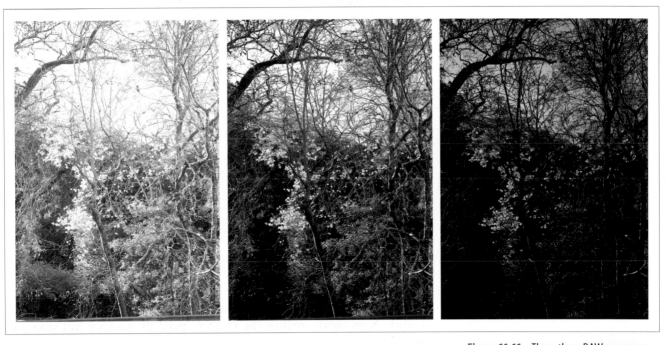

Figure 11-11. These three RAW exposures were bracketed two stops apart in Aperture Priority mode.

> **NOTE**
>
> *If you shot your HDR sequence as RAW images, open them all at once in Camera Raw, select them all, and Synchronize Everything. Then turn off all the auto selections. Otherwise, you'll get three versions of the image that have been automatically adjusted to very similar tonal ranges.*

HDR Merge behaves a bit differently, depending on whether you do it from Bridge or Photoshop.

- If you HDR Merge from Bridge, there's no checkbox to insure a match in handheld shots. That's because there's no dialog at all until after the images are already merged.

- If you do the HDR Merge from the Photoshop menu (rather than Bridge's), a preliminary HDR Merge dialog provides a checkbox that asks if you want the program to Attempt to Automatically Align Source Images. If you shot the images handheld, be sure to check this box. Also, if you shot the images handheld, *do not* merge them from Bridge unless you want to see repeated edges that look a bit like this was a special effects filter's stroboscopic motion blur. This preliminary HDR dialog is shown in Figure 11-12. You can adjust a wide overall brightness range by dragging the slider until you see the values you want.

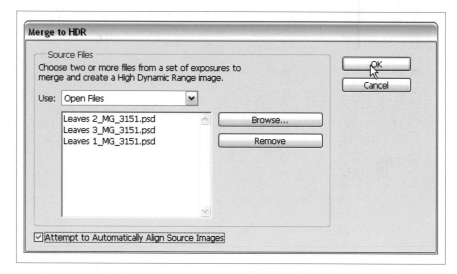

Figure 11-12. The Preliminary HDR dial.

If you shot the original images in Camera Raw, select all the images in the sequence in Bridge and choose Tools→Photoshop→Merge to HDR. All the images will open as they were originally shot, without adjustments, in the HDR dialog and be processed automatically. Figure 11-13 shows the result of the merge to a 32-bit file, after the initial adjustment of the slider in the HDR Merge dialog. Dragging to the right darkens the highlights and, to a lesser degree, the rest of the image. Don't worry; you can refine this interpretation using the Exposure command when you convert the image to 16- or 32-bit mode.

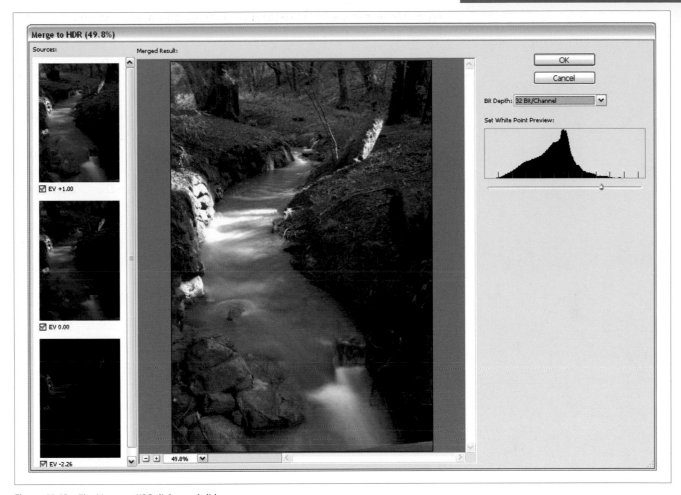

Figure 11-13. The Merge to HDR dialog and slider.

If you do the HDR Merge from Photoshop, the Photomerge dialog provides a checkbox that asks if you want the program to Attempt to Automatically Align Source Images. If you shot from a really steady tripod and there's no chance the camera moved at all between frames, then leave the box unchecked. It takes a lot of extra time to attempt to align images manually.

Using the Exposure command

You now have your file in 32-bit format. Be *sure* to save it in this format so that if you want another interpretation, you don't have to do the merge all over again. However, there is so much brightness information in this file that it makes Camera Raw look impotent. Of course, you can't use this file as it is because nothing known to man can see this huge brightness range. First, you have to convert it to a 16- or 8-bit file. When you click OK in the

Merge to HDR dialog, the Exposure dialog immediately pops up to the screen, as shown in Figure 11-14.

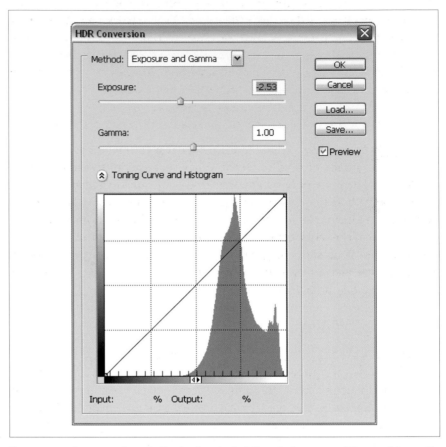

Figure 11-14. Be sure you have the Preview box checked. Drag the Exposure and Gamma sliders until you see the desired tonal values in the merged image.

> **NOTE**
>
> *You can use the Exposure dialog on any image and, especially in conjunction with a Curves adjustment layer, exert a huge amount of control over the interpretation of highlight and shadow brightness and over the overall contrast of the image. However, you're much more likely to get noise in the darker areas of the image and to experience highlights that show no detail.*

You have four choices on the HDR Conversion dialog's Method menu: Exposure and Gamma, Highlight Correction, Equalize Histogram, and Local Area Correction. I find Local Area Correction the most useful most of the time because it lets you use the Curves dialog to match the Histogram.

Converting Photos to Paintings

There are as many ways to turn a photograph into something that looks more like a painting as there are little round O's in a truckload of Cheerios. So I'm not going to cram a book of those techniques into this chapter. However, I will tell you that, like most everything else in this chapter, you should start with a layer that is a consolidation of all the other layers you've created up until now (Cmd/Ctrl-Opt/Alt-E, remember?). Since it's a fair likelihood that you'll want to somehow blend or merge your "painting" with your photo, it's also not a bad idea to make a copy of that merged layer.

Although I've just told you that there are more ways to make a painting from a photo than grains of sand in Death Valley that applies to the individual techniques. There are only two main methodical categories: natural media brushes and Photoshop-compatible plug-ins. Both of these categories are available from inside Photoshop and both are available in far more sophisticated versions from competitive or third-party vendors of both independent software and Photoshop plug-ins. Of course, you can also mix natural media brushes and filters, which may be the most efficient way to produce something that actually looks like a painting.

Using Plug-in Filters

Plug-in filters are the most accessible way to make a painting from a photograph. In fact, it's possible to do a fairly credible job by simply running any of a number of filters on a copy of that merged layer. Since the only way to find out which of these will work best for the image you have in mind is experimentation, there's no point in even going in to all the possibilities. Figure 11-15 shows you an image before and after filtering with the Photoshop Colored Pencil filter.

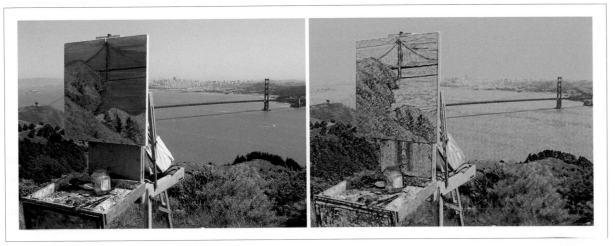

Figure 11-15. The figure on the right definitely looks more like a painting or drawing than a photograph, but would only momentarily fool most into thinking it wasn't some sort of digital trick.

The biggest problem with single built-in Photoshop filters is that they've been around for so long that their effects tend to look cliché and fake. One way to get partially around that is to combine filters using the Filter Gallery. In Photoshop CS2, the Filter Gallery opens every time you use a filter. Then you can combine the effects of multiple filters as though they were one. This process explains how to use a single filter and combine the effects in the Filter Gallery.

1. Open your image and make a merged layer of it.

2. Choose Filter→Filter Gallery (if you choose any filter that's in the filter gallery, it will open in the Filter Gallery anyway, see Figure 11-16). If you have already used a filter since you last opened Photoshop, it will already be the one (or ones) loaded. If not, pick a filter from any of the menus by clicking the down arrow key for that menu. You'll see a preview thumbnail of the effect that each filter will create. As soon as you

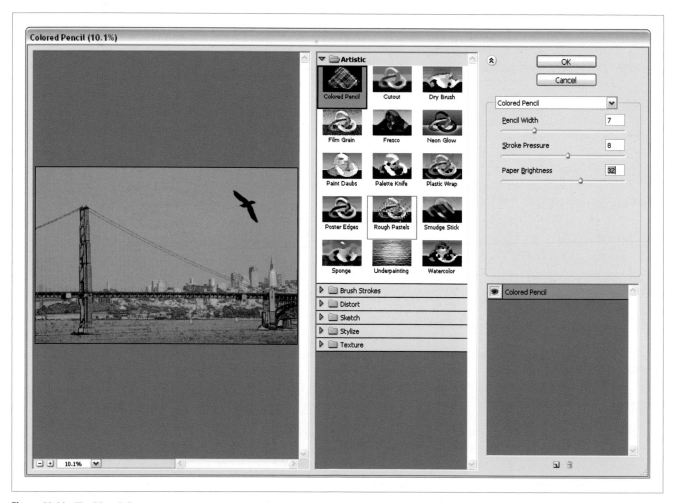

Figure 11-16. The Filter Gallery.

pick a filter, it will start to process the image. You'll see a progress bar moving at the very bottom of the image preview window.

3. In the far right column you can see the Filters menu and the adjustments sliders. Some filters also have a texture menu and sliders. Make your adjustments and wait to see the results in the preview window. You can switch from one magnification to another by using the Zoom menu at the bottom of the screen. I like to switch from Fit on Screen, where I can see the whole effect to 100 percent, where I can see how each stroke looks.

4. If you want to add another filter, simply click the New Filter icon at the bottom of the righthand column, then either choose another filter from the thumbnail menus or from the Filter menu at the top of the righthand column. The name of the new filter and an On/Off icon will appear in the gray window at the bottom of the column. Follow the same procedures for the new filter as in Step 3.

You can add as many filters as you like, as well as change the order in which they are processed, which changes the look of the end result. To change the processing order, simply drag the filter name in the window at the bottom of the righthand palette. You can see the result of combining three filters in Figure 11-17.

Figure 11-17. Two filters have been combined in the Filter Gallery to produce the effect on the right. At least it's a little less cliché.

Combine filters by erasing through layers

The results from combining filters will look more natural if you copy the merged layer two or three times, probably for the object of importance, less important background objects, and the background itself. Put the foreground object (subject) layer on top, less important but not too distant objects in the middle, and the layer for background objects at the bottom (this is *not* the Photoshop Background layer). Choose the Eraser tool and

select the top layer, then erase or partially erase (lower the eraser opacity) everything but the subject. If you're in a hurry, you could make a feathered selection and then hit Backspace/Delete. Now select the middle layer and erase all of what you want to be the background objects. Finally, select each layer and use either a different filter or very different size and intensity settings for the same filter for each of the three layers. Figure 11-18 clearly shows that this is the superior method for semi-automatically creating something that looks like a painting.

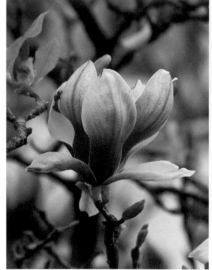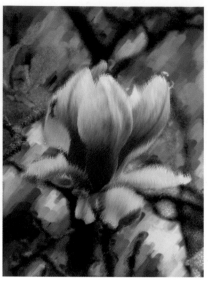

Figure 11-18. The image on the right is the result of using Xaos Tool's natural media filters to paint each of three layers with a different stroke and size. The result bears more resemblance to techniques a real artist might use.

> **NOTE**
>
> *You don't need to have a texture in a filter to make the "painting" look as though it were printed on canvas, watercolor, or sandstone. All of those textures are available in Photoshop's Lighting Effects filter, which you can add to the end result by copying the filtered image(s) to a new (merged?) layer.*

Using Natural Media Brushes

Natural media brushes actually don't exist in the digital photography world; they are digital techniques that can do an amazingly good job of imitating the brushes and media used in traditional painting. In fact, they can be so good at it that many traditional painters and illustrators have switched over to digital so that they can offer their clients multiple interpretations of the same painting. A good many photographers—particularly portrait and wedding photographers—have also found digital painting to be a highly profitable additional service.

You can do "natural media" painting in Photoshop or you can opt to do it quite a bit faster and more believably by using Corel Painter. Frankly, I find the "junior" version of Painter, Painter Essentials 3, quite adequate for my needs. This software is free with the Wacom Graphire tablet, which comes in a 4×5-inch version that costs only $10 more than the software.

Using Photoshop's natural media brushes

Unbeknownst to many photographers, you can choose brush shapes in Photoshop and other options that allow you to come pretty close to imitating natural media brushes. So if you wanted to create a painting from a photograph that looked something like it was painted in oils or watercolor, you can do it. Merge a copy of your layers so you can paint or clone the end result from the original onto a new layer. To do this, duplicate the image,

choose the Brush tool, and then use the Brush Presets menu in the Options bar to load natural media brushes. I'm not very good at using Photoshop for this purpose, but here's how I usually go about it (getting good at it is mostly a matter of practice, practice, practice).

1. Open the image you want to paint, make a consolidated layer so you'll have the tonal values and details from all the layers and then duplicate the image. You're going to use the original image for picking up color, as though it were a traditional artist's color palette.

2. Select the Brush tool and go to the Brushes palette in the Options bar (the icon on the right end of the bar that looks sort of like a jukebox menu). Click it and a menu drops down. From the Brushes Palette menu, choose Natural Brushes and click OK when you're asked if you want to replace the current brushes.

3. Go to the Brush Presets and make sure you have Shape Dynamics checked (unless you don't have a pressure-sensitive pad—in which case you should probably forget trying to imitate natural media except in filters such as Xaos tools or in Painter by doing automatic cloning).

4. Check any of the other Brush Tip shape boxes and adjustments to give you the effect you want.

5. Go to the original image and click the color you want to start painting in.

6. Go to the target image and create a new, blank layer. You're going to use the photo below the blank layer to "trace over" with your brush.

7. As you paint, keep picking up color from the original image. Press Opt/Alt and place the cursor on the color you want to make the foreground color. Then paint all the strokes for all the areas you want in that color.

8. When you have the basic painting painted, temporarily lower the opacity of the painting layer to 50 percent so you can see the details from the original photo. If you see small details that you'd like to add to the painting, make your brush smaller, pick up the right colors from the original, and paint in the small details.

9. When you're done, return the painting layer to 100 percent opacity. Then copy and paste it into the original image. You then have both versions of the image in the same file.

Using Corel Painter or Painter Essentials

Corel's Painter and its "junior" Painter Essentials are the de facto standards in software that imitates the tools, brushes, and media used by traditional 2D artists of all stripes. If you're familiar with these programs, you already know what I'm talking about and how to use it. If you've never explored this area, you probably should. There will always be times when one of

your photographs could be the idea basis for some sort of non-objective illustration.

What I'd recommend for starters is Corel Painter Essentials (see Figure 11-19). If you own a Wacom Graphire pressure-sensitive pen and pad, you already have this program. If you don't, the pad will make it much easier to do a score of things that don't have anything to do with painting. The combination of the two will give you a good head start on converting your photos to something that really does look like a painting. From there, with some practice, you can take it to much higher levels. When you get pretty good at it, you're ready to tackle the complexity of Painter a bit further:

1. Choose the Brush tool from the Toolbox.

2. In the Options Bar, from the Stamp menu, choose Cloners.

3. From the Cloners menu, choose any brush style.

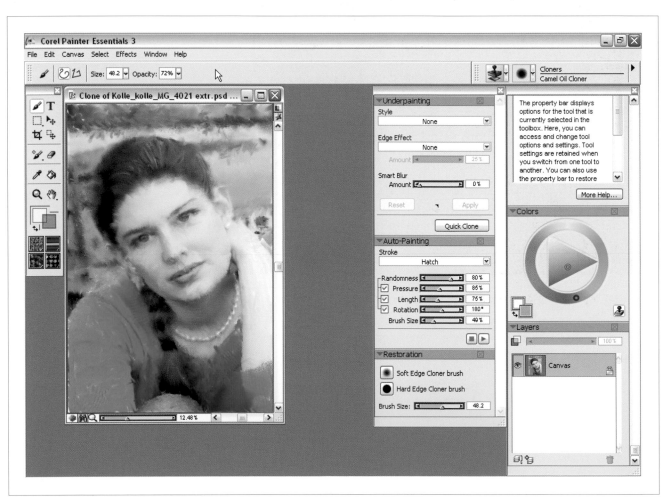

Figure 11-19. The Painter Essentials interface.

4. Choose Canvas→Tracing Paper. The image will appear to fade.

5. Size your brush with the square bracket keys.

6. Start painting and stop when you like what you get, then save the file.

You can change the brush style and other characteristics at any time. I used a large, impressionist brush to make the background less detailed. I then used a Camel's Hair brush to paint the face. If the large brush mushed things up too much, I just painted over it with a smaller brush to get more detail. You can also use a Restore brush to gradually restore detail to the finished photo, in case there are important details such as eyes or a diamond ring. Figure 11-20 shows the original and the finished portrait of Kolle.

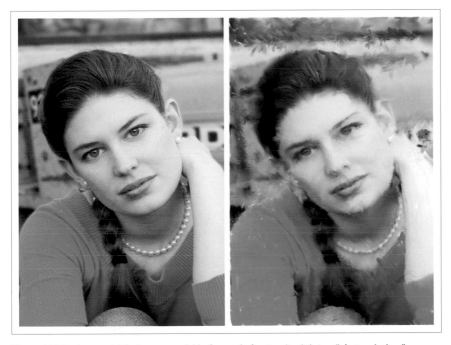

Figure 11-20. A portrait of a famous model before and after turning it into a "photopainting."

Presenting Your Work to the World

12

The last and perhaps most crucial step in the digital photographer's work-flow is finding ways to share your images with the world, perhaps even to create income from something you enjoy doing so much. Even if you're not a pro, surely you'd rather be able to afford a 5D than a 20D. Photography is like a sailboat: a hole in the water that you throw money into. Hopefully, this chapter will suggest some cool and easy ways to become better known and more highly paid. "You gotta find a way to be recognized," as my old studio partner Ed Zak used to say.

> ### HOW THIS CHAPTER FITS THE WORKFLOW
>
> ## Output, at Last
>
> This chapter assumes you've already completed the winnowing, image man-agement, and digital darkroom workflows. Now you're ready to market your work. Just be advised that if you've done everything in the sequence sug-gested, you'll be in much better shape to efficiently market your work. There are a thousand ways to do that, this chapter has suggestions to jumpstart and perhaps help you think of more possibilities. More possibilities mean more money—even if this is only a part-time pursuit.

Printing Your Digital Images

Before standardized color management came along, imaging professionals simply had to keep experimenting with the settings for different combina-tions of camera, scanner, monitor, printer, and printing press. There were measuring instruments, but they were so expensive that only enterprises doing enough volume to justify the cost (or amateurs who had just won the lottery) could afford them. Today, you can buy a full system color manage ment system (CMS; camera, scanner, monitor, and printer), complete with instruments for making the measurements to compare color interpretation between one device and another, for less than $600. And the prices con-tinue to fall as the accuracy and ease of use keep getting better!

NOTE

Monitor calibration is covered in the "Calibrate Your Monitor" section in Chapter 2 because it's one of the very first steps in a proper workflow. Now is a good time to reread that section and recalibrate your monitor.

Calibrate the Printer

Every printer model and ink set interprets color in a different way. The only way you can be reasonably sure that the print you get will look like the image you prepared in Photoshop is to calibrate the printer for the particular set of inks and paper that you will use to make that particular print. (By the way, it's often a good idea to use a test image, such as the ones in Figure 12-1.) Then the monitor calibration profile and the printer calibration profile can be matched so that what you see on the monitor is what you get on paper. Figure 12-2 shows the Monaco EZcolor printer calibration dialog.

Figure 12-1. The ColorVision PDI Test Image, available from PhotoDisc, is an excellent example of the kind of test image you should use to calibrate manually.

Figure 12-2. The Monaco EZcolor printer calibration dialog.

In this section you'll learn the significance of accurate printer profiles, where to find prepublished profiles if they exist for your printer (highly likely if you've bought a name brand), and how to install them for your OS and image editing software (with Photoshop 7+ used as the benchmark). You'll also learn how to make your own printer profiles with trial and error or profiling kits.

Calibrating an LCD Monitor

Up until very recently, the weakest link of color management systems has been the increasingly popular LCD flat-panel displays. Now, however, most LCDs made for desktop use and all of those made for Mac laptops can now be calibrated—provided you have a monitor calibration system that uses a colorimeter that can be placed over an LCD monitor without resorting to suction cups (which can severely damage an LCD screen). The screen can "filter" the LCD display so that it looks to the colorimeter like a CRT display. Today, the most recent colorimeter models from ColorVision, Monaco Systems, and ITEK all meet this requirement. If you have an older model and are using an LCD screen, consider updating your calibrator. If you are considering an LCD screen purchase, choose one with a brightness range of 500:1 or better

and do not attempt to use a colorimeter that was made strictly for calibrating CRTs—it won't work and could damage your LCD screen. Also, all of the companies just mentioned offer older colorimeters that do not work on LCDs, so make sure you buy the most up-to-date model. The other problem with LCD screens is that most have a very narrow angle of view in which color relationships appear as they are intended to appear. That is to say, the brightness of different colors changes as you view the screen from different angles. Be sure you are viewing the screen from directly in front of it. Finally, you will be able to calibrate your colorimeter more accurately if your monitor has separate controls for brightness and contrast for each separate color.

Purchase or download a profile

If you don't want to make your own profiles and need to get acceptable prints with a minimum of fuss, check around for a supplier who will sell you a profile for an ink and paper combination that you find acceptable for your subject matter. Then buy both the ink and paper combination and the profile from the same source, since each vendor's supplies may differ slightly if purchased at different times or came from different batches.

The drawback to purchasing profiles is that the cost can add up quickly, since you need a different profile for each ink and paper combo. Worse, profiles are often available only in sets, so you may have to pay for profiles that you don't really need. For instance, the profile libraries sell for $175 and each library consists of a set of profiles for a specific ink and printer that covers several choices of papers. The library that supports the Epson 1270 printer and Epson inks includes 42 different papers from a variety of manufacturers. So if you had several printers and used several different ink sets, purchasing profile libraries could run you thousands of dollars. To be fair, there are individual profile downloads for about $25 each, but those choices are limited to only a few of the most popular combinations.

Make your own profile

The biggest problem with other people's profiles, however, is that they're (obviously) created by other people. Since each of us has subjective ideas about color, contrast, and lighting, what works for someone else (no matter how expert) will seldom work as well as something you've created yourself.

Once you've calibrated your monitor, find a test chart that shows a typical image and a set of standard colors. You can make up your own test chart by creating a screen-size file that includes most of the basic colors in the Swatches palette for your OS, a grayscale chart that progresses in 10 percent gray level increments, and a photograph of something colorful.

I have three different models of Epson printers and often print larger images on a friend's Epson 9800. However, the instructions below should work reasonably well for most models of printers—just be sure to keep your printer manual handy. Then do the following:

1. Open the calibration image on your calibrated monitor, choose the printer you want to print on, load a sample of the paper you want to print on, and print it.

2. Install a light source next to your monitor that is the same color temperature as your monitor. (You should be able to get monitor color temperature from your monitor's manual or from the manufacturer's web site, and the bulbs from a large photography supply house such as B&H Photo or Samy's Camera.) Place the print next to the chart displayed on the monitor.

3. The rest of this process is intended to make the printer's output match what you see onscreen in the color chart. Start by using the printer adjustments in Photoshop. Choose File→Page Setup to bring up the dialog shown in Figure 12-3. Choose the name of the printer you want to profile from the Name drop-down menu and click the Properties button. The printer's setup dialog will appear (see Figure 12-4).

4. From the Media drop-down menu, choose the paper with the surface that's closest to what you'll be printing on. For instance, if you're printing photographs using an Epson 1270 printer, choose Premium Glossy Photo paper or Matte Paper–Heavyweight. If you're using another printer make or model, the choices will be different. The paper you're actually using may not be listed if it's from a third-party vendor or is of a later generation than the papers supported by your printer. In the Quality Setting, choose Best. In the Color section, choose Color only if you are not printing a black and white image. Duotone images and toned images count as Color images.

Figure 12-3. The Page Setup dialog.

Figure 12-4. The printer's setup dialog.

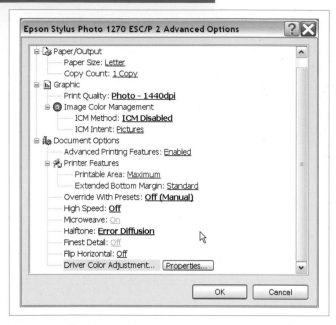

Figure 12-5. The Advanced Options dialog.

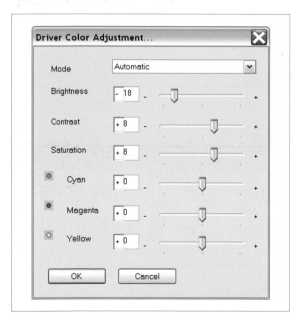

Figure 12-6. The Driver Color Adjustment dialog.

5. Now we come to the most important part. Click the Advanced button to bring up the Advanced Options dialog (see Figure 12-5). Each underlined item in this dialog opens a drop-down menu. First, choose your paper size; half-letter is usually big enough for a test like this. Choose 1 for the Copy Count. Select the highest available resolution for print quality (it usually results in richer colors), unless you have printed on a paper that is uncoated (uncoated papers tend to cause dots to spread, and too much ink can exacerbate the problem). From the ICM Method menu, choose ICM Disabled. For ICM Intent, choose Pictures. Advanced Printing Features should be Enabled. Since you probably want your picture exactly centered on the page, choose Maximum for Printable Area and Extended for Extended Bottom Margin. Override with Presets should be off, High Speed should be off, Halftone should be Error Diffusion, and Flip Horizontal should be off. Finally, click Driver Color Adjustment to bring up the dialog shown in Figure 12-6.

6. From the Mode drop-down menu, choose Photorealistic. You don't want to make any other driver color adjustments until you see how the default settings compare to the soft proof of the test chart on your monitor, so just click OK for this dialog and for all the other open dialogs.

7. Now you're ready to make your first test print. It will be most informative if you use the Print with Preview command. You can either choose File→Print with Preview or Cmd/Ctrl-P. The Print with Preview dialog is shown in Figure 12-7.

8. In the Print with Preview dialog, you will see a bounding box for your image. If the image isn't precisely centered on the page, check to make sure the Center Image box is checked. The Scaled Print Size should be 100 percent because it might make it easier to judge the intensity of inks, especially in the midtones. From the Print Space menu, choose the profile for your printer (if one is installed). Click the Print button.

9. When your print is done, hold it next to the monitor under that light you just installed. Don't aim the light at the monitor, and don't make it so bright that the white of the paper is whiter than the brightest white on the monitor. Now you should be able to accurately judge how close your print is to the soft proof on the color chart.

10. Now let's make the proof print match the soft proof on your monitor. Do this by repeating Steps 1 through 4. However, when you reach Step 5, this time move the sliders to adjust for the differences between the last printed proof and the soft proof on the monitor. Then print the result and make another comparison to the soft proof. I typically start by leaving the individual color sliders alone and guessing at the compensation needed for Brightness, Contrast, and Saturation. I then print, compare that print, and repeat the process until I'm as close as possible to what I want using just those three adjustments. I then start fine-tuning for color balance, changing only one color slider per print.

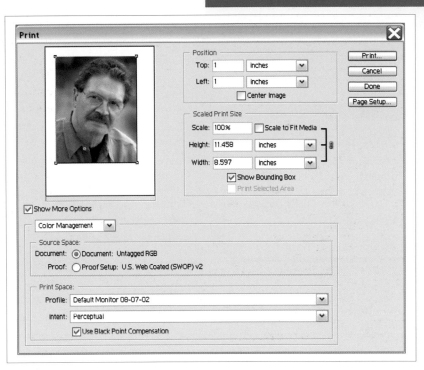

Figure 12-7. The Print with Preview dialog.

11. When you like what you see, save the profile so that you can easily repeat it for other images. Choose Image→Mode→Convert to Profile to bring up a dialog like the one in Figure 12-8. From the Profile menu, choose Custom RGB and enter a name that describes your printer/paper/ink combination in the resulting dialog in Figure 12-9. The other settings should already be the same as your original profile and whatever adjustments you've made, so just click OK.

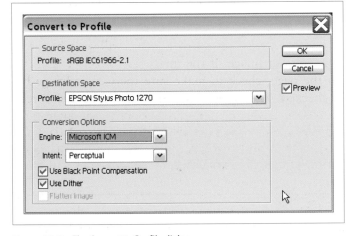

Figure 12-8. The Convert to Profile dialog.

Figure 12-9. The Custom RGB dialog.

Use a traditional profile maker such as Monaco EZcolor

The two profiling kits I'm specifically recommending here, Monaco EZcolor and ColorVision PrintFIX are both accessibly priced (under $500) and have a reputation for producing decent results.

Monaco EZcolor is the best route to take if you need one piece of software that can be adapted to a variety of situations and devices. It can profile cameras, scanners, monitors, and printers. It's been around for a while (the current version is the XR), and you can upgrade from any older version, such as the one that comes bundled with many Epson printers.

The method described here shows you how to use EZcolor to create a printer profile. However, it also has the capability of calibrating monitors in a manner similar to ColorVision's Spyder and OptiCAL.

To create the printer profile, you first have to create a scanner profile for your flatbed scanner. EZcolor can also profile film scanners, but that requires you to purchase a separate target, and you'll still need to profile a flatbed scanner in order to create a printer profile. Profiling a film scanner is similar to profiling a flatbed, and the program comes with documentation, so we'll only cover profiling a flatbed in this section.

Here's how you'd typically go about creating a printer profile using Monaco EZcolor XR:

1. Power on your printer and load the paper you intend to use. Remember, you have to make a different profile for each printer/paper/ink combination. Be sure to make note of the combination.

2. Open Monaco EZcolor, select Create Printer Profile, and click the Next button. Choose RGB as the printer type you plan to output to and click Next. Now, click Print. The Print dialog will appear, as shown in Figure 12-10.

3. From the drop-down menus, choose the following: the paper you will be printing on; the resolution you will be printing at; Auto Color Correction options off (see your printer manual if necessary); and 100% as the size to print the target. Be sure to write down all these settings so you can refer to them later. In the "Print a Target" dialog, click the Next button. Now save the printer target file as a TIFF file.

4. Attach the IT8 target that was supplied with EZcolor to the target you just printed. If you have other targets, don't use them—they won't work. Let the printed target dry in the dark for an hour or so, then place the attached targets on your scanner and click the Next button. The Monaco EZcolor dialog for preparing to scan will appear (see Figure 12-11).

Write Things Down

I typically use the base word processor on my operating system to create a file called "profile notes" that contains all the settings for all my profiles.

Figure 12-10. The EZcolor Print dialog.

Figure 12-11. The Monaco EZcolor "Prepare to Scan" dialog.

Chapter 12, Presenting Your Work to the World ——————————————— 337

5. Choose the TWAIN or Mac driver for your scanner. (Note that a few scanners are incompatible with EZcolor, but the program gives you a workaround if that is the case.)

Figure 12-12. The Select Reference File dialog.

6. Set the scanner resolution at 200 dpi. Turn off all color correction and management options in the scanner driver's dialog. Take note off all the scanner settings that stay in effect so that you can make sure they are consistent from one profile to the next.

7. Prescan (preview) the targets and then crop them to exclude all whitespace.

8. Click the Scan button and scan the targets. EZcolor will display a thumbnail of the scanned targets. Make sure the scan is straight and properly cropped. If it's not, reposition, recrop and rescan. When you've got it right, click Next. The Select Reference File dialog will appear (see Figure 12-12).

9. Locate the proper reference settings in the Select Reference File dialog; you'll have to refer to the EZcolor manual for directions for locating these files on your particular OS version. EZcolor then asks you to confirm a variety of settings for cropping, straightening, scan resolution, etc. Once you've done that, you can name and save the profile that EZcolor will automatically generate during the printer profiling process. You can name the profile whatever you want, but you'll probably want to use something that describes the printer, model, paper type, printing resolution, and date in some kind of understandable shorthand. EZcolor also gives you the option to save the scanner profile that was automatically created by this process.

Use ColorVision PrintFIX

The problem with most printer calibrators is that you also need to have a calibrated scanner. If the scanner is reset, you risk getting unreliable results. What sets PrintFIX apart is that it comes with its own scanner that is dedicated to doing nothing but reading a test chart printed on a given printer with a given ink and paper set, and automatically creating a printer profile that will honor the soft proof on your calibrated monitor. Since that's the scanner's only job, it becomes an easy, quick process. Another thing that

differentiates PrintFIX is that it runs right inside Photoshop as an Import plug-in. Here's how it works:

1. Open Photoshop and choose File→Import→PrintFIX. From the PrintFIX dialog, choose the ColorVision color chart for your specific printer (see Figure 12-13). This is a very specific color chart that is sized and resolved for the small scanner that comes with PrintFIX (see Figure 12-14).

2. Choose File→Print with Preview and go through the routine you normally use to choose your printer, print size, paper type, and other settings (some printer-and model-specific settings are recommended in the PrintFIX documentation).

3. When the chart is printed, remove it from the printer and trim it precisely to the dotted lines indicated in the print.

Figure 12-13. The PrintFIX color chart.

Figure 12-14. The PrintFIX Patch Reader scanner.

4. Follow the short routine recommended for cleaning and calibrating the Patch Reader scanner.

5. Insert the print in the holder made for the Patch Reader and place it in the scanner slot.

6. Choose File→Automate→PrintFIX to bring up the dialog shown in Figure 12-15. Don't change any of the default settings in the dialog.

Figure 12-15. The PrintFIX dialog.

7. Click the Read Patch Reader button. The scanner will read the calibration chart and display the result in Photoshop. Crop the result so that only a narrow white margin is visible around the color chart.

8. Choose File→Automate→PrintFIX. This time, when the PrintFIX dialog appears, choose Build Profile from the drop-down menu. Leave all the sliders at their defaults and click OK. When the Save As dialog appears, name your profile with a name specifying the printer, paper, and ink combo, and perhaps a six-digit date or a version number to distinguish it from profiles made at other times.

9. Close Photoshop and reload it so that the profile you just saved will appear when you need it in the next step.

10. You'll now make a test print. Load the PDI Test Image, which is an excellent image to use for making your first print because if you can match all of its content, then virtually any image should match.

11. Choose File→Print with Preview, and be sure that Show More Options is checked in the resulting dialog. From the Show More Options drop-down menu, choose Color Management. Choose the Document radio

button and then select the profile you just created from the Profile menu. From the Intent menu, choose Saturation.

12. Click the Page Preview button. When the first Page Setup dialog appears, click the Printer button. When the second Page Setup dialog appears, click the Properties button. In the printer's setup dialog (see Figure 12-16), choose any matte paper available on the Media menu, and choose the Best and Color radio buttons. (You may also want to adjust some of the Advanced settings.)

13. Click as many OK buttons as it takes to get you back to the main Print with Preview dialog. Click the Print button; the second Print dialog will appear. Click the Print button.

14. When the chart is printed, let it dry for at least five minutes—ideally, a few hours. Printer dye inks take a bit of time to really stabilize. Then take it over to the monitor and compare it to the original.

15. Fine-tune your adjustments if necessary.

Figure 12-16. The setup dialog for the Epson 1270.

Use a software profile maker such as ColorVision's DoctorPRO

Trying to match color charts by entering numbers in a traditional profile making application can seem pretty counterintuitive, especially to those of us used to making all of our adjustments on the fly using traditional darkroom techniques or the Photoshop commands that emulate them. Happily, there is a tool from ColorVision that records your adjustments and then has Photoshop apply them to a profile so that any image you print subsequently can use the same adjustments. It's not the most precise method for creating a profile that works well on every image, but it sure is a godsend when you want to cut the number of needed test prints for those images that just seem to work better when you tweak them manually. It's also a lifesaver if you just don't have the discipline required for using a traditional printer profiler. You can use DoctorPRO to tweak a profile you've already created (for instance, with ColorVision's PrintFIX) or any of the existing profiles in your system.

> **NOTE**
>
> *When using PrintFIX, always choose a matte paper in the printer's setup dialog, regardless of the paper you are actually going to print on. The surface differences of other papers are automatically taken into account as a result of the scan.*

Here's how to use DoctorPRO:

1. Install the software and restart Photoshop.

Figure 12-17. The Photoshop Memory & Image Cache dialog.

2. DoctorPRO requires lots of RAM, so you should be using a system with at least 512 MB. In Photoshop, choose Edit→Preferences→ Memory & Image Cache and enter at least 75 percent as the maximum amount of RAM used by Photoshop (see Figure 12-17). You should also make sure that all applications other than Photoshop are closed.

3. Open the image that you want to create a new profile for, open the Actions palette, and create a new action. Name it something like "DoctorPRO *Profile Tweak*" where *Profile* is the name of the monitor calibrator or printer profile that created the image you are going to alter and *Tweak* is an abbreviated description of how you made the adjustments. You can use any Photoshop image–adjustment command in this action. When you've finished making the adjustments, stop recording the action.

4. Making sure that the name of the action is selected in the Actions palette, choose File→Automate→DoctorPRO to bring up the dialog in Figure 12-18.

Figure 12-18. The DoctorPRO dialog.

5. Select the DoctorPRO radio button and choose the name of the profile you want to modify (this could be your printer's native profile or one you created). Choose the printer's color printing mode (RGB for most inkjets) and click OK. A DoctorPRO image of a horse will appear (don't ask why it's a horse—I have no idea) as well as a Save As dialog that opens the folder where your OS keeps its color management profiles. Create a new profile name that incorporates the name of the profile you are modifying and its intent. Finally, click the Save button.

6. Close Photoshop, reopen it, and open the image you want to print with the new profile. Choose File→Page Setup. When the Page Setup dialog appears, choose the printer and the advanced printer settings that you normally use for this paper and ink combination.

7. Choose File→Print with Preview. Make sure the Show More Options box is checked, set your Source Space as Document, and choose the profile you saved from DoctorPRO from the Print Space Profile menu.

8. Verify that your other printer settings are set for the correct paper size, media, number of copies, and so forth. To print the now correctly profiled image, click OK.

Be sure to recalibrate each particular ink and paper combination whenever you get an unexpected result. Large manufacturers sometimes buy their supplies from more than one source or improve the formulation as they gain experience with it. Also, the materials themselves may interact in different ways because of the influence of atmospheric chemicals, storage temperature, and the plain fact that nothing really stays static over time.

> **NOTE**
>
> *As you've probably figured out by now, you have to quit Photoshop and restart it whenever you create a new profile. Otherwise, it won't show up in the Profiles menu when you try to apply it.*

Showing Your Work

There are a variety of ways to show your work to clients and other interested viewers. In this section, we'll take a look at a few tools to make that presentation accessible and professional looking.

Contact Sheets

Photoshop contact sheets have several advantages over the analog variety, where you simply place a piece of photographic paper face up under an enlarger head, lay the negatives atop it, lay a piece of glass over that to keep everything flat, make a brief exposure with the enlarger, and then process and dry the result.

In Photoshop, open your shoot's folder in Bridge, then: I am assuming you've already followed this book's workflow for image management.

1. From the Unfiltered menu, choose three or more stars. When those images show up, press Cmd/Ctrl-A to Select All.

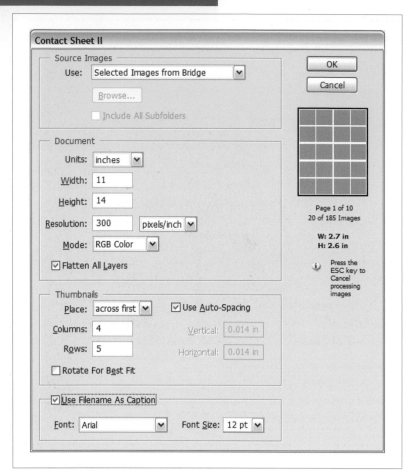

Figure 12-19. The Contact Sheet II dialog, as it should be specified. If you have a letter size printer, make the Width 8 and the Height 10.

2. Choose Tools→Photoshop→Contact Sheet II. The Contact Sheet II dialog opens (see Figure 12-19).

3. From the Use menu, choose Selected Images in Bridge.

4. Under Document, choose Inches, then the Width and Height of your printer's largest paper size (I use 11×14 for my Epson 1270 because it's easier for art directors to judge a larger thumbnail). Be sure the Flatten All Layers box is checked to minimize your file size. Resolution should be 300 ppi and Mode should be RGB.

5. Under Thumbnails, choose Place Across First, check Auto for Spacing, and make your columns 4×5. This gives you 20 images per page—equivalent to about half roll of film.

— **N O T E** —

Be sure Use Filename as Caption is checked. This assures that you're all talking about exactly the same frame when choosing a particular image.

Creating a Portfolio

When it comes to making yourself and your images look good, let's face it: presentation is everything. The problem arises from the fact that no single presentation method, size, style, or form factor is right for all situations. For example, a web-based portfolio is shown in Figure 12-20. A binder portfolio is another possibility, and is shown in Figure 12-21. No matter what route you go, you need to know what sizes, styles, and form factors are accepted in specific industries and specific places; and of course, you also want to *adopt a style that promotes your own unique perspective.*

There isn't room here to tell you everything there is to know about portfolio presentation, but you'll find concise, rule-based techniques for creating binder, boxed, and electronic portfolios.

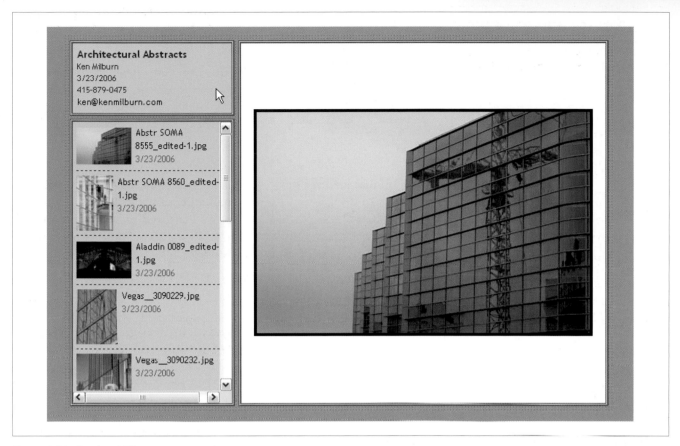

Figure 12-20. A web portfolio.

Figure 12-21. A typical presentation binder portfolio book.

Binder portfolios

Loose-leaf binder portfolios are a great way to make a quick presentation with a few prints. Prints are generally placed inside an acid-free *glassine sleeve*, which helps to protect them as clients flip through the portfolio. Prints are most often shown borderless and hinge-mounted on black matte paper. The loose-leaf rings allow you to remove any blank pages. Loose-leaf portfolios come in a variety of sizes, but the ones that hold 11×14 and 16×20 prints seem to be the most popular. Be sure that any loose-leaf portfolio you buy is clearly labeled as archival.

With binder portfolios, photos are held in place with acid-free tape hinges (see Figure 12-22) so they can be easily removed and replaced without damage to the book, print, or page. This allows you to easily vary the size of prints and pages.

Figure 12-22. Taped hinge for temporary mounting of prints in a portfolio.

> ——— N O T E ———
>
> *Itoya makes a large series of black polypropylene ("poly") binders in sizes ranging from 4×6 to 18×24 inches. The pages are acid- and lignin-free black pages with polypropylene sleeves. The poly sleeves keep the prints safe and unscathed, and even better, you can easily slide prints in and out of the sleeves so you can quickly target a book toward a specific client. Since the average cost of these books is well under $20, it's not a bad idea to just keep a couple around.*

Most art supply and photographer's supply stores also provide leather zippered binders with handles or black hardcover binders that will hold the same archival sleeves with black pages. Of course, these portfolios tend to be a bit pricier than the Itoya binders. If you need to protect those less expensive Itoya binders while you are pounding the pavement in search of clients, there are portfolio-size briefcases that will both do the job and add a look of class and prestige to your presentation.

Most professionals make borderless prints for loose-leaf portfolios. The black backgrounds make it possible to include prints in a variety of sizes and shapes by providing an element of uniformity.

Boxed portfolios

Despite the convenience of loose-leaf portfolios, I generally prefer boxed portfolios of loose prints, such as the one shown in Figure 12-23. I leave the prints unmounted so that the viewer can easily flip through and rearrange them to put their favorites at the top of the stack. This has its drawbacks, most notably that you'll have to warn the viewers to keep their fingers off the surface of the prints, but I still like knowing that the audience gets to see and appreciate the quality of the printing, printing paper, and image in a more honest, up-close, and personal way.

In My Humble Opinion

I don't love the look of plastic sleeves, but so many pros use this type of presentation that it's not likely to prejudice your audience against your portfolio. You do gain the benefit of being able to use the same portfolio for different presentations, as the images just slide in and out.

Figure 12-23. A typical boxed portfolio.

I always make prints for a boxed portfolio in a uniform paper size and use the most heavyweight paper that is consistent with the image type I'm presenting—for instance, sports and food seem to look snappier on glossy papers, romantic portraits and nature scenes seem to be more compatible with the softer look of matte papers, and painterly interpretations of digital photos work best on watercolor or other types of artist's papers. I also leave a generous amount of border space around each image.

Create a Limited-Edition Book

If you specialize in fine-art photography or want to move some of your commercial work into that arena, you might find that the high cost of large prints and the lack of consumer wall space (given today's high cost of real estate) are limiting the market for fine-art prints. You might consider a fairly new idea that is catching on quickly in the fine-art world—the limited-edition book, which is sometimes referred to as a *monograph*. Monographs are bound volumes of limited-edition fine-art prints. At press time, a typical price for a book of 8×10 prints on 11×14 paper from a credentialed but not internationally known artist is between $400 and $1,200.

Monographs should have all the same parts as other books: a title page, table of contents, and text introduction. The most important function of the introduction is to present the techniques and the materials that were used to make the monograph. There should also be a statement regarding the edition number, the archival qualities of the prints, and the value of the monograph versus the value of framing individual prints. Finally, you

should also include an artist's biography, credit and credentials, and a statement of purpose and artistic philosophy.

> **NOTE**
>
> *Just as this book was going through it's final copy edit I was lucky enough to be able to test a new web site called Blurb.com. I created a 60 page book with a full-color dust-over and roughly 100 photos. The book is perfect bound and has a very elegant cloth hard-bound cover. I worked from ColorVision's Spyder 2 calibrator and saved the files as full-resolution sRGB JPEGs before pasting them into the book template software. You could have picked me off the floor when the result arrived in the mail. Every single image looked exactly and precisely as I have envisioned it. The end book looked thoroughly professional. It has snagged me several jobs in just the past few days. And it cost a mere $35, plus about $8 shipping. I'm going to make up a lot of these. Oh…and the software is free and took only minutes to learn. Check out www.blurb.com.*

Event Monographs

A monograph is also an impressive way to present a book or brochure idea to a publisher or client. For example, there is currently a huge market for monograph books in wedding and event photography.

Online Options

If you want to experiment with the idea of a monograph or would like to create a less expensive version to use as a leave-by (a give-away promotional item left with a potential client), consider submitting your photos as pre-edited digital images to an online photo-processing service. Here are a few:

- Blurb, Inc. (*www.blurb.com*): $29.95 for 40 8×10 pages. Wide variety of layout pages and types. Can include unlimited amounts of text, captions, forwards, etc. Software is free. These are the most professional-looking books I've seen and the price is outstanding. It offers twice as many pages as others services, a photographic dustcover, and cover. You can do a book with a few photos and lots of text or a portfolio or any mix. It's a great way to publish a book proposal.

- Picaboo (*www.picaboo.com*): Lots of choices of page color, themes, etc. $9.95 for 20 small pages; $29.95 for 20 8.5x11 pages hard-bound.

- Shutterfly (*www.shutterfly.com*): Hard-cover $29.99 for first 20 8.5x11 pages. 15 different styles with 20 layouts each. Softcover books are $12.99 and have 20 pages with additional pages at $0.40. You can even do a spiral bound mini-album—$10 for 4×6 or $15 for 5×7.

- PhotoWorks (*www.photoworks.com*): For $12.95 it offers a 20 page 5×7 book. Additional pages are $0.99. The 8.5×11 size is $29.95 for 20 pages, $1.99 for each additional. The hardcover album is 12×8.5 and the pages lace together so you can add as many pages as you like whenever you like.

- Winkflash (*www.winkflash.com*): Not only books, but also all sorts of gifts and specialized prints, such as posters. The maximum printing is 100 pages and extra pages are $0.50 each. You could put a photo on the cover with rubber cement. The title is embossed. Layout styles can include multiple photos. The prices per book are: $26.95 for a 12×16, $18.95 for a 9×12, and $12.95 for a 6×8. Gifts include aprons, bibs, calendars ($12.95), stretched canvas, coasters, cutting boards, paperweights, t-shirts, tote bags, and sticky note holders.

Here's a useful list of tips for creating monographs:

- Follow the recommendations earlier in this chapter for archival printing. For example, use archival inks and papers. The paper should also be heavy enough to have a substantial feel.

- Choose a paper surface that suits your style and, more importantly, the subject matter being portrayed.

- Decide whether you want to print on both sides of the paper. Even if you don't, it's a good idea to print on double-sided paper because the backs of the pages won't be discolored or have watermarks showing. Also, papers coated on both sides will lie flatter.

- Consider using binders that are premade for monographs; this will allow you to make smaller editions at more affordable prices. These monograph-friendly binders come in several styles and sizes and usually have space for a title and/or cover art.

- Test the layout and content of your book by first making an electronic version. I love what FlipAlbum Pro can do in this area.

- One of the simplest easiest and most affordable ways to create a book is through an online service. Adobe Photoshop Album, Apple iPhoto, and Apple Aperture offer this option, among other products.

- You can also send your printed pages to a custom book bindery, which will stitch the pages together and bind the book in leather, canvas, linen, or some other traditional and professional-looking material. Prices for this service range all over the map.

Many artists, and especially fine-art photographers, have small digital offset press books made of their work. They generally print around 500 to 1,000 copies, and the cost of printing averages around $15 per book. These artists then sell these books at the art fairs, festivals, and galleries where they exhibit their work, and often also make them available online. At an average retail price of $25 to $35, these books are an affordable way for people to start collecting an artist's work and showing it to friends. Over time, making these books available also builds mailing lists and repeat orders for both larger art prints and monographs. Most of the books I've seen in this category are either 8.5×11 or smaller, contain 25 to 50 images, and are printed on good varnished stock.

Make Self-Promoting Postcards

No one will hire or buy from a photographer they don't know about, so it is essential that you have something impressive that you can leave behind. If you have an event coming up, it is also a good idea to let everyone who has shown an interest in your work and career know about it. Furthermore,

you'll be giving them something that they can hang on the wall, the refrigerator, or the company soft drink machine to remember you by.

Figure 12-24. A self-printed promotional card.

There are two ways you can make promotional cards: print them yourself, as shown in Figure 12-24, or have them commercially printed. Either way, you'll be designing and picking the subject matter yourself.

Printing the card yourself

When printing your promotional cards, you'll want to use an inexpensive paper, but one that shows off the photograph well. Personally, I'm more concerned about cost than archival properties—obviously, you don't want to give away the same quality of photograph you'd be printing as a limited-edition print. Of course, you could also argue that the more you are collected, the more you will be remembered.

Of course, if the time you spend printing your own cards keeps you from a more profitable endeavor, it's not a smart idea. However, by and large, the real advantage of printing my own cards lies in the fact that I can print an unlimited number of different subjects for the same amount of time and money.

Having the card offset-printed

Offset-printed cards tend to look a bit more professional just by the fact that, well, they are offset printed. If you go this route, remember that offset printers work from CMYK images. The easiest way to see what will happen when the image is converted to CMYK is simply to duplicate the image in Photoshop, convert the duplicate to CMYK, and compare it side-by-side with the original.

A quick look through *Sunshine Artist* or *Photo District News* (PDN) magazines will supply you with several sources for printing promotional cards and postcards. To give you a quick reference and an idea of what's available and what pricing is like, here's a short list of card printing services:

Postcard Press
At press time, 1,000 4×6 cards were priced at $145; 1,000 5×7 cards were $219. Both prices are for full color front, black printing on reverse.

A Six-Color Printer

Consider buying an inexpensive six-color printer that prints a very good photoquality image and equipping it with a Continuous Inking System (CIS) just for printing promotional work. Printing from 4 oz. bottles of ink, I can print hundreds of pages of glossy photos before I have to replace the ink.

PSPrint

This company prints all sorts of promotional materials including calendars, stickers, and postcards. Several of the galleries in my area employ PSPrint's services steadily. Postcards can be ordered in gloss or matte surfaces, and are available in 4×6, 5×8, and 6×9. Again, at press time, 1,000 full-color front 5×8 cards were $191.25 with a 10-day turnaround.

The Great American Printing Company

At press time, this company printed 4×6 cards only, at a cost of $99.50 for 500 cards. Other items such as extra text to the back, new type to the front, etc., can be added for an additional price. You can download an order form from the web site.

Promoting Your Images on the Web

By far the most efficient means of selling yourself and your work is getting it on the web as many ways as possible. That includes communicating with clients and potential clients with photo-illustrated e-mail newsletters, putting up your own web site, and getting your photos out to one or more stock agencies.

Optimize Images for Web Viewing

If you're going to the trouble and expense of putting up a web portfolio, you're going to want as many people to view it as possible. You'll also want plenty of space for all of your best images. If your thumbnails don't appear instantly—or if people have to wait more than three or four seconds for the larger image to appear—it is quite likely that your audience will quickly surf to someone else's web site.

By the same token, if your pictures don't impress the viewer with their quality, it is unlikely that you'll get swamped with requests for assignments or orders for exhibition prints. You must learn to make the right compromises so that your portfolio will perform efficiently and still look stunning.

Most of the routines for creating a web gallery, suggested further on in this chapter, automatically optimize your JPEGs at an acceptable level. Still, there will always be exceptions—and some of them may be truly glaring. (See Figures 12-25 and 12-26.) Every picture is different, and the same compression rules won't work for all of them. The automation programs choose a compression formula that works more often than not.

Here's the most efficient workflow I've found for optimizing web photos:

1. Using the Photoshop Browser (or an image management program that produces large thumbnails and lets you drag and drop), go to the folder where the auto-generated web portfolio has been stored. Open each image in Photoshop and examine it carefully.

2. Make sure that each image is set at 100 percent magnification. If you can't see compression problems at normal magnification, neither can your audience.

If an individual image seems just fine, simply close it without saving it. If it doesn't, minimize the window or drag it out of the way so that you can use it in the next step.

Figure 12-25. This image was oversharpened and saved at low JPEG quality and resolution. It loads fast, but would you want to show it to an art director?

Figure 12-26. The same image as Figure 12-25—when optimization is not an issue.

3. When you have a set of images that you'd like to see improved, make a list of them and their dimensions and then close them. You are going to have to resize the originals and then do your own manual optimizations on each image.

4. Minimize Photoshop and use your operating system's file browser in thumbnail mode to open the folder that contains the original JPEGs. Press Cmd/Ctrl and click on each image you want to reoptimize. Now create a new subfolder in a new browser window (Finder on the Mac) that uses the name of the original folder with "man-opt" appended to the end of the filename (this will tell you that the folder contains manually optimized files). Now drag the files that you wish to optimize into the new folder.

Digital Photography Expert Techniques

5. Create an Action that will automatically resize the files in the new "man-opt" subfolder to the same size as was created automatically by the web gallery program you used. Be sure to save them with the same filenames and that the JPEG quality is set to the maximum of 12. Now run the Action and resize all the files in the subfolder.

6. Click the Edit in ImageReady button at the bottom of the Tools palette. The on-screen interface will change to the ImageReady interface and you will see a series of tabs at the top of each image window.

7. Start with the image on the top of the stack and click the 2-Up tab. You will see the original image on the left and the version that has been optimized according to the present Optimize palette settings on the right (see Figure 12-27). On the right side of the screen are several palettes; one of them should be the Optimize palette (if it's not there, choose Window→Optimize).

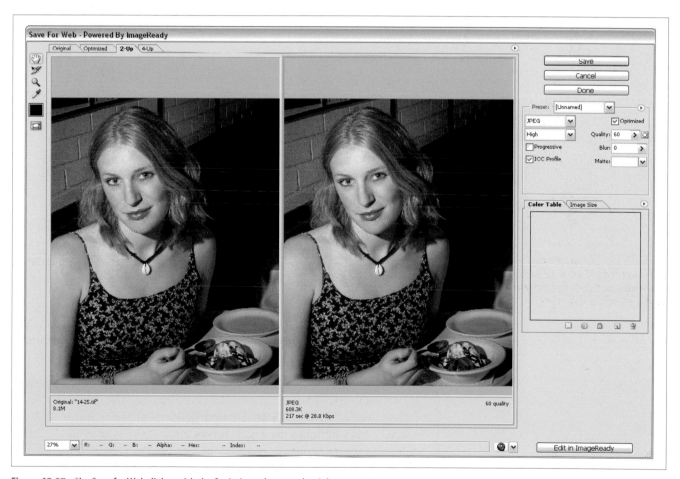

Figure 12-27. The Save for Web dialog with the Optimize palette on the right.

8. Make adjustments in the Optimize palette and watch the results in the righthand image of the 2-Up window. Because you can immediately see the effects of your optimizations, you'll know when the result is of acceptable quality. When you reach that point, the next question will be whether the image will display quickly enough for your purposes.

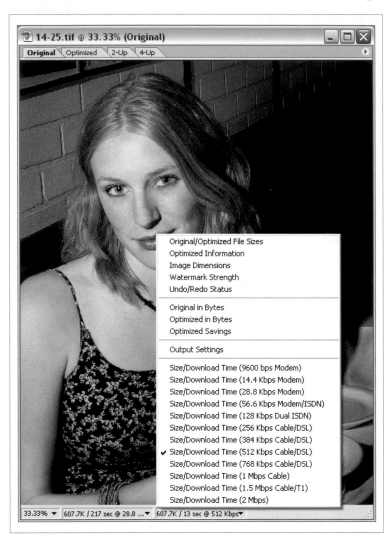

Figure 12-28. The Information menu at the bottom of the document window.

9. If you edit the image in ImageReady in Photoshop, you will see the Information menu in the status line at the bottom of the document window (see Figure 12-28). Since most people viewing my site will be professional buyers and gallery owners, and since high-speed Internet connections are now the rule rather than the exception, I generally go by how the image looks and how fast it loads at 512Mb, an average speed for DSL and cable high-speed Internet connections. I also look at its performance at 56 Kb, the typical speed for dial-up modem connections. If that speed is slower than 15 seconds, I will consider lowering the quality of the image. However, my rationale is that dial-up viewers are used to relatively poor performance and are willing to put up with it to some extent.

10. Once an image is optimized, save it to the same directory from which it was opened. When all the files have been optimized and saved, copy and paste them into the Image directory in the HTML folder that was created by the web gallery program. When the program asks if you want the new file to overwrite the original, click Yes.

Additional Tabs

There are also tabs for showing only the optimized version of the file and for showing a 4-Up view that displays the original and three optimized views. You can then apply three different optimizations to the same original and choose the one you like best.

Protecting Your Copyright with Watermarks

Many expert photographers are afraid to put their photos on the Web for fear they'll be stolen and then used without pay or be claimed as the work of someone else. But giving up web exposure for your photography means giving up one of best ways of becoming known (especially if your career is just starting) and of communicating with clients. Also, web graphics are highly compressed and merely 72 dpi in resolution, which is so low that, even if an image is easily stolen, its use is pretty much limited to the Web anyway. You certainly couldn't make prints of high enough definition to have any commercial value, nor could you use the images in print publications (unless they were just used as small icons). Of course, it's still not a very pleasant idea that someone could use your image for their own web site or put it into their web portfolio and claim it as their own. And although there's no surefire way to prevent that, there is a way to prove the image is yours if it's stolen. At least, that could be grounds for a profitable lawsuit.

The way to do this is to watermark your images. Watermarking places identification text over the surface of the image in such a way that it is not visible to the naked eye, but can be easily read by the appropriate software—even if the image has been cropped or otherwise modified.

The most widely used—and therefore easiest to verify—watermarking system at the time of this writing is Digimarc. Digimarc ships with Photoshop 5.5 and later, as well as with some other image editing programs such as PaintShop Pro.

> **NOTE**
>
> *You can only watermark RGB images. If you want to watermark GIFs, you have to cheat by first converting the GIF to JPEG, embedding the watermark, and converting it back to GIF.*

Creating a watermark with specialized software

Before you can actually watermark your images, you need to create and register your watermark with the company whose watermarking software you are using. Instructions for doing this will be included with the program. The following method shows you how to watermark your files using Digimarc from within either Photoshop or ImageReady. (Note that you must be online for this procedure to work.)

1. Choose Other→Digimarc to bring up the Embed Watermark dialog (see Figure 12-29). Click the Personalize button.

2. The Personalize Digimarc ID dialog will appear (see Figure 12-30). You will first need to register with Digimarc, so click the Info button.

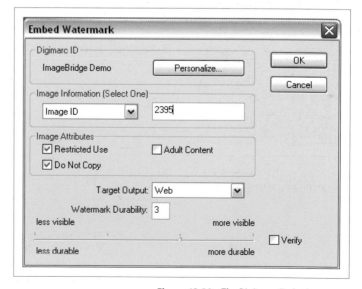

Figure 12-29. The Digimarc Embed Watermark dialog.

Figure 12-30. The Personalize Digimarc ID dialog (the information shown in the fields is entirely fictitious).

3. The Digimarc registration site will appear. You will see a chart of rates for different numbers of images. (These rates may inspire you to watermark only your most important images, but that's up to you.) Also note that for an additional charge, Digimarc can automatically search the Web for your watermarked images, which can be a very valuable service. Follow the instructions to register with Digimarc for the number of images you want to watermark.

4. When you have finished registering, enter your Digimarc ID and PIN number in the appropriate fields in the Personalize Digimarc ID dialog and click OK.

5. A new dialog will appear; fill in the required fields and click OK when complete.

Watermarking is an annual and not inconsequential expense. You can do it a little at a time, however, by adding new registrations whenever you have new images to watermark.

Creating a free watermark in Photoshop

There is another free way to protect your images: use Photoshop (or any other layer-supporting image editor) to superimpose your copyright information over the image. Unlike the Digimarc watermark, these are readily visible. To do this, simply create a new transparent layer at the top of the Layers palette and then use the Text tool to type in any size and style that will fit inside the image frame. You can make the watermark semi-transparent by adjusting the layer's Transparency or Fill sliders. If you have lots of contrast in the print, use transparent type and a Layer Style that creates a dark edge (choose Window→Layer Styles to get a thumbnail dialog that will automatically apply the style shown). This way, your watermark will be readable in both light and dark areas of the photo.

There are two major drawbacks to such free watermarks:

* They can't be automatically traced.

* You'll probably end up hiding the most important part of your picture if you place them so they can't be easily cropped out.

Still, it's good to have options, and you will probably discover situations in which these watermarks will work just fine.

Creating the Web Gallery

Creating a web gallery is by far the most immediate and efficient way to show your portfolio—you can then post it on your own web site or on

other sites that cater to photographers. There are also numerous sites that will allow you to display your web portfolio for the purpose of selling your prints. Best of all, Photoshop CS2 and Lightroom let you create web portfolios pretty much automatically.

One of the things you can do with those portfolios is use them on your own web site. You could have a button on your home page for specific categories of work that you do. And each of those buttons could open a different portfolio. If you own your own web site domain, you can create different pages for different categories of photos. For example, you might want to have a link called "portfolios" or "photographs" on your main menu and have that link direct the viewer to another page listing different styles, types of subject matter, specific events, or what have you. Each of these topics could then link to an individual page.

Preparing the images for your gallery

There are a number of additional considerations that you'll want to keep in mind if you're publishing your images on the Web. For example, your images may be perfectly exposed, color-balanced, and adjusted for viewing individually as prints. However, when you put them on a web site they're going to be viewed as part of a group, so it's ideal to have more uniform brightness, contrast, and color values between them. (For example, compare the three side-by-side photographs in both Figures 12-31 and 12-32.) You'll also want to crop and transform these images in such a way as to make them complement one another as much as possible. The difficult part is doing this efficiently to many images at once so you don't run into any holdups getting your site up and running.

Figure 12-31. The original images as the camera saw them.

Figure 12-32. After matching the exposure and contrast so that all three images have a uniform appearance.

The solution to these issues lies in setting up a routine that is likely to produce the most pleasing and uniform results. Don't have one yet? No problem. Just use mine:

1. First, gather all the files together and place them in individual folders that will hold the contents for each portfolio category.

2. Use the Image Processor to save the files in each folder to JPEG format at the highest quality setting mode (12). This keeps the originals in excellent shape but also compresses them so that they will be easy to store on a CD. (It also makes them quick to render if the portfolio-making software has to resize and optimize them.) Feel free to add whatever other changes you need (e.g., color correction) to the images before you save them.

3. Use the Photoshop File Browser to quickly compare images. Here, you can eliminate any duplicates, check to make sure all files are large enough for your purposes, and easily see which images require adjustments in color saturation, contrast, or brightness when seen in the context of the rest of the collection (Figure 12-33).

Figure 12-33. Viewing the adjusted images in the Photoshop Browser after matching their exposure and contrast.

4. If the files have coded names, go through all the images and give them names that will serve as titles. This will make it much easier to retitle images when you do the final editing on your gallery in your HTML editor (e.g., Macromedia Dreamweaver or Adobe GoLive).

Once you've done all this, use the Photoshop Browser to pick the images that are most in need of editing. Then use the following routine for each of those images:

1. Crop and transform the image to improve composition and straighten perspective.

2. Use the Levels command to adjust the range and brightness of that image.

3. Use the Curves command to tweak the brightness and contrast of the image, if needed.

4. Use the Soft Light layer technique (and/or Photoshop Shadows/Highlights command) to extend the range of shadows where needed.

5. Use a Brightness/Contrast adjustment layer for vignetting, burning, or dodging large areas. To do this, use the Lasso to select the general area and then feather the selection so that the Brightness/Contrast command will blend smoothly with the rest of the image.

6. Use the Hue/Saturation command to bring the images' colors to life, if necessary.

7. Consider *preframing* your images. The quickest way to do fancy framing is to pick a plug-in that automatically frames images, create an Action that preframes one image, and then use the Photoshop File Browser's Automate→Batch command to frame all the images in the gallery.

8. You may want to watermark the images that will appear in your web galleries. Refer to the "Protecting Your Copyright with Watermarks" section earlier in this chapter.

If you've followed the recommendations above, you'll find that most of the automated web gallery routines do a decent job of optimization on their own. (If they don't, see the "Optimize Images for Web Viewing" section earlier in this chapter for information on how to do it yourself.) Note, however, that what you'll actually be doing is optimizing the images individually and substituting them for the images automatically optimized by the web gallery application.

Put Together the Web Gallery

Great web designers are expensive to hire and hard to find. Even if you do end up having someone else do most of your web design, it's a good idea to learn enough about it to speak knowledgeably to your designer and to have reasonable expectations.

You'll probably end up creating web portfolios and email/CD portfolios in Photoshop or Lightroom since they are the applications you'll have at your disposal and they get better at it with each new version. However, it would be worth your while to examine all the products mentioned in this section

> ### A Solid-Color Frame
> If you just want a quick, solid-color frame, record the following Action. First, choose Select All; choose Image→Canvas Size and increase the canvas size by half the number of pixels you want in the frame; choose Edit→Stroke and enter a pixel width for the frame that's twice the desired width (the other half will be outside the current canvas); choose the color you want for the frame and click OK. Stop recording the Action. You can now play it for all the images you want to frame.

because each one creates galleries (portfolios) in different styles and some of them have bigger style collections. For example, Figure 12-34 shows a web gallery dialog in Photoshop CS2.

Figure 12-34. Creating web gallery created in Photoshop CS2.

Creating the pages is the easy part; you can do it in either Photoshop (actually Version 6 and above), in Photoshop Elements 2-4, or in Lightroom, each of which offer different sets of gallery styles. The styles in Photoshop CS2 are much more professional and flexible than those in earlier versions. With a basic understanding of HTML, it is quite easy to customize any gallery you automatically create. Photoshop writes the end result in legal HTML code, which you can easily edit using the search and replace command in your HTML editor if you want to change the positioning, size, text style, or any other characteristic of an element.

> **NOTE**
>
> *If you've followed my advice about keeping an original JPEG library for each gallery, you can even create larger image sizes in your editor. You'll know which image belongs in each frame, so just run Image Processor to re-size the originals to the size you want and then paste them into the large space specified in your edited version of the gallery.*

The following method will give you a good idea of how to create an automatic portfolio in Photoshop. By studying the screen shots, you'll see that you have quite a few modifiable style and format options.

1. Use the keyword search capability in Bridge to locate, organize, and place the photos into any of the individual galleries. Once the search is completed, you'll see all of the thumbnails for the photos in the Bridge Workspace. Select all the images you want to include or (better yet) use a label color you rarely use for anything else or that you use to designate pictures to include in a project. Then use the Unfiltered menu to show only the images with that label.

2. From the Bridge menu, choose Tools→ Photoshop→Web Gallery. The Web Photo Gallery dialog will open, as shown in Figure 12-35.

3. Choose the Style you want to use. You'll get a preview of these styles each time you choose one, so you can go through the list until what you see is as close as possible to what you want. Actually, I'd suggest you choose about six images in the Browser and then create a test of each style.

4. When the gallery opens, make a screen capture of each "page" in the gallery. Then paste the screen capture into a Photoshop New file with an 8×10 dimension at printer resolution. You can then put the gallery style, settings, and both the thumbnails and large image view on the same page and print out a catalog. You'll get a much better of what style you want to use for what purpose. Besides, you can show it to a client and let the client decide.

Figure 12-35. The Web Photo Gallery dialog.

5. Enter your email address in the email field—unless you don't want any feedback from the people who view your gallery, or want to make it really difficult for them to contact you.

6. Under Source Images, choose Folder as the source and click the Browse button to locate the folder into which you placed the images for the gallery. Be sure to uncheck the "Include all Subfolders" box unless you had a very odd way of storing your images. Next, click the Destination button, browse to the location where you want to place the finished web gallery and HTML code, and create a folder.

7. Now comes the fun part: choose the Options settings that will allow you to customize your gallery. In Photoshop CS2, they appear as a set of configurable items inside the Options box that switch depending on which drop-down menu is selected (see Figure 12-36).

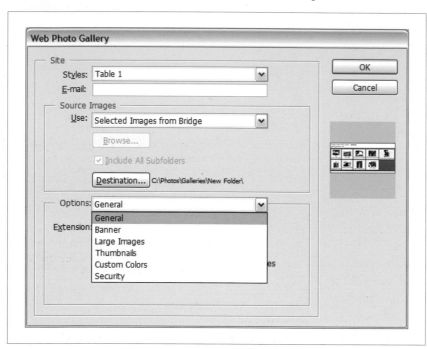

Figure 12-36. The options in Photoshop Album's Web Photo Gallery dialog.

— NOTE —

In order for the Titles Use settings to have any effect at all, you must have entered additional EXIF data in the File Browser for the images in your gallery before you start creating the gallery according to these instructions. To do this, open the source image folder in the Photoshop CS File Browser. Click the Metadata tab in the bottom left of the File Browser dialog and scroll down until you start to see pencil icons in the left columns, which indicate editable fields into which you can enter data. (Note that this does not work in Photoshop Elements 2.0.)

8. Choose Banner from the Options tab or drop-down menu. In the Site Name field, enter the name as you want it to appear on your site. In the Photographer field, enter the name of the person or organization you would like to designate as the owner of the photo (e.g., yourself). You can actually enter any information you wish in any of the Banner Options fields. For instance, I put all my contact information in the Contact Info field, but if I want to include ordering instructions or comments about the photos, I write that information in the Date field. (I don't like to "date" my galleries, unless it's a private gallery for use by a specific client, where the creation date might be important. Note that the date is automatically entered in the date field by default, so be sure to delete it if you don't want that information there.) Finally, you can change the font style and size of the banner text—just be sure to choose a small enough font size that all your information will fit within the banner when the gallery is displayed on the Web.

Getting Feedback on Styles

There are many noteworthy features in Photoshop Web Gallery command, such as gallery styles with the word "feedback" in their name. Choosing one of these styles creates a gallery with a feedback banner that appears beneath the large image. If the viewer clicks the feedback banner, a two-tab dialog appears. One tab says "Image Info" and the other says "Image Feedback."

If the Image Info tab is clicked, all of the EXIF data for that image appears—provided you have told the program to preserve EXIF data. If the Image Feedback tab is clicked, an email form appears. The viewer can click the email tab, type a name into the Explorer User Prompt dialog, and click OK. This opens the viewer's OS-assigned email editor. The viewer can then type an email message of any length and automatically mail it to the address assigned to that web gallery.

9. Choose Large Images from the Options drop-down menu in Photoshop (see Figure 12-37). The options presented here tell Photoshop how to resample and resave your existing images for the Web. Happily, Photoshop does all the work for you, saving you much time and pain. These settings also allow you to customize the look of the currently chosen style. For example, you can automatically place borders around the images. Note that you can't choose the border color, but you can change the width of the border by entering a specific number of pixels in the Border Size field. You will also notice a Titles Use section with several checkboxes. This will extract the appropriate EXIF information about the photo and insert it into the title. Be sure to experiment to find the settings you like best.

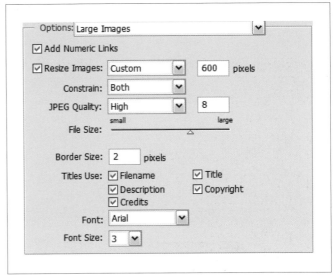

Figure 12-37. The Large Images options in the Web Photo Gallery dialog.

The Custom Colors tab or drop-down menu options will let you choose any color for the following items: Background, Text, Link, Banner, Active Link, and Visited Link. To change a color, simply click the color swatch for that item to bring up the standard Color Picker for your OS, and then follow the standard procedure for picking that color.

The remaining options are self-explanatory and a matter of personal preference. You'll often find that the defaults are the best choices for a given style. When you click the OK button at the top right of the Web Photo Gallery dialog (regardless of which Options screen is showing), the program will do everything it needs to do to optimize and size both the thumbnail and large images, implement all the options for styling the gallery, store the images in the appropriate folder, and write all the HTML code needed to run the gallery on your web site. When it finishes doing all that, your default file browser will automatically open and your web gallery will appear. It will behave exactly as it does on the Web.

NOTE

Options vary for different gallery styles. So if I've mentioned making a change that you don't find in the style you pick, either pick another style or just don't worry about it.

I believe it's important to use several different programs for creating automatic web galleries so that you can choose from a wider variety of prefab styles. That way, you can get some quick previews of a variety of visual alternatives. Most of these programs are quite inexpensive. Here's a few that I like:

iPhoto 06 (www.apple.com/ilife/iphoto)
 This Mac-only program has a new feature called Photocasting that Windows photographers will really yearn for—if you email a gallery to a client and then change the gallery on your computer, it will automatically update on the computer you sent it to. Imagine the possibilities.

ImageRodeo (www.imagerodeo.com)
 This Mac-only program is by far the best and most versatile of all the products that automatically create web galleries. There are 15 templates

that you can edit. You can also drag and drop to rearrange images in the gallery, delete the ones you don't want, and add your own HTML text and titles. Now, if someone would just make a program just like this for Windows, we'd all be happy. Here's the best part—sometimes the best things in life really are free.

iView Media (www.iview-multimedia.com)

This is a cross-platform, $49 program that does slide shows and web galleries. iView Media pro is $199 and gives you the added benefit of currently being the fastest and most efficient media management program for Windows.

ACDsee 8.0 (http://na.acdsystems.com)

This excellent $49 image management software for Windows lets you create web galleries for both your own and for their own online image sharing service.

Thumbs Plus 7.0 (www.cerious.com)

This Windows-only program comes in Professional ($89.95) and Standard ($49.95) versions. The program offers easy choices for background colors, generates easily editable HTML, and can be made to publish directly to your web site.

Express Thumbnail Creator (www.neowise.com)

Thumbnail Creator is strictly for making thumbnail galleries and uses editable HTML. There's a free trial download. The program is $39.95.

Ulead PhotoImpact 11 (www.ulead.com)

Windows only; not only does web galleries, but publishes web pages with interactive slide shows. In this latest version, you can edit your HTML galleries with JavaScript enhancements, according to the literature.

Ulead Photo Explorer 8 (www.ulead.com)

For a mere $29.95, you get a program that creates web slide shows or web galleries. There's a lot of versatility here; you can change the background color of all the elements, choose font styles (but not, oddly, text color), and choose from a number of template layouts. There's only one style, but it is very clean and professional looking.

Corel Paint Shop Pro 10 (www.corel.com)

This $79.95 package has many useful tricks up its sleeve. It will publish a single image to an HTML page, but doesn't create web galleries as a whole. It now comes with what used to be JASC PhotoAlbum, one of my favorites for automatic web gallery creation because it's intelligent enough to use the filenames as image titles without adding the file extension (which is usually one of the main reasons for editing the results of most other WYSIWYG HTML editors). You can also instantly add your own photos as backgrounds—just make them up in your image editing program and pop them in. The one issue I have is

that there's no way to scale the thumbnails and gallery shots; hopefully this will change with the next upgrade. The last upgrade added a couple of new features, not least of which was very nice automatic web gallery creator with a set of 40 templates that create easily edited HTML pages. Windows only.

Roxio PhotoSuite 8 (www.roxio.com)

This $29.95 program does a very complete job of letting you create and edit sites. The templates are oriented toward holidays and family photos and therefore do not look very commercial or business-like, but it is much easier to redesign various aspects of these templates than in most of the other programs. PhotoSuite also lets you send a web site as email, so you can make interactive attachments.

Extensis Portfolio 8 (www.extensis.com)

Available for both Mac and PC, it can now automatically generate web galleries that automatically update as you add new images to a category. I haven't tested it yet, but this sounds like a photographer's dream come true.

Canto Cumulus (www.canto.com)

Can export thumbnails to HTML, which is not the same as creating a web gallery. It creates a web page with thumbnails, but there's no obvious way to edit the page in Dreamweaver. A web publishing option for Cumulus, Web Publisher Pro, is available for $1,495. This add-on will publish in a Dreamweaver-compatible format and offers so many options that there's no room to cover them here. If you're interested in an industrial-strength solution, check out Canto's web site.

Create a Digital Slide Show

Creating a physical portfolio can take both time and money. Fortunately, the solution is easy: digital slide shows, such as the one shown in Figure 12-38, that will run on virtually anyone's computer. If there are only a few images in the slide show (or if you don't mind keeping them small), you can simply email them to anyone you like. If you want to show more or larger photos in the collection, you can record them to CD and drop them in the mail. At $0.30 to $0.50 per CD, you won't even mind too much if it doesn't get sent back—in fact, if the CD is kept and passed around the office, it may have a greater potential for bringing you new business.

It is every bit as easy to create slide shows automatically as it is to create web galleries. In fact, it's even easier because optimization is less critical (unless you're sending it via email) and because there's no need to do any HTML editing afterward. Using the method described below, you can create a slide show using Photoshop Album, Photoshop Elements 2.0, or any post-6.0 version of Photoshop. All of these programs create an Acrobat PDF slide show that can be played on any computer as long as a recent version of the Adobe

A Good Way to Start

Even if you want a very sophisticated design for your Web gallery, it's a good idea to start with a program that automatically creates it. This way, all the basic HTML is written and all the images are collected into the appropriate folders. You can then use a WYSIWYG HTML editor (such as Adobe Dreamweaver, Adobe GoLive, or Microsoft FrontPage) to open your site and tweak it from there. If you're familiar with Photoshop, a little practice makes it easy to change titles and captions, background colors and patterns, and text styles.

Before You Start Handing Out CDs

Be sure that the images on the CD are copyrighted and have all the pertinent metadata imbedded in them and that they are not print-quality size and resolution. I only give out DVDs that are 8×10 resolution JPEGs at no more than quality level 8. I also have a notice on the label that all images are copyright the owner and not licensed for publication.

PDF reader is installed. PDF readers can be downloaded and distributed for use on most computer operating systems and Internet browsers.

Figure 12-38. A digital slide show. You can view it as either pages in a PDF document or full-screen on the monitor (the default).

1. Before you get started, you might want to collect all the images for your slide show into their own folder. There is no need to resize images, since they will all be scaled automatically by the PDF routine. On the other hand, if you have only a dozen or so images, you can just drag them out of Bridge into the Elements 2 workspace.

2. In Photoshop, choose File→Automate→PDF Presentation. You will get the dialog shown in Figure 12-39.

3. In the PDF Presentation dialog, check the Add Open Files box if you have opened the files you want to include in Photoshop or Photoshop Elements 2. The names and paths of all these files will immediately

appear in the dialog. If you want to add more files or if you want to start from scratch, click the Browse button to navigate to and open any additional files.

4. The PDF presentation slide show doesn't offer any controls (e.g., stop, play, fast-forward, reverse, and pause); instead, it either runs automatically at timed intervals or changes slides when the viewer clicks the mouse button or Return/Enter. You can move back and forth in the sequence by clicking the Up/Down or Right/Left arrow keys as well. It is up to you how you want your slide show to run. Under Slide Show Options, check the Advance Every (integer) Seconds box and enter a specified number of seconds if you want your slide show run automatically. If the box is unchecked, the slides will advance only when the mouse is clicked.

5. Check the "Loop after last page" box to make the slide show play continuously until the Escape button is pressed.

6. You can use the Transition menu to choose between any of the specific transition types, or, if you choose Random Transition, the program will automatically change the transition type each time the slide changes. If you are making this show for a professional audience, I suggest you simply choose Dissolve or None (Cut) as the transition type.

7. To control image compression and scaling, click the Advanced button to bring up the PDF Options dialog. Set the options to the defaults shown in Figure 12-40, unless you have a specific reason to change them, and click OK.

8. Click OK in the PDF Slideshow dialog. A file-saving dialog will let you specify where you want to save the file. I usually save slide shows to the desktop—that way, I can easily find them when I want someone to view the show or when I want to quickly review certain slides.

Figure 12-39. The PDF Presentation dialog.

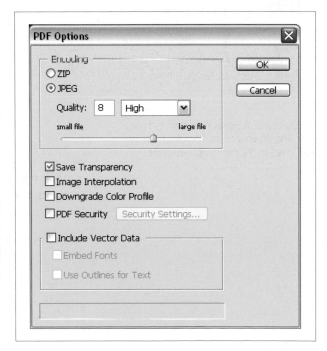

Figure 12-40. The PDF Options dialog.

NOTE

One way to give a unique look to slide shows is to create frames or edges for the images. Each slide show will then have a unique look and feel that is appropriate to the subject matter or will help brand your photographs as unique.

Several other Adobe products also create slide shows: Photoshop Album, Photoshop Elements 4, and Lightroom. For the most part, the third-party programs I mentioned above as capable of producing web galleries will also produce slide shows.

There are at least two advantages to using an alternative program:

- You won't need to worry about whether your target audience has a PDF reader installed.

- Other programs give your slide shows different design styles. Many of these may be too cute for a pro, but could be just the thing for a family or wedding client.

And just as with web galleries, you can create a unique look for your slide shows by preframing the images before you create the slide show.

Create a Text Slide

It is a good idea to create a text slide for the first image in the show so that your viewer can read instructions telling them to click when they are ready to move ahead and to press Esc to show the images as pages in a PDF document so that they can move to specific images at will. All it takes to create a text slide is to duplicate one of your horizontal images, flatten it, and choose Edit → Fill. Then choose Black (or whatever color you want) from the Color menu. Then use the Text tool and its Options Bar options, including Font, Size, and Color to type in the words you want on the slide. When you're done, flatten the image and save it as a JPEG in the same folder with all your other slides. Be sure to give it a name that's alpha-numerically going to make it the first slide.

Sell Through Other People's Web Sites

The more places your photographs appear, the sooner you will become a household name. However, you'll want to keep it looking professional at all times. The Web is no exception. There are any number of family photo processing services that allow you to post your digital images to the Web. These programs work in various ways, but for the most part, you have very little control over the appearance and layout of the pages. Visitors to the site can look up your name, browse your photos, and order any photos they'd like to add to their collections. A few of these sites allow you to require a password from anyone who orders the pictures, but you still have no control over the price or quality of the photos. As a professional or serious photographer, you are going to want to be in complete control over the pricing and distribution of your art.

Fortunately, there are many sites that cater to professionals and fine artists. Most of these sites will want a commission on your sales, which can be up to 50 percent. They may also jury your submissions (there is often a jurying fee), accepting only those artists who live up to their quality or artistic standards; they may also impose a waiting period. Many of these sites will help you set up pricing structures, payment options, shipping services, and promotional services. Different web sites offer different methods of selling your photography, such as the use of online galleries. You can use the site as a place for visitors to place orders for your work. You may also be able to work on cross-promotional deals with the site.

Each site listed below gets thousands of visitors per month, so they are a potentially great way to call attention to your work. Most of these sites cater to collectors, gallery owners, and art directors who are looking for artists with fresh approaches. Figure 12-41 shows a photo ordering site on Printroom.com.

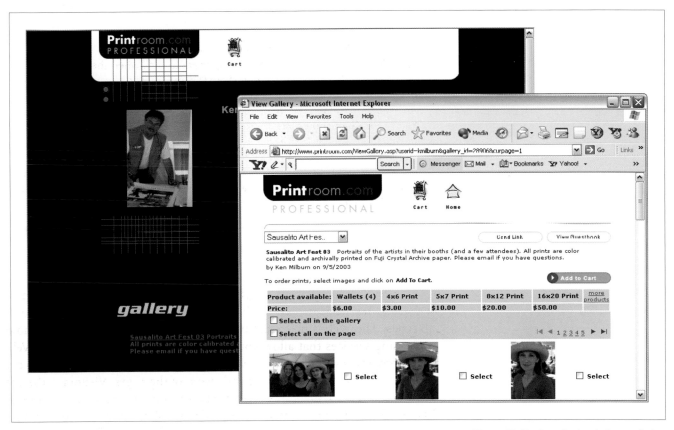

Figure 12-41. A professional photo ordering site on Printroom.com.

The gallery at photo-eye (www.photoeye.com)

Sells collector's prints from famous photographers and art prints from anyone who can get in. There is also a huge online collection of photography books. Just looking at these photos is an eye-popping education in great photography.

Mark Zane's International Photo Galleries (www.markzane.com)

Provides links to photographic gallery sites. You can submit your site for consideration and any sales are made directly from your site.

FolioFinder (www.foliofinder.com)

Lists bios and provides links to all sorts of artists, including photographers. FolioFinder does not enter into deals or act as an agent. This is a good place to go if you just want to see other photographers' portfolios or to find yet another place to house your own mini portfolio (limited to five images).

ArtistBiography (http://artistbiography.artprice.com/en)

Publishes bios and small folios (five images, maximum) of all artists who submit. There's no charge, but you must submit diplomas, prizes, exhibition announcements, and newspaper cuttings (as applicable) to establish the validity of your bio. This is a division of ArtPrice.com, which maintains a huge amount of information on the pricing of art.

ArtCrawl (www.artcrawl.com)

Currently has about 50 members, two of whom are photographers. You can have your own web address on the site and can change the content of what is shown at any time. There is an annual fee of $250 for up to 20 pieces, plus $5 for each additional piece.

ElectronicCottage (www.electroniccottage.com)

Features all sorts of artists, including photographers. The site claims to host links to more than 1,000 online galleries of photos. Listings must have their own domain names, so subsites are not accepted. Since this site simply guides others to your site, you can do all sales and other contacts directly. ElectronicCottage will view your site and decide whether it meets their standards; there's an extensive (but easily met) list of qualifications meant to ensure that the sites are tasteful.

Afterzed (www.afterzed.com)

Is sort of an all-purpose site—it's hosted by a web design firm that specializes in creating web sites for artists of all stripes. These designs are reasonably priced and look quite professional. You can also design your own site and use their web hosting services, or simply link to their site. If you take the last option, there is no charge.

This list is in no way exhaustive—it's only a beginning. I haven't really discussed any the plethora of online consumer photo processing sites, most of which will let you post galleries of your own images. Even though

they're more consumer-oriented, pros may find some uses for these galleries; for instance, they're a great way to have promotional items printed with your photos so that you can give them away at trade shows or sell them at outdoor exhibits. They also offer a quick way to get prints made on actual photographic paper. Below is a list of some of the best-known sites. A few of these sites allow you to download their profiles, so I suggest you test before ordering any large quantities. Even then, there's no guarantee that there won't be variations. One notable exception is Printroom.com, but then it's a service meant for pros.

Club Photo (www.clubphoto.com)
> Only sells prints in one size—4×6 at $0.19, no cut for the photographer.

DotPhoto (www.dotphoto.com)
> Lots of services and gifts, along with a full range of prints. You can also have unlimited online storage. Be careful, though. Anyone can order from this service. You might want to make your copyright clearly readable at the bottom of the image. Also offers mugs, calendars, 4×8 greeting cards (too bad they don't have a template for self-promotion), holiday ornaments and much, much more. Prints start at a dime and can be had in a variety of sizes.

ez prints (www.ezprints.com)
> Yet another $0.19 service, with cards.

Kodak EasyShare Gallery—formerly Ofoto (www.kodakgallery.com)
> Prints are made on Kodak photographic paper, not Fuji Crystal Archive (duh!). You can have prints made from 20×30 ($22.99) to 4×6 ($0.15). Wallet size prints come in sheets of four for $1.79. That's $0.45 each! There are also 17 different categories of gifts. Have a gallery party and give away one of these photo gifts to each attendee.

PhotoAccess (www.photoaccess.com)
> Also offers books. Strangely, they don't even let you look at their site or products without first registering.

Printroom.com (www.printroom.com)
> This site is a real blessing to any photographer who wants to provide a quick way for any subject to order pictures at a price the photographer sets. Printroom.com will also provide you with a profile. The quality of the prints I've had from them has been outstanding. You give the prospective customer a card, they go to the site, order prints, and you get a check for the amount you asked for minus the cost of the print (pretty comparable to the other online services mentioned in this list). Recently, they've added a means for allowing clients to purchase stock photos directly from Printroom.com.

A Slide Show on the Side

If you host open houses or do photo exhibits, you might consider running a slide show on a computer alongside the exhibit. That way, you can show many more images than you're likely to have room for on the walls. Slide shows of your images are also excellent for running before and after you make a presentation. They give you a chance to show a lot a people a portfolio or two.

Getting Above Wholesale

The problem with almost all of these photo processing sites is that anyone can order and download prints or projects made with your photos at the site's wholesale prices. One exception is Printroom. com, which has a division especially for professionals that will not allow downloads by anyone who is not paying the price you set for your prints. This can be an especially good scheme for event photographers who want to allow others to purchase pictures taken at the event, and may also have applications for fine-art photographers. Prints are made on photographic paper and prices are quite reasonable, so it's easy to make a profit. It's surprising that most of the other sites listed above don't offer similar services for professionals (yet). By the time you read this, some of them undoubtedly will let you set your own retail.

Shutterfly (www.shutterfly.com)

The typical array of 4×6 ($0.19) prints and the whole variety of other sizes up to 20×30 ($22.99). There's also a good variety of gifts and books.

Snapfish (www.snapfish.com)

The prints start at a mere $0.12 and the company brags that they are the best bargain online. The usual array of gifts is available, too.

Walmart.com Photo Center (www.walmart.com)

Click the Photo Center tab at the top of the page. They, too have $0.12 prints and you can walk right into a Wal-Mart store and use their photo kiosk.

Saving a Digital "Positive"

Regardless of how you decide to share your final images with the world, Once you've done all this work you've learned about in this book, you'll want to save final image that you've so carefully created.

> **NOTE**
>
> *You can do this for a single image, if it's one you've been spending a great deal of time on. If you've been doing more automated processing on groups of images, you can use the Image processor to do it for a whole group.*

Here's the process for flattening and converting a single image to TIFF:

1. Save the last version of the image, preserving all of its workstages in layers. Be sure to add the suffix "fnl" (for final) to the file name. Be sure the color profile is still Adobe RGB 1998. Also, place a copy in a folder you've created called Temp for Backup. Whenever that folder contains enough data to fill a CD or DVD (whichever covers the volume of work you've done in the two or three days), back it up to CD.

2. Either choose Layer→Flatten Image or go to the Layers Palette menu and choose Flatten Image.

3. Choose File→Save As. The Save As dialog will appear. Choose TIFF from the Format menu. Use the Save As Menu to navigate to the Temp for Backup Folder you created earlier. Create a new folder named after client code, subject/location, and date and open it. Click the Save button.

Here's the Digital Positive process for flattening and converting a group of images to TIFF:

1. Once you've finished each of the images and saved them with *.psd* and the suffix "fnl" added to the name, go to Bridge and open the folder you saved them to.

2. In Lightable mode, look for all the filenames that have "fnl" as a suffix. Temporarily place a label of a color you haven't used for anything else on those that belong in your target group.

3. From the Filtered/Unfiltered menu, choose the label color you just assigned to your group. Now there are no other files in the Lightbox, so press Cmd/Ctrl-A to select them all. Be sure to deselect any folders that happened to get selected.

4. Choose Tools→Photoshop→Image Processor. The Image Processor dialog will appear. Be sure to make all the settings as you see them in Figure 12-42.

Figure 12-42. Image Processor dialog.

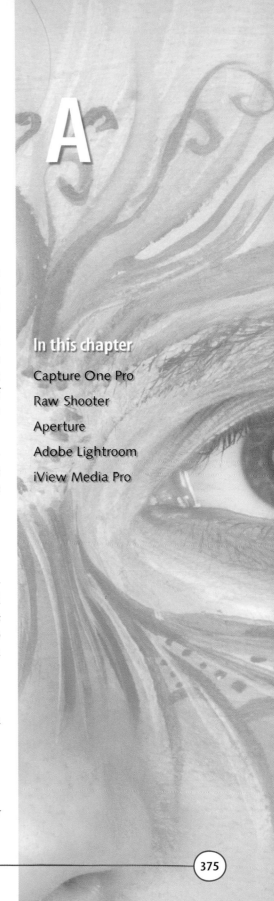

Workflow Alternatives

Most of this book has been devoted to processing your images files with the software that is included with Photoshop CS2, namely Bridge, Camera Raw, and with Photoshop CS2 itself. After all, that is the software that's almost guaranteed to be owned by virtually every serious photographer, and it does an amazingly good job and it's basically free (considering you've probably already paid for Photoshop). On the other hand, you may be one of those photographers who will absorb extra cost and expend extra effort if it improves the amount of time that you have to get more work done. If your hard work has paid off to that degree, by all means, take the time to inform yourself about the products listed below.

These products are significantly faster at loading, previewing, and magnifying so that you can get through your culling and ranking much more quickly. There are some exciting products out there, here's a look at some of them.

Capture One Pro

Capture One (see Figure A-1) has traditionally been the raw processing software to beat. These days, it's getting to be a close contest, but there are still plenty of pros that swear by it. It's definitely fast and gives you a bit more control than Camera Raw in some respects. You'll have to be the judge as to whether it's worth the extra cost and of giving up Camera Raw's integration with Photoshop.

Capture One's advantages are as follows:

- Is the program that has been traditionally up-to-date on digital camera back formats

- Has both Levels and Curves; can adjust individual color channels

- Multimode sharpening tools

- Apply one or multiple image settings by clicking a thumb or many thumbs or by preselecting and clicking the apply to all button

In this chapter

Capture One Pro

Raw Shooter

Aperture

Adobe Lightroom

iView Media Pro

- Can batch process in the background

- Has a focus tool for quickly checking thumbs for blurs, noise

- You can buy camera profiles (two come with the program)

Capture One's disadvantages are:

- Has traditionally lagged behind slightly when it comes to supporting brand-new cameras—although that gap seems to be narrowing of late

- Isn't integrated with Photoshop

To learn more, visit *http://www.phaseone.com/Content/Software/PROSoftware.aspx.*

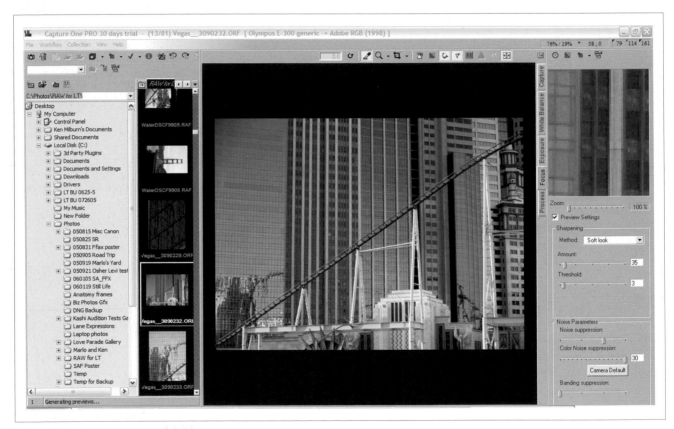

Figure A-1. The Capture One Pro interface.

Raw Shooter

People from the original development team for Capture One have formed their own company, Pixmantec, and created a new RAW image processor that is really catching the public eye and imagination. It's really too bad (for Mac GX users) that it's a Windows-only product. (If your Mac has an Intel processor, you could use Boot Camp.) The best news is that it comes in two versions: Premium and Essentials. Essentials is an excellent program and does enough things differently from Camera Raw that, in my opinion,

it's worth downloading...especially since it's free and always will be. It gives your images a somewhat different—and some would say better—"look" to your images than Camera Raw. Nevertheless, it's still completely non-destructive, so you could experiment with the results from both programs and save the one you like best as a high-bit PSD file. And at any time you or your client has a mind change about the image qualities, you just reload the RAW file and reprocess it.

Now, here's the thing you might really seriously consider: Raw Shooter Premium. It does virtually everything Capture One Pro does and costs $300 less. Figure A-2 shows you the basic Raw Shooter Premium interface.

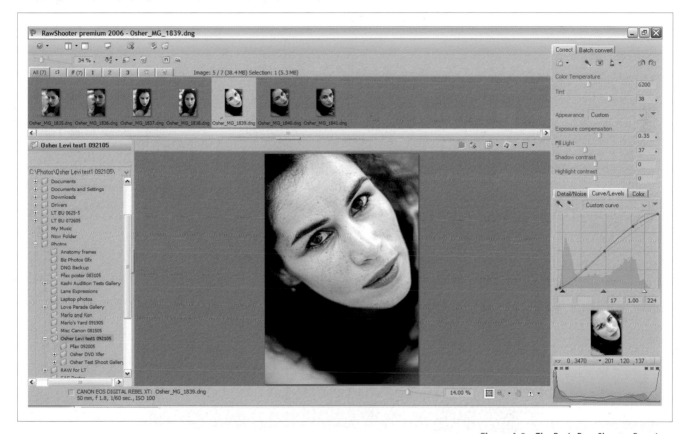

Figure A-2. The Basic Raw Shooter Premium interface.

There are quite a few features in RSP that are missing in Camera Raw. Many of these are nice, but optional. These are the ones that push my shutter button:

Direct download
 You can download directly from your camera card or card reader into any folder, including a default folder for downloading all RAW files, but I'm not so sure you'd be able to find similar images quickly unless you also used another program, such as iView Media Pro, Photo Mechanic or Portfolio for actually organizing your work.

All adjustment tools in one panel

So you don't have to go flipping through tabs to find the command you want.

Combination Curve/Levels tool

If you've used Photoshop's Curves and Levels tools, using these will be just as intuitive, but faster because both command sets are in the same interface, so you can use both interactively.

Instant Magnifier

I'd like it better if it was a tool (rather than a command), but it works really well (see Figure A-3). Just press Opt/Alt-M to toggle it on or off. If you place the cursor in the image and Opt/right-click, you get an in-context menu that lets you choose the size of the magnified area.

Figure A-3. The Instant Magnifier shows a 100 percent magnified view centered anywhere you place the cursor.

Adobe Acquires Raw Shooter

This program, and the company that makes it, have recently been acquired by Adobe, and their code will be appearing in the released version of Lightroom and in Bridge/Camera Raw for Photoshop CS3.

Aperture

If you own a very fast (think dual-core, and more is more) Mac with (at least) a gig or (better) two of RAM (think 4 MB) and you're thinking of investing $500 in Capture One, fuggedaboudit. Apple's new production processing and workflow software does more and does it at blazing speed. It is designed from the ground-up to perform all the workflow stages you need to perform for either instant high-volume (think news and magazine) or fast turnaround (think ad and publicity agencies) pros. Aperture also does everything Bridge does, as well as having the most essential functionality of Photoshop itself. Since it can be made to plug-in to Photoshop, you can still use all the esoteric Photoshop features as well.

Adobe Lightroom

On the other hand, if you're a Mac user, before you decide on Aperture, download and test Adobe's Lightroom Beta. If you go to *http://digitalmedia. oreilly.com/lightroom*, you'll find a whole new "Overview" chapter on the Beta 3 version of Lightroom and exactly what it can do. In fact, you'll find a whole web site dedicated to this new product that will keep you up-to-date with what is surely a future workflow linchpin. It isn't as pretty to look at as Aperture (although it is quite lovely all the same), or as feature rich (yet...Lightroom is far from finished). On the other hand, Aperture costs more and takes significantly more computer overhead. All I'm doing here is telling you what's really worth your consideration. The thing about workflow products is that the complexity of workflow takes time and energy to set up and organize. So whatever you settle on is going to be very hard to let go of.

> **NOTE**
>
> *If you're a Windows user (and now the majority of Photoshop users are), Aperture isn't a choice, but Lightroom is now available in a rough beta.*

The thing that really makes choosing Lightroom a no-brainer is that the routines for adjusting the image include everything we are already familiar with in Camera Raw. So there's very little to have to re-learn and a whole lot to gain in terms of speed and efficiency.

iView Media Pro

If you're a Windows user and can't wait for Lightroom because you have to speed up your ranking, winnowing, and filenaming, you can download iView Media Pro's 30-day trial version. I've been using it since I started looking into Lightroom and realized what a bottleneck accurate winnowing could be in the process of establishing an efficient workflow. A friend at a

local ASMP meeting showed me this program after I described Lightroom. I immediately downloaded the trial copy, dumped a whole card full of RAW images into its open window and was amazed to see all the thumbnails appear almost instantaneously. You can quickly trash the obvious duds (such as the infamous picture of your feet). To eliminate those images in which the timing or composition is off, you can instantly click a tab to go to a full-screen, full-frame view and see them all by pushing the Page Down key, and press a key combo to trash any near misses. To get rid of any slightly unsharp photos in a series, double-click the first thumb in that series to see it at 100 percent and page up and down through the series, deleting any image that isn't as sharp as its predecessor. There's also a very nice Batch Rename command that works several times faster than doing the same thing in Camera Raw. iView will do much more, but I usually switch over to Camera Raw at that point just because I feel more secure in that environment and because I know I'll be moving on to Lightroom when the time comes.

Index

presentation (*continued*)
 galleries, 13
 PDFs, 14
 contact sheets, 343–344
 event monographs, 348–349
 limited-edition book, 347
 portfolios
 binder portfolios, 346
 boxed, 346
 postcards, 349–351
 sell through others' sites, 368–373
 web, 351
 optimizing images, 351–354
 watermarks and, 355–356
 web gallery, 356–359
previews, Bridge, 44–45
printer
 calibration, 330–343
printing
 postcards, 350
profiles
 creating, 331, 332–335
 downloading, 331
program mode, 25

R

radial blurs, 272–273
ranking images, 11
 Bridge, 38
 JPEGs, 71
 light table, 69–71
 RAW, 71–72
 RAW files, CS2, 108–109
RAW
 Adjust tab, 81–86
 advantages, 75
 archiving files, 77
 automation, 100–103
 auto adjustments, 79
 Bridge, ranking images, 71
 Calibrate tab, 94–100
 color balance, 75
 color fringing, 92–93
 converting files to Adobe DNG, 7
 cropping, 79–81
 CS2 and, multiple files, 107
 CS2 Elements 4 comparison, 105–106
 Curve control, 78

Curve tab, 87–88
deleting files, CS2, 108
Detail tab, 88–90
DNG and, 73–79
effects, 109–122
 black and white images, 120–121
 dynamic range, HDR command, 112–115
 dynamic range, multiple renditions, 110–112
 high-key version, 115–119
 low-key version, 119–120
 multiple exposures, 110
 toned monochrome, 122
exposure, 76, 84–86
image processor, 103–105
Lens tab, 90–93
leveling, 79–81
losers, 76
multiple files, 76
nondestructive editing, 75
Photoshop, 16-bit mode, 77
Photoshop CS, 77
pre-setting camera and, 18
ranking, CS2, 108–109
saving, CS2, 109
settings, Bridge, 103
vignettes, 90–92
when not to shoot, 24
white balance, 81–83
winnowing, 100
Raw Shooter, 376–378
re-lighting portraits, 211–213
reflector, 23
regional adjustment layers, Blend modes, 182–183
renaming, 11
 batches, Bridge, 45–47
 files, Bridge, 47
 image batches, Bridge, 55–56
renditions, multiple (RAW), 110
repair projects
 glamour photography, 202–210
 restoring youth, 200–202
 (see also Healing tools)
Repair Toolkit, 190
 Healing tools, 190–192
Replace Color command, destructive adjustments, 168
retouching, client approval, 12
rotating images, Bridge, 47–72

S

saturation, 159
 Adjustment layers, 130
 mapping to new color model, 160
 when to change, 159
Screen Blend Mode, targeted adjustments, 187
Screen mode, glamour photography, 210
screen size, 4
scripting, Bridge and, 39
searches, Bridge, 65–66
selections
 alpha channels, 174
 from black and white images, 176–178
 brightness/contrast, 174–175
 from knockouts, 178–179
 layer masks, 181
 lifting to new layer, 180
Selective Color adjustment layer, 153
Selective color option, Adjustment layers, 130
sell through others' sites, 368–373
sensor-cleaning kit, 3
sensor noise, Detail tab (RAW), 89
sepia-toned images, 122
sepia effects, 299
sequences, stop action and, 33
sequence shooting, 2
Shadow/Highlight command, destructive adjustments, 169
shadows
 knockouts, 246
 levels, 139
 targeted adjustments, 183–188
Shape blur, 268
sharpening, 299
 Detail tab (RAW), 88–89
 effects sharpening, 300–301
 Smart Sharpen, 302
Shutterstock, 229
shutter priority, when to use, 25
shutter speed, stop action and, 32
silhouette, portrait enhancement, 216–222
situational calibrations, 98
slide show, Bridge, 40
Smart blur, 268
Smart Object, montages, 231–232

Ken Milburn started his career as a professional photographer when he was still in high school by specializing in weddings and portraits of his classmates. Since then, his photographic career has included starlet publicity photos for Universal Pictures, album covers for several labels (including Capitol Records), editorial work for a number of publications (including *The Los Angeles Times Sunday Magazine* and *TV Guide*), and a long list of advertising clients (including Southern California Gas, Cole of California, Strega Liqueurs, and the Fleur Corporation). He sells his photographs and digital art at art festivals and fine art galleries, and his work has been featured three times in *Design Graphics Magazine* and twice in *Computer Graphics World*. Most recently, he won *Sunshine Artists Magazine*s annual award for best art festival poster of the year; the poster was featured on the cover of the May 2006 issue.

Ken's photographic career has been paralleled by a long career as a writer. He started by writing two feature films, but most of his writing has been in the form of columns, how-to articles, and technical books on the subject of computer graphics. He has written more than 300 columns and articles (many of which have featured his photographs) for such national trade magazines as *Publish*, *DV Magazine*, *MacWorld*, *Computer Graphics World*, *PC World*, and *InfoWorld*. He has also been a contributing editor and columnist for *Computer Currents* and *MicroTimes*.

In addition, Ken is the principal author of 27 computer books, the majority of which focus on various versions on Photoshop and digital photography. Ken is the author of both the first and second editions of *The Digital Photography Bible* (Wiley), as well as *Digital Photography, 99 Easy Tips to Make You Look Like a Pro* (Osborne), *Photoshop Elements 2.0 Complete* (Osborne), *The Photoshop 7 Virtual Classroom* (with live-motion lessons on the CD-ROM), *Master Visually Photoshop 6.0* (Wiley), *Master Visually Photoshop 5.5* (Wiley), and *Photoshop 5.5 Get Professional Results* (McGraw-Hill). His latest books are *Photoshop CS2 for Photographers Only* (Wiley) with co-author Doug Sahlin and, of course, the first edition of *Digital Photography: Expert Techniques* (O'Reilly).

Ken has taken his Photoshop and digital photography expertise to an even broader user base by working as a contributing editor for the *MSNPhoto* web site, authoring user hints for the *PhotoWorks* online film processing and printing service, and serving as an instructor for three courses at *www.sessions.edu*.

Colophon The cover images are original photographs by Ken Milburn. The cover fonts are Linotype Birka and Adobe Myriad Condensed. The text and heading fonts are Linotype Birka and Adobe Myriad Condensed, and the sidebar font is Adobe Syntax.

Better than e-books

Buy *Digital Photography Expert Techniques*,
2nd Edition, and access the digital edition FREE
on Safari for 45 days.

Go to www.oreilly.com/go/safarienabled
and type in coupon code 7UIA-5ZAG-JQTQ-9JGY-ZM4G

Search
thousands of
top tech books

Download
whole chapters

Cut and Paste
code examples

Find
answers fast

Search Safari! The premier electronic reference
library for programmers and IT professionals.

O'REILLY NETWORK
Safari Bookshelf

Addison Wesley

Adobe Press

Sun microsystems

O'REILLY

SAMS

ALPHA

New Riders

Java

Cisco Press

Microsoft Press

que

macromedia PRESS

Peachpit Press

PRENTICE HALL PTR

Related Titles from O'Reilly

Digital Media

Adobe InDesign CS2
One-on-One

Adobe Encore DVD: In the
Studio

The DAM Book: Digital
Asset Management for
Photographers

Digital Audio Essentials

Digital Photography: Expert
Techniques, *2nd Edition*

Digital Photography Hacks

Digital Photography Pocket Guide,
3rd Edition

Digital Photography:
The Missing Manual

Digital Video Hacks

Digital Video Pocket Guide

Digital Video Production
Cookbook

DV Filmmaking: From Start
to Finish

DVD Studio Pro 3: In the Studio

GarageBand 2: The Missing
Manual, *2nd Edition*

Home Theater Hacks

iLife '05: The Missing Manual

iMovie 6 & iDVD:
The Missing Manual

InDesign Production
Cookbook

iPhoto 6: The
Missing Manual

iPod & iTunes Hacks

iPod & iTunes: The Missing
Manual, *4th Edition*

iPod Fan Book

iPod Playlists

iPod Shuffle Fan Book

PDF Hacks

Stephen Johnson on Digital
Photography

Window Seat: Photography and the
Art of Creative Thinking

O'REILLY®

Our books are available at most retail and online bookstores.

To order direct: 1-800-998-9938 • *order@oreilly.com* • *www.oreilly.com*

Online editions of most O'Reilly titles are available by subscription at *safari.oreilly.com*

The O'Reilly Advantage

Stay Current and Save Money

Order books online:
www.oreilly.com/order_new

Questions about our
products or your order:
order@oreilly.com

Join our email lists: Sign up
to get topic specific email
announcements or new
books, conferences, special
offers and technology news
elists@oreilly.com

For book content
technical questions:
booktech@oreilly.com

To submit new book
proposals to our editors:
proposals@oreilly.com

Contact us:
O'Reilly Media, Inc.
1005 Gravenstein Highway N.
Sebastopol, CA U.S.A. 95472
707-827-7000 or
800-998-9938
www.oreilly.com

Did you know that if you register
your O'Reilly books, you'll get
automatic notification and upgrade
discounts on new editions?

**And that's not all! Once you've registered
your books you can:**

» Win free books, T-shirts and O'Reilly Gear

» Get special offers available only to registered
 O'Reilly customers

» Get free catalogs announcing all our new
 titles (US and UK Only)

**Registering is easy! Just go to
www.oreilly.com/go/register**

O'REILLY®

BOCA RATON PUBLIC LIBRARY, FLORIDA

3 3656 0373103 7

775 Mil
Milburn, Ken, 1935-
Digital photography